CRACKING
CODES

— THE —

ROSETTA
STONE

AND DECIPHERMENT

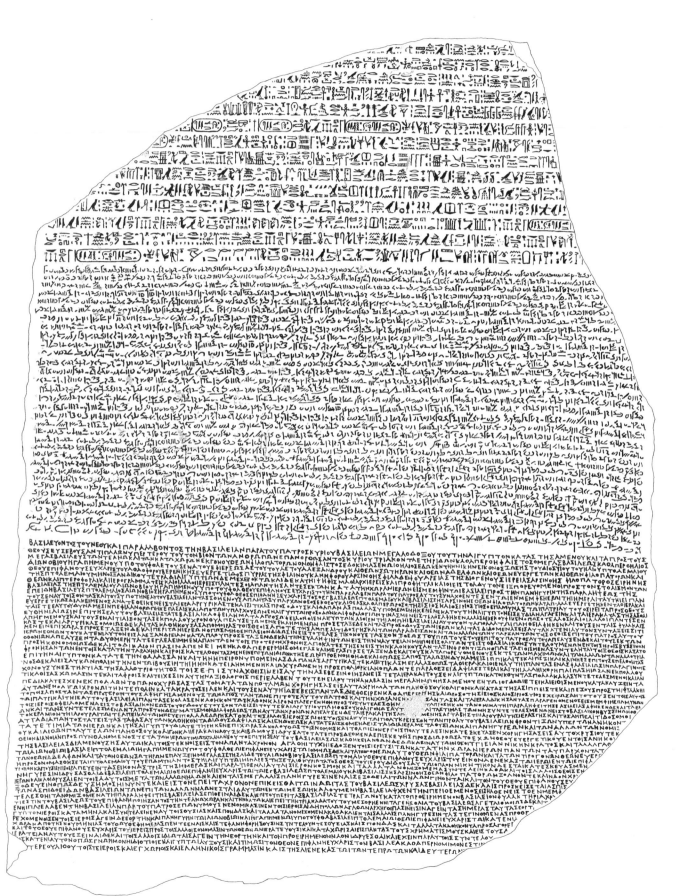

CRACKING CODES

THE

ROSETTA STONE

AND DECIPHERMENT

RICHARD PARKINSON

WITH CONTRIBUTIONS BY

W. DIFFIE, M. FISCHER

AND R.S. SIMPSON

BRITISH MUSEUM PRESS

First published in 1999 by British Museum Press
A division of The British Museum Company Ltd
46 Bloomsbury Street, London WC1B 3QQ

A catalogue record for this book is available from the British Library

ISBN 0 7141 1916 4

Designed by Harry Green
Typeset in Bembo
Hieroglyphs typeset by N. Strudwick in the Cleo font,
designed by Cleo Huggins, based on the font commissioned
by A.H. Gardiner and used by Oxford University Press

Printed in Great Britain
at Cambridge University Press

FRONTISPIECE
Facsimile drawing of the Rosetta Stone, by S. Quirke

CONTENTS

O craftsmen of Thoth,

entire teams of the Ibis,

who travel guided by the heart,

... who look at these inscriptions

– fix your heart on the contents,

without neglecting special phrases! Copy the texts!

Be firm in its utterance, to perfection!

STELA OF PETEHORNEBKHEM, *c.* AD 140

Le lecteur-modèle d'aucun Égyptien n'est un égyptologue.
Celui-ci, en revanche, ne peut savoir comment étaient
les lecteurs-modèles des anciens, puisqu'il ne peut
même pas connaître leurs lecteurs réels, la lecture,
par nature, ne laissant pas de traces.

The model reader of any Egyptian writer is not an Egyptologist.
The latter, on the other hand, cannot know what the model readers
of the ancients were like, since he cannot even know their
actual readers, reading by its nature leaving no traces.

PHILIPPE DERCHAIN, *Le dernier obélisque* (Brussels, 1987)

LIST OF ABBREVIATIONS AND CONVENTIONS

CONVENTIONS

()	Indicates a cartouche in the original text.
<>	Pointed brackets indicate an erroneous omission by the ancient copyist in translated matter from an ancient text.
{}	Curled brackets indicate a superfluous addition by the ancient copyist in translated matter from an ancient text.
[]	Square brackets indicate gaps due to damage to the manuscript in translated matter from an ancient text.
★	An asterisk indicates a hypothetical reconstruction of a word, or a hypothetical grammatical example.
SMALL CAPITALS	Written in red in original.

FOREWORD

One of the most famous antiquities in the world, the Rosetta Stone needs little introduction. Discovered in July 1799 at Rosetta (now el-Rashid) in Egypt's north-west Delta, and part of the British Museum's collections since 1802, the Stone, a fragmentary granite stela inscribed with a bilingual text in ancient Egyptian and Greek, played a crucial role in the eventual decipherment of Egypt's hieroglyphic script – a beautiful but complex writing system, true knowledge of which had been lost for over thirteen centuries.

The special exhibition 'Cracking Codes: The Rosetta Stone and Decipherment' has been mounted to celebrate the bicentenary of this momentous discovery. It tells the story of the Stone's fortuitous unearthing, of the sustained scramble for the prize of decipherment, of the dramatic breakthrough after years of frustration, and of the brilliant final 'decoding'. Placing the achievement in its wider context, it compares the hieroglyphic script (and its derivatives) to other writing systems, and its decipherment to that of other ancient scripts. It explores in depth the role of writing in ancient Egypt – its aesthetic, iconographic and magico-religious properties, as well as its more mundane scribal uses – and considers the extent to which the cracking of a linguistic code and the reading of a text allow one to 'read' the underlying cultural code, inevitably an uncertain process in the case of a long-dead society. It also assesses the relative efficiency of different types of script and questions the widely held but simplistic view that the modern western alphabet represents the high point of a process of evolution. It ends with the future, with codes yet to be cracked, with scripts still unyielding of their secrets, patiently awaiting their own 'Rosetta Stone'.

The exhibition contains over two hundred objects, most of the them, including of course the Stone itself, from the British Museum's collections, a small but significant number from other sources in the UK and abroad. The curator of the

exhibition is Dr Richard Parkinson, an Assistant Keeper in the Department of Egyptian Antiquities and an authority on ancient Egyptian literature, who has worked throughout in close collaboration with staff of the Museum's Design Office and of the Conservation Department, who in preparation for the exhibition have cleaned the Stone carefully and to wonderful effect. Dr Parkinson is also the principal author of this associated volume, which contains a selective, fully illustrated catalogue of the objects on display, and is divided into four main sections, with an explanatory narrative. It includes a brief but highly stimulating contribution by Dr Whitfield Diffie of Sun Systems Ltd, California, and his wife Mary Fischer, an Egyptologist, on the subject of modern cryptanalysis and its applicability to undeciphered scripts; and a valuable up-to-date translation of the Rosetta Stone demotic text by Dr R.S. Simpson of Oxford. The final appearance of the book is owed to the expertise of Joanna Champness and her colleagues at British Museum Press.

The following individuals and organizations kindly agreed to loan material to the exhibition: Mr and Mrs Airey, M. and Mme Chateauminois, Mr Ronald Searle, Mr and Mrs S.Z. Young, the Ägyptische Museum und Papyrussammlung, Berlin, the Ashmolean Museum, Oxford, the European Space Agency, the Musée de Picardie, Amiens, the Musée Champollion, Figeac, The National Trust, the Ronald Grant Archive, London and the Victoria and Albert Museum. We are enormously grateful to them for their co-operation and for helping us to make 'Cracking Codes' worthy of the great anniversary that it marks.

W. V. DAVIES
Keeper of Egyptian Antiquities
British Museum

PREFACE

Read on, Reader, read on,
and work it out for yourself

S. SMITH, *Novel on Yellow Paper* (1936)

This book examines some aspects of decipherment to celebrate the bicentenary of the discovery of the Rosetta Stone in 1799. It presents a range of cultural (and mostly textual) artefacts from Egypt to show how writing shapes and is shaped by cultures, and how it can allow us to enter a dialogue with the past in interpreting its records. It does not provide a narrowly focused description of the Stone's contents, context or decipherment, since several such are already widely available; instead it presents an accessible account of various questions aroused by the Stone.

Most of the following chapters are narrative, but the centre is a catalogue; this format has been adopted to allow the reader to come face to face with some of the artefacts and sources. Due to limitations of space, this is a selective catalogue of items in the exhibition that this publication accompanies. Attempts have been made within the format to provide translations of at least samples of each text; I have only rendered into verse those texts from the catalogue which are marked as such by verse-points, although most are in metrical form. Pieces have been selected with the aim of presenting hitherto unpublished items, and have been drawn from the better known periods of Egyptian history in order to increase accessibility for the general reader; references have likewise been kept to the minimum and are not comprehensive.

It is always an exciting challenge to have to write about artefacts and phenomena that are millennia outside one's area of specialized study, let alone from different cultures, and I am grateful to colleagues who have corrected some of my errors when dealing with these areas: Dominique Collon, Vincent Daniels, Christopher Date, Irving Finkel, Lesley Fitton, Lynn Meskell, Andrew Middleton, Eric Miller, Mike Neilson, Robert Simpson, Dorota Starzecka, Derek Welsby, Ted Woods. Jacob Simon of the National Portrait Gallery kindly offered an opinion of the portrait of Thomas Young, which was generously lent to the exhibition by Mr

and Mrs Simon Young. Bruce Tate facilitated a trip to admire the Bankes obelisk. Tom Hardwick chased several elusive items of bibliography.

I am extremely grateful to Whitfield Diffie, a noted modern cryptographer, and Mary Fischer for contributing a masterly summary of decipherment and cryptography, and to Robert S. Simpson for his recent translation of the Memphis Decree.

Thanks are owed above all to W.V. Davies for conceiving, enabling and supporting the project, and for generously providing money from Departmental funds to subsidise the colour plates. Within the Department of Egyptian Antiquities, Carol Andrews, English doyenne of the Rosetta Stone, has provided assistance and advice, especially about demotic, and cat. 22–5, all of which has been invaluable. John Taylor has offered much advice with objects, and Claire Thorne her specialized graphics skills. An immense debt is owed to the Departmental staff, particularly John Hayman and the Museum and Masons' Assistants, Claire Messenger and Tania Watkins. The conservation of the artefacts for the exhibition was coordinated by Eric Miller, and the conservation of the Rosetta Stone itself has been done by Eric Miller and Nic Lee; the result is breathtaking. The photographs have been taken by Jim Rossiter, Sandra Marshall and Janet Peckham. Iain Ralston has also provided much help in collating all manner of materials. The expertise of Jill Hughes and Jon Ould in the Design Office has been much appreciated. The production of the book has been overseen skilfully and calmly by Joanna Champness.

In the preparation of this publication Patricia Usick has been of invaluable assistance, interrupting her work on the Bankes papers to check facts, dates and complete sentences that I have lacked the time to achieve. Without her the text would not have been finished, and her research has also been integral to the exhibition. John Baines has read and commented on a draft of the text, which is indebted to him in both form and content.

Personal gratitude is also owed to two people in particular: my partner Tim Reid has sacrificed his own research time to read the text, which owes much to conversations with him about linguistic and interpretative matters; he has also patiently endured its tedious invasion of many domestic hours. The second person has been an ever-invaluable oracle on many matters, and has been shamefully, if generously, guilty of giving time that should have been better spent on his own inspirational work.

R.P.
Highgate

DECIPHERING THE ROSETTA STONE

Des prêtres égyptiens m'ont montré leurs antiques symboles, signes plutôt que mots,
efforts très anciens de classification du monde et des choses, parler sépulchral d'une race morte.

Egyptian priests have shown me their antique symbols, signs rather than words,
very ancient attempts at classifying the world and things, the sepulchral speech of a dead race.
M. YOURCENAR, *Mémoires d'Hadrien* (1951)

SCRIPTS

Museums are full of ancient voices, even though verbal expressions of passion, politics and belief are perhaps not what every Museum visitor expects to encounter; they think of collections as consisting of objects rather than of words. Nevertheless, the most popular single object in the British Museum is perhaps the Rosetta Stone, famous for the texts inscribed upon its surface which have made it an icon of all decipherments and of all attempts to access the ancient past in its own terms.

The distinction that is often made between text and artefact is a false one; the concept of philology as being opposed to archaeology has long been abandoned by scholars who realize that the recovery of the past is more than either practical archaeology or textual criticism alone. Texts offer one of several possible ways of reclaiming the past. Decipherment and reading, in particular, can be metaphors for understanding another culture, either dead or alive, whose every activity can be examined as a 'cultural text', as the anthropologist Clifford Geertz has done for the Balinese cockfight.[1] If objects and practices are cultural texts, texts are also cultural and material artefacts, inseparable from their social context and the means of their production and circulation within a society.

Egypt is a striking example of how integral texts can be to the preserved remains of a culture: out of over 110,000 objects in the British Museum's representative collection of Egyptian antiquities, around a third are inscribed with a text in some manner. This bias towards inscribed materials is not only the result of philologists and art historians rather than archaeologists forming the collections: in Egypt even mud-bricks could be stamped with texts, so closely united were writing and elite cultural production of any sort. Nevertheless, the prominence of certain types of text has lead to Egyptology's being overly concerned with philology, art history and political – as opposed to social – history, whereas

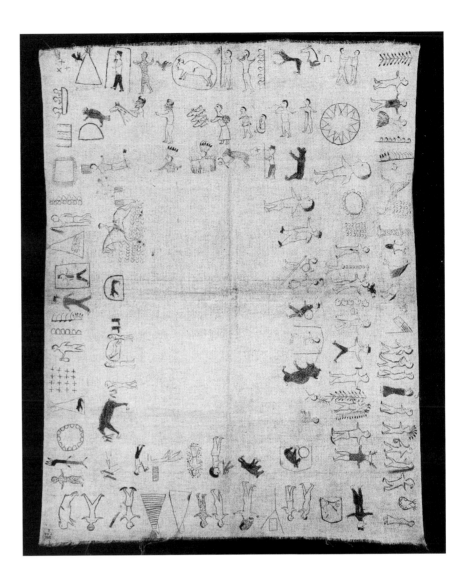

Fig. 1 A Yanktonai (Sioux) Winter Count, associated with Blue Thunder, with pictographs, one for each winter. 119 years are included, covering 1785 to 1901. The buffalo placed vertically represents the death of Sitting Bull, who was surprised in bed and killed by two Indian police sergeants, Red Tomahawk and Bullhead, on 15 December 1890, his arrest having been ordered on suspicion of fomenting the Ghost Dance. H. 112 cm. Ethno 1942.Am. 7.2.

attempts to recover the lives of ordinary individuals from most of society must comprise archaeological investigations. Archaeological data can be as eloquent as any text, and, as the Egyptologist John Baines has noted, archaeology and writing 'complement each other's silences'.[2] While it is impossible to travel to the past, a measure of dialogue with the dead is possible. In countering the constraints imposed by the passage of time, rigorous scholarship and archaeology are the only effective tools. Reading texts over the shoulders of the dead, as it were, is among the most immediate ways of entering such a dialogue.

The world's writing systems are numerous and varied. The reader of this book takes writing for granted, and it is surprisingly difficult to specify what one means by the term. The definition offered by Peter Daniels in *The World's Writing Systems* is 'a system of more or less permanent marks used to represent an utterance in such a way that it can be recovered more or less exactly without the intervention of the utterer'.[3] Writing is bound up with language, and thus picture writing (fig. 1) is not true writing, even though information can be

recorded with pictures, and writing can encode extra-linguistic information. Picture writing is often assumed to be a universal phenomenon, and was once thought to be the origin of all writing and even of language itself, through the means of sign language. It is, however, itself bounded by local interpretative conventions, as Thomas Sebeok realized when asked to devise a warning about nuclear waste sites in the form of pictures that could still be read precisely in future millennia.[4] Picture writing, such as Central American picture codices, is a mnemonic device that can prompt the reader to remember a narrative, but it can never record the exact phrasing of the original narrative.[5]

The pictorial nature of some scripts, such as Egyptian hieroglyphic, disguises the fact that writing relies on language. Written language and spoken language differ immensely. The impact of writing on societies and how it shapes cultural memory and expression are topics much discussed in anthropology: different societies have different conventions of what can be written and for what purposes, as much as they have different shapes of script. The prominence of the alphabet in the modern world favours the assumption that it is inherently the best writing system, but this is not the case, even though many studies, with titles such as *The Triumph of the Alphabet*, have presented the history of writing as an evolution towards this modern, primarily Western, ideal. This evolutionary model can suggest that the birth of writing was a single event, and it has sometimes been maintained that all forms of early script in the ancient Near East were derived from a single 'discovery' or 'invention', and that the appearance of writing in the Far East was a result of cultural contacts with the Near East. While this is conceivable, it is highly unlikely. The existence of independent writing in Central America was previously considered uncertain and its systems taken to be picture writing, but the recent decipherment of Mayan hieroglyphs has shown that it is a true writing system, and thus that writing has indeed independently arisen in different parts of the world. The predominance, or 'triumph', of the alphabet is due to the cultural fortunes of the users of alphabetic scripts rather than to the inherent superiority of the system.

'AMONG THE RUINED LANGUAGES'

The pictorial allure of hieroglyphs was felt by contemporary cultures throughout Egyptian history, as can be seen in Egyptianizing artefacts with pseudo-hieroglyphs from the Near East. Hieroglyphs also inspired an essentially alphabetic script in the empire of Meroe, and possibly also the Proto-Sinaitic script, which is arguably a distant ancestor of the modern alphabet. The Egyptian script, however, remained intimately bound up with Egyptian culture; unlike contemporaneous cuneiform scripts, Egyptian hieroglyphs were never used outside Egyptian dependencies.[6]

The Hellenistic Hermetic tractate *Asclepius* describes, in an apocalyptic section that was probably written in Egypt, how the former glory of Egypt would be overcome: 'Then this most sacred land, home of shrines and temples, will be completely filled with tombs and dead things. O Egypt, Egypt, of your religions

only fables will survive, unbelievable to posterity, and only words will survive inscribed on stones that narrate your pious accomplishments.'[7] Ironically, the 'words inscribed on stones' later came to indicate something mysterious and unintelligible. The Hermetic tractate survives in a Latin translation, and a portion of it also in a Coptic version in the Gnostic library discovered at Nag Hammadi and probably copied in *c.* AD 350. At this period, the hieroglyphic script had almost disappeared from use. The Roman emperors of the first two centuries AD could still commission hieroglyphic inscriptions, not only in the Egyptian heartland, but also on obelisks erected in Italy, such as that of Hadrian in memory of Antinous, who died in AD 130. This was probably placed in a mortuary chapel at Rome, where it is now in the gardens of the Monte Pincio (fig. 2).[8] Its inscribed text is skilfully composed in classical Egyptian, almost certainly by an Egyptian, and conceivably by a lector priest of the temple at Akhmim, called Petehornebkhem, who is known from a funerary stela. The inscription itself, however, was probably carved onto the obelisk in Italy. Nevertheless, the hieroglyphic script, which was a sacred system whose use was restricted to temples and similar monuments, had become increasingly cut off from the living scripts and languages of Egypt, and its last flowering on temple walls was in the third century AD.

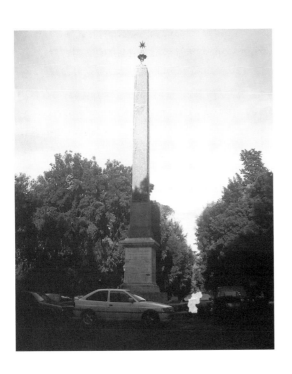

Fig. 2 The last Egyptian obelisk, erected by Hadrian. It was re-erected in the gardens of the Monte Pincio in 1822, some months after Champollion's decipherment. Courtesy J. Gathercole.

Pharaonic Egyptian culture was gradually subsumed in other cultures, and by the time its repute had arrived in the West, it had become irrevocably associated with oriental and antique mystique, in part through its distinctive religious and funerary practices. The hostile images of Egypt in the Bible compounded the indecipherable repute of hieroglyphs, which became synonymous with hidden and impenetrable mysteries. Accounts of hieroglyphs by classical authors survived into the European Renaissance; these understandably emphasized the symbolic pictorial nature of the script – its most distinctive aspect for people accustomed to an alphabet – and they conveyed little understanding of how hieroglyphs were read linguistically. Renaissance tradition continued to present each sign as an emblem, and elaborated on the neo-Platonic description of Plotinus (third century AD). It considered hieroglyphs to be a writing system that recorded pure things and ideas without the confusion of different languages, thus forming the 'best evasion of the confusion of Babel' in Thomas Browne's words.

These classical and European interpretations were not due to simple misunderstanding, but were a direct result of the Egyptians' tendency, particularly in the Greco-Roman Period, to foreground the script's figurative nature as 'a sensual presence of the greatest imaginable intensity'.[9] An influential Greek manuscript containing the *Hieroglyphics of the Egyptian, Horapollo* was recovered in 1419. The first part of this emblematic-style treatise was probably composed in Alexandria by a Hellenized Egyptian philosopher who lived at the end of the fifth century AD.[10] Its account seems to be based in part on native Egyptian lists

of hieroglyphic, hieratic and demotic signs, probably from libraries at Alexandria or Akhmim, which included explanatory and often theological glosses.[11] Thus the Renaissance view of hieroglyphs was part of a continuous tradition of reception, originating in the hieroglyphic writing system of the Greco-Roman Period. This system, with its elaboration on the script's symbolic aspects, should not be seen as the last vestiges of a written tradition sinking into obscurantism, but rather a final flowering of intellectual sophistication that ensured the tradition's survival by captivating the imagination of Europe in later centuries.

From the Renaissance on, attempts at decipherment involved a process of explaining the mystical significance of hieroglyphs rather than trying to read them. In his study of the obelisk now in the Piazza Minerva in Rome (1667), one of the most accessible Egyptian monuments at the time, the Jesuit antiquarian Athanasius Kircher (1602–80) claimed that 'the Sphinx has been killed, her riddles answered'. He interpreted the cartouche containing simply the name of King Apries (589–570 BC) as follows: 'The protection of Osiris against the violence of Typho must be elicited according to the proper rites and ceremonies by sacrifices and by appeal to the tutelary Genii of the triple world, in order to ensure the enjoyment of the prosperity customarily given by the Nile against the violence of the enemy Typho.'[12] Although Kircher's readings subsequently attracted derision, interest in and knowledge of Egyptian matters was stimulated by his publications, which included much work on Coptic, the language of Christian Egypt and now known to be the descendent of the language of pharaonic Egypt. The relevance of Coptic to the hieroglyphic script was, however, underestimated, since it was believed hieroglyphs could not record linguistic information directly. In 1741 the bishop of Gloucester, William Warburton (1698–1779), dismissed Kircher's attempts as neo-Platonic shadows of dreams, and argued (correctly) that hieroglyphs were not ways of concealing mysteries from the vulgar masses; but his publications offered little practical progress towards decipherment.

By the early eighteenth century neo-Platonism was no longer so influential, although reverence for the influence of Egypt continued to be strong in masonic circles (as seen in Mozart's *Die Zauberflöte* of 1791). The 'mysteries' encoded by the hieroglyphs came to be identified with Nature, and thus appealed also to Enlightenment scholars: hieroglyphs as a 'language of things' had a new appeal. The pictorially based Aztec and Chinese writing systems were explored as possible parallels, as they had been by Kircher, but these investigations did little to remove fundamental misconceptions about the script.

The first significant decipherment of an ancient script was that of Palmyrene, the language of which was known from the church fathers to be similar to Syriac.[13] In 1756 accurate copies of paired inscriptions in Greek and Palmyrene were published, allowing Abbé Jean-Jacques Barthélemy (1716–95) to correlate the two, and in the 1760s he also deciphered Phoenician on the basis of bilingual coin legends. In 1761 he suggested that the oval cartouches in Egyptian inscriptions might contain royal names, many of which were known from classical

authors, a suggestion that was fundamental to later progress. Cuneiform writing had been known since the discovery of Persepolis in the early seventeenth century. G.F. Grotefend (1775–1853) studied inscriptions from Persepolis and made the plausible assumption that certain names known from classical authors would occur in them. His comparisons produced values for about a third of the known signs, which was enough for him to identify the language as Persian with the help of comparative philology. This progress continued with the work of Henry Rawlinson (1810–95) and the Revd Edward Hincks (1792–1866), whose interest in cuneiform sprang from the hope that the inscriptions would help with the decipherment of Egyptian, which was his main interest. Hincks' publications marked great advances during the period 1846–52, and since Persian inscriptions were often accompanied by translations into other cuneiform scripts, his work went beyond a single decipherment.

Scientific studies of language were becoming more numerous, including the typological studies of the French *encyclopédistes*, and the comparative work on Sanskrit by Sir William Jones (1746–94). Many earlier investigations into historical languages had sought to identify the language spoken by Adam, the single original language of mankind given by God, which was usually suggested to be Hebrew.[14] In 1786 Jones noted in an address to the Asiatic Society of Calcutta that 'no philologer could examine the Sanskrit, Greek, and Latin, without believing them to have sprung from some common source, which, perhaps, no longer exists'. This statement of the Indo-European hypothesis is a milestone in the development of comparative philology.[15]

With Egyptian hieroglyphs the great impediments to progress were the lack of a large corpus of accurately copied inscriptions, the lack of any bilingual inscription and the false assumption that the script was not based on language, compounded by ignorance of the language of pharaonic Egypt. The Egyptian campaign of Napoleon (1798–1801)[16] marks the turning point in the modern history of ancient Egypt. As well as the campaign's political objectives against Ottoman rule in Egypt, it had symbolic overtones since it colonized in the name of the Enlightenment a country that was supposedly the origin of all wisdom. Napoleon himself had adopted the bee as a personal heraldic emblem, instead of the French royal fleur-de-lys, because the bee was a hieroglyphic symbol for 'ruler' according to classical authors.[17]

The French occupation of Egypt began in July 1798, and the invading force was accompanied by a body of scientists, scholars and artists, initially numbering 151 persons. Their work culminated in the magnificent and monumental *Description de l'Égypte*, whose volumes included antiquities, the modern state of the country and its natural history, and were published in that order of topics between 1809 and 1828.[18] The *Description* is now valued principally as a visual record, and although it provided access to many more inscriptions than had been previously available to European scholars, its attempts to analyse its discoveries were hampered by the savants' inability to read hieroglyphs. This inability prevented them, for example, from distinguishing between temples and palaces, as

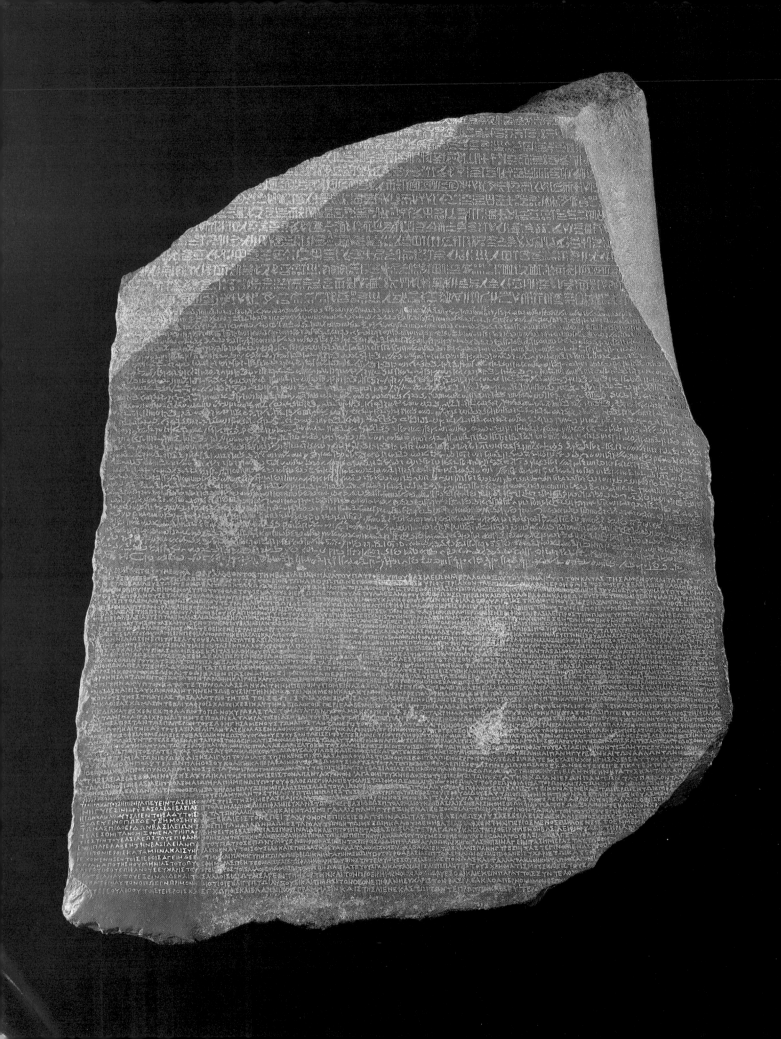

Fig. 3 The Rosetta Stone (EA 24). The area at the bottom left corner has been left unconserved to show the darkened wax and white infill.

Fig. 4 A view of the interior of Fort St Julien at Rosetta, the site of the Rosetta Stone's discovery. Courtesy M. Bierbrier.

well as causing them to date the Greco-Roman temples of Philae to 2500 BC.[19] The image of Egypt presented in the text volumes is idealistic, drawing on classical traditions, and is dominated by the ideas of Egyptian religion as a cult of Nature, of its society as ruled absolutely by a wise king, and of its priests as seekers after scientific truth rather than theologians. One consequence of the publication was the unleashing of a tide of Egyptomania in European art and design.

REVEALING THE ROSETTA STONE: DISCOVERY, PUBLICATION AND DISPLAY

As a result of the French campaign, a new piece of evidence concerning the nature of hieroglyphs was discovered in 1799. The Rosetta Stone (fig. 3, pl. 1) was quickly recognized as 'a most valuable relic of antiquity, the feeble but only yet discovered link of the Egyptian to the known languages',[20] and has become perhaps 'the most famous piece of rock in the world'.[21] To place its discovery in context, the same year witnessed Beethoven's *Grande sonate pathétique*, and the following year the appearance of Coleridge and Wordsworth's *Lyrical Ballads*, Malthus' *Essay on the Principles of Population* and the posthumous publication of William Jones' *Discourse* (cited above).

The Stone is an irregularly shaped slab of a dark hard rock, 112.3 cm tall, 75.7 cm wide and 28.4 cm thick; its weight is estimated at 762 kg. The discovery

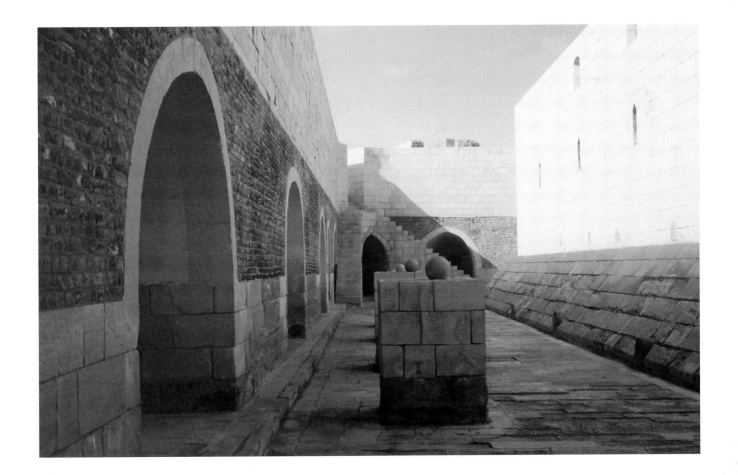

was made in mid-July, shortly before the second battle of Abuqir on 25 July. Published accounts of its early history vary in details, but it seems to have been found during works on the defences at Fort St Julien on the west bank of the Nile, at the small port of el-Rashid (ancient Rosetta), apparently when an old wall was demolished during the construction of foundations for extended fortifications. A plaque commemorating the discovery is now placed on the outside wall of the fort to the left of the main entrance, although the exact spot was apparently inside the outer wall, under what is now an internal turret (fig. 4, pl. 2). Other fragments of hieroglyphic inscriptions are still built into the walls of the fortress.

The Stone was found and excavated by an officer of the Engineers, Pierre François Xavier Bouchard (1772–1832) who immediately realized that it was part of a stela inscribed in three scripts. Of these, the fourteen lines of the incomplete hieroglyphic section and the fifty-three lines of the Greek section were immediately recognizable, but the thirty-two lines of the middle section, in a script now known as demotic, were initially assumed to be Syriac. Bouchard reported the find to the French general, Abdallah-Jacques Menou (1750–1810), who was then in Rosetta. Menou had the Stone taken to his tent and cleaned, and he also arranged for a translation of the Greek to be made, which confirmed that the inscriptions recorded the same text in three different scripts. Attempts to locate any additional fragments of the Stone – 'worth their weight in diamonds'[22] – in the vicinity were unsuccessful, although they were undertaken immediately and over several subsequent years. Later, in 1818, Thomas Young noted in a letter that 'Mr Salt was empowered by the British government to expend a liberal sum in digging in the neighbourhood of Fort St. Julien, or otherwise, in pursuit of this object'.

News of the discovery spread quickly. A letter by the engineer Michelange Lancret was received by the Institut d'Égypte in Cairo at its meeting of 19 July and the Stone itself reached Cairo under the charge of Bouchard in mid-August, as Napoleon was departing. It was deposited at the Institut, and 'at this news, each man ran to see the marvellous stone'.[23] The discovery of what might be 'the key' to hieroglyphs was publicly announced in the *Courrier d'Égypte* in September (no. 37). However, it proved difficult to copy the Stone's lightly incised inscriptions by hand. The expedition's senior orientalist Jean-Joseph Marcel identified the middle section as demotic, an Egyptian script known from classical authors, and realized that the stone could act as a printing block in a sort of proto-lithography. On 24 January 1800 this process successfully produced a reverse image with the hieroglyphs in white on a black background. Copies were also taken by the savant Nicolas-Jacques Conté, who treated the Stone like an engraved plate, producing prints with the hieroglyphs in black on a white background.[24] By the autumn of 1800 these copies had reached Paris. The enthusiasm with which copies were made shows the extent to which the Stone's significance was recognized; it was also well grounded, since the decipherment eventually came from examination of these copies rather than from the Stone itself.

The year 1801 saw the progressive surrender of the French to the Anglo-Turkish forces, with General Menou holding out in Alexandria until August. He was determined to maintain the French occupation at all costs, and was unpopular with the savants. The British landed at Abuqir Bay in March, and the bloody battle of Canopus followed. The Institut left Cairo for Alexandria in early April, transporting the Stone with them. This ironically delayed the Stone's departure from Egypt, since, despite Menou's orders to fight to the death, the French withdrew from Cairo; under the terms of this capitulation, they returned to France with their equipment intact. Had the Stone remained in Cairo it would probably have left for France before the final defeat. As it was, the Stone remained in Alexandria with the savants and Menou, whose relationship with them was increasingly fraught. Menou refused to acknowledge the surrender of Cairo, but was finally forced to concede on 31 August. Under article 16 of the capitulation of Alexandria, the British general John H. Hutchinson (1757–1832) demanded that the French should surrender everything that they had acquired in Egypt to him. Menou agreed, but the savants were horrified at the thought of giving up both the collections and their records for the planned *Description*. They formed an impassioned delegation to the diplomat and antiquary William Hamilton (1777–1859), then in Egypt on a mission for Lord Elgin; the interview culminated in the savant Geoffroy Saint-Hilaire crying: 'We will burn our treasures ourselves. You can then dispose of our persons as seems good to you . . . So, trust to the remembrance of history: You too will have burned a library at Alexandria.'[25] The delegation was in part successful: it secured the agreement that everything that could be construed as personal property would be kept by the French, including the natural history collections formed by the expedition.

At this point Menou, who was now openly scornful of the savants in his correspondence with Hutchinson, tried to argue that the antiquities were also personal property, and in particular that the now hidden Rosetta Stone was his own property as much 'as the linen of his wardrobe or his embroidered saddles'.[26] Hutchinson, however, was determined to secure the 'valuable Tablet', and denied this claim. The negotiations over the surrender of the antiquities were conducted in September, initially by the Revd (later Professor) Edward Daniel Clarke (1769–1822), and then on 12 September by him together with William Hamilton. The accounts later published by various English participants in this drama once again differ in details. Clarke vividly recalled: 'We remained near the outside of the tent; and soon heard the French General's voice elevated as usual, and in strong terms of indignation remonstrating against the injustice of the demands made upon him. The words *'Jamais on n'a pillé le monde!'* [Never has the world been so pillaged!] diverted us highly, as coming from a leader of plunder and devastation . . .'

Col. Tomkyns Hilgrove Turner (1766–1843) later asserted that when the French army learned of the English plan to possess the antiquities, they tore off the packing and protection that had been put round the Stone for its transport, and that 'it was thrown upon its face'.[27] It is impossible to tell how far these accounts are reliable and how far distorted by nationalist sympathies and personal concerns.

According to Clarke's account, a French officer and a member of the Institut eventually handed over the Stone from where it had been hidden under mats in a warehouse with Menou's other baggage to Hamilton, Clarke and a Mr Cripps in the Alexandrian streets, after which, on the French officer's advice, it was hastily transferred to a 'place of safety' and entrusted to Turner.[28] Turner, however, later described how he had 'carried off the stone, without any injury, but with some difficulty, from the narrow streets to my house, amid the sarcasm of numbers of French officers and men'; the detachment of artillerymen who 'enjoyed great satisfaction' doing this, were 'the first British soldiers who entered Alexandria'. Subsequently the urbane savants were allowed to take a cast of the Stone before they left Egypt at the end of September. Turner stated (erroneously) that at this time the Stone was 'well cleared' from the ink used to produce the earlier copies.

Turner embarked on HMS *L'Égyptienne* and set sail for England with this 'proud trophy of the arms of Britain – not plundered from defenceless inhabitants, but honourably acquired by the fortune of war'. News of the Stone had first reached England in the *Gentleman's Magazine* for 1801, and the ship arrived at Portsmouth in February 1802. The Stone was placed in the Society of Antiquaries, London, on 11 March, and the Society decided in July to have plaster casts taken. These were sent to the universities of Oxford, Cambridge, Edinburgh and Dublin; receipt of these copies was acknowledged by December. Of these only the Oxford one seems to survive, in the Ashmolean Museum, although its identity as one of the original casts is not certain.[29] In 1802, while the Society of Antiquaries was preparing printed copies of the inscription, a contribution in the *Gentleman's Magazine* lamented that 'the Frenchman [de Sacy, see below] has undertaken the explanation of the most difficult inscription before the English literati are in possession of a single copy of the easiest [the Greek]'.[30]

Further casts seem to have been made over the next few years, including one which was registered in the Hunterian Museum in Glasgow in 1812.[31] Others were made for the French to collate for the illustration in the *Description de l'Égypte*; the Stone eventually appeared as pls 52–4 in volume 5 of *Antiquités* (1822). Full-sized engravings were also issued by the Society of Antiquaries in 1802–3, and engravings of 'this precious monument' were widely distributed throughout Europe, to universities and learned institutions, including the Vatican, the National Library in Paris and the universities of Leiden and Uppsala, as well as the Philosophical Society at Philadelphia.[32] In 1812 the Society of Antiquaries published 'An account of the Rosetta Stone, in three languages, which was brought to England in the year 1802'.[33] This included the account of (by then) Major General Turner, cited above, and Revd Stephen Weston's translation of the Greek which had been presented as a paper in 1802. The report surveyed the responses to requests for suggestions on how to restore the lacunae in the Greek text, and concluded sadly 'there is little reason to expect that any further information should be received'.

The Stone itself was officially donated to the British Museum by George III, and in June 1802 it entered the Museum's buildings in Bloomsbury, together

with the other antiquities collected by the French expedition. These were to 'be seen in the outer court of that building. Many of them were so extremely massive, that it was found necessary to make wooden frames for them'.[34] The Stone has remained inside the institution ever since, apart from when it was lent to an exhibition in Paris in the 1970s for the 150th anniversary of Champollion's decipherment. The Stone still bears nationalistic texts painted on the sides: CAPTURED IN EGYPT BY THE BRITISH ARMY 1801 on the left edge of the slab, and on the right, PRESENTED BY KING GEORGE III (fig. 5).

Fig. 5 The nineteenth-century painted texts on the sides of the Rosetta Stone. H. of letters 2.7 cm. EA 24.

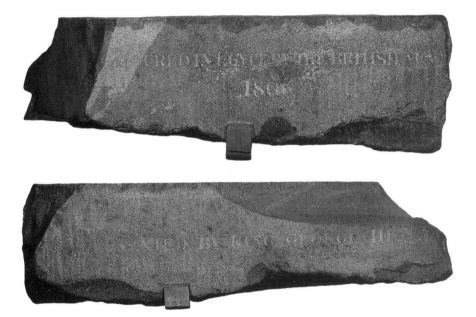

The familiar appearance of the Stone as black and white is not its original appearance. The incised signs were filled with white chalk early in its museum history, a procedure that was designed to make the text more legible. The white was retouched most recently by the British Museum curator Carol Andrews in the early 1980s. The black colour was due not to its use as a printing block, but to the application of (amongst other materials) carnauba wax, which was intended to help preserve the surface. This has absorbed dirt from the London atmosphere and finger-grease from visitors touching the Stone over two centuries, obscuring its true colour (fig. 6). Recently, following the comments of Professor Dietrich Klemm of Munich, a small sample was taken from the underside and prepared as a polished thin section for examination with a petrographic microscope and observation and chemical analysis in a scanning electron microscope in the British Museum's Department of Scientific Research. The petrographic observations and compositional analyses show that the stone is not basalt, which until recently it has been described as, but rather a fine- to medium-grained quartz-bearing rock containing feldspar, mica and amphibole. The stone has many characteristics of an igneous rock, but appears to have been subject to the effects of metamorphic/metasomatic processes. In the course of recent conservation the stone was cleaned to a dark grey colour that sparkles; a pink vein runs through

Fig. 6 A detail of the hieroglyphic inscription
before and after the removal of the modern infill
and the conservation of the stone.

the top left-hand corner. The incised signs were cleaned separately under magnification, and the water-based white infill was removed. The uncoloured inscription is clearly legible; if it seems less immediately so to a modern viewer accustomed to reading texts in black and white print, one should remember that the ancient past is not always as easily decipherable as one might expect.

The stone is hard and durable, but its conservation has always been a prime concern of the Museum authorities. For many years it has been displayed at a semi-horizontal angle, as seen in the *Illustrated London News* of 26 September

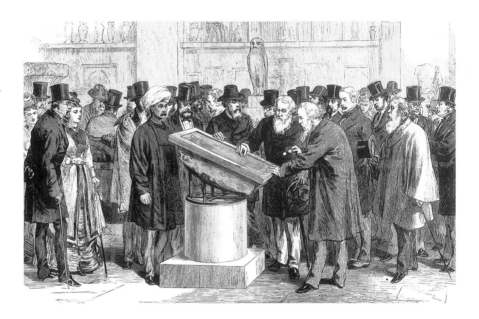

Fig. 7 The 'International congress of orientalists viewing the Rosetta Stone in the Egyptian Sculpture Gallery in the British Museum', from the *Illustrated London News*, 26 September 1874. The Stone is covered with a glass frame. H. 28 cm.

1874, which shows an international congress of orientalists viewing the Stone (fig. 7). It had initially been displayed without any cover, and records from the 1840s contain instructions to the Museum attendants to be particularly watchful that no one should touch it. In 1847 the Trustees reluctantly agreed that the Stone should be covered with the glazed frame shown in the *ILN*. This inevitably made viewing the details of the inscription less easy, and in the 1980s the Museum responded to public complaints and removed the glass cover. The difficulty of finding a compromise between protecting the Stone and keeping its inscription fully visible and accessible to an increasing number of visitors has been a constant concern. Unfortunately, the Stone's iconic status seems to encourage visitors to reach out and touch the almost miraculous object.

THE ORIGINAL CONTEXT OF THE ROSETTA STONE

The fact that the Rosetta Stone is known as 'the Stone' obscures its status as an ancient artefact carved in a particular culture at a particular date. The Stone is not a monolithic force of nature, but a fragment of a stela inscribed with a priestly decree – the Memphis Decree – concerning the cult of King Ptolemy V Epiphanes (205–180 BC) in three ancient scripts, hieroglyphic, demotic and Greek. The immediately recognizable shape of the Stone is a product of chance

breakages: the original edges of the stela survive only along the left vertical edge, along much of the right vertical edge and along most of the bottom. The designation 'Rosetta' is also slightly misleading, since the Stone cannot have been originally placed at Rosetta – the land on which the town was built did not exist in Ptolemaic times, being the result of later sedimentation. The stela is likely to have been brought to the site with other blocks as building material from a more ancient site further inland. Labib Habachi suggested the famous city of Sais, nearby by on the same branch of the Nile, as the site where it was originally set up.[35] Throughout Egyptian history, statues and blocks of hard stone have been moved into and between sites in the Delta. Given this, and the failure of all attempts to locate further fragments of the stela at Rosetta, it is probable that it was already broken when it was moved to the site of its discovery.

More than half of the decree is lost from the hieroglyphic section, originally an estimated twenty-nine lines. The Greek occupies fifty-four lines, with many errors in the inscription,[36] and the demotic thirty-two, with its last two lines inscribed in a fulsome style to fill the space. The sides taper slightly towards the top (fig. 8). The original shape of the stela is shown in a sign in line 14 of the hieroglyphic text: ∩. The stela almost certainly had a rounded top headed by a winged sun-disk, and probably a scene with figures in Egyptian style, similar to that showing the king and queen between two groups of gods on another stela with a copy of the Canopus Decree issued in 238 BC under Ptolemy II Euergetes I, from Kom el-Hisn, now in the Egyptian Museum, Cairo, and other stelae of the period (figs 9–10). From the distribution of the texts and from comparison with the Kom el-Hisn stela, the Rosetta Stone's original height can be calculated as being around 149 cm.

The text on the Rosetta Stone is lightly incised and the slightly inclined front surface is smoothed, with only minor damage in a few places. The surviving inscribed face seems to have suffered very little erosion, and has only occasional small areas of damage. The sides are worked to an even, if unsmoothed, surface, but are not as highly finished as the inscribed front face. The back face is roughly finished (fig. 11); although some areas have broken away from it,

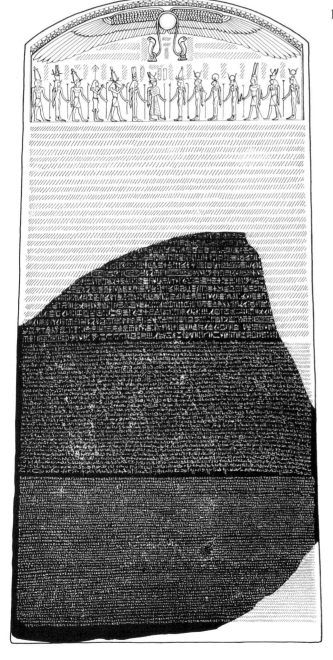

Fig. 8 A reconstruction of the original stela, based on other copies of the Memphis Decree and the Canopus Decree. Drawn by C. Thorne and R. Parkinson.

Fig. 10 A dark, hard stone stela with an inscription dated to Year 1 of Ptolemy II Philadelphus (285 BC); the stela is unfinished but the lunette is similar to that which originally topped the Rosetta Stone. H. 64 cm. EA 616.

Fig. 9 A fragment of a red granite stela from Aswan commemorating the visit of Ptolemy IX. The text is exclusively in Greek, while the scene is in the Egyptian style showing the deities of the cataract region, with hieroglyphic captions. The stone was later recarved for reuse, apparently as a building block. H. 270 cm. EA 1020.

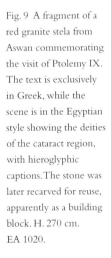

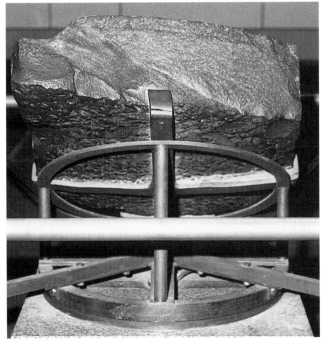

Fig. 11 The back surface of the Rosetta Stone, showing the roughly worked texture; individual chisel marks are still visible. The stone was removed from its metal supports and placed upright in 1999.

this is the original surface, and it indicates that the uneven back was not intended to be visible, suggesting that the stela would have been placed upright against a wall. In 1998 the removal of the modern white infill revealed extensive traces of a pink pigment and traces of black printer's ink (presumably from the savants). The pink lies underneath the ink when these are found together. Analysis of the pink material by polarized light microscopy showed it to be a type of iron earth. Energy dispersive x-ray analysis revealed the presence of calcium, iron, phosphorous and silicon. The main component has not been fully identified, but could be a calcium phosphate mineral (pl. 3). The infill could be ancient pigment, although early modern attempts to take copies are known to have used red chalk (see n. 26).

The text on the Rosetta Stone states that it was to be placed in a temple, 'beside the statue of the Dual King Ptolemy' which was the object of worship. It is clear that the statue was set up within a shrine, but the stela was perhaps placed outside, rather than immediately next to the statue. The text would have been clearly legible if placed outside in the sunlight, even without pigment. The stela was positioned against a wall, probably of mud brick, in the outer area of a temple, rather as a stela of Year 24 of Ptolemy VI at Philae is placed against the outer face of the second pylon of the temple of Isis (pl. 4). The Philae stela was situated in the outer reaches of a sacred enclosure of restricted access, not within the main temple building, so that it was on display to a select public.[37]

The stela records a decree issued on 27 March 196 BC. The decree had a pedigree of more than two thousand years in Egypt, with royal decrees often being displayed in monumental contexts. The stela was created in times as troubled as those in which it was discovered: although the ruler was presented in Egyptian style, the Ptolemaic dynasty was Macedonian. The dynasty, of whose monarchs Cleopatra VII (51–30 BC) was said by the historian Plutarch (d. AD 120) to have been the first to learn Egyptian, ruled from the culturally predominantly Greek city of Alexandria. The pattern of the complex fusion of linguistic and other cultures in the period is still being studied intensively by scholars.[38] Greek was the official language of the court and government, while the native temples still used the Egyptian scripts; one can compare the usages of Latin, English and French in Anglo-Norman England. There was an indigenous priestly class that was a potential source of dissident activity, and the tensions between ruler and ruled seem to have centred around the temples, which were the strongholds of native Egyptian culture and of its formal language. The temples retained their traditional lands and cultic importance. Priests were important figures in the royal administration, but by the late third century BC a royal subvention financed the cost of temples, lessening their independence.

In the temples, the king was depicted performing the traditional role of high priest and officiant in the cult. Although Ptolemy V was only thirteen years old when the decree inscribed on the Rosetta Stone was composed, the text describes him in traditional Egyptian terms as restoring order, 'establishing Egypt and making it perfect, his heart beneficent towards the gods'. In contrast with the

practice of earlier periods, when the king was the issuer of all decrees, the decree of the Rosetta Stone was promulgated by the indigenous priests; this demonstrates a marked change in the siting of high culture. Behind much of the period's cultural syncretism, political ends can often be detected.

The years before the stela's erection had been full of strife, with the far south of Egypt being in revolt and partly controlled by rebel native kings from late in the reign of Ptolemy IV Philopator until 186 BC. The rebellions were probably motivated by social and economic factors as well as by nationalistic resentment of Greek rule. In the summer of 204 BC Ptolemy IV died suddenly in his midthirties, and Ptolemy V came to the throne as a six-year-old child. In the courtly intrigues that followed, Ptolemy IV's death was concealed until the boy-king's mother Arsinoe had been killed.[39] This weakened the government severely. Soon afterwards the Seleucid king Antiochus the Great resumed hostilities against Egypt that continued until 200 or 198 BC. Rebels in the Delta town of Lycopolis (whose exact location is unknown) and in the capital Alexandria were eventually defeated, and they were punished as part of the coronation of the by now thirteen-year-old king, eight years into his reign. The coronation was celebrated with traditional Egyptian rites, in the traditional capital, Memphis. The high priest of Ptah, Harmachis, son of Anemhor, crowned him, probably together with the company of priests listed in the Rosetta Stone (demotic text, lines 4–5):

> the high priests and prophets and the priests who enter the sanctuary to
> perform clothing rituals for the gods, and the scribes of the divine book, and
> the scribes of the House of Life, and the other priests who have come from
> the temples of Egypt [to Memphis on] the festival of the Reception of
> Rulership by Pharaoh Ptolemy

The festival was celebrated in the presence of priestly delegates from all the areas of the country that were under allegiance to the Alexandrian court.

A decree was issued to record the priests' granting of a royal cult to the king in return for his favours to them, including exemption from taxes, and is known after its place of issue as the Memphis Decree. The Greek text provides two dates, 27 March 197 BC as the date on which the Decree was issued, and 27 November as the anniversary of the day on which the new king 'inherited the kingship from his father'. The hieroglyphic text also gives these two different dates, but the demotic version carved on the Rosetta Stone gives two consecutive dates in March for the festival and the issue of the Decree on the following day. Some of these discrepancies may be due to errors, but it is possible that the date of the actual coronation was in November, and the coronation decree was only issued in the following March, the intervening months being a period of intense negotiation and haggling about the substance and wording of the Decree. Other reconstructions to account for these discrepancies, however, are possible.[40]

The priestly decrees of the Ptolemaic period may not be the result of special annual synods, as is often assumed, but seem to be linked with other national ceremonies when the priests would have gathered. The Memphis Decree proclaims that the royal cult should be established in 'all the temples of the first,

second, and third rank', and that a copy of the Decree in three scripts on a stela should be set up near by. It is uncertain how literally this proclamation is to be understood. Other copies of the Decree are known, including several sandstone fragments from Elephantine, now in the Louvre; an unfinished and poorly preserved basalt stela from Nub Taha, near Tell el-Yahudiya, now in Alexandria; an exclusively hieroglyphic version of the Decree, dated fourteen years after the Rosetta Stone (Year 23 of Ptolemy V, 183 BC), from el-Nobaira, near Damanhur in the Delta, and now in the Cairo Museum.[41] It is probable that the cult was not established in all Egyptian temples as simultaneously as the Decree implies: text and historical reality are not the same.

The presence of the three scripts on the stelae has inevitably raised questions about the language of the original composition; scholars such as Philippe Derchain and Heinz Josef Thissen have argued that the different versions were composed simultaneously. The priests used archaistic diction in the hieroglyphs, but there are also occasional 'demoticisms', lapses into a register closer to the language the priests usually wrote. Stephen Quirke has emphasized that 'the record of the decree represents an intricate coalescence of three vital textual traditions'.[42] This was a culture in which a person who bore names in Greek and in Egyptian lived in a town with Greek and Egyptian names and worshipped gods with Greek and Egyptian names (modern Wales with its bilingual signs and publications provides a very partial parallel for the modern English reader): a symbol of this culture is the composite god Serapis, introduced by the Ptolemies.[43] The Egyptian temples were the preservers of a vibrant distinctive culture, but even they interacted with Greek literature and thinking; thus Philippe Derchain has identified allusions to Homer in the hieroglyphic inscriptions of the myth of Horus carved in the temple of Edfu.[44] From these coexisting and competing linguistic and cultural spheres came the need to compose the Decree three times, making its substance relevant to the major cultural groups within the country, exemplified by the supposed users of the three scripts: the traditional audience of Egyptian monuments, the gods and priests; the Egyptian-speaking literate populace; and the Greek administration. This need is formulated explicitly in its final lines, which proclaim that it should be inscribed on '[a stela] of hard stone, in sacred, and native, and Greek characters and set it up in each of the first, and second, [and third rank temples beside the image of the ever-living king]'. This is the sentence of the Greek text that confirmed that the Stone was a bilingual text. The hieroglyphic version of this, however, reads: 'on a stela of hard stone in the script of god's words, the script of documents, and the letters of the Aegeans, and set it up in all the temples of first, second, and third rank, beside the statue of the Dual King: Ptolemy living forever, beloved of Ptah, the God who Appears (i.e. 'Epiphanes'), lord of goodness'. This passage exemplifies the differences in phrasing between the Greek and the two Egyptian versions. The Greek script is referred to as *Ellenikos* in the Greek text, while in hieroglyphs the classical Egyptian phrase *Hau-nebu*, 'Aegeans' (literally 'Islanders'), is used and the demotic has a third term, *Wynn* ('Ionians'), for the Greeks. The three versions cannot be

matched word for word, and for this reason the process of decipherment involved greater difficulties than scholars expected from what was apparently an exact bilingual and triscript key to the 'code' of the hieroglyphs.

THE DECIPHERMENT OF THE ROSETTA STONE

The story of the decipherment and the miraculous birth of Egyptology has been much told,[45] but the narrative has been obscured by the rivalry between the two main participants, and aggravated by nationalistic sympathies. The work of other scholars, which was fundamentally important, has been repeatedly underplayed. Significant contributions were, for example, made by the Swedish diplomat and orientalist J.H. Åkerblad (1763–1819) and the orientalist Baron A.I. Silvestre de Sacy (1758–1838). The narrative is dominated by hieroglyphs, but demotic played an immense part because scholars attempting to decode it were not misled by assumptions that it was a symbolic system. The demotic inscription on the Stone is also more completely preserved than the hieroglyphic and thus provided versions of the personal names that occur at the start of the Greek text. None of the inscriptions marks the word-breaks, which added to the difficulties facing the scholars. Silvestre de Sacy achieved the first breakthrough with the demotic, identifying personal names including that of Ptolemy, although he was incorrect in his analysis of the individual signs. In 1802 Åkerblad published his *Lettre sur l'inscription égyptienne de Rosette, addressée au citoyen Silvestre de Sacy*, in which he identified several important features of the demotic, including the third person pronouns, and correlated them with their Coptic equivalents, as well as isolating the demotic equivalents of 'Egypt', 'the temples', 'many', 'the king', and 'Greek'. However, he assumed wrongly that the script was alphabetical, and his discoveries about the demotic did not challenge the false premises about the hieroglyphic script.

The two main protagonists in the myth that has arisen around the decipherment of the hieroglyphic script were Thomas Young (1773–1829) and Jean-François Champollion (1790–1832). Thomas 'Phenomenon' Young (pl. 5) was a distinguished and internationally acknowledged polymathic genius, now principally remembered for his work on physiological optics and the theory of light. Young became interested in the Rosetta Stone through a papyrus belonging to a friend, Sir W. Rouse Boughton, and he worked on the Egyptian script during summer vacations at Worthing on the south coast of England in 1814–18. His unpublished notebooks are now in the Department of Manuscripts in the British Library. By 1816 Young could identify the name Ptolemy as a cartouche on the hieroglyphic section of the Stone, and with the help of the demotic versions he assigned the correct values of *p, t, ma/m, i, s* to five signs, as well as incorrect values to a further eight. This achievement was considerable, since most of the cartouches also contain other signs and epithets as well as the alphabetically written name. To reconcile this analysis with the classical accounts of hieroglyphs, he proposed that only foreign names such as Ptolemy were written 'alphabetically', and other words such as the epithets in the cartouche were written symbolically.

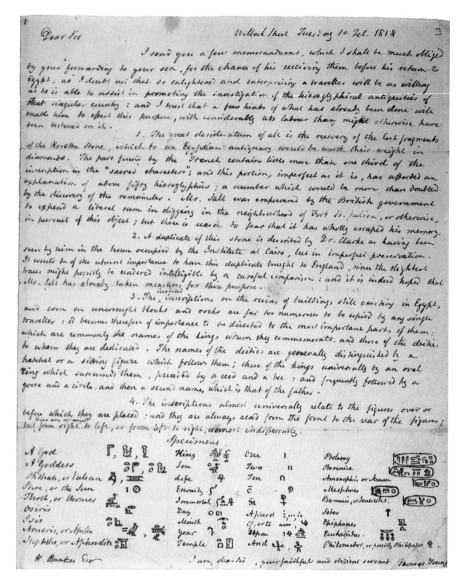

Fig. 12 A letter written by Thomas Young to William John Bankes' father, dated 'Tuesday 10 Feb. 1818'. The letter includes a summary of the principal hieroglyphic groups then known to Young, with translations (almost all correct). H. 22.5 cm. In the Department of Egyptian Antiquities, British Museum.

Young suggested that demotic and hieroglyphic signs were related by shape. By systematically comparing lines of the text between three scripts, he succeeded in correlating words such as 'king', 'and' and 'Egypt'. Although he isolated many demotic word groups successfully, he was unable to produce reliable analyses of them. Nevertheless, he could identify quite a remarkable number of hieroglyphic word groups and suggest their meanings correctly, as summarized in a letter written for William John Bankes in 1818 (fig. 12). Although he realized that demotic was not a purely alphabetic script and that it included ideograms as well as phonetic signs, he did not apply this insight to hieroglyphs despite his correlation of the differing forms of the scripts. He resolutely maintained the classical tradition that hieroglyphs were symbolic and that the phonetic signs were used only 'in some particular cases, and not universally employed where sounds were required'.[46]

Champollion (pl. 6) was born at Figeac in Quercy on 23 December 1790. He was a highly precocious, brilliantly imaginative scholar and linguist, whose fascination with Egypt began at an early age. Baron Jean-Baptiste Joseph Fourier (1768–1830), who had worked on the *Description* and had been perpetual secretary of the Cairo Institut, was appointed to be prefect of Isère when he returned to France in 1801, and it is said that he told tales of Egypt to the ten-year-old Champollion. A copy of the *Courrier* report of the Stone's discovery reached Champollion's elder brother and life-long mentor, Jacques Joseph (1778–1867) in 1802, followed by a print of the Stone itself two years later. The elder Champollion presented a paper on the Rosetta Stone that year to the Société des Sciences et Arts de Grenoble, and he advised Jean-François that if he was interested in hieroglyphs, he should study the inscription. At the age of sixteen the younger Champollion presented a paper to the Grenoble Académie arguing that Coptic was the language of ancient Egypt, a belief that, although not original, laid the foundation of his later achievements.

In 1807 the two brothers left for Paris; the younger studied Arabic under

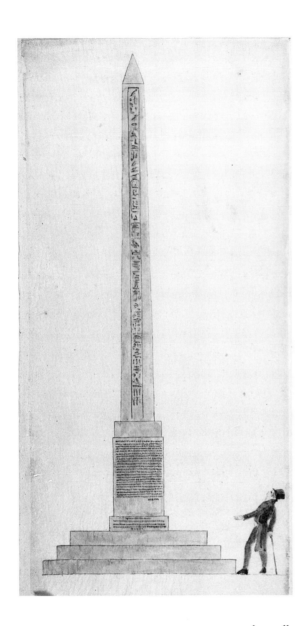

Fig. 13 A drawing of the Bankes obelisk, made in preparation for the publication 'Geometrical elevation of an obelisk from Philoe [*sic*]', 1821. H. 18.5 cm. From the Bankes MSS, Kingston Lacy. By kind permission of the National Trust.

Silvestre de Sacy and acquired a full familiarity with all the languages considered relevant to Egyptian, including Sanskrit and Chinese. He was also taught Coptic by a Coptic priest. Before he was nineteen he had been awarded a chair at the University of Grenoble together with his brother, and Napoleon himself signed the necessary paper making him a doctor in 1809.

In 1814 Champollion wrote to the Royal Society, whose Foreign Secretary was Young, starting a correspondence that continued until Young's death.[47] He wrote that he had only an engraving of the Stone made by the English Royal Society, and the French copy in the *Description*, and since these differed in some respects, he requested a cast. Difficulties over the accuracy of copies of inscriptions were a persistent problem, and epigraphy like other scholarly activities was a potential object of nationalistic competition. Young obliged only by checking the passages Champollion requested, and some phrases in his letter suggest a certain reserve: 'I have not yet had time to skim through your interesting work, which I have only had for two or three months.'[48] The following year Silvestre de Sacy, disillusioned with his pupil, wrote to Young: 'I think, Monsieur, that you are further forward today, and you read a great part at least of the Egyptian text. If I had one piece of advice to give you, it would be to not communicate your discoveries too much to M. Champollion. It could happen that he might then claim to have been first.'[49] In another letter, Silvestre de Sacy used the word 'charlatanism', as well as noting that Champollion's Napoleonist political sympathies had done him little honour. Again he warned, 'He is prone to playing the role of a jackdaw in borrowed peacock's plumes.'[50]

The need for further bilingual inscriptions and supplementary keys in order to advance decipherment was keenly felt by several of the collectors who were working in Egypt (see cat. 10), and in 1815 an obelisk was discovered at Philae by the British dilettante, antiquarian and close friend of Byron, William John Bankes (1786–1855). At Young's request he had copied many inscriptions on his travels through Egypt, and he had the monument brought to England, where it arrived in 1821 (after passing through the port of Rosetta en route).[51] The obelisk (fig. 13) is inscribed with hieroglyphs, but on the base are Greek inscriptions that record official correspondence between Ptolemy VIII Euergertes II and the priests of Isis on Philae in 124 BC concerning tax exemption. Bankes, Young and the English collector and consul in Egypt Henry Salt (1780–1827) considered that the hieroglyphs and Greek must represent the same text, thus providing another potential bilingual key. In this they were mistaken, as Champollion recognized, but Bankes correctly supposed that a cartouche on the obelisk should write the name of Cleopatra III, the queen of Ptolemy VIII, who was mentioned in the Greek, although he was unable to read

the individual signs. This identification remained unpublished, although Young adopted and used it; in 1821, however, Bankes issued a publication of the obelisk, and in some copies he added in pencil the name 'Cleopatra' beside the relevant cartouche. The presumed bilingual nature of the inscriptions generated a brief period of fame for the obelisk as a second Rosetta Stone. In 1827 the Duke of Wellington laid a foundation stone for it at Kingston Lacy, Bankes' Dorset estate. It was finally erected in 1839, but two years later Bankes fled from England after being committed for trial for indecency with a guardsman. The inscription on the pedestal implicitly and discreetly maintains Bankes' and Young's assertion that the monument was a bilingual text. The obelisk can still be seen in the grounds of Kingston Lacy, considerably eroded by the English weather and overlooked by the roughly contemporaneous Iron Age hill fort of Badbury Rings, but looking remarkably at home among the swallows and cedars. Like many protagonists in the decipherment, its role is now largely forgotten (pl. 7).

In France Champollion's political sympathies for Napoleon had caused him to be deprived of his post in Grenoble, and he arrived in Paris in July 1821 to live with his brother, then secretary to Baron Joseph Dacier (1742–1833), who was perpetual secretary of the Académie des Inscriptions et Belles Lettres in Paris. Despite his precarious situation, Champollion read his 'De l'écriture hiératique des anciens Égyptiens' to the Académie des Inscriptions. In this paper, actually written two years earlier, he still held that hieroglyphs were exclusively symbolic and logographic, a published view that later English critics asserted he had subsequently attempted to suppress. The paper, however, established that the hieratic script found on papyri was also a form of hieroglyphs, and the corpus of texts was consequently enlarged. In December 1821 he compared the number of signs on the Rosetta Stone with the number of Greek words (1,419 and 486 respectively), and showed that the script could not be purely logographic, with a single picture representing each word.

By this date Young had proposed a set of alphabetic signs used to write the names of Ptolemy and Cleopatra, publishing these findings in the *Supplement to the Encyclopaedia Britannica* (4th edition) in 1819. A copy of the inscriptions on the Bankes obelisk reached Champollion in 1822 and he arrived at the same conclusion as Young about the alphabetic signs in the names Ptolemy and Cleopatra. From these names he had fourteen alphabetic signs, which were sufficient for him to decipher the cartouches of other members of the Ptolemaic Dynasty and of the Roman emperors, expanding the alphabet as he progressed. It was later claimed that Champollion's work was based, without acknowledgement, on Young's published work, and also on Bankes' pencilled theory about the name on the obelisk. In the case of the latter, however, there is no definite evidence that Champollion saw a copy of the obelisk's inscriptions with Bankes' pencil annotations,[52] although Salt subsequently claimed that they were present on the copy sent to the French Institute in Paris which Champollion did see.

Champollion's insight about the nature of the hieroglyphic script is often presented as an almost mythical event, as a moment of superhuman revelation.

On 14 September 1822 he received copies of inscriptions from the temple of Abu Simbel which had been sent by a travelling friend, the architect of the Arc de Triomphe, Jean Nicolas Huyot (1780–1840), who had been at the site with Bankes' party.[53] These included the cartouche ⊙𝍰ⵏⵏ. Champollion could read the final two signs ⵏⵏ as *ss*, and his knowledge of Coptic suggested that the sun-shaped sign might represent the word for sun, in Coptic *re*; hence the name could be read as Re?ses, instantly suggesting the royal name Ramses familiar from the accounts of the Greek historian Manetho as *Ramesses*. Champollion's reading of the cartouche was substantially correct, although he believed that each phonetic sign represented one consonant (taking 𝍰 as *m*), whereas some signs were subsequently recognized to represent more than one (𝍰 actually being *ms*).

Another sheet from Huyot had a similar group of signs in a cartouche, but, instead of the sun-disk, it contained an ibis which classical sources described as the animal of the god Thoth. By comparison with the cartouche of Ramses, this cartouche could be read Thotmes, another name preserved by the Greek historians as *Touthmōsis*. From these names Champollion realized that the script was predominantly phonetic, but also included logograms. More importantly, it was used to write native names from the pharaonic period, and so could have been used to write the Egyptian language in the same manner. According to the account of his nephew Aimé Champollion-Figeac, he rushed to his brother's room in the Institut on the afternoon of the same day, cried 'I've done it' ('je tiens mon affaire!') and collapsed in a dead faint lasting five days.[54]

Champollion's famous report, the *Lettre à M. Dacier* (figs 14–16), was read at the Académie des Inscriptions et Belles Lettres in Paris on Friday 27 September 1822, a romantically dark and rainy day, in a romantically eventful year that saw declarations of independence in Greece (from the Ottoman Empire) and in Brazil (from Portugal). Bankes' friend Byron was writing *Don Juan* and the plans for the present buildings of the British Museum were being drawn up by Robert Smirke. The *Lettre* is officially dated 22 September to match the day on which its text was completed. In the report Champollion described the alphabet which was used to write non-Egyptian names, and in the concluding pages he announced that he was certain that the phonetic signs were an integral part of earlier 'pure hieroglyphic writing'. Among the select audience was Thomas Young, whose initial reaction is recorded in a letter written to Sir William Hamilton on the Sunday after the reading:

> I have found here, or rather recovered, Mr. Champollion, junior, who has been living for these ten years on the Inscription of Rosetta, and who has lately been making some steps in Egyptian literature, which really appear to be *gigantic*. It may be said that he found the key in England which has opened the gate for him, and it is often observed that *c'est le premier pas qui coûte* [it's the first step that costs the effort]; but if he did borrow an English key, the lock was so dreadfully rusty, that no common arm would have strength enough to turn it; and, in a path so beset with thorns, and so encumbered with rubbish, not the first step only, but every step, is painfully laborious; especially such as

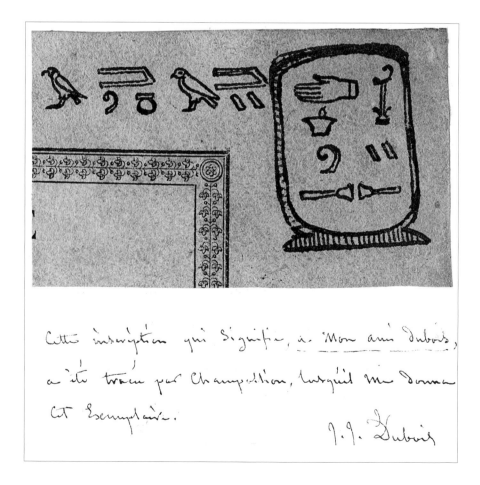

are retrograde; and such steps will sometimes be necessary: but it is better to make a few false steps than to stand quite still. If Mr. Champollion's latest conjectures become confirmed by collateral evidence, which I dare say *you* will not think impossible, he will have the merit of setting the chronology of the later Egyptian monuments entirely at rest.

Young's summary of the report concludes with the remark that 'at any rate Champollion has displayed great ingenuity in the investigation', and he then made more personal comments:

> You will easily believe, that were I ever so much the victim of the bad passions, I should feel nothing but exultation at Mr. Champollion's success: my life seems indeed to be lengthened by the accession of a junior coadjutor in my researches, and of a person too, who is so much more versed in the different dialects of the Egyptian [i.e. Coptic] language than myself.[55]

Young's reaction to Champollion's success is gracious, but underlying it is his belief that many of Champollion's 'ingenious' claims would be proved false.

Polite letters continued between the two, with Champollion asking in November 1822 for the use of Bankes' copy of the Abydos king list of Ramses II (now in the British Museum). In March 1823, however, Champollion wrote in an outraged tone to Young complaining about a review of the *Lettre à M. Dacier* in the English *Quarterly Review* (no. 55). He also protested: 'I find in the same

Fig. 14 The title page of the *Lettre à M. Dacier*. H. 22.6 cm.

Fig. 15 A dedication on a copy of the *Lettre à M. Dacier* written in hieroglyphs by Champollion. It reads 'à mon ami (Dubois)|' ('to my friend Dubois'), as recorded in a note by the draughtsman, Léon Jean Joseph Dubois (1780–1846). This copy was later owned by the eminent English Egyptologist Percy E. Newberry (1868–1949), and is now in the Department of Egyptian Antiquities, British Museum. H. of cut-out section 4.6 cm.

OPPOSITE Fig. 16 The plate containing the 'alphabet', listing demotic and hieroglyphic signs with their Greek equivalents, from the *Lettre à M. Dacier*. At the bottom is Champollion's name written in demotic signs in a cartouche. H. 44.10 cm.

Tableau des Signes Phonétiques
des Écritures Hiéroglyphique et Démotique des anciens Égyptiens

Lettres Grecques	Signes Démotiques	Signes Hiéroglyphiques
A		
B		
Γ		
Δ		
E		
Z		
H		
Θ		
I		
K		
Λ		
M		
N		
Ξ		
O		
Π		
P		
Σ		
T		
Υ		
Φ		
Ψ		
X		
Ω		
ΤΟ. ΤΩ.		

journal the announcement of a volume that you are to publish and the title of which promises to name the original author of an alphabet which I have only extended. I will never consent to recognize any other original alphabet than my own.'[56] Later in the same year Young published *An Account of Some Recent Discoveries in Hieroglyphical Literature and Egyptian Antiquities Including the Author's Original Alphabet as Extended by Mr Champollion*. Such rivalry was not the result of these individuals' temperaments: contemporaneous letters make it apparent that all cultural activities in Britain and France were infused with a spirit of great personal as well as national competition.[57]

In September of the same year Young announced to the classicist Sir William Gell (1777–1836) that his planned series of volumes of hieroglyphic inscriptions was costing him too much money. The Rosetta Stone was to be published in the second fascicule, and after that there was nothing 'of sufficient importance to continue the series'. He commented: 'Champollion is doing so much that he will not suffer anything of material consequence to be lost. For these three reasons I have now considered my Egyptian studies as *concluded*.'[58] He did, however, note that he had communicated his major discovery:

> *I sent it at that time to Champollion, as I have stated, and he acknowledged the receipt of it.* To have placed more emphasis on the precise dates than I have done would have been to display more parade than the thing required, or to have shown too much hostility to Champollion, to whom I would rather give up something that is my right, than take from him anything that ought to be his.[59]

Young died on 10 May 1829, and was still working on demotic matters on his death bed. His memorial in Westminster Abbey records that 'he first penetrated the obscurity which had veiled for ages the hieroglyphics of Egypt'.

The full realization of the nature of the hieroglyphic script, hinted at in Champollion's *Lettre*, was published in 1824. The *Précis du système hiéroglyphique des anciens égyptiens par M. Champollion le jeune* marks the decisive step in decipherment. The publication was presented to Louis XVIII in person on 29 March, and the fame attendant on the decipherment restored Champollion to political respectability with the authorities. A later edition, which followed in 1828, included the description of 'determinative' signs: Champollion's study of the Dendera zodiac, which had been displayed in the Louvre since 1822, showed that some signs were pictures indicating the category of the preceding words, and Egyptologists still use the term he coined, 'determinatives'.

In the spring of 1824, before setting out for Italy, Champollion travelled briefly to England with his brother and visited the British Museum.[60] It was the only time that the decipherer gazed on the Stone itself, as opposed to the copies of the inscription. The visit, however, is not well documented, and some English Egyptologists have doubted that it ever actually took place.[61]

In 1825 there appeared an *Essay on Dr. Young's and M. Champollion's Phonetic System of Hieroglyphics by Henry Salt*. This was a test of the proposed new decipherment on inscriptions in the British Museum, and it convinced Salt of its validity.

He noted that there was 'a very decided prejudice against the phonetic system, as conceiving it to be founded on too conjectural a basis'.[62] However, he also asserted in strong terms that Young had been the first to discover the alphabet, and that Champollion had failed to acknowledge his debt. The brilliance and the nationality of Champollion were not likely to endear him to any English scholar. His personal character was not admired, and contemporaneous accounts of his behaviour can still give a modern reader the impression of immature arrogance. He appears impatient, easily thrown into despair and a 'monopolist' in all things Egyptian, but utterly brilliant. Many assessments of his personality are obviously inspired by nationalistic antagonism – William John Bankes for one would not give him a copy of an inscription 'because he thought him a dirty scoundrel, and would not answer his letter'[63] – but some unfavourable comments about him were also made by a French official in Egypt. A limerick-like poem in French, supposedly written by Champollion, is known from a letter of the British Egyptologist and traveller John Gardner Wilkinson (1797–1875). The poem gives an impression of his absolute-sounding tone:

Les Pyramides, 'sans aucun doute'
(Je veux le dire coûte ce qu'il coûte),
Ont sept mille ans, quelque chose de plus:
Le [sic] preuve est dans un papyrus.[64]

[The pyramids 'without a doubt'
(I will say it no matter the cost)
are seven thousand years old, or somewhat older;
the proof is in a papyrus.]

Champollion was given to writing poetry, and composed a witty letter supposedly a petition from Ramses II to the modern keepers of his statues in Turin,[65] but this poem is probably a parody written by Gardner Wilkinson.

The problematic relationship between Young and Champollion and their respective contributions demonstrates how partial written records are, and how they do not correlate exactly with events; many partisans have subsequently rewritten the discovery. The letters of Young, quoted above, were published posthumously in 1855 in an attempt to show that Young had discovered the 'Egyptian alphabet' 'several years before Champollion suspected its existence'. The preface makes this programmatic intent clear: 'That Champollion himself, indeed, should have put forward pretensions to that great discovery could excite no astonishment in those who were acquainted with his character . . . the ingenious but unscrupulous Frenchman', and: 'Throughout the correspondence we have carefully omitted every expression that might reasonably be supposed to hurt the feelings of any one; except in the case of Champollion . . .'[66] Modern attempts to evaluate the competing claims to priority are made the more difficult by delays in the original publication and circulation of ideas. The work of French scholars, notably Michel Dewachter, continues to clarify the process and to help us to assess the impact of Champollion's genius. The claim of Thomas Young, as

an unacknowledged English underdog, has proved influential with English historians, especially English scholars of Egyptian demotic,[67] but Young can hardly be given the credit for Champollion's decipherment of Egyptian hieroglyphs, when he refused to admit its validity and remained 'trapped in the symbolist interpretation'.[68] Equally, French scholars have sometimes championed Champollion's claims almost to excess. Champollion himself admitted in 1824:

> I recognise that [Young] was the first to publish some correct ideas about the ancient writings of Egypt; that he also was the first to establish some correct distinctions concerning the general nature of these writings, by determining, through a substantial comparison of texts, the value of several groups of characters. I even recognise that he published before me his ideas on the possibility of the existence of several sound-signs, which would have been used to write foreign proper names in Egypt in hieroglyphs; finally that M. Young was also the first to try, but without complete success, to give a phonetic value to the hieroglyphs making up the two names Ptolemy and Berenice.[69]

Even if one allows that Champollion was more familiar with Young's initial work than he subsequently claimed, he remains the decipherer of the hieroglyphic script: as Peter Daniels states, any 'decipherment has to stand or fall as a whole'.[70] Young discovered parts of an alphabet – a key – but Champollion unlocked an entire language. Rather than dwelling on competing national claims, the modern reader should remember the achievements of the scholars, which relied on international dialogue and cooperation in difficult circumstances.

The period of decipherment also witnessed the foundation of the great Egyptian collections outside Egypt. On Champollion's return to Paris from travelling and collecting in Egypt in 1830 – a trip that confirmed, as he wrote to Dacier, 'our alphabet is valid' ('notre alphabet est bonne') – he was installed as curator at the Louvre. He died from a stroke on 4 March 1832, in the same year as Goethe and three years after Young. His death was probably due in part to exhaustion. He had already completed the sheets of his *Grammaire égyptien*, which he entrusted to his brother as his 'calling card to posterity'. His death at the relatively early age of forty-one has added to the romanticism of his role. De Sacy, fully reconciled to his former pupil's genius, spoke the funerary eulogy in the Académie des Inscriptions et Belles Lettres, raising him to mythical status as the decipherer of the Sphinx's riddle, the 'new Oedipus' (a claim that Kircher had made for himself): 'few men have rendered to scholarship services equal to those which have dedicated the name of Champollion to immortality'.[71] The Englishman Wilkinson's comments, in a letter to the British traveller and antiquarian Robert Hay (1799–1863), were slightly more qualified, but also expressed a sense of deep shock: 'What a loss – there is an end to hieroglyphics – for say what they like no one knew anything about the subject but himself, though wrong – as must necessarily happen in a similar study – in some instances.' In another letter to William Gell, Wilkinson reviewed Champollion's character as follows:

> he seldom hesitated but made a dash according to probability, this was

his fault, but he frequently made a happy hit where the sense was
obscure & where another would have given it up. At other times he was
genuinely mistaken. He had great self confidence & much ingenuity.
I do not expect to see another like him for this study.[72]

Champollion was buried in Père Lachaise cemetery in Paris under a simple
obelisk, inscribed only with his name 'Champollion le jeune'; one still finds
flowers placed at its base, and occasionally a few stems of Egyptian papyrus. The
elder Champollion supervised the publication of his posthumous papers, but the
decipherment remained a speculative hypothesis to many scholars. As late as
1854 the brilliant orientalist and archaeologist Gustavus Seyffarth (1796–1885)
was still lecturing in New York under the highly spurious billing the 'discoverer
of the key to the hieroglyphs', and opposing Champollion's work.[73] As Edward
Hincks noted, 'even the warmest admirers of Champollion must admit that he
left his system in a very imperfect state'.[74] He had, however, provided scholars
with all the means to consolidate his ground-breaking work. The subsequent
progress of Egyptian philology and Egyptology shows to what extent the act of
decipherment was not a single event. It is one thing to start reading a language,
but another to read a culture.

THE ROSETTA STONE AFTER CHAMPOLLION

The first complete translation of the Rosetta Stone in the New World appeared
in Philadelphia in 1858, in the *Report of the Committee Appointed by the Philomath-
ean Society of the University of Pennsylvania to Translate the Inscription*, and it earned
the congratulations of Alexander von Humboldt.[75] A cast of the Stone had been
presented to the University, and three undergraduate members of the Society,
C.R. Hale, S.H. Jones and H. Morton, undertook a translation of all three copies
of the text 'based entirely upon Champollion's principles and elucidating many
passages not before explained in a satisfactory manner'.[76] The whole was repro-
duced by chromo-lithography; the vivid cover includes an Egyptian-style scene
suggestive of the veil of hidden mysteries being lifted, and an inscription com-
posed in hieroglyphs by the authors. The Philomathean Society is now the oldest
literary society in America, and its account of the reign of Ptolemy V shows the
influence of its own democratic ideals, continuing an Enlightenment view of
ancient Egypt. While it ranks among the first publications of American Egyptol-
ogy, it was not the first influential attempt to 'translate' Egyptian texts, since the
Mormon prophet Joseph Smith Jr had in 1835–44 worked on three Roman
period funerary papyri, one of which he translated by direct inspiration as the
now canonical Mormon scripture, *The Book of Abraham*.[77]

In the decades following Champollion's death, the Irish cleric who had de-
ciphered Mesopotamian cuneiform, Edward Hincks, continued to advance the
decipherment. He argued correctly that hieroglyphs do not contain any vowels,
and published in 1847 *An Attempt to Ascertain the Number, Names and Powers of the
Letters of the Hieroglyphic or Ancient Egyptian Alphabet Grounded on the Establishment
of a New Principle in the Use of Phonetic Characters*. The paper reveals how uncertain

the exact nature of the hieroglyphic script still was at that period. In general, the lead in Egyptology quickly passed to Germany though the achievements of Carl Richard Lepsius (1810–84), who learnt from Champollion's posthumous *Grammaire*, accepting, correcting and expanding his system. He established that there were bi- and triconsonantal signs, and not merely a multiplicity of alphabetic signs. He also produced the great seventeen-volume *Denkmaeler aus Aegypten und Aethiopien* (1849–59) – the only publication that both rivalled the *Description* in size and lavish production, and exceeded it in the accuracy of its copies. A specific example of Lepsius' progress is P. Sallier II (now P. BM EA 10182) (pl. 8), which contains a copy of the poem *The Teaching of King Amenemhat*, copied by the apprentice scribe Inena during the reign of Sety II (*c.* 1210 BC). Champollion had viewed this papyrus on his way to Egypt in 1828 as part of the collection of François Sallier (1764–1831) at Aix-en-Provence; Champollion, however, failed to recognize the literary genre of this text, and suggested instead that it was an ode in praise of the pharaoh 'Psammis'.[78] It was Lepsius who in 1849 translated the title as 'The Wisdom', by reference to a related Coptic word,[79] and correctly identified the king as the founder of the 12th Dynasty, Amenemhat I. (A report on another of the Sallier papyri had been published by Champollion's Italian student F.P.G. Salvolini (1809–38) as *Campagne de Rhamses-le-Grand* in 1835, but this was actually based on notes stolen from Champollion[80] – an extreme illustration of how all interpretation of a text is ultimately an appropriation.)

On an expedition to Egypt in April 1866, Lepsius studied another trilingual decree found at Tanis. This was a fine limestone stela, with a copy of the so-called Canopus Decree of Ptolemy III (238 BC), and is now in the Egyptian Museum, Cairo. The well-preserved stela, 220 cm high, has the hieroglyphic text and the Greek on the front face, underneath a lunette with a winged sun-disk, but without a figured scene. The demotic text is on the left thickness of the stela, where it remained unnoticed at first.[81] With this discovery, Champollion's hypotheses could be checked using a hieroglyphic text that had a certainly identified ancient translation; the Tanis stela is thus as important a milestone in Egyptology as the better known Rosetta Stone: only now did Champollion's decipherment become certainty, not hypothesis.

The Berlin school shaped Egyptian philology for the nineteenth and twentieth centuries, in particular through the work of scholars such as Adolf Erman (1854–1937) and Kurt Sethe (1869–1934). They laid the systematic basis for the study of the language, together with Francis Llewellyn Griffith (1862–1934), Battiscombe Gunn (1883–1950) and Sir Alan Gardiner (1879–1963) in England. The publication of Gardiner's *Egyptian Grammar: Being an Introduction to the Study of Hieroglyphs* was a major step in codification, the first edition appearing in 1927, and the third and last in 1957. In terms of language the work of Hans Jacob Polotsky (1905–91) established the 'standard theory' of Egyptian grammar, which has recently been modified extensively by approaches that stress the verbal aspects of classical Egyptian syntax.[82] Champollion's achievement was the turning point of a study which is still progressing. Egyptology has developed into a

truly international arena of collaboration, continuing the spirit in which the copies of the Rosetta Stone were circulated, and has transcended nationalistic concerns.

Although Egyptology offers a huge range of material, the Rosetta Stone remains outstanding. It is among the best-known inscriptions in the world, although, given the sacerdotal nature of its contents, it is also one of the least generally read. The Philomathean Society report candidly remarked that the Stone 'fails to furnish the student of history with that amount of information his love of ancient lore had anticipated'.[83] The Stone is the subject of much fascination, to the extent that the Museum still receives occasional letters from people claiming to have cracked its code, or to have even discovered an unknown language inscribed on the (uninscribed) back of the Stone. It has become the icon of all decipherments: the European Space Agency has planned a mission for 2003 to investigate the origin and composition of comets in order to decipher something of the history of the solar system; this has been named the International Rosetta Mission. Although the Rosetta Stone fascinates as a concept, it has featured visually in surprisingly few pieces of Egyptomania; souvenirs, including mouse-mats, T-shirts and paper weights, as well as replicas of various sizes, are its principal media of visual dissemination. The grandest is perhaps the commemorative pavement at the Musée Champollion, Figeac (fig. 17). The Stone is almost always reproduced as a black and white flat surface, as if silently ignoring its existence as an ancient monumental artefact and subsuming it into the world of Western printing. Its fascination comes not from its visual form but from the concept of its importance in the history of writing, and as such it has occasionally featured in more conceptual works of art, such as an etched zinc plate by David Hiscock exhibited in the British Museum in 1994 as part of a contemporary art exhibition,[84] in which the Stone was transformed into 'a contemporary hieroglyph, a Bar Code'. As the artist commented, 'the connection between our world today and the ancient Egyptian seems too vast a gulf to contemplate. The Rosetta Stone bridges this divide.' It remains, however, a fragile and uncertain bridge.

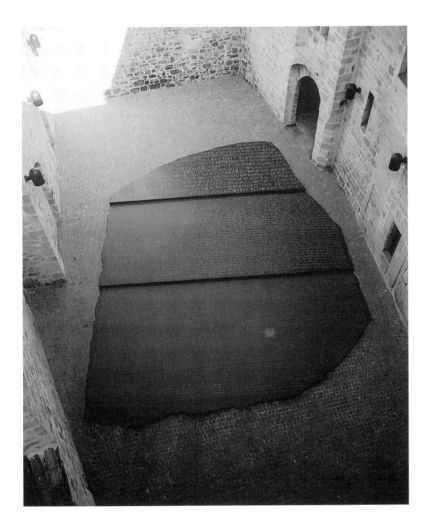

Fig. 17 The courtyard of the Musée Champollion, Figeac, decorated with a giant replica of the Rosetta Stone. Courtesy the Musée Champollion, Figeac (all rights reserved; photograph by Chotard Vasseur).

NOTES

1 'Deep play: notes on the Balinese cockfight', in *The Interpretation of Cultures* (New York, 1973), 412–53.

2 'Literacy, social organisation, and the archaeological record', in J. Gledhill *et al.* (ed.), *State and Society: The Emergence and Development of Social Hierarchy and Political Centralization* (London, 1988), 192–214; quotation from 209.

3 P.T. Daniels and W. Bright (eds), *The World's Writing Systems* (New York and London, 1996), 3.

4 See U. Eco, *The Search for the Perfect Language* (London, 1997), 176–7.

5 E.g. J. Goody, *The Interface Between the Written and the Oral* (Cambridge, 1987), 3–18.

6 See Chapter 4.

7 Asceplius 24: D.M. Parrott (ed.), *Nag Hammadi Codices* v, *2–5 and* vi *with Papyrus Berolinensis 8502, 1 and 4* (Nag Hammadi Studies 11; Leiden, 1979), 420–21.

8 E. Iversen, *Obelisks in Exile*, I: *The Obelisks of Rome* (Copenhagen, 1968), 161–73; P. Derchain, *Le dernier obélisque* (Brussels, 1987); A. Grimm *et al.*, *Der Obelisk des Antinoos: eine kommentierte Edition* (Munich, 1994).

9 J. Assmann, 'Ancient Egypt and the materiality of the sign', in H.U. Gumbrecht and K.L. Pfeiffer (eds), *Materialities of Communication* (Stanford, 1994), 15–31; quotation from 26.

10 See, e.g., G. Boas, *The Hieroglyphics of Horapollo* (Princeton, 1993 [1st edn 1950]); H.-J. Thissen, *Von Bild zum Buchstaben – von Buchstaben zum Bild: von der Arbeit an Horapollons Hieroglyphika* (Abhandlungen der Geistes- und Sozialwissenschaftlichen Klasse Jahrgang 1998, no. 3, Stuttgart, 1998).

11 See Chapter 2.

12 Translation after M. Pope, *The Story of Decipherment: From Egyptian Hieroglyphic to Linear B* (London, 1975), 31–2.

13 Daniels and Bright, *Writing Systems*, 145.

14 Eco, *Search*.

15 See R.H. Robins, 'The life and work of Sir William Jones', *Transactions of the Philological Society* (1987), 1–23.

16 See H. Laurens *et al.*, *L'expédition d'Égypte 1798–1802* (Paris, 1989).

17 E. Iversen, *The Myth of Egypt and its Hieroglyphs in European Tradition* (Copenhagen, 1961), 132–3.

18 C.C. Gillispie, 'Historical introduction', in C.C. Gillispie and M. Dewachter (eds), *Monuments of Egypt: The Napoleonic Edition: The Complete Archaeological Plates from La Description de l'Égypte* (Princeton, 1987), 1–38.

19 C. Traunecker, 'l'Égypte antique de la "Description"', in Laurens *et al.*, *L'expédition d'Égypte*, 351–70.

20 As described by Turner in 1812: see n. 33 below.

21 M. Coe, *Breaking the Maya Code* (New York, 1992), 37.

22 A letter of Thomas Young to William Bankes' father (10 February 1818), an unpublished manuscript now in the British Museum; fig. 12. Also quoted below.

23 X.-B. Saintine *et al.*, *Histoire scientifique et militaire de l'éxpedition française en Égypte* (Paris, 1832), VI, 434–5; quoted: C. Lagier, *Autour de la pierre de Rosette* (Brussels, 1927), 8–9.

24 Gillispie and Dewachter, *Monuments of Egypt*, 21–2.

25 Following the version of Lagier, *Autour de la pierre de Rosette*, 15.

26 E.D. Clarke, *Travels in Various Countries of Europe, Asia and Africa*, II.2: *Greece, Egypt and the Holy Land* (London, 1814), 239; also 270–9, cited below.

27 *Archaeologia: or Miscellaneous Tracts Relating to Antiquity* (The Society of Antiquaries of London) 16 (1812), 212–14.

28 For the other antiquities, including the sarcophagus of Nectanebo (EA 23), see J.-J. Fiechter, 'La pierre de Rosette et les autres antiquités égyptiennes prises par les anglais en 1801', *RdE* 48 (1997), 283–9; M. Bierbrier, 'The acquisition by the British Museum of antiquities discovered during the French invasion of Egypt' (in press).

29 H. Whitehouse, in K. Eustace (ed.), *Canova: Ideal Heads* (Oxford, 1997), 106–10, esp. 109.

30 *Gentleman's Magazine* 72 (1802), 726.

31 H. Whitehouse, in Eustace, *Canova*, 110 n. 12.

32 The publications are surveyed in R. Simpson, *Demotic Grammar in the Ptolemaic Sacerdotal Decrees* (Oxford, 1996), 8–9.

33 In *Archaeologia* 16, 208–63.

34 *Gentleman's Magazine* 72, 726–7.

35 'Sais and its monuments', *ASAE* 42 (1943), 369–415, esp. 390–3; other pieces in the British Museum (EA 20, 22, 964) have been described as coming from Rosetta, and thus possibly from Sais, but this supposed provenance is unsubstantiated in contemporaneous records. Sais is currently being surveyed by P. Wilson for the Egypt Exploration Society.

36 B.F. Cook, 'Greek inscriptions', in J.T. Hooker *et al.*, *Reading the Past: Ancient Writing from Cuneiform to the Alphabet* (London, 1990), 300–01.

37 See, e.g., F. Daumas, *MDAIK* 16 (1958), 75; for temples in general see, e.g., R.B. Finnestad, 'Temples of the Ptolemaic and Roman periods: ancient traditions in new contexts', in B.E. Shafer (ed.), *Temples of Ancient Egypt* (London and New York, 1998), 185–237.

38 For a survey of the period see, e.g., D.J. Thompson, *Memphis under the Ptolemies* (Princeton, 1988); A.K. Bowman, *Egypt after the Pharaohs 332 BC–AD 642: From Alexander to the Arab Conquest* (London, 1986).

39 A.E. Astin *et al.* (eds), *The Cambridge Ancient History*, VIII (2nd edn; Cambridge, 1989), 250–1.

40 Thompson, *Memphis*, 118–19; cf. S. Quirke, in C. Andrews and S. Quirke, *The Rosetta Stone: Facsimile Drawing* (London, 1988), 8, 24 n. 30.

41 For a recent list of demotic copies see Simpson, *Demotic Grammar* (Oxford, 1996), 4–5.

42 In Andrews and Quirke, *The Rosetta Stone*, 10.

43 See, e.g., R. Bagnall, *Egypt in Late Antiquity* (Princeton, 1993); J.H. Johnson (ed.), *Life in a Multicultural Society: Egypt from Cambyses to Constantine and Beyond*, SAOC 52 (Chicago, 1992).

44 'Miettes', *RdE* 26 (1974), 1–20, esp. 15–19.

45 See Pope, *Decipherment*, 60–84; W.V. Davies, *Egyptian Hieroglyphs*, Reading the

Past (London, 1987), 47–56; Simpson, *Demotic Grammar*, 8–10; review: P.T. Daniels, 'Methods of Decipherment', in Daniels and Bright (eds), *Writing Systems* , 141–59, esp. 148–9.

46 *Supplement to the Encyclopaedia Britannica* IV.1 (1819), 35.

47 Both scholars corresponded in French (translated here).

48 J. Leitch, *Miscellaneous Works of the Late Thomas Young, M.D., F.R.S., &c., . . . ,* III: *Hieroglyphical Essays and Correspondence, &c.* (London, 1855), 65.

49 Ibid., 51.

50 Ibid., 59.

51 E. Iversen, *Obelisks in Exile,* II: *The Obelisks of Istanbul and England* (Copenhagen, 1972), 62–85.

52 Ibid., 81 n. 1.

53 P. Usick, pers. comm.

54 M. Dewachter, *Champollion: une scribe pour l'Égypte* (Paris, 1990), 45.

55 J. Leitch, *Works of the Late Thomas Young,* III, 220–3.

56 Ibid., 256.

57 See, for example, P. Usick, *William John Bankes' Collection of Drawings and Manuscripts Relating to Ancient Nubia* (PhD thesis; London, 1998).

58 Leitch, *Works of the Late Thomas Young,* III, 370.

59 Ibid., 371.

60 So H. Hartleben, *Champollion: sa vie et son œuvre 1790–1832* (Paris, 1983), 267.

61 Morris Bierbrier, pers. comm.

62 *Essay on Dr Young's and M. Champollion's Phonetic System of Hieroglyphics by Henry Salt* (London, 1825), 3.

63 Thomas Young, in Leitch, *Works of the Late Thomas Young,* III, 371.

64 J. Thompson, *Sir Gardner Wilkinson and his Circle* (Austin, TX, 1992), 125.

65 L. De La Brière, *Champollion inconnu: lettres inédites* (Paris, 1897).

66 Leitch, *Works of the Late Thomas Young,* III, iv-vi.

67 E.g. J. Ray, 'Thomas Young et Champollion', *BSFE* 119 (1990), 25–34.

68 S. Quirke, in Andrews and Quirke, *The Rosetta Stone,* 4.

69 *Précis du système hiéroglyphique des anciens égyptiens* (Paris, 1824), 7–8.

70 *Writing Systems,* 145.

71 *Notice sur la vie et les ouvrages de M. Champollion le jeune* (Paris, 1833); text in Dewacher, *Champollion,* 130–1.

72 Both letters quoted in Thompson, *Sir Gardner Wilkinson,* 126–7.

73 J.A. Wilson, *Signs and Wonders upon Pharaoh: A History of American Egyptology* (Chicago and London, 1964), 19.

74 *An Attempt to Ascertain the Number, Names and Powers of the Letters of the Hieroglyphic or Ancient Egyptian Alphabet . . .* (Dublin, 1847), 5.

75 A letter dated 12 March 1859 held in the Philomathean Society archives.

76 *Report of the Committee . . .* (Philadelphia, 1858), 84.

77 See J.A. Larson, 'Joseph Smith and Egyptology: an early episode in the history of American speculation about ancient Egypt, 1835–1844', in D. Silverman (ed.), *For his Ka: Essays Offered in Memory of Klaus Baer* (Chicago, 1994), 159–78.

78 H. Hartleben (ed.), J.-F. Champollion, *Lettres et journaux écrits pendant le voyage d'Égypte* (Paris, 1986 [1st edn 1909]), 11.

79 C.R. Lepsius, *Die Chronologie der Aegypter,* I (Berlin, 1849), 49 n.1.

80 See M. Dewachter, 'Le paradox des "papiers Salvolini" de la Bibliothèque nationale (MSS NAF 20450–20454) et la question des manuscrits des frères Champollion', *RdE* 39 (1988), 215–27.

81 Simpson, *Demotic Grammar,* 15–16.

82 See oveview in A. Loprieno, *Ancient Egyptian: A Linguistic Introduction* (Cambridge, 1995), 8–10.

83 *Report of the Committee . . .* (Philadelphia, 1858), 115.

84 J. Putnam and W.V. Davies (eds), *Time Machine: Ancient Egypt and Contemporary Art* (London, 1994), 10–13.

READING A TEXT: THE EGYPTIAN SCRIPTS OF THE ROSETTA STONE

On n'a pas assez souligné que tandis que nous possédons du passé une masse énorme de documents écrits, et de documents visuels, rien ne nous reste des voix avant les premiers et nasillards phonographes du XIXᵉ siècle.

It has not been sufficiently emphasized that while we have an enormous mass of both written and visual documents from the past nothing remains for us of *voices*, before the first nasal phonographs of the 19th century.
M. YOURCENAR, *Le temps, ce grand sculpteur* (1983)

The Rosetta Stone was produced in a multi-cultural, multi-script society, and it remains uncertain exactly who would have read the three different scripts used to write the Decree. To the discoverers of the Stone, however, the Greek was comprehensible and knowledge of it was integral to European high-cultural self-identity. The Stone records a form of Greek, and it is inscribed in the Greek alphabet used from *c.* 740 BC until the present day. Greek is one of the Indo-European languages, which are a family of 'genetically' related languages (some now extinct) that includes most of the modern languages of Europe, including English, and many of Asia. Close study of these languages by what is known as the comparative method has allowed the theoretical reconstruction of their linguistic ancestor, known as Proto-Indo-European (as envisaged in part by William Jones), for which there is no direct documentary evidence, spoken at some time in prehistory in an unknown location. It should be noted that it is impossible to prove what language a people associated with a particular material culture in the archaeological record spoke, without textual evidence. This makes it extremely difficult to correlate linguistic prehistory with archaeological prehistory.

Although Greek belongs to a different family from Egyptian, contacts between the two languages went back several centuries. Greek mercenaries left a graffito on the leg of one of the rock-cut statues of Ramses II (1290–1224 BC) at Abu-Simbel, the site that provided the material for Champollion's revelation in 1822. The graffito is dated to Year 3 of Psammetichus II (592 BC):

When King Psammetichos came to Elephantine this was written by those who went on by boat with Psammetichos son of Theocles; they went beyond Kerkis, up to where the river allowed it; Potasimto was in command of the foreigners and Amasis of the Egyptians; Archon son of Amoibichos and Pelekos, son of Eudamos wrote us (i.e. these words).[1]

Greek was the language of the administration and administrative elite in the Ptolemaic Period, and this continued to be the case under Roman rule, as with other eastern provinces of the empire. Greek, however, was not the only non-Egyptian language used in Egypt in the period of the Rosetta Stone. Some scholars have estimated that possibly forty languages were used there, between the New Kingdom and the Muslim conquest in the seventh century AD. Of these, Latin was limited to military and official contexts which involved Roman law, although its use increased in the fourth century AD, while Aramaic had been the official language of the foreign administration during the period of Persian domination (525–404 BC). Others such as Carian were limited to specific ethnic groups.

Of the three scripts on the Rosetta Stone, demotic is the one studied by the smallest proportion of Egyptologists and the one least familiar to the public (to the extent that it was consistently referred to as 'demonic' in a recent television documentary), although it provided some of the earliest successes in the process of decipherment. Here I concentrate on the hieroglyphic system since it under-lies the demotic.[2]

THE EGYPTIAN LANGUAGE

The pictorial nature of the hieroglyphic script tends to stand in the way of real-izing that the script writes a language, just as it obscured the way to decipher-ment until Champollion himself. Even after 1824 early scholars were initially uncertain whether a 'hieroglyphic dictionary' should be ordered by sign or by phonetic value, whereas it is now obvious that two different reference works are needed, a list of signs that allows one to read and transliterate the words written by the signs, and then a dictionary of the language.

The Rosetta Stone is a monumental vestige of the later stages in a long history of the Egyptian language that can be traced back up to three thousand years earlier.[3] The Egyptian language belongs to the Afro-Asiatic language family (also known as Hamito-Semitic), which spreads geographically over northern Africa, the eastern Mediterranean and western Asia. Branches of the family include Egyptian, Semitic, Cushitic, Omotic, Berber and Chadic. Egyptian shows the closest connections with Beja (Northern Cushitic), Semitic and Berber. Attempts to trace underlying 'super-families' of languages that would, for example, link Afro-Asiatic and Indo-European are highly speculative, because they involve a vast time-depth and a paucity of similar features so that the established compara-tive method (referred to earlier) breaks down and 'genetic' relationships cannot be proven in the same way.

Egyptian is first attested in written form around 3300 BC, and survived as a spoken language until the fifteenth century AD; it is still used as a liturgical language in the Coptic church. In this recorded span two major stages of the lan-guage can be identified: Early Egyptian (down to 1300 BC) and Later Egyptian (down to the Middle Ages). Early Egyptian comprises the consecutive stages known to Egyptologists as Old Egyptian and Middle (or classical) Egyptian.

Later Egyptian comprises New (or Late) Egyptian, then demotic, and finally Coptic, which was the key to the decipherment of the earlier stages of the language, although its relationship to the language of hieroglyphs was long unrecognized. 'Coptic' is a modern term, derived from the Arabic *qubti*, and ultimately from the Greek *aiguptios*, 'Egyptian'. It refers to the language and culture of Christian Egypt; in this period the language was written in a modified form of the Greek alphabet.

All these stages of the language are, of course, attested only in writing, so that its development must be traced, as it were, at second hand. Demotic and Coptic are terms for the scripts used in specific periods more than for the stages of the language which used those scripts. Spoken languages change continuously, as is evident if one compares versions of the beginning of the English Lord's Prayer in Anglo-Saxon (*c.* AD 950) and in modern English:

Fader urer dhu bist in heofnum . . .

Our Father who is in heaven . . .

Similarly, differences have developed between British and American English in the three and a half centuries since English colonies were established in the Americas, including differences in pronunciation (e.g. 'vase'), grammar ('got' and 'gotten') and vocabulary (including different terms for the same object, such as 'pavement' and 'sidewalk', and different meanings for the same word, such as 'suspenders'). It is impossible to be sure how the written Egyptian language was related to the spoken language in any period, but it is certain that by the end of the Old Kingdom (*c.* 2100 BC) the spoken and written languages had already diverged strongly.

The subsequent change from Early to Later Egyptian can be observed in a new phase of the language which became the standard used for written records in the 19th Dynasty. However, some official texts continued to be written in classical Middle Egyptian, and New Egyptian texts are not linguistically homogeneous. The change in written language did not reflect linguistic change directly, and developments towards New Egyptian in the spoken language probably occurred over many centuries. The changes in the written language were due to complex cultural factors: the introduction of New Egyptian into texts was heavily influenced by the reforms of the Amarna Period under Akhenaten (*c.* 1353–1335 BC), which affected religion, art and administration, that is, the entire elite culture. It is impossible to say what people were actually speaking at the time, but it is unlikely that the Amarna reforms brought about a fundamental change in the spoken language of the population.

Various models have been proposed for the linguistic changes that can be seen in texts. In one model, the spoken language was considered to have developed and evolved at a steady rate, while the written language was thought to be taken directly from the spoken language at the start of a period of political unity and to have remained fixed until there was a political breakdown; at the start of the next settled period a new written language would have been adopted from the then spoken language. This simplistic model was modified in the 1940s by Bruno

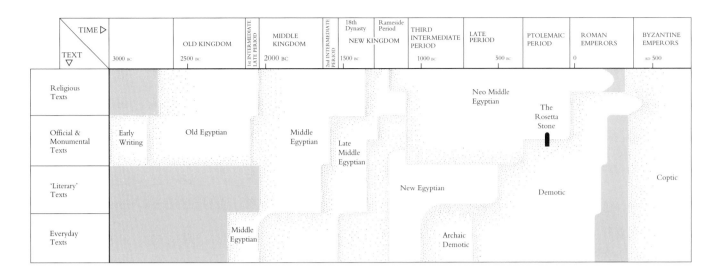

TIME ▷			OLD KINGDOM	1st INTERMEDIATE LATE PERIOD	MIDDLE KINGDOM	2nd INTERMEDIATE PERIOD	18th Dynasty	Rameside Period	THIRD INTERMEDIATE PERIOD	LATE PERIOD	PTOLEMAIC PERIOD	ROMAN EMPERORS	BYZANTINE EMPERORS
TEXT ▽	3000 BC	2500 BC			2000 BC		NEW KINGDOM 1500 BC		1000 BC	500 BC	0	AD 500	

Fig. 18 The evolution of written language; adapted from F. Junge, *LÄ* v (Wiesbaden, 1984), 1176–1211, Table 2. Shaded areas indicate blanks in the record.

Stricker and in the 1980s by Friedrich Junge.[4] In Junge's model (cf. fig. 18), the changes in the spoken language gradually penetrate written forms over time and are not determined by political periodization; his model also takes the different genres of writing into account.

It is impossible to estimate what was the rate of change in language. Different genres of text incorporated changes at different times, and genres themselves did not evolve at a consistent rate: in some periods certain genres of text may not have been composed at all. There is, for example, little trace of fictional literary texts being composed in the early 18th Dynasty, although this may be due to the chances of manuscript preservation. Thus attempts to trace the changes in language are very constrained. Classical Middle Egyptian first appeared in letters of the 6th Dynasty and dominated official discourse from the First Intermediate Period, while the phase known as 'late Middle Egyptian' appeared first in letters and administrative documents at the start of the 12th Dynasty and only reached literary texts at the end of the dynasty, but was never adopted into formal religious texts. The latter remained in a fossilized form of classical Middle Egyptian, or in 'neo-Middle Egyptian', a self-consciously archaizing form of the formal language of the Middle Kingdom, which originated in the 20th Dynasty. The hieroglyphic section of the Rosetta Stone was composed in neo-Middle Egyptian, a form of the language that was then around a thousand years old, and modelled on a phase of the written language older by a further thousand years. The composers of the Decree seem to have favoured rare words that were not current in demotic, as if they wished to foreground the difference between the two versions: such formality was particularly appropriate to a temple text, harking back to prestigious earlier periods of Egyptian history, and ultimately to the mythical ages when the gods ruled the earth.

The differences between the two Egyptian languages on the Rosetta Stone might seem bizarre to modern readers, but all societies, even when not so multi-cultural or possessing such long cultural traditions as Ptolemaic Egypt, show tendencies to diglossia, that is, the use of radically different forms of the same

language in different social contexts. For example, contemporary literary Welsh is considerably different from any of the modern spoken dialects that Welsh speakers have as their mother tongue and is partly a conservative and artificial creation. As with ancient readers of neo-Middle Egyptian in relation to their earlier literature, the positive result is that a modern reader can read Welsh poetry composed almost fourteen centuries earlier far more easily than modern readers of early English. Such differences between different registers of a language that are used in a society often pass half-unnoticed by their speakers and readers, so much do they become second nature. One recites poetry, speaks in conversation, delivers a lecture, writes an academic catalogue or produces a paperback with an embossed cover in widely differing registers of language, and any confusion between them would be both startling and potentially comic. People do not speak in full sentences but do usually try to write them; for this reason if for no other, all written language is to some extent artificial. Formal written language is not simply what the elite speak at any one time, but is shaped by past language, history and concerns such as display. In Egypt, where antiquity automatically conferred prestige, the preference for older stages of the language in composing formal texts produced an extreme position, which would have required translations and paraphrases for inscriptions to be understood, as if all formal publications of the English government, church and universities were composed in Middle English or even Anglo-Saxon.

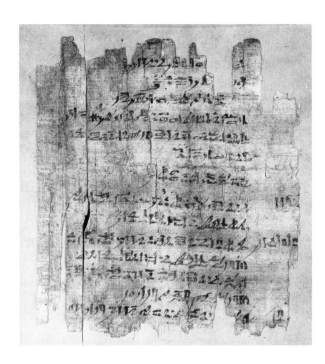

Fig. 19 A fragmentary Third Intermediate Period papyrus in Middle and New Egyptian. H. 18.9 cm. P. BM EA 10298.

Diglossia can require translations and dual language editions of texts. One example of the need to translate from one level of the language into another is a fragmentary Third Intermediate Period papyrus (P. BM EA 10298) (fig. 19) which includes proverbial-sounding sayings written in Middle Egyptian with translations into New Egyptian in the next line.[5] Later examples include the *Ritual for Repelling the Aggressive One*; this is preserved in a Ptolemaic manuscript (P. BM EA 10252), but the composition is in Middle Egyptian, and is provided with a line by line translation in New Egyptian.[6] Similarly, a Middle Egyptian astronomical treatise carved in hieroglyphs on the temple cenotaph of Sety I (1306–1290 BC) at Abydos and in the tomb of Ramses IV (1163–1156 BC) is found written in hieratic with a demotic translation and commentary on a first century AD papyrus (P. Carlsberg I). In such cases, the more contemporaneous language into which the archaic text was translated had often itself been formalized centuries before the dual-language manuscript was written. Another instance of this is, of course, the Rosetta Stone.

Egyptian changed in vocabulary, word-structure and sentence-structure. There were also changes in sound, which the writing system of the pharaonic period largely disguises. The hieroglyphic script contains the following uniconsonantal signs, the so-called 'alphabet' discovered by Young and Champollion:

phonological value	conventional transliteration	Schenkel's transliteration	sign	entity represented
a glottal stop (as in Cockney 'bottle')	*3*	*3*	𓄿	Egyptian vulture
y (as in 'yoke')	*j*	*i*	𓇋	reed
y	*jj, y*	*y*	𓏭 (or //)	two reeds
a gutteral sound (Arabic *ayin*)	ʿ	ʿ	𓂝	forearm
w	*w*	*w*	𓅱 (or 𓏲)	quail chick
b	*b*	*b*	𓃀	foot
p	*p*	*p*	𓊪	stool(?)
f	*f*	*f*	𓆑	horned viper
m	*m*	*m*	𓅓 (or 𓐙 or ⇒)	owl
n	*n*	*n*	ﻮﻮﻮ (or 𓈖)	water
r	*r*	*r*	𓂋	mouth
h (as in 'he')	*h*	*h*	𓉐	reed shelter
emphatic h	*ḥ*	*ḥ*	𓎛	twisted wick
ch (as in German 'Buch')	*ḫ*	*ḫ*	𓐍	placenta(?)
ch (as in German 'ich')	*ẖ*	*ẖ*	𓄡	animal's belly
z	*z*	*s*	𓊽	door-bolt
s	*s*	*ś*	𓋴	folded cloth
sh (as in 'she')	*š*	*š*	𓈙	pool
q (as in 'queen')	*q* (or *ḳ*)	*ḳ*	𓈎	hill-slope
k	*k*	*k*	𓎡	basket
hard g	*g*	*g*	𓎼	jar-stand
t	*t*	*t*	𓏏	loaf of bread
ch (as in 'choke')	*ṯ*	*č*	𓍿	rope tether
d	*d*	*t*	𓂧	hand
j (as in 'joke')	*ḏ*	*č̣*	𓆓	snake

Fig. 20 Fragment of limestone raised relief with hieroglyphs for uniconsonantal signs in a vertical column, facing left. The central sign is a finely carved uniconsonantal sign (*ȝ*); above it are traces of an *h* and below, the top of an *s*. Provenance unrecorded. H. 7.1 cm. EA 2436.

These signs represent consonantal and semiconsonantal phonemes (such as English *y*), including semiconsonantal or semivocalic glides that were recorded in the script; they comprise the basic phonological units of the script, into which all texts are transliterated, with the exception of the sound *l*, which is represented by the signs for *n* + *r* (fig. 20). The signs do not match the sounds of the modern Western alphabet; for this reason, in part, Champollion used Greek letters for his transliterations in the *Lettre à M. Dacier*, and then the Coptic alphabet in his *Grammaire*. The current system of transliteration presented above was proposed by Adolf Erman in the late nineteenth century; previous Egyptological systems had included an alphabet used by Wallis Budge in many, now outdated, publications.[7] Wolfgang Schenkel has proposed a revised transliteration alphabet that should be closer to the actual ancient sounds, but this has yet to gain widespread acceptance.[8] In transliterated texts, a point (.) stands before grammatical affixes, and : stands between suffix pronouns and the preceding word.

The lack of signs representing vowels is not a deficiency. Grammatical inflection is indicated in Semitic languages by different patterns in the vowels around a core of typically three consonants (that is termed the 'triconsonantal root'): this applies to some extent to Egyptian, and explains the written stress on consonants. Egyptian sonants such as *n* and *m* are often written without vowels in Coptic. Coptic itself displays many dialect features, and these must have existed in earlier Egyptian; thus, a Ramesside literary text implies that 'the speech of a Delta-man with a man of Elephantine' would be utterly confused.[9] The consonantal hieroglyphic script incidentally obscures such dialectal variations, as is also true of standard written English, which smooths out much variation. Writing systems that are completely phonological are not necessarily the most efficient for native readers of the language. For example, in the English words 'photograph', 'photography' and 'photographic', the main stress is in a different position in each word and the vowels are pronounced differently; the spelling does not represent the pronunciation, but on a different level it does make clear that all the words derive from the same stem, as would a purely consonantal spelling.

The history of the modern transliteration of demotic exemplifies these issues clearly.[10] The sound system of demotic had developed far from that of earlier stages of the language, and the demotic script does not distinguish the phonemes *t* and *d*, writing only *t*, but it does distinguish *l* and *r*, in contrast to earlier hieroglyphic writing. Thus, a different, only recently standardized, transliteration is now used for demotic. Two earlier systems included the English or phonetic system, employed by scholars such as Francis Llewellyn Griffith (1862–1934), which was based on a reconstructed pronunciation, derived largely from Coptic; the older German system was based on historical etymology, and was the same as that used for classical Egyptian. The transliteration system preferred by scholars at the Oriental Institute of the University of Chicago, who are preparing a comprehensive dictionary of demotic, includes a fifth *h*, (*ḫ*); a third *t* (*ṱ*) is also used, and a vowel marker *e*. Thus, the demotic equivalent for the hieroglyphic 'alphabet' is as follows:

sign	derivation	transliteration
? or 2ɔ	(bird)	3 .
↓	(reed)	i
ΙΙ	(double reed)	e
ʒ	(arm)	
⟨⟩ or ⟨	(arm)	c
ΙΙΙ	(double reed)	y
ʒ	(quail chick)	
ʃ	(quail chick)	w
Ι	(vertical)	
4	(bird)	
ΙL	(leg)	b
⸆ or ⸌	(stool)	p
✓	(horned viper)	f
Ɔ or ⊃	(owl)	m
—	(water)	
ᴐ	(water)	n
⸌ or ⸜	(mouth)	
/	(mouth)	r
✗	(lion)	l
∩	(shelter)	h
4		
9		ḥ

sign	derivation	transliteration
6	(sieve)	ḫ
⸨	(sieve)	ẖ
⊐		
⸜		ḥ
4	(folded cloth)	
⟨ΙΙ		
+ or ⸊		s
Ιʔ or ʔΙ or ?		
3 or ʒ	(pool)	š
⸧ or ⸨	(hill)	q
⸤ or —	(basket)	k
⋊ or ⋈	(stand)	g
⟨ or ⟨	(loaf)	
4		t
⸗	(water / loaf)	d
ᴊ or ᴊ or /		ṱ
⸌		ṯ
⸗ or ΙL		
ʔ		ḏ

Transliteration is at best only a half-way stage to vocalized pronunciation. For any word it represents in alphabetic characters the traditional spelling that had been formalized centuries earlier than the text, rather than the contemporaneous pronunciation (a feature that is common to many orthographic systems including English). When Egyptologists voice a text, they insert a neutral murmur vowel sound (a 'schwa', the sound written as an 'e' in 'mother') between consonants, and treat many of the weak consonants as vowels ('a' and 'i'), to provide a standardized academic pronunciation. This is purely conventional and does not seek to recreate ancient pronunciation. For example, the final line of the Rosetta Stone (written right to left) can be transliterated, and might be pronounced by an Egyptologist, as follows:

Transliteration: *ḥr ꜥḥꜥjj ntj ꜥ3t rwḏ m sḫ n mdw nṯr sḫ n šꜥjj sḫ3jj n Ḥ3w-nbw*
Pronunciation: *her ahay neti aat rudj em sech ni medu netcher sech ni shay sekhay ni Hau-nebu*
Literal gloss: upon stela which stone hard in writing of god's words writing of letter script of Aegeans
Translation: upon a stela of hard stone in hieroglyphic writing, in demotic writing, and in the script of the Aegeans

The parallel phrase in demotic, a different stage of the language and a different transliteration system, would be transliterated as follows:

n wyṯ iny ḏry n sḫ md-nṯr sḫ šꜥt sḫ Wynn

and pronounced:

ne weytj iiny djery ni sech med-netcher sech shat sech Weynen.

The difference between the phonemes recorded in the script and contemporaneous pronunciation can be glimpsed in occasional words that are also preserved in other writing systems, such as Akkadian cuneiform. For example, the Egyptian word for headrest, *wrš*, is rendered *urušša*, the Egyptian place name *Iwnw* ('Heliopolis') is *Ana*, and the prenomen of Amenhotep III, *Nb-m3ꜥt-rꜥ*, is *Nibmuaria*. *Imn-rꜥ-njswt-nṯrw*, 'Amun-Re king of the gods', is preserved in Greek texts as *Amonrasōnthēr*. One particularly valuable source is P. BM EA 10808, a fragment of a magical text of the second century AD from Oxyrhynchus[11] (fig. 21) in which the Egyptian language was transliterated into a combination of Greek and demotic signs similar to the Coptic script. The opening line can be reconstructed into a Middle Egyptian curse against the enemies of the gods:

★*j srwt sbj n-Wnn-nfr*
ḫftj n-Wsjr ḫntj-jmntt
O Ram, rebel against Wennefer,
enemy of Osiris Foremost of the West!

This is written on the papyrus as:

o sro sēb nouenafr
cheft nousr chntemnt

This is the closest one now has to a phonetic transcription of Middle Egyptian 'as she was spoken', or how in post-pharaonic antiquity she was believed to be spoken.

Other sources for the study of Egyptian phonology include comparative Afro-Asiatic linguistics and the Egyptian versions of foreign words. The most extensive is the continuation of Egyptian in Coptic, when the language is written with an adaptation of the Greek alphabet which records vowels (see p. 102). An example is the Middle Egyptian word for 'cat', which is recorded in hieroglyphs as *mjw*; this would be conventionally pronounced *miu*, but in Coptic the word is written ⲈⲘⲞⲨ (*emou*). This preserves an initial vowel that may always have been present but was unrecorded in the hieroglyphic script, allowing Werner Vycichl to reconstruct a hypothetical original form of the word as *iammaya*.[12] He analysed it as an agentive noun from a verb *my, to 'mew'; the final *w* in the hieroglyphic word is a grammatical ending, and not part of the stem. Coptic vowels also reveal the linguistic patterns underlying the standardized consonantal orthography: in Middle Egyptian the adjective 'pure', the infinitive 'to be pure' and the noun 'priest' (lit. 'purified one') are all written *w'b*, while Coptic records 'pure/holy' as ⲞⲨⲀⲀⲂ (*ouab*), 'to be pure' as ⲞⲨⲞⲠ (*ouop*) and priest as ⲞⲨⲎⲎⲂ (*ouēb*).[13]

The changes between Early and Later Egyptian affected vocabulary, word order and grammar. Their nature can be exemplified for the important category of non-verbal sentences by two hypothetical sentences proposed by Friedrich Junge:[14]

sẖ3w njswt nfr m pr:f
scribe king perfect in house-his
the perfect scribe of the king is in his house.

In Later Egyptian this would be:

p3 sẖ nfr n pr-'3 m-ẖnw t3j:f 't
the scribe perfect of Pharaoh in his house.

In Early Egyptian *sẖ* can be 'a' or 'the scribe', while Later Egyptian uses definite and indefinite articles. The word order in verbal sentences changes from verb + subject + object ('hears he his wife') to subject + verb + object ('he hears his wife'). In verb forms, functions that are indicated by suffixes in Earlier Egyptian (e.g. *sḏm.n:f*, 'he heard', where *sḏm* is the stem 'hear', *n* marks the past, and *:f* the person and number) are replaced by periphrastic constructions, such as *jr:f sḏm* 'he heard', where the grammatical functions are indicated by the word *jr:f* 'he made' (lit. 'he made a hearing'). Similar changes occur in Romance languages between Latin (*feci*, 'I have done') and French (*j'ai fait*, 'I have done'), and are described in linguistic terminology as developments from a 'synthetic' to an 'analytic' type. In Coptic the *jr:f* has become a prefixed tense-marker, so that 'he heard' is ⲀϤⲤⲰⲦⳘ (*afsōtm*) (*jr:f* becoming *af*, and *sḏm* becoming *sōtm*). Coptic has therefore re-synthesized the analytic type of New Egyptian.

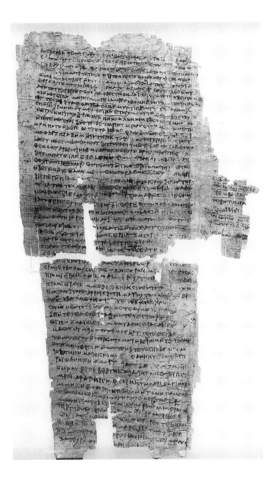

Fig. 21 A second-century AD papyrus with a Middle Egyptian magical text written in Greek and demotic signs. H. 29.2 cm. EA 10808.

THE CLASSICAL EGYPTIAN WRITING SYSTEM

The number of hieroglyphic signs in use varied from around one thousand in the Old Kingdom to perhaps 750 in Middle Egyptian, increasing again to several thousands in the Greco-Roman Period. At first sight the number and types of signs can seem boundless, but this is partly due to the use of different forms of signs in different types of texts, materials, contexts and periods. Sir Alan Gardiner's *Egyptian Grammar* provides a list of some 750 signs, categorized according to what the sign depicts. Almost all are representations of creatures and objects, although some are now hard for the Egyptologist to identify; a few are abstract strokes and signs. Orly Goldwasser has termed the system 'the crossroads par excellence of word and picture',[15] stating that in structuralist terms 'many hieroglyphic signs actually play the *double role* of a *written signifier* and a *signified*'.[16] Just as they fascinated pre-decipherment scholars, so they continue to exert a fascination over modern semioticians such as Jacques Derrida. Hieroglyphs retain their pictorial aspect in very many contexts, although cursive forms developed very early and most practical writing was cursive. While cursive forms are derived directly from the full pictorial forms, they are usually very different in appearance, and it is clear that ancient readers often experienced difficulty in translating the cursive into hieroglyphs.

THE SHAPES OF SIGNS

The images used as hieroglyphic signs depict figures, animals, natural features and a range of artefacts.[17] The forms almost always follow the conventions of Egyptian representational art and are executed in the same style: the hieroglyph for a tree (𓆭) is the same as representations of trees in paintings and reliefs. Sign forms were standardized very early, by the 4th Dynasty, although minor changes continued to occur. The sign for *sẖ*, 'write' 𓏞, shows the archaic scribal kit including a pair of inkwells, a container for pigment and a tubular brush holder. By the 5th Dynasty it is clear that this equipment had been replaced by the scribal palette (see cat. 58–60). Only elements of the old equipment were retained, such as the holders which were still used in New Kingdom,[18] but by this time the old sign was so archaic that it was in part misunderstood and the bag of pigments reinterpreted as a water pot. The dichotomy between the signs and the new shape of what it represented was not disguised: in the New Kingdom scribes were represented as writing with the new equipment while the hieroglyphic caption above them included the hieroglyph based on the archaic equipment.

Sometimes, however, signs were updated. This is especially true of elaborately executed signs showing human figures, which can follow changes in fashion, and of some signs overtaken by technological advances, such as the hieroglyph of a razor, the Old Kingdom form of which shows a shape ⊂− that was updated in the New Kingdom to ▽. Conversely, signs also became stylized when it was forgotten what they represented. Another development was the creation of composite signs such as 𓅱 from 𓅱 (*w*) + ◡ ('), writing *wˁ*.[19] Completely new

Fig. 22 A fragment of limestone inscription in raised relief, perhaps from the tomb of Sety I in the Valley of the Kings (cf. cat. 5). The direction in which the birds face shows that the fragment is part of a longer inscription in vertical columns reading from left to right. H. 14.67 cm. EA 65224.

Fig. 23 A fragment of limestone inscription in raised relief, perhaps from the Old Kingdom. The carefully executed hieroglyph, which shows an aged man, reads *j3w* 'old age'. H. 9.6 cm. EA 65453.

signs were occasionally introduced, such as the hieroglyph showing a chariot, a piece of equipment that was introduced into Egypt in the New Kingdom.

Sign forms incorporate an elite view of the world. The determinative used for 'sleep' and related words shows a body flat on a wooden bed, which was probably a fairly prestigious piece of furniture, to judge from the way in which beds are mentioned in some literary texts. From the Middle Kingdom onwards, the sign was altered to show a mummy on a bier (⊨⊣), representing a still more elite state of affairs. The choice of sign forms also reveals which objects the inventors of the script regarded as prototypical.[20]

The order in which signs are to be read is most clearly indicated by the birds, which almost always face towards the beginning of the text (fig. 22). There is a general preference for rightward orientation in which the writing is read from right to left, just as there is in Egyptian visual art, where the main figure is usually on the left of a scene, facing right. Henry George Fischer has explained this preference as reflecting the general right-handedness of humans – it is easiest to start writing on the side where the hand holding the writing implement is – and this has been confirmed by experimental studies.[21] The uppermost signs are read first; hieroglyphs can also be written in vertical or horizontal lines. There are some exceptions to these general principles of orientation, due to the physical context of a text on a wall or statue,[22] especially with hieroglyphs; the cursive forms of signs almost invariably face right. Retrograde hieroglyphs, usually in vertical lines, are found in the Old Kingdom, but become commoner in the Middle Kingdom and very common in New Kingdom Books of the Dead which were written in cursive hieroglyphs on papyri; they are read as it were from the backs of the birds and human figures. The backwards system may have arisen in part in cases where texts were written in cursive script, where signs normally face to the right, but on coffins in an iconographic context where the lines had to be read from left to right; this was subsequently adopted as a means of signalling the arcane and specialized nature of a text.[23] There are some horizontal examples of retrograde writing, including cases where retrograde lines alternate with normal ones, and some late Middle Kingdom stelae even have horizontal lines which read from bottom to top.[24]

THE USES OF SIGNS

The use of signs can be summarized as follows, grouped by function rather than by category because many signs can be categorized in several ways.

One basic function of a sign is as a logogram, in which a word was represented by a picture (also termed 'ideograms', or 'sound-meaning signs'). This usage can be simply iconic, as when a schematic ground-plan of a house writes 'house' (in Egyptian *pr*): ▢ . The usage can also be extended so that a sign can write semantically associated words (fig. 23). Thus a picture of the sun (☉) can write 'sun' (*r'*) but also 'day' (*hrw*), two different roots. Extension can also be symbolic or metaphoric, as with the word for 'god', which is written not with a fetish or an

image of a god, but with a flag-pole used to mark off temple areas as sacred space: ⌐.[25] Logograms can also be rebuses, so that a picture of a duck (🦆) writes the word 'son' (*s3*) because this is phonemically similar to the word for a species of pintail duck (*s(3)t*). By this rebus principle, logograms gave rise to phonograms (signs representing sounds), including the uniconsonantal 'alphabet': the sign ▭ writes the consonant *š*, since it is a logogram depicting a rectangular 'pool', in Egyptian *š*. A single sign could act in different words as logogram and as phonogram; a stroke is often placed beside signs that act as logograms: e.g. 𓏞 'scribal equipment', or ▭ 'pool'. In the derivation of the phonological value by the rebus principle, only the strong consonants were taken from the original word; in some specialized later usages the phonological value was taken from the first consonant only (the 'acrophonic principle').

Phonemic signs ('phonograms' or 'sound-signs') can represent one, two or three consonantal phonemes. There are the twenty-six uniconsonantal signs listed above, but also about eighty biconsonantals (two phonemes) (fig. 24) and about seventy triconsonantals (three phonemes). Examples include:

⊔	*k3*	𓆣	*ḫpr*
⌐	*ḥ'*	♀	*'nḫ*
∖	*tj*	⊻	*ḥtp*

The signs are not syllabic (representing a consonant + vowel) as in, for example, Mesopotamian cuneiform. Bi- and triconsonantal signs are often accompanied by additional signs, usually uniconsonantal ones, which act as 'phonetic comple-ments', helping the reader to determine between possible alternative readings, for example, ⊻ : *ḥtp* + *t* + *p*. Because the majority of Egyptian words have triliteral roots in Egyptian, there is no sharp distinction between a triconsonantal sign and a logogram.

From the use of signs as logograms another function is derived: the signs can be used as semograms (that is, signs conveying meaning, rather than sounds or words). These were used especially as 'determinatives', to use the term devised by Champollion, which are placed at the end of words and mark them off as belonging to a lexical or semantic group (taxograms). They can be specific (such as a picture of a pig to determine the word 'pig') or general (such as a general-ized tree for any word to do with trees). Some examples are:

𓀀	*seated man*	personal names, and words to do with man, man's relationships and occupations
𓀁	*man with hand to mouth*	words to do with eating, drinking, speaking, thinking and feeling
𓂡	*arm holding stick*	words to do with physical force, effort and strength
𓈉	*hill-country*	words for hill-country and desert or foreign lands; also foreign place names
𓏛	*bookroll*	words for book, writing and written things; hence for abstract notions

Fig. 24 A fragment of black basalt inscription in raised relief, from the Middle or New Kingdom (?). The left face has an original edge, suggesting that it is from an architectural element.
The fragmentary inscription consists of the biconsonantal sign *ms* followed by the uniconsonantal signs *w* and *t*, probably originally reading [*wḥm*]-*mswt*, 'repeater of manifestations', a royal epithet. H. 7.2 cm. EA 90422.

These signs are similar to logograms in that they depict a concept, but unlike them they do not represent a specific word or phonemic pattern. Very often an individual sign can have two functions, acting as a logogram and a determinative in different words. As an example of the relative frequency of different usages of signs, it has been estimated that in a passage of literary Middle Egyptian, written in cursive script, uniconsonantal signs dominate (55%), followed by determinatives (19%), logograms (15%) and finally other phonetic signs (11%).[26]

Hieroglyphic writing sounds complicated and potentially unstable when described in the abstract, but a mixed system of this sort, in which a single sign can be used in all three basic ways, is very flexible in practice. Although there might appear to be limitless possibilities of varying the orthography of words, the most characteristic pattern is phonograms + determinative. Some very common words are written only with phonograms (especially prepositions and the like) or logographically, and more than one phonetic complement and more than one determinative can be written, but the system is very rarely ambiguous. The most significant factor for ease of reading is that almost all words have a distinctive and consistent orthography at any given period. In the Old Kingdom there was a certain amount of variation in writing words, as well as a more frequent use of logograms than in the Middle Kingdom, when orthography became more standardized. In the New Kingdom, especially in cursive scripts, more phonetic complements were used, partly to indicate phonetic changes. In the Ptolemaic Period, however, the tendency to use figurative writings came to the fore (see cat. 9–12).

Words that appear to have identical consonantal skeletons often have different orthographies; thus *ḥmt* ('wife') and *ḥmt* ('maid') are written with different signs: and . Distinct orthographies like these were probably not chosen simply to distinguish homonymous words of different meaning, but rather to show that they derived from different roots, as well as perhaps being phonologically distinct. A few sportive orthographies seem to be determined in part by pictorial considerations: thus (*sbḥ*, 'to cry out') has a tooth sign () as a phonetic complement, to write *bḥ*; the choice of this particular sign is apt since teeth are bared when crying out.[27]

Determinatives are very useful aids to reading, both for the ancient reader and the modern decipherer. Their usual position at the end of words allows the reader to identify breaks between words which are otherwise unmarked, and they distinguish between consonantally identical words such as *nfrt* ('beautiful woman') and *nfrt* ('cow'), conveying information not otherwise recorded. In English 'bear' can be a noun (an animal) or a verb (to carry); the reader can usually tell immediately from the context which is meant, but hieroglyphs give the categorization to the reader. For the Egyptologist determinatives allow an unknown word to be partially identified: thus *tbsw*, which is known from only one 12th Dynasty text, can at least be identified as a type of plant from its determinatives: ; its root can then be connected with the verb *tbs* ('to prick'), suggesting that the plant may be prickly. Determinatives can also often add information that would not

have been present in the spoken language, except by context. For example, a *wḥ͑* ('catcher') could be someone who caught either fish or fowl, but writing can specify whether fish or fowl, or both, are being hunted by the use of one or two determinatives of categories of animal: 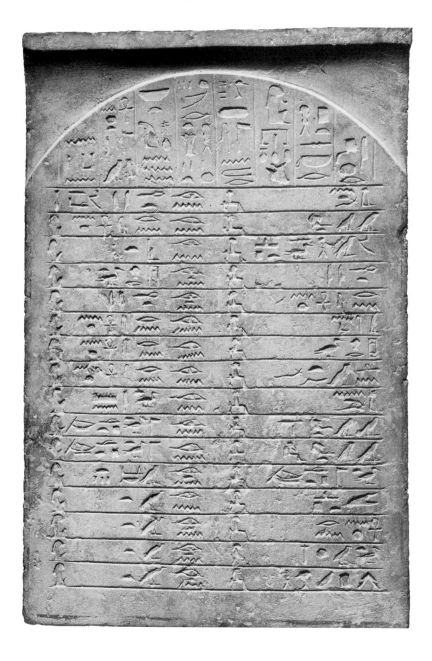 .

Determinatives assign words to classes and are not just decorative. This lexical recording is central to writing as an institution that does not merely transcribe linguistic utterances but rather incorporates classification and cultural memory. The Egyptians indicated their awareness of the distinctive use of signs as determinatives in many ways. Even funerary stelae that list names occasionally arrange the names in columns, with the determinative of each name set in a sub-column. One example is a Middle Kingdom round-topped limestone stela (EA 253) (fig. 25); after the standard funerary invocation, which is written in vertical lines

Fig. 25 The limestone funerary stela of Intef, with inscriptions in sunk relief. Late Middle Kingdom. H. 51 cm. EA 253.

at the top of the stela, the names of the recipients of the invocation are written in sixteen horizontal lines. The right column gives the name of the recipient, with the determinative 𓀻 (a man seated on a chair, showing that the person is prestigious), arranged in a sub-column; after this comes the phrase 'born of' followed in all but the first line by the name of the recipient's mother, with the determinative 𓁐 (a figure of a woman), arranged in a sub-column at the left edge of the stela. The text begins:

> Blessedness before Ptahsokar, invocation offering of bread and beer, flesh and fowl, incense and oil, and every good and pure thing on which a god lives, for the spirit of

Intef	born of Khety true-of-voice
Horemhat	born of Renesankh
Mahsehetep	born of Aset . . .[28]

The importance of lexical categorization can also be seen in a type of text now known as the Onomastica, in which words are listed according to category. In these lists the determinatives coincide with the categorization. The words are sometimes arranged in columns with the determinatives in a sub-column, as in the Middle Kingdom onomasticon of P. Ramesseum D (P. Berlin 10495). A more developed, but less tabulated, example of an onomasticon is P. BM EA 10202 (P. Hood) (fig. 26), a Third Intermediate Period hieratic manuscript containing a copy of *The Onomasticon of Amenemope*. This extensive work, which is known from eight other manuscripts, was probably composed in the late New Kingdom. The first column reads:

Beginning of the Teaching for making intelligent, instructing the ignorant, and knowing all that is – what Ptah fashioned and Thoth copied down: heaven in all its constellations, earth and all that is in it, what the mountains extrude, what the flood inundates, all things on which the sun-god has shone, all that is made to grow on the surface of the earth, deliberated by the Scribe of the Divine Books in the House of Life, Amenemope son of Amenemope. He says:

Heaven; sun-disk; moon; Orion; Great Bear; Ape-constellation; Strongman-constellation; Sow-constellation; storm-cloud; tempest; dawn; darkness; sunlight; shade; sunshine; sun's rays; dew; *3wdt* (unknown word); snow; rain-water(?); primeval water; flood; River; sea; wave; marshy place; pond; well; irrigation basin; waters; pool; southern reaches; northern reaches; dug well; tongue of land(?); flood-waters; overflowing water(?); current; water-hole; riverbank; river-shores; *rnw* (unknown word); standing water; island; fresh agricultural land; worn-out land; high (i.e. agricultural) land; mud; low-lying land; wood-(land); sand; new land; irrigable

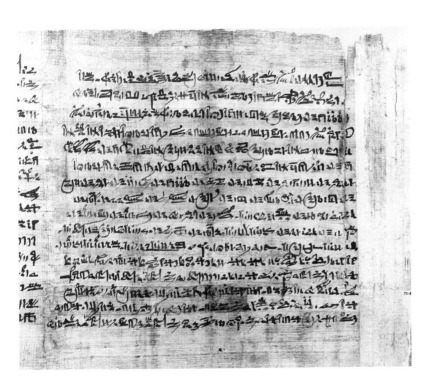

Fig. 26 The first column of P. Hood containing *The Onomasticon of Amenemope*, written in cursive hieratic. Third Intermediate Period. H. 23.2 cm. EA 10202.

land(?); river-land; god; goddess; blessed dead, male; blessed dead, female; King; King's Wife; King's Mother; King's Son; patrician; Vizier; Sole Friend; Eldest King's Son; Great Army Commander; Courtiers; Book-scribe of Horus the Mighty Bull; Great One of the Chamber of the Perfected God; First Royal Herald of his Person; Standard-bearer on the Right of the King; He who does the Excellent Works of the Lord of the Two Lands; Overseer of the Chamberlains of the Mighty King; Great One of the Office of his Lord l.p.h.; Royal Scribe in the Interior of the Palace; Vizier and Overseer of the Towns of the Homeland; Overseer of the Army; Scribe of the Infantry; Lieutenant Commander . . .[29]

Several of the words in this text are known only from the onomastica, and some may just be variant writings of the same word, as *3wdt* may be of the preceding word for 'dew' (*j3dt*). At one point the papyrus omits several rare words included in other manuscripts. Some words, such as *srq*, 'snow', are loan words from other languages. The numerous terms for types of land, the exact meaning of several of which is unknown to us, embody the predominant agricultural focus of Egyptian society.

The list is arranged in categories of heavenly bodies and natural phenomena, types of water and types of land, together forming the cosmos, moving then to its inhabitants in a characteristically Egyptian order of the gods, the blessed dead and then humanity, headed by the king, his family and his immediate subordinates. The *Onomasticon* is partly a didactic training text, but also an encyclopedic work of reference, as the grandiloquent title implies. As Barry Kemp notes, it allows the entire cosmos to be fitted into one's own mental and linguistic universe.[30] In this 'teaching', Egyptian society is summarized in a list, with a hierarchy of gods, dead kings and officials which is fundamental both to the Egyptian world-view and to the reality of Egyptian social life. Such texts, as well as the prominence of lists in Egyptian written genres, suggest the importance of writing as a means of recording information; words, name-giving and listing also underlie the modern science of taxonomy.

The use of determinatives also reveals much about cultural practices and resonances. Thus, the word for 'mourning' (*j3kb*) (⟨hieroglyphs⟩) can have two determinatives, a man with hand to mouth (⟨hieroglyph⟩) which represents the expression of emotional states, and a sign representing hair (⟨hieroglyph⟩), because people in mourning dishevelled their hair.[31] The determinative group for words such as 'people' shows a seated man and a seated woman above a group of three strokes representing plurality ⟨hieroglyph⟩; the man always comes first, embodying the male bias of Egyptian society.[32] Metaphoric aspects of Egyptian attitudes to emotions are revealed by transferred uses of determinatives; the determinative showing a pig (⟨hieroglyph⟩) can denote words for types of pig, but also pig-like movements: a verb 'to wander' (*tnbḫ*) has a pig as determinative in one manuscript, showing the associations that were uppermost in the scribe's mind. A crocodile determinative is applied to words for crocodile, but also to various words expressing greed, rage and other predatory emotions. In this way, extra-linguistic information, such as

semantic extensions and associations rather than formal features, can be recorded graphically. In one Middle Kingdom poem a sequence of metaphors involving crocodiles is continued on a purely graphic level in a later verse where a metaphor includes a word that is written with a crocodile sign but has no semantic connection to crocodiles. A similar visual poetry can be found in such royal inscriptions as the 'poetical stela' of Tuthmosis III, where the metaphoric descriptions of the king are written with hieroglyphs including a series of powerful animals.[33]

To most ancient readers of most types of text, the pictorial aspects of hieroglyphs, literal or metaphoric, probably existed as a sort of 'dead metaphor'. They would have passed unnoticed, especially when reading a cursive manuscript, unless the text foregrounded this aspect and 'revived' the metaphor (see cat. 9–12). Reading and writing seem to have been learned by memorizing word-groups rather than by learning lists of signs and abstract principles. There seems to have been a set order in which people listed and learned sounds, rather as the order of the modern 'roman' alphabet is learned. A very fragmentary early demotic papyrus of the third century BC from Saqqara contains a string of sentences in which 'alphabetically' ordered birds perch on 'alphabetically' ordered bushes, and then a sequence in which birds fly away to various places: 'the ibis (*hb*) (was) on the ebony (*hbyn*) tree; the *rd*-bird (was) on the vine (*rr*) . . . the Phoenix (*bnw*) went away to Babylon (*Bb*)'.[34] This seems to be a way of learning consonants by bird names, similar to the modern 'A is for Apple'. (Incidentally, the word *hbyn*, earlier *hbny*, is one of the words that survives into English from Egyptian, having originally come from a region of Africa that supplied the wood.) Fragments of lists of words arranged by their initial consonant are attested in the Late Period; the order was probably standard, since both the Saqqara fragment and another list begin with the sacred ibis (*hb*), which the Greek writer Plutarch (*c.* AD 40–120) stated was the first sign of the Egyptian 'alphabet'. There are also fragments of a carbonized papyrus (EA 10672), known as the Tanis Sign List, found in a house in Tanis.[35] In this, however, hieroglyphic signs are listed in categories, beginning with human figures, and are followed by the same sign in cursive hieratic, and then a relevant word in which the sign appears or a description of the sign, for example:

 , (a logogram for 'year') 'year'

or

 , (a determinative for words to do with night) 'sky and star'.

In a similar list of the first century AD from Tebtunis in the Faiyum (P. Carlsberg VII),[36] the glosses to the hieroglyphs are more mystical-sounding, incorporating elements of priestly exegesis; sign lists of this type seem to have been a principal source for Horapollo's allegorical *Hieroglyphica*. These lists were probably scholastic or reference works, rather than teaching texts.

Most modern learners of hieroglyphs find the system when described in principle bewilderingly complex, but once they start to read it becomes less forbidding. So, to exemplify the previous discussion, I consider here the words for 'cat' and for 'hear'.

The word for 'cat', mjw

The word for 'cat', *mjw*, which was discussed above, is written [hieroglyphs]. The first sign writes the two consonants *mj* (it ironically represents a milk-jug, the word for which was *mr/mj*). A second sign writing *j* complements this (a phonetic complement); the third sign provides the next consonant, *w*. The final sign is the determinative, expressing the lexical class of the word, in this case very specifically: it shows that the word refers not just to an animal, but to a small feline.

A finely executed example of the word occurs on the limestone funerary stela of the lady Tamyt (*T3-mjjt*) (fig. 27), from the New Kingdom. She is shown seated, and above her a hieroglyphic caption reads: 'The Lady of the House, Tamyt'. Another woman is shown before a table piled with food, presenting offerings to the deceased lady, and the caption identifies her as '<Her> daughter, Kiya'. Tamyt's name means 'The (female) Cat';[37] the final *t* is the feminine ending, and *t3* is the definite article: [hieroglyphs]. For graphic and aesthetic reasons the signs are arranged thus: [hieroglyphs]. The final sign, a seated woman, shows the word is a woman's name.

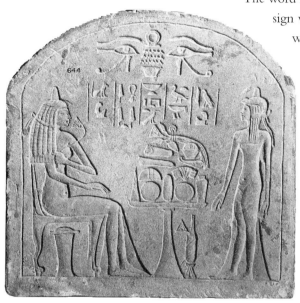

Fig. 27 The limestone funerary stela of the lady Tamyt, carved with scenes in raised relief and an inscription in sunk relief, under a group of emblematic hieroglyphs. Late 18th Dynasty. H. 38.1 cm. EA 644.

The penultimate hieroglyph uses what the Egyptians considered to be the most characteristic posture of the cat, which can be seen in three dimensions in a votive statuette (fig. 30).[38] This posture, however, is not the only one that the animal takes in Egyptian representations. A blue glazed composition figure of a cat (fig. 28) from a Middle Kingdom tomb at Qurna in Thebes[39] shows the

Fig. 28 A blue glazed composition ('Egyptian faience') funerary figure of a crouching cat. H. 3.37 cm. EA 24405.

Fig. 29 The final section of the illustrated Book of the Dead of Hunefer, from the 19th Dynasty, with a vignette (at the right) showing the Great Cat killing a serpent. The word for 'cat', written in cursive hieroglyphs, occurs in the second line from the left. H. 46.3 cm. P. BM EA 9901.8.

Fig. 30 A Late Period votive bronze figure of a seated cat wearing an amulet around its neck. H. 20.3 cm. EA 47547.

animal crouching on a rectangular base with the details painted in black. Here the posture relates to the symbolic aspect of the cat as a hunter and protector of the deceased: both the sun-god and his daughter could take the form of a cat to destroy his enemies. The lady Tamyt was not named for a domestic 'pussycat', as a modern reader might assume, but rather for the feline goddess who protected the cosmos.

Although the word *mjw* is clearly onomatopoeic – as for example is the Mandarin Chinese word for cat – a surviving Egyptian etymology relies on the cat's religious significance as a solar animal who destroys the enemies of daylight and order, rather than on the sound of its mewing. The 'Great Cat' is mentioned in Spell 17 of the collection of funerary spells now known as the Book of the Dead. In the copy preserved in the 19th Dynasty Papyrus of Hunefer, a royal scribe, an etymological gloss is given, in a manner common in many religious texts, as Hunefer declares (fig. 29): 'I am that Great Cat beside whom the Ished tree was split in Heliopolis on that night of conflict . . . WHO IS THAT? The Great Cat, he is the sun-god himself, who was called "Cat" (*mjw*) when the god Perception spoke (of him) "Truly (*m3ʿ*)!"' This is not etymology as a linguistic science but as an expression of belief, a mythopoeic and aetiological approach that relates the sound of the word to an exclamation uttered in the course of an obscure mythical event. Such mythological etymologies, which explain things through word-play, are not historical: it is virtually impossible that the word for cat and 'truly' are derived from a single root. It is, however, a useful reminder to the modern student that language cannot be disassociated from cultural context.

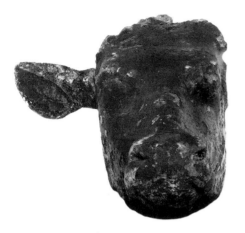

Fig. 31 A 19th Dynasty wooden terminal from a royal funerary bed in the form of a cow's head, covered with black resin, and originally fitted with horns and a sun-disk. From the Valley of the Kings. H. 20.5 cm. EA 61610.

Fig. 32 A wooden votive ear from Deir el-Bahri. H. 12.9 cm. EA 41077.

The word for 'hear', sḏm

The word for 'hear' is *sḏm*, written ✑🦅 . The first sign is a representation of a cow's ear (fig. 31) and occurs as a logogram or determinative in the word for both human and animal ears (*msḏr*). It also acted as the determinative in the semantically related word *jdj* ('to be deaf') and most frequently as a logogram for *sḏm* ('to hear'), when it is followed by the uniconsonantal sign for *m*, which acts as a phonetic complement and shows the reader which phonetic reading of the sign is to be adopted. In Coptic the word is ⲥⲱⲧⲙ, *sōtm*. The hieroglyphic writing of the word survives in Horapollo's *Hieroglyphica* (i.47), which comments that 'they paint a bull's ear to indicate hearing', but provides an erroneous gloss, saying that this is because the bull is summoned to mating by hearing the mooing of the cow. Many hieroglyphs show a tendency to use the body parts of animals rather than of humans, possibly due to an early taboo against depicting parts of the human body as separate entities. The human ear usually occurs as a hieroglyph only in occurrences of the word for 'ear' where the ear was specifically human; in those cases it is probably a self-consciously witty, 'sportive' writing.

The idea of 'hearing' is important in Egyptian culture, often being synonymous with being responsive to people's needs, and is expressed in both language and iconography. The complementary but distinct relationship between the hieroglyphic script and pictorial representation can be seen in the different treatments of hearing. A three-dimensional example of the representation of hearing is in royal statuary of the Middle Kingdom. EA 36298 (pl. 9) shows the head and upper body of a green mudstone figure of a king wearing the *nemes* crown and an amulet (of unknown provenance). The surviving fragment is not inscribed, but the features are those of Senwosret III (1878–1841 BC).[40] The statue's huge ears almost certainly do not represent a feature of personal physiognomy but the king's capacity to hear his subjects' petitions; the king was an intermediary between men and the gods, who were also characterized by the capacity to hear and respond to the prayers of men. Private statues that were dedicated in temples sometimes carry inscriptions stating that they would act as intermediaries between worshippers and the gods. The same may have been true of royal statues, which could have represented the king as the intended recipient of prayers or have shown his ability to hear as a more abstract characteristic. This pictorial representation of hearing inhabits the same world of ideas as the use of the ear hieroglyph, but is iconographic and not written.

The same invocation of hearing is even more graphically expressed in a large wooden votive ear (fig. 32), which is a three-dimensional version of the hieroglyph of the human ear. This was placed in the shrine of the goddess Hathor at Deir el-Bahri in the late New Kingdom. It is rather crudely carved and unpainted, and lacks any holes for attaching it to something. It is an image conveying a message without text. Without parallels it would, however, be difficult to identify what message the ear conveyed: it could be a request to cure the dedicatee's deafness, or an invocation of the goddess' hearing of a prayer. Its purpose can, however, can be clarified by comparison with other votive artefacts, including

Fig. 33 The limestone votive stela of Mahwia, with images of ears in sunk relief and inscriptions in incised hieroglyphs. H. 28.5 cm. EA 1471.

stelae decorated with images of the human ear,[41] such as the Ramesside limestone stela of Mahwia (fig. 33).[42] Forty-four ears are carved on this stela, which were originally coloured red and blue, and divided by a column of hieroglyphic text including a prayer to Ptah; there is also a line of hieroglyphic text along the bottom. Pictures and writing complement each other on this votive stela: the images are of human ears and the text is a hymn to the ears' owner, the god Ptah: 'Praises to the spirit of Ptah, lord of Truth, great of strength, the Hearer'. 'The Hearer' (sḏm) is written with an animal's ear (). The bottom line records that it was 'made for the miller(?) Mahwia', who will have dedicated it to encourage the god to hear his prayers. This stela was discovered in the temple of Ptah at Memphis. Other similar stelae were set up in popular shrines within state temples, although one example has been discovered in a household shrine, providing comparatively rare evidence for private cultic activity.

We conclude this chapter with an assessment of the relative merits of the alphabetic and hieroglyphic systems. The hieroglyphic script can seem unnecessarily complex to a modern reader, but one example will suggest otherwise: in the Naucratis stela of Nectanebo I (380 BC), as on some other inscriptions from the 26th to 30th Dynasties, a number of words are written not in the conventional mixed orthography but in uniconsonantal signs, perhaps under the influence of the Greek alphabet. These words have actually proved more difficult for scholars to identify and read than ones written with the normal, supposedly more cumbersome system, since they record only the consonantal skeleton of words (e.g. is written for jb, 'heart', which is normally written with a logogram showing an animal's heart:).[43] As Battiscombe Gunn commented, these difficulties should prevent one from 'chiding the Egyptians for not "taking the step which seems to us so obvious", and discarding all but their uniliteral signs'.[44] Such a step would have sacrificed both much ease of reading and much cultural information.

The commonly assumed simplicity of alphabetic writing systems is based on the implicit notion that they represent the sounds of languages in a direct manner. This is mistaken: reading the English alphabetic script involves many complex encodings of sound and letter, such as 'gh' pronounced f in 'enough'. The alphabet is not as precise a representation of phonetic sounds as can appear to someone used to reading automatically: the letter 'l' can represent a range of sounds that different cultures will read differently (thus, a Welsh reading of the letter 'f' sounds very different from an English one). Most people are familiar with a range of the bêtes noires of spelling reformers (e.g. 'plough', 'enough', 'thought', with three different sound values for the group 'ough'), but the non-phonetic nature of the English writing system is more extensive still; moreover, English is not unique in this respect: few writing systems are not mixed systems to some extent.[45]

Despite its supposedly purely alphabetic system, there is a sizable logographic element in the writing of English, the numerals being the most obvious example,

which derive from India by way of Arabic.[46] Even within the use of the alphabet itself there are systematic departures from phonetic spelling, such as the use of abbreviations based on alphabetic spellings (such as 'St' for 'Saint' and 'St.' for 'Street'). This use of abbreviations was probably much more prevalent in medieval Europe than it is now. Phonetic spelling is not in itself an advantage because it has to be based on the pronunciation of a language at a particular time and place, so that it is not transparent to anyone outside that context. By contrast, standardized spelling, no matter how arbitrarily based, will be equally easy or difficult for readers in different times and places; it can distinguish between homophones such as 'Hugh', 'hew' and 'hue'. The fact that the hieroglyphic script is not a purely phonetic script does not make it inefficient.

The alphabet is supposedly the easiest writing system to learn because of the small number of symbols involved, and has thus been falsely called a 'democratic' method of writing,[47] allowing universal literacy. In practice, non-alphabetic scripts (such as Japanese) do not prevent high literacy rates, and literacy even with alphabetic scripts has rarely been democratic. Moreover, the small number of signs to be learned can bring with it a much larger number of groups of signs with special sound values, as well as variation in the values of individual single signs. The one undeniable advantage possessed by alphabetic scripts is that texts in them are technically easier to produce than in non-alphabetic systems, but the system is not conceptually much simpler, as its readers usually assume. By contrast, the hieroglyphic script expresses both lexical categories in addition to phonemic ones and the more metaphoric semantic connotations of words. It is expressive not only graphically but also visually, as well as being, when executed in certain contexts, one of the most beautiful scripts ever devised by the human race. Its potential for variation rendered it an efficient tool for a wide range of cultural roles, including many where easy reading was not the prime concern, during more than three millennia, as will be examined in the next chapter.

NOTES

1 After P. W. Pestman, *The New Papyrological Primer* (Leiden, 1990), 7.

2 An excellent survey is M. Depauw, *A Companion to Demotic Studies*, Papyrologica Bruxellensia 28 (Brussels, 1997).

3 See, in general, A. Loprieno, *Ancient Egyptian: A Linguistic Introduction* (Cambridge, 1995).

4 See F. Junge, 'Sprache', *LÄ* v (Wiesbaden, 1984), 1176–1211.

5 R. Caminos, 'A fragmentary hieratic school-book in the British Museum (Pap. B.M. 10298)', *JEA* 54 (1968), 114–20; H.-W. Fischer-Elfert, 'Vermischtes IV: Randnotiz zur spätägyptischen Diglossie

(P. BM 10298)', *GM* 127 (1992), 44–7. On diglossia see A. Loprieno, 'Linguistic variety and Egyptian literature', in A. Loprieno (ed.), *Ancient Egyptian Literature: History and Forms* (Leiden, 1996), 515–29, and P. Vernus, 'Langue littéraire et diglossie', in ibid., 555–64.

6 S. Schott, *Urkunden*, VI: *Mythologischen Inhalts* I (Leipzig, 1939).

7 Budge's variants are: *a (3); ȧ (j); ā (ʻ); i (jj); u (w); X* or *kh (ḫ); sʻ (š); ḳ (g̱); ṭ (d); θ (ṯ); tʻ* or *tch (ḏ)*. For a discussion of transliteration systems, see F. Kammerzell, 'Zur Umschreibung und Lautung', in R. Hannig, *Großes Handwörterbuch Ägyptisch-Deutsch* (Mainz, 1995), i–lix.

8 *Tübinger Einführung in die klassische-
ägyptische Sprache und Schrift* (Tübingen,
1991).

9 P. Anastasi I 28.6.

10 See Fr. de Cenival, 'Rapport sur les
travaux du Groupe C: Études démotiques –
Unification des méthodes de
translittération', *Enchoria* 10 (1980), 1–13.
The chart given here is based on
J.H. Johnson, *Thus Wrote 'Onchsheshonqy: An
Introductory Grammar of Demotic* (Chicago,
1991), 2–5.

11 W.E. Crum, 'An Egyptian text in Greek
characters', *JEA* 28 (1942), 20–31; J. Osing,
Der spätägyptische Papyrus BM 10808, ÄA 33
(Wiesbaden, 1976).

12 W. Vycichl, *Dictionnaire étymologique de la
langue Copte* (Leuven, 1983), 42–3. Another
reconstruction is offered by J. Osing, *Die
Nominalbildung des Ägyptischen* (Mainz,
1976), 354 n.16, as *m(a)jaw*.

13 For a summary of Egyptian phonology,
see Loprieno *Ancient Egyptian*, 28–50;
Kammerzell, 'Zur Umschreibung und
Lautung'.

14 Junge, 'Sprache'.

15 O. Goldwasser, *From Icon to Metaphor:
Studies in the Semiotics of the Hieroglyphs*, OBO
142 (Fribourg and Göttingen, 1995), 1.

16 Ibid., 30.

17 For a survey of the hieroglyphic system
see H.G. Fischer, 'Hieroglyphen', *LÄ* II
(Wiesbaden, 1977), 1189–99.

18 H.G. Fischer, *Varia nova*, Egyptian
Studies 3 (New York, 1996), 222–5.

19 H.G. Fischer, 'The evolution of
composite hieroglyphs in ancient Egypt',
Metropolitan Museum Journal 12 (1977), 5–19.

20 Goldwasser, *From Icon to Metaphor*, 33.

21 H.G. Fischer, *The Orientation of
Hieroglyphs*, I: *Reversals*, Egyptian Studies 2
(New York, 1977), 6–8; P. van Sommers,
'Where writing starts: the analysis of action
applied to the historical development of
writing' (Paper presented at the Fourth
International Graphonomics Society
Conference, Trondheim, 1989).

22 See Chapter 3.

23 H.G. Fischer, *L'écriture et l'art de l'Égypte
ancienne* (Paris, 1986), 105–30.

24 Fischer, 'Hieroglyphen', 1192–3.

25 J. Baines, 'On the symbolic context of
the principal hieroglyph for "God"', in U.
Verhoeven and E. Graefe (eds), *Religion und
Philosophie im alten Ägypten: Festgabe für
Phillippe Derchain zu seinem 65. Geburtstag am
24. Juli 1991*, Orientalia Lovaniensia
Analecta 39 (Leuven, 1991), 29–46.

26 Kammerzell, 'Zur Umschreibung und
Lautung', xxxv–xxxvi.

27 This example owed to Angela
McDonald.

28 H.R. Hall, *Hieroglyphic Texts* 3 (London,
1912), pl. 4. In the first line of names, the
funerary epithet 'true-of-voice' takes the
place of the determinative.

29 A.H. Gardiner, *Ancient Egyptian
Onomastica* (Oxford, 1947), 24–63, 1*–26*,
pl. 14.

30 B.J. Kemp, *Ancient Egypt: Anatomy of a
Civilization* (London and New York, 1989),
29.

31 Goldwasser, *From Icon to Metaphor*, 92.

32 Ibid., 31.

33 Ibid., 60–62.

34 H.S. Smith and W.J. Tait, *Saqqâra Demotic
Papyri* I, Texts from Excavations 7 (London,
1983), 198–213.

35 F.Ll. Griffith, 'The sign papyrus', in *Two
Hieroglyphic Papyri from Tanis*, MEEF 9
(London, 1889), 1–19, pls 1–8. Examples
cited are from lines XII.1 and XIII.8.

36 E. Iversen, *Papyrus Carlsberg Nr. VII:
Fragments of a Hieroglyphic Dictionary*
(Copenhagen, 1956).

37 H.R. Hall, *Hieroglyphic Texts* 7 (London,
1925), pl. 14; G. Robins, *Reflections of Women
in the New Kingdom: Ancient Egyptian Art from
the British Museum* (San Antonio, TX, 1995),
no. 11. The name could also mean 'She of
the Cat'.

38 See, in general, J. Malek, *The Cat in
Ancient Egypt* (London, 1993).

39 A similar example with a more secure
provenance is published by J. Bourriau,
*Pharaohs and Mortals: Egyptian Art in the
Middle Kingdom* (Cambridge, 1988), no. 108,
dated to the 12th to 13th Dynasty.

40 H.R. Hall, 'A portrait-statuette of
Sesostris III', *JEA* 15 (1929), 154; D. Franke,

*Das Heiligtum des Heqaib auf Elephantine:
Geschichte eines Provinzheiligtums im Mittleren
Reich* (Heidelberg, 1994), 60 n. 192. In
general, see F. Polz, 'Die Bildnisse Sesostris
III. und Amenemhets III. Bemerkungen zur
königlichen Rundplastik der späten 12.
Dynastie', *MDAIK* 51 (1995), 227–54, and
R. Tefnin, 'Les yeux et les oreilles du roi', in
M. Broze and P. Talon (eds), *L'atelier de
l'orfèvre: Mélanges offerts à Ph. Derchain*
(Leuven, 1992), 147–56.

41 G. Pinch, *Votive Offerings to Hathor*
(Oxford, 1988), 247. For general context see
also B.J. Kemp, 'How religious were the
ancient Egyptians?', *Cambridge Archaeological
Journal* 5 (1995), 25–54.

42 M. Bierbrier and R.B. Parkinson,
Hieroglyphic Texts 12 (London, 1993), pls
96–7; Pinch, *Votive Offerings*, 248–53.

43 B. Gunn, 'Notes on the Naukratis stela',
JEA 29 (1943), 55–9.

44 Ibid., 56.

45 See B.G. Trigger, 'Writing systems: a
case study in cultural evolution', *Norwegian
Archaeological Review* 31 (1998), 39–62. See
also, e.g., L. Henderson, *Orthography and Word
Recognition in Reading* (London and New
York, 1982).

46 J.S. Pettersson, 'Numerical notation', in
P.T. Daniels and W. Bright (eds), *The World's
Writing Systems* (New York and London,
1996), 795–806.

47 By, for example, J. Goody, *The Interface
Between the Written and the Oral* (Cambridge,
1987), 53–6, 59–77.

TOWARDS READING A CULTURAL CODE: THE USES OF WRITING IN ANCIENT EGYPT

Notre arrogance, qui sans cesse refuse aux hommes du passé des perceptions pareilles aux nôtres . . .

Our arrogance that continually denies to the people of the past perceptions similar to ours . . .
M. YOURCENAR, *Archives du Nord* (1977)

Human beings are embedded in their culture, which fashions them, and which they also absorb, reproduce and fashion; as anthropologists have observed, they are not unchanging essences simply clad in differing cultural garments.[1] Cultural artefacts should be approached through 'thick description', as is readily demonstrated by any item treated in the following catalogue. It is relatively easy to translate Egyptian texts word for word, but to comprehend them fully and to convey cultural implications behind the words requires an altogether different level of understanding. The same is true even of physical gestures and expressions, whose significance varies between cultures. As Mikhail Bakhtin noted, 'it is impossible to understand the concrete utterance without accustoming oneself to its values, without understanding the orientation of its evaluations in the ideological environment'.[2] The principle that meaning is created through context and through association is relevant to the study of all cultural phenomena, ancient or modern;[3] writing is a cultural system, not a monolithic entity, and its potential and usage vary from culture to culture.[4]

Each item briefly catalogued in this chapter was embedded in its own living culture. Although the objects are often not fully provenanced, the amount of description – of aspects including material, manufacture, linguistic and textual features – that is possible for each is potentially boundless: like the Rosetta Stone, each is the product of complex cultural forces. The catalogue exemplifies some of the uses of writing in the pharaonic period and later. Objects from a large time span are chosen in order to give a sense of the evolving and changing nature of the written and cultural codes, of the range and wealth of the preserved evidence, and of the complexities of interpreting it. The aim of the selection of objects is to provide an impression of both the history that led up to the Rosetta Stone and the history that it unlocked for the modern audience, rather than reconstructing the Stone's own context in detail. It is possible to represent here

only one part of the streams of tradition that lie behind the Rosetta Stone. The catalogue also exemplifies how a simple transliteration into alphabetic characters that abstracts a text from its context is always inadequate to convey all the information in a hieroglyphic text, especially when it is an integral part of a larger architectural or sculptural context.

The 'cultural code' of ancient Egypt runs through all aspects of the record, from elite art to the material that is usually referred to as archaeological data, and to settlement patterns. Cultural institutions do not determine what is written down only in terms of 'propaganda' or 'censorship'. Some things are 'unspeakable' in certain social contexts, but many more are unwritable and unrecordable. This complex system contains hierarchies that are fashioned by physical context, by the medium in which a text is produced and consumed, and by specific, often self-promoting social contexts, communities, structures of power.

The way in which writing and language express, articulate and constitute hierarchy is clear in the description of the two Egyptian scripts as 'native' (enchorial) and as 'sacred characters' in the Greek text on the Rosetta Stone;[5] other Greek descriptions use the terms 'popular' (demotic) and 'sacred carving' (hieroglyphic). In the Ptolemaic Period the demotic and hieroglyphic scripts were known in Egyptian as 'letter/document script' (*sḫ-š't*) and 'script of god's words' (*sḫ-mdw-nṯr*) respectively; the Canopus Decree additionally uses the phrase 'script of the House of Life' (*sḫ-Pr-'nḫ*) – that is, of the temple scriptorium – to describe its hieroglyphic section. These terms reflect the usage of the different scripts by relating them to different functions and institutional contexts. This range of script forms is a distinctive feature of Egyptian civilization and was remarked on by many classical writers.

The usages of, and literacy in, the everyday cursive scripts and the sacred hieroglyphic script were sharply distinct; most of the literate could only read the former.[6] There was not a simple bipolar distinction between secular and sacred scripts, but a range or hierarchy that paralleled a cultural hierarchy, changing over time but remaining in place throughout Egyptian history. Thus the cursive script now known as hieratic was a script for letters and the like in the Middle Kingdom, while in the Ptolemaic Period it was used exclusively for priestly purposes, with the more cursive demotic having become the 'letter script'. Hieroglyphs always remained associated with the highest levels of the Egyptian universe. They were regarded as objects of learning in themselves, not merely an elaborate means of recording information that could be written more quickly in cursive scripts. One 'Overseer of Craftsmen, the Draughtsman, Iriusen' declared on his funerary stela: 'I knew the secrets of the hieroglyphs.'[7] Such hierarchy is not limited to texts and language, but runs through all cultural production, comprising a set of rules of what can be termed 'decorum', a concept advanced by John Baines.[8] Decorum patterned both written discourse and the decoration of tombs and temples, determining the position and manner of the representation of topics, as well as the exclusion of some. It was 'probably based ultimately on rules and practices of conduct and etiquette, of spatial separation and religious avoidance'.[9]

The chances of preservation in Egypt give the impression that monumental discourse was primary. The surviving evidence is dominated by temple and tomb walls, reinforcing the classical and popular preconceptions of the Egyptians as the most religious and morbid of peoples. Papyri, however, are more fragile, and the quantities that have been lost cannot be estimated, although Georges Posener suggested that only about 0.0001% of papyri have survived;[10] while such a figure is virtually meaningless, it is a useful reminder of the fragility of the sources. Here one can compare Mesopotamia, where clay tablets survive burial much better and may give a more balanced sample of the range of writing's usages. The monumental aspects of Egyptian written culture are, however, distinctive on any comparison, and the Egyptian tradition of commemoration on tombs is lacking from other civilizations of the ancient Near East.

In terms of the aims of writing, it is striking how many official and monumental texts focus on eternity. They are ostensibly addressed to actual readers but are often placed in places of limited access, both socially and because some would have been physically inaccessible: they were addressed largely to the gods and the blessed dead. The reading of such texts was not a practical concern; they embody high culture almost for its own sake, and the original context of the Rosetta Stone stood at the culmination of this tendency. The many temples built in the Greco-Roman Period were designed, supported and served by the native elite, and were not understood by the actual rulers, who nevertheless supported them financially and politically. Inside, while most of the pictorial scenes and inscriptions were physically and intellectually inaccessible to most of the population, they formed a self-sustaining, celebratory world, representing the great tradition of Egyptian culture and comprising 'the richest expression of [it] that was perhaps ever achieved'.[11]

THE BIRTH OF WRITING

The place and date of the origins of Egyptian writing are uncertain.[12] In 1989 Gunter Dreyer discovered in the tomb of a Predynastic ruler at Abydos (tomb U-j) ivory labels that are evidence for writing from some two centuries before the 1st Dynasty, suggesting a date for its invention around 3400–3300 BC.[13] Evidence from this period is very fragmentary, but most of the uniconsonantal signs, as well as the categories of logograms and determinatives, are attested by the early 1st Dynasty; a range of biconsonantal signs is attested by the end of the dynasty. The system appears to be highly orderly, with the orthography often affected by the iconographic context of inscriptions.

At the moment the earliest known evidence for writing in the Near East is from Egypt rather than Mesopotamia. It is often claimed that writing came to Egypt as 'stimulus diffusion' from Mesopotamia. While the idea of writing may well have come from there, the writing systems are significantly different, suggesting that they were effectively separate. The period of writing's invention in Egypt saw the consolidation of the state, presumably involving the development of a complex centralized administration and the institution of kingship, integral to both of which were display and pictorial representation. The origins of Egyptian writing seem bound up with this creation of the centralized state.

It is likely that Egyptian writing was the result of a single invention rather than a gradual development: scholars such as Herman Vanstiphout argue that it was 'a conscious invention with perhaps a definite purpose, although partly based on an existing technique for limited and specific communication'.[14] One documented case of a script being invented is the Cherokee script, which was invented by Sequoyah (*c.* 1770–1843) at the period when Champollion was working on the decipherment of Egyptian. Sequoyah was illiterate, but was inspired by seeing European scripts, and after twelve years of experimentation his script was presented at a public demonstration in 1821 and spread widely and rapidly, with Cherokee literacy rates soon exceeding those of non-native Americans.[15]

The Egyptian script may have been devised, as in Mesopotamia, for recording administrative information, or as a tool for cultural and elite display. Much of early writing is either incorporated into representational works, such as ceremonial palettes, or on small labels. Some labels record the number and origin of the goods to which they were attached in the tomb, while in others pictorial matter is combined with signs to record the events of a particular year. Utilitarian and ceremonial purposes are not necessarily opposed, and inscribed pottery and stone vases can both display the state's ownership of prestigious goods and record deliveries of royal goods in the administration, while labels show royal rituals and record the names of administrative officials in a single scene. All surviving pieces of writing derive from royal and elite contexts, revealing a conscious use of writing as an ideological tool, and for symbolic display, as opposed to recording linguistic narratives. Writing is secondary to language, but the first matter recorded was not transcripts of spoken messages.

The usages of writing gradually expanded in range. Labels referring to a specific year provide a record of that year's events, but did not involve the writing of continuous sentences; writing occurs in works of art as captions. The earliest cursive forms of signs are found on pots from the Naqada II Period; they are more extensively attested in the 0th Dynasty, and were presumably used for administrative documents, which probably comprised primarily tables and lists; it is unlikely that even letters of correspondence in continuous language were written at this period. Full sentences only appear at the end of the 2nd Dynasty (*c.* 2650 BC), when writing is more extensively attested on monuments; they were presumably also used in administration. This period is also marked by a regularization of sign forms and a reduction of their total number, suggesting that there was a wholesale reform of the writing system, an event perhaps associated by later Egyptian historiographers with the culture hero Imhotep.

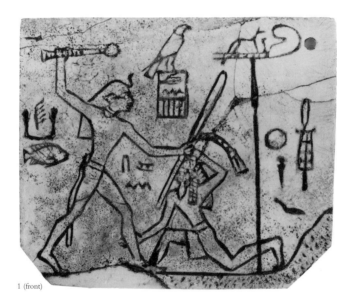

1 (front)

1 (back)

1 Ivory label for King Den's sandals

EA 55586
H. 4.5 cm, W. 5.4 cm, D. 0.2 cm
1st Dynasty
From Abydos
Purchased through Sotheby's and Co.,
from William Macgregor; acquired in 1922

Rectangular ivory label for a pair of sandals from the tomb of King Den (*c.* 2850 BC). The front has an incised representation of the king smiting a captive before the standard of the god Wepwawet. The main hieroglyphic caption, facing the same direction as the king, reads 'Horus: Den'. On the left edge of the label a caption writes *jnk3* with phonetic signs; this could be an official's name. The small caption between the two main figures has not been successfully read as yet. The caption on the right edge faces the same direction as the captive, and reads:

'First occasion of Smiting the East'.
The motif is a standard icon of Egyptian royal power subduing foreign representatives of chaos and disorder, although many of the details are unparalleled.

The back bears an incised representation of a pair of sandals; the royal scene is thematically relevant, since sandals from later periods are sometimes painted with figures of enemies, so that the wearer would trample on them with every step. The two lower corners have been cut off, and the lower edge is damaged; there is a drilled hole for attachment at top right-hand corner.

BIBLIOGRAPHY: PM v, 84; P.E. Newberry, 'The wooden and ivory labels of the First Dynasty', *PSBA* 34 (1912), 278–89; P.E. Newberry, 'Miscellanea IV: a label of the First Dynasty', *JEA* 14 (1928), 110; A.J. Spencer, *Catalogue of Egyptian Antiquities in the British Museum*, IV: *Early Dynastic Objects* (London, 1980), no. 460. Recently discovered parallel: G. Dreyer *et al.*, 'Umm el-Qaab: Nachuntersuchungen im frühzeitlichen Königsfriedhof 9./10. Vorbericht', *MDAIK* 54 (1998), 163 (e), pl. 12e.

THE IDEAL SCRIPT

From earliest times the Egyptian script was employed on a wide variety of surfaces. The most prestigious form of hieroglyphs from the Old Kingdom onwards was as carefully delineated, detailed pictorial representations; these were executed as parts of royal and courtly works, usually with royal and religious content. In extreme cases, the full pictorial aspect was given free rein, although such elaboration generally concerned detail rather than the basic shape of a sign. The ideal was to have each sign carved in relief, with its internal details incised, and then painted or inlaid. Such an elaborate and slow method of production meant that the signs themselves were a display of wealth and prestige, regardless of their meaning and the significance of the text they recorded. Hieroglyphs were also carved in sunk relief, often with incised details, or simply carved as silhouettes and painted monochrome, producing a similar effect to carved hieroglyphs that had been inlaid. Both the forms of individual signs and orthography vary over time and with contexts, but also between groups of artists. For the modern scholar, an incidental value of such elaborations and changes is that details and colour are of great importance in dating inscriptions that lack a secure context.

2 Fragment of a painted coffin

EA 46655

H. 41 cm, W. 39.5 cm, D. 3.1 cm

Late 11th Dynasty

From Asyut

Excavated by D.G. Hogarth; acquired in 1907

End of a wooden coffin of a provincial official, decorated with paint on plaster; three pegs survive which would have secured the joins to the sides of the coffin. The inner face is undecorated, while the outer face has two horizontal and two vertical lines of blue hieroglyphic text in Middle Egyptian; these are painted on a yellow background, and read from right to left:

> Words spoken by the sun-god: I have placed Nephthys for you under your feet, that she may beweep you and mourn you. An offering which earth and the Sky [goddess] have given [. . .], an offering which the ent[ire] earth has given [. . .].

The text shows that this was originally the foot end of the coffin, and relates to mourning practices. The mythical mourning of the goddesses Isis and Nephthys at the head and foot of the dead Osiris was reenacted in rituals for the deceased. Other texts on coffins such as this would include protective spells to ensure a successful afterlife, and the titles and name of the deceased owner.

BIBLIOGRAPHY: hitherto unpublished.

2

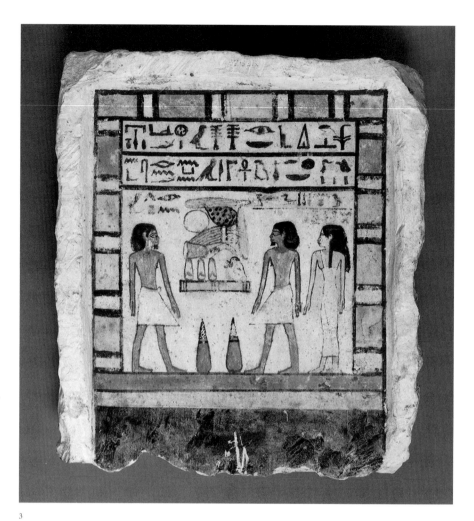

3

3 Funerary stela of Renefseneb (pl. 10)

EA 636

H. 33.7 cm, W. 31.5 cm, D. 9 cm

Middle Kingdom

From Thebes

Purchased through Revd Chauncey Murch from Mohamed Mohassib; acquired in 1900

Rectangular painted limestone stela of Renefseneb, with a polychrome border, and a raised band of stone framing the scene. The stela was presumably placed in his tomb chapel, where it would have acted as a focus for the funerary cult. The scene shows three figures and a heap of offerings. Two rows of black monochrome hieroglyphs on a yellow background record the traditional prayer in Middle Egyptian for an invocation offering, whereby the recitation of the words would provide sustenance for the deceased, taking the place of actions and actual offerings. They read (right to left):

> An offering that the King gives to Osiris Lord of Busiris, that he may give an invocation of bread and beer, flesh and fowl, and every good and pure thing on which a god lives, for the spirit of Renefseneb, begotten of Hapu.

The final words are painted in a third line that encroaches on the scene. All the hieroglyphs face the same direction as the figures to which they refer: opposite Renefseneb are two relatives, a man and a woman who are named in painted hieroglyphs added above them as 'Sainher true-of-voice; Senu[..?]ankh'.

BIBLIOGRAPHY: P.D. Scott-Moncrieff *et al.*, *Hieroglyphic Texts* 2 (London, 1912), pl. 39 (inaccurate copy).

4 Fragment of a tomb chapel inscription (pl. 11)

EA 71539

H. 7.4 cm, W. 11.6 cm, D. 7.3 cm

12th Dynasty, temp. Amenemhat II – Senwosret III (*c.* 1870 BC)

From Deir el-Bersha, Tomb 2

Donated by the Egypt Exploration Fund; acquired in 1894

A small fragment of limestone bearing a painted hieroglyphic inscription in raised relief. It was part of the right-hand wall of the main chamber of the painted tomb chapel of the nomarch of the Hare nome, Djehutyhotep son of Kay, which was covered with scenes of his servants' activities in house and estate. The text is painted in red, green, blue and black, on a yellow background. The group reads (right to left) 'washing the heart', an idiom for 'relief', but

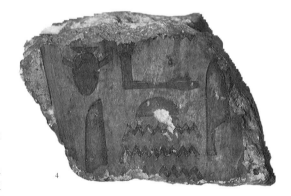

4

it is uncertain what type of scene it would have captioned; a white area to the left of the fragment is probably the remains of the kilt of the figure to which the hieroglyphs were a caption.

BIBLIOGRAPHY: PM IV, 179–81; P.E. Newberry, *El Bersheh* I, ASE 3 (London, 1894), pl. 27.6.

5 Fragment of an inscription from a royal tomb (pl. 12)

EA 5610

H. 24.5 cm, W. 38 cm, D. 12.5 cm

19th Dynasty, temp. Sety I (1306–1290 BC)

From the tomb of Sety I, Valley of the Kings (Tomb no. 17)

Purchased from Sir John Gardner Wilkinson; acquired in 1834

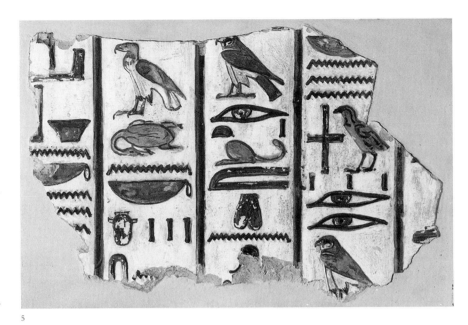

5

Fragment of limestone relief from the tomb of Sety I, from the lower parts of a wall of one of the lower corridors (corridor H). The signs face towards the burial chamber, and since they face left, this shows that this fragment came from the north wall of the corridor. The hieroglyphs are painted in full colour and carved in raised relief on a white background. The fragment contains parts of five vertical lines of hieroglyphic text, from the Middle Egyptian offering liturgy known as *The Litany of the Eye of Horus*.

The high standard of workmanship in the royal tombs reflects the centrality of the king in material as well as political culture. In terms of decorum, certain texts and scenes such as this were restricted to royal monuments.

BIBLIOGRAPHY: W.V. Davies, *Egyptian Hieroglyphs*, Reading the Past (London, 1987), front cover; E. Hornung and E. Staehelin, *Sethos: Ein Pharaonengrab* (Basel, 1991), 56, fig. 39.

6 A royal temple inscription (pl. 13)

EA 782

H. 51.5 cm, W. 46 cm, D. 10.5 cm

18th Dynasty, temp. Hatshepsut (1473–1458 BC)

From Deir el-Bahri, presumably the temple of Hatshepsut (exact provenance unrecorded)

Donated by the Egypt Exploration Fund; excavated by H.R. Hall and Henri Edouard Naville; acquired in 1906

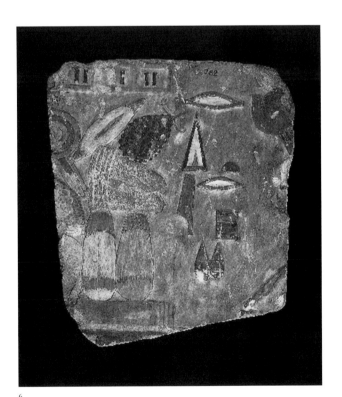

6

Fragment of painted limestone relief, showing part of an offering table, with meat, grapes and bread, against a pale blue background. The scene and text are carved, with details being added in paint (such as the stalk of the bunch of grapes). The hieroglyphic caption in a vertical line reads 'giving wine'; the signs face left, the same direction as the royal figure making the offering, remains of whose kilt and hands holding a vessel survive. Above the offering table are traces of numbers, in a tabulated list, recording the offerings. Such scenes on temple walls representing the temple ritual enacted the reciprocity of divine and human embodied in the king that was essential to maintaining the cosmos. Cultic service was the symbolic prerogative of the king, and was shown as such, but the daily practice was different.

BIBLIOGRAPHY: hitherto unpublished.

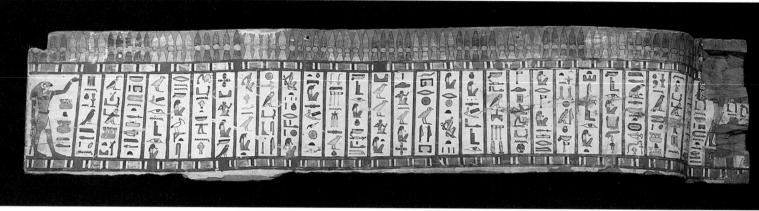

7 (outer side)

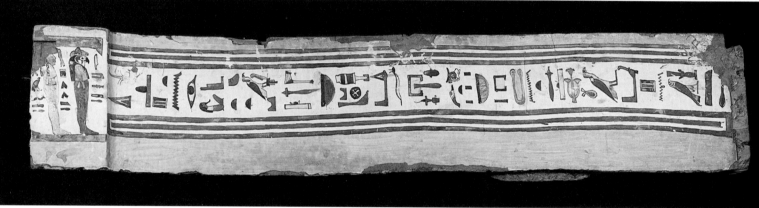

7 (inner side)

7 Part of a coffin of Tanetaa (pls 14–15)

EA 30360

H. 39 cm, L. 190 cm, D. 4.5 cm

Third Intermediate Period, end of eighth century BC

From Thebes

Purchased from R.J. Moss & Co.; acquired in 1898

Left side of the anthropoid outer coffin of Tanetaa, painted on a linen ground over the wooden surface. On the inside a single right-facing vertical line of polychrome hieroglyphs writes the offering formula, between coloured column-lines:

An offering which the King gives to Osiris Foremost of Westerners, great god, Lord of Abydos, that he may give an invocation offering of bread and beer, flesh and fowl for the lady of the house Tanetaa, the wife of Pasenhor true-of-voice.

On the outside the text is arranged in twenty-eight vertical lines reading from right to left, the start of the text being placed next to the head of the coffin. The text reads:

Words spoken by the lady of the house Tanetaa, the wife of the Libyan Pasenhor, true-of-voice, son of Shoshenq true-of-voice, her mother being Tanetamen: 'Hail to you Osiris, bull of the West . . .'

In the hymn which follows, the deceased claims to be 'the one who justified Osiris against his enemies'. The determinate for 'enemies' (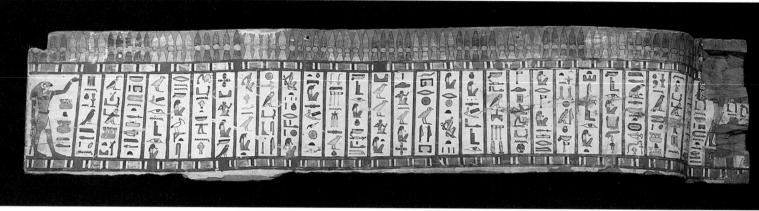) shows the captive enemy as decapitated (e.g. ninth line from left).

Although the Middle Egyptian text is finely painted, it contains textual errors, only a few of which were noticed and corrected (as at the bottom of l. 10); this is typical for the period and may reflect the quality of the sources rather than the painter's workmanship, although even the lady's name is garbled at the opening of the text.

The outer side of the coffin is topped by a decorative frieze. At the end of the text is a scene showing a falcon-headed god, and at the head was another scene, now lost, showing a god performing libations to purify Tanetaa. The mummy case of Tanetaa's husband is also in the British Museum (EA 24906); her mummy, mummy case and cartonnage case are in the Field Museum of Natural History, Chicago.

BIBLIOGRAPHY: hitherto unpublished; see J. Taylor, 'Pasenhor and Tanetaa', *British Museum Magazine* 15 (Autumn 1993), 9.

SYLLABIC ORTHOGRAPHY

What is now termed 'syllabic orthography' is first attested from the late Old Kingdom, as a subsystem of the script that can express sequences of consonant + vowel, using biconsonantal signs and combinations of signs representing strong + weak consonant. Thus, ⌐⌐⌐⌐⌐ is to not be transliterated with the consonants *k3* (⌐) – *tj* (⌐) – *jr3* (⌐), but simply *Ktr*, and represents the name of the Greek island Kythera; the word ends with the determinative for foreign countries (⌐). The system was standardized in the New Kingdom, perhaps under the influence of the cuneiform script, which is a logosyllabary. Another earlier system for writing foreign names is well attested from the Middle Kingdom in the 'Execration Texts', which list foreign enemies for cursing rituals; this system was, however, more alphabetic in character.[16] Syllabic orthography was used to write words of foreign origin, especially Northwest Semitic, and was frequent in the New Kingdom for writing terms for imports, and place names.[17] The correspondence between the weak consonants represented and the vowels of the original words is often uncertain; sign groups may also represent only an initial consonant, with no specific following vowel.

8

8 Temple inscription of Ramses II

EA 1104

H. 100.5 cm, W. 55.5 cm, D. 50.5 cm

19th Dynasty, temp. Ramses II (1290–1224 BC)

From Tell Basta

Donated by the Egypt Exploration Fund;

acquired in 1891

A fragmentary block of red granite, inscribed in sunk relief, originally an architectural element in the temple complex at Bubastis, modern Tell Basta. The hieroglyphic inscription in sunk relief (reading right to left) is arranged heraldically with the royal titulary of Ramses II being placed over the names of his enemies:

> . . .] chosen of the sun-god)| Son of the sun-god: ([. . .] beloved of Amun [. . .

The names are placed in rings, which are elsewhere sometimes shaped like city walls, from which emerge torsos with distinctively foreign beards. These figures, which face in the same direction as the hieroglyphs, have their hands bound behind their backs and are tied together at the neck. The names are arranged in geographical order from south to north, and comprise *Itr*, a place in Nubia; *Mšwš*, a Libyan ethnic group; *Kškš*, Gasga in northern Anatolia on the southern coast of the Black Sea. The representation of foreigners was generally limited to such depictions in pharaonic ideology. The red pigment infill is modern.

BIBLIOGRAPHY: PM IV, 31; M. Bierbrier, *Hieroglyphic Texts* 10 (London, 1982), pl. 13; K.A. Kitchen, *Ramesside Inscriptions* 2 (Oxford, 1979), 194: K.A. Kitchen, *Ramesside Inscriptions Translated and Annotated: Translations* 2 (Oxford, 1996), 58.

FIGURATIVE HIEROGLYPHS, OR 'CRYPTOGRAPHY'

The term 'cryptography', as used in Egyptology, does not refer to a code for sending messages so that they cannot be intercepted; rather, it is 'figurative', 'ludic' or 'sportive' writing.[18] It is a subsystem of the hieroglyphic script and is discussed here in some detail since it is the origin of the idea that the hieroglyphic script is a symbolic system.

In the figurative hieroglyphic system old signs were used with new values, but new signs were also created: orthographic puns were devised, such as one that can be seen on the Rosetta Stone (l. 8): ⟨glyph⟩. In this, the two phonemic signs ⟨glyph⟩ (*gs*) and ⟨glyph⟩ (*f*) were combined into a single sign, showing a snake leaving a hole; this does not read *gsf* or *fgs*, but writes the verb to 'go forth' (*prj*). The fully developed figurative system was created mainly through the application of what has been termed the 'consonantal principle', whereby bi- and tri-consonantal signs could stand for the strongest consonant of the sign's original meaning, and the 'acrophonic principle', whereby a sign could stand for the first consonant of the sign's original value, regardless of whether the second and third consonants were strong or weak. In general, these transformations of existing signs centred around making the 'dead' pictorial metaphors of the sign alive and significant. Figurative orthography occurs mainly in texts written in a style in which the representational character of the signs is apparent (unlike in cursive hieratic).

Figurative hieroglyphs occur as early as the Old Kingdom, from which it is attested on funerary monuments, often in lists of the tomb owner's titles, where it was apparently intended to intrigue the passer-by and encourage him to read an otherwise standard formulaic inscription. It was also used to impart emblematic significance to a text. On a Middle Kingdom funerary stela now in the Louvre,[19] a standard sequence of epithets becomes a row of figures bearing divine emblems, complementing the list of gods elsewhere on the stela, and assisting the deceased stela owner, as well as intriguing the reader. The epithets begin:

The great favourite of the sovereign, placed at the head of the Friends . . .

The first word, 'favourite', reads *ḥs* (normally ⟨glyph⟩) and is written with several figures (fig. 34). The first two figures carry a 'hyena' (*ḥtt* > *ḥ*), and the third a figure of 'Sekhmet' (*sḥmt* > *s*): *ḥ* + *s*.

Such writing was virtuosic: the high official of Hatshepsut, Senenmut, described a figurative image as a

sign which I made according to my heart's thought, as a man who works in the field (i.e. as my own labour), and which is not found in the writings of the ancestors.[20]

The virtuosic nature meant that cryptography was not a consistent or fixed tradition (see cat. 12).

Fig. 34 The word 'favourite' written figuratively. Drawn by R. Parkinson.

In the Greco-Roman Period figurative writing was also used to refashion the hieroglyphic system wholesale, especially for temple inscriptions, producing a sort of graphic alchemy and poetry running parallel with, and enriching, the verbal meaning of the texts. The immediate intelligibility of such texts decreased, making the system the preserve of an exclusive intellectual community of perhaps as few as one person in a thousand. This development was enabled by the use of demotic for everyday writing and for more practical purposes. The number of signs increased, and the system became 'more perfect as a pictorial-linguistic form'[21] which mobilized religious knowledge; this was part of a general sacralization of Egyptian high culture.

One example of such orthographic theology can be seen in a Roman Period papyrus containing a hieratic copy of the funerary *Book of Breathing* of a woman named [. . .]tasheret (EA 10303) (fig. 35). The word *ḏt* 'eternity' was standardly written with the 'alphabetic' signs of a snake (*ḏ*) and a loaf of bread (*t*), followed by a phonetic determinative: ⟨sign⟩. The word for 'statue' (*twt*) could be written with a sign representing a mummiform statue. Following the acrophonic principle, this sign reading *twt* could be used to write a simple *t*. Thus *ḏt* could be written with signs showing a serpent and a mummy, with the serpent sign adapted to curl around the mummy: ⟨sign⟩. This writing presents an image of the myth of the end of the world, known from earlier funerary spells, in which the cosmos sinks into chaos, and only two gods survive for eternity: the mummiform god Osiris and the sun-god who takes the form of a primeval serpent.

Another example is provided by writings of the name of the god Ptah. This was usually written with three alphabetic signs for the consonants: ⟨sign⟩. However, the logogram for the sky ⟨sign⟩ (in Egyptian *pt*) can write the *p*, while the logogram for the earth ⟨sign⟩ (*t3*) can write the *t*; the *ḥ* can be supplied by the logogram ⟨sign⟩ which writes the name of a deity called Heh (*ḥḥ*). The signs for heaven and earth are then arranged, not in phonetic order, but according to the heraldic framing of scenes in temples, where the sky covers and the earth supports a scene. Heh, who supports the sky, is placed between the *p* and *t*. Thus, the name of the creator god could be written with an iconic scene showing the cosmos he created: ⟨sign⟩.

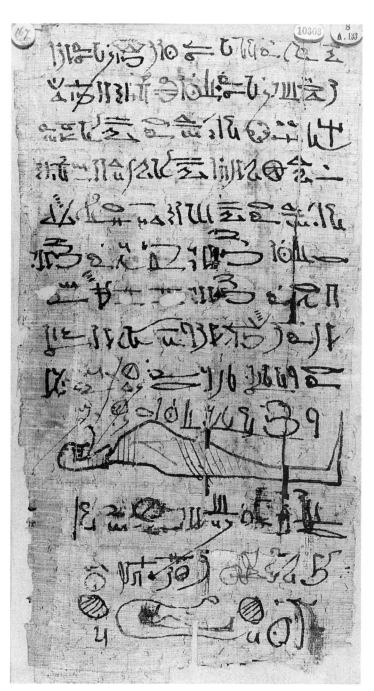

Fig. 35 Detail of a Roman Period papyrus written in hieratic, containing the final lines of the funerary *Book of Breathing* of a woman named [...]tasheret. The bottom line contains a figurative writing of the word *ḏt* ('eternity'). H. 27.5 cm. P. BM EA 10303.

These examples are single words, but whole texts, including both formulaic and highly esoteric ones, were written figuratively. The most spectacular instances are two hymns in the hall of the temple at Esna, decorated in the late first century AD (fig. 36). The opening words, 'Praises to you . . .', are followed by the name and epithets of the ram-god Khnum, which are written with a multiplicity of ram signs.[22] Consequently, only the opening words can now be read with any certainty. A similar, but slightly more legible, hymn to Khnum-Re written in crocodile-signs is also inscribed in the hall.

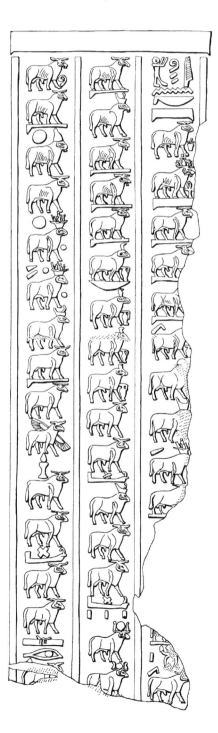

Fig. 36 The figurative hieroglyphic hymn to Khnum, written with ram hieroglyphs in the temple of Esna. Drawn by C. Thorne after S. Sauneron, *Le temple d'Esna* II (Cairo, 1963), 204.

9 Statue of Meryptah

EA 2291

H. 14 cm, W. 3.8 cm, D. 6.4 cm

19th Dynasty, temp. Ramses II (1290–1224 BC)

Provenance unrecorded

Purchased from François Sallier; acquired in 1839

A small black steatite statue of a kneeling man adoring the cartouche of Ramses II. The right-facing inscription in Middle Egyptian on the statue's back pillar identifies him as:

> The one greatly praised of the Lord of the Two Lands, whom his Person loves because of his character, the King's Scribe of the Offering Table of All the Gods, Meryptah.

He is perhaps the same Meryptah who was buried in Theban Tomb no. 387.

Meryptah's arms are raised in adoration of a cartouche reading '(*Wsr-m3't-r'*, chosen of the sun-god)'. A figure of the goddess Maat ('Truth') writes *m3't*; she wears her hieroglyphic emblem on her head, and holds in her hand the hieroglyph *wsr*, which represents an animal-headed staff. This iconographic scene embodies the meaning of the name, which has a programmatic sense, consciously chosen (like most names): 'One Mighty of the Truth of the sun-god'. As often, the cartouche rests on a sign for gold, and wears a royal headdress of plumes and sun-disk; it is flanked by two hieroglyphs for 'year' (now broken), evoking a long reign for the king.

BIBLIOGRAPHY: M. Bierbrier, *Hieroglyphic Texts* 10 (London, 1982), pl. 62; M. Dewachter, 'Nouveaux documents relatifs à l'expédition franco-toscane en Égypte et en Nubie (1828–1829)', *BSFE* 111 (1988), 64; G. Robins, *Reflections of Women in the New Kingdom: Ancient Egyptian Art from the British Museum* (San Antonio, TX, 1995), no. 15.

9a (front)

9b (back)

10 The 'Crossword' stela of Paser

EA 194

H. 112 cm, W. 84.5 cm, D. 11.5 cm

20th Dynasty, temp. Ramses VI (1151–1143 BC)

Discovered in the vicinity of the temple of Amun at Karnak

Excavated by Giovanni Battista Belzoni

A square limestone stela, now badly damaged, with an incised frieze of deities along the top; these worship a figure of the goddess Mut, which is now lost. The area below is covered with a grid, each square of which contains a group of hieroglyphic signs originally filled with blue pigment. This 'crossword' is sixty-seven squares wide and eighty squares deep, but may originally have been eighty by eighty. The stela was erected by one 'Paser, true-of-voice', whose name is inscribed in the left margin.

The top horizontal line of text reads from right to left and provides the title for the rest of the inscription, which is a Middle Egyptian hymn to Mut, as well as indicating how the stela is to be read:

> As for this writing, it is to be read three
> times. Its like has not been seen before, or
> heard since the time of the god. It is set
> up in the temple of Mut, Lady of Isheru,
> for eternity like the sun, for all time.

One would, however, expect the instructions to say 'twice', since the text has only been successfully read in two directions (right to left): horizontally, and also vertically; a possible third way was perhaps to read the text around the outer edge of the inscribed grid areas, but the stela is too broken for this to be attempted. Ironically, Belzoni, who discovered it near its original site in the temple of Mut, thought that it would be 'of much service to Dr. Young in his undertaking of the discovery of the alphabet of the Egyptians'.

A few squares of text show the principles (vertical lines nos 38–42; horizontal lines nos 1–4):

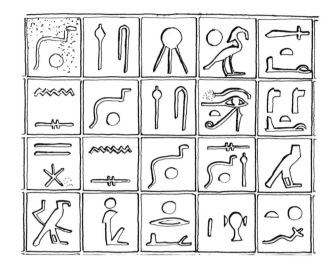

d	*sḫd*	determinative	*3ḫ*	*'3t*
n:s	*d*	*sḫd*	*jrt*	*pḫtj*
t3wj-dw3	*n:s*	*d*	*sḫd*	*m*
m3	determinative/*r'*	*r'*	*ḥr*	*ḫft*

Horizontally this reads:

> . . . great of radiancy, who illumines . . .
> . . . strength; ⟨her⟩ eye, it illumines . . .
> . . . as the illuminator of her(?); the Two
> Lands and the Otherworld . . .
> . . . in the presence of the sun-god who
> sees . . .

while vertically it reads:

> . . . great of strength in the presence of . . .
> . . . radiant; the eye which illumines the
> face . . .
> . . . the sun-god illumines . . .
> . . . the sun-god illumines for her . . .
> . . . She has illumined the Two Lands
> early . . .

In square horizontal 4/vertical 41, the sign 𓀭 is read horizontally as the determinative for the word sun-god (*r'*) in the preceding square, while vertically it acts as a logogram for the same word. The 'game' does not lie in filling in words left blank, as in a modern crossword, but in the skill needed to compose and then to read the hymn. Verbal wordplay was a common stylistic device in hymns, and this is a graphic extension of the same principle.

BIBLIOGRAPHY: PM II, 270; H.M. Stewart, 'A crossword hymn to Mut', *JEA* 57 (1971), 87–104; L. Troy, 'Mut enthroned', in J. van Dijk (ed.), *Studies on Ancient Egypt in Honour of Herman te Velde* (Groningen, 1997), 301–15, esp. 301–6.

11 'Cryptographic' scarab

EA 48703

H. 1.3 cm, W. 0.9 cm, D. 0.6 cm

Late Period

Provenance unrecorded

Purchased from Maurice Nahman;
acquired in 1909

A faded white steatite scarab with an incised right-facing figurative inscription. The sun-disk (☉) can be read as *jtn* ('sun-disk'), the cat () as *mjw* ('cat'), and the basket (⌣) as *nb* ('lord'). On the acrophonic principle, these signs can then be read *j+m+n*. The vase () before the cat is *ḥsj*, allowing the whole motto to be read *ḥsj-jmn* ('Someone favoured of Amun'), a wish for the person wearing the scarab, or having it buried with him. At the same time the inscription can be viewed, as it were literally, as a representation of a cat (a manifestation of the sun-god) sitting on the sign for lordship with an offering vase in front of it.

BIBLIOGRAPHY: J. Malek, *The Cat in Ancient Egypt* (London, 1993), 92; cf. E. Hornung and

E. Staehelin, *Skarabäen und andere Siegelamulette aus Basler Sammlungen*, Ägyptische Denkmäler in der Schweiz (Mainz, 1976), 173–80, 406.

11

12 P. Salt 825: a ritual text

10051.4

H. 18.3 cm, W. 65 cm

Ptolemaic Period

Provenance unrecorded

Purchased from Henry Salt; acquired in 1835

Papyrus Salt 825 dates from the Ptolemaic Period and contains a composition entitled *The End of the Work*. This is a ritual that was performed probably at the end of the mummification of Osiris as part of the festivals of the ritual year. It was intended to be recited by a 'scribe of the chamber which is called the House of Life', and includes a symbolic description of that institution, which was the temple scriptorium. The ritual comprises spells against enemies of Osiris and concludes with the placing of a copy of the book as an amulet on the neck of a statue of Osiris. Such divine rites were adopted by private individuals, who became identified with Osiris in death, for their own funerary use, as a gloss in the text makes explicit. Since papyri rarely survive from settlement or temple sites, this manuscript probably came from a tomb.

This section of the papyrus consists of columns 8 and 9 and is written in a mixture of cursive hieratic, hieroglyphs and figurative hieroglyphs. Column 8 opens with a description of an amulet that is shown in a vignette at the bottom left of this section. The neo-Middle Egyptian text invokes the power of the god of the air, Shu (reading right to left):

> Shu manifests himself as a predatory wing; he makes a knot from the bristles of a bull, to be placed on the neck of this god – variant: to be placed on the neck of a man. Shu makes air for the nose of his son Osiris, to drive away those who rebel against him. They are intended for making the protection of this god, to safeguard the king in his palace, to fell those who rebel against him. WHAT IS SAID BY Shu, hidden in the sun-disk:

12

'Hide yourself in your house, (Osiris)! Rebels – that which comes as air will turn you away! You will turn back your faces, for I have made a knot to destroy your souls. I am Shu who burns your corpses to cinders!' (8.1–5)

The vignettes show other images designed to protect Osiris, including a bucket-shaped vase that contains an image of the god. On this is written a text in eleven figurative hieroglyphic signs:

𓏏	*sm3 > s*
𓄿	*šmrt > s*
𓈙	*š' > š*
𓄿	*mwt > m*
𓏏	*wd > w*
𓊽	*s3b > s*
𓄿	*rs > r*
𓊽	*mnw > m*
𓊽	*swtwt + bsk > sb*
𓊽	*jdḫw > j*
𓊽	*fdq > f*

This can be read as:

s(3w) sšmw Ws(j)r m-sbj(w):f

A protection of the image of Osiris from his rebels.

This is a description of the jar's symbolic function in the ritual. However, the ancient scribe who copied P. Salt wrote in hieratic to the right of the jar what he understood the interpretation of the cryptographic text to be:

May you have power over the rebels! He had failed to decode the cryptography of signs 5–7, and had decoded signs 3–4 and 11 wrongly, reading them as follows:

𓏏	*sm3 > s*
𓄿	*šmrt > š*
𓈙	*m3ḫ > m*
𓄿	*k > k*
𓏏	*wd > ?*
𓊽	*s3b > ?*
𓄿	*rs > ?*
𓊽	*mnw > m*
𓊽	*swtwt + bsk > sb*
𓊽	*jdḫw > j*
𓊽	*w'bt > w*

The sign for *k* (no. 4) is based on a misreading of the shape of the sign. All he was able to read of the text was:

sšm:k (for *sḫm:k*) ??? *m-sbjw*

May you have power ??? over the rebels!

Different temples used distinct figurative systems, and the errors of the copyist of P. Salt indicate how far figurative hieroglyphs were a fluid intellectual practice rather than a regulated system.

BIBLIOGRAPHY: É. Drioton, 'Une erreur antique de déchiffrement', *RdE* 12 (1960), 27–31; P. Derchain, *Le papyrus Salt 826 (BM 10051): rituel pour la conservation de la vie en Égypte* (Brussels, 1965), esp. 140; F.-R. Herbin, 'Les premières pages du Papyrus Salt 825', *BIFAO* 88 (1988), 95–112.

CURSIVE HIEROGLYPHS AND HIERATIC

Cursive versions of hieroglyphs, written with ink and a reed pen, are first attested in the Naqada II Period. The variety of script forms embodies and runs parallel to a hierarchy of uses of writing and of texts that evolved over the periods of history. For the Old Kingdom and later, the normal cursive form of the script that evolved out of early usage in ink is termed 'hieratic', from its use in the Greco-Roman Period as a 'priestly' script (fig. 37).

The style of a hieratic hand is often the only means of dating a manuscript, and also relates to the type of manuscript. Palaeography (the study of ancient handwriting), however, can offer only a relative chronology: only a minority of manuscripts bear dates. Thus, the Heqanakht letters, a group of early Middle Kingdom documents now in the Metropolitan Museum of Art, New York, were first dated to the 11th Dynasty by the hand, but have now been assigned to the early 12th on archaeological and contextual evidence.

By the mid-Middle Kingdom hieratic had developed into two varieties, formal and administrative, the latter using more ligatures (two or more joined signs). A ligature-free form of script with less abbreviated sign forms than formal hieratic was also retained. This, which is now known as cursive hieroglyphs, was a careful 'book-hand' used for temple manuscripts in the Middle Kingdom and retained for funerary manuscripts in the New Kingdom. It is characteristic of temple scriptoria. Older script types were considered more formal and prestigious, and thus moved higher up the scale of decorum, in parallel with the use of older forms of the language.

Hieratic of the New Kingdom appears much more calligraphic than that of the Middle Kingdom, but there was also a reform to reintroduce the pictorial aspect of the signs. Literary and administrative hands also became more distinct. Cursive and fully pen-drawn hieroglyphs were retained for illustrated and funerary papyri, and some are even painted in full colour; where a text is part of a pictorial scene, the hieroglyphic script is almost always used. Later, at the end

Hieroglyphic Form	*gem* 'to find'	*nub* 'gold'	*akhet* 'flood season'
Cursive hieroglyphs			
Old Kingdom to early Middle Kingdom *c.*3000–1900 BC. Hieratic			
Late Middle Kingdom *c.*1900–1700 BC. Literary			
Administrative hieratic			
Second Intermediate Period *c.* 1700–1550 BC. Hieratic			
Early New Kingdom *c.* 1550–1300 BC. Hieratic			
Late New Kingdom *c.*1330–1100 BC. Literary hieratic			
Administrative hieratic			
Third Intermediate Period *c.*1100–700 BC. Formal hieratic			
'Abnormal hieratic' (Administrative hieratic)			
Late Period to Ptolemaic Period *c.* 700–30 BC. Late hieratic			
Demotic			

Fig. 37 Three hieroglyphic signs and groups of signs in various cursive scripts, from Old Kingdom hieratic through to demotic. From R. Parkinson and S. Quirke, *Papyrus* (London, 1995), 25.

of the New Kingdom, a formal form of hieratic took over the role of cursive hieroglyphs in these texts, becoming the principal priestly script, partly as a result of the increasing specialization of administrative writing styles.

In hieratic, the pictorial aspect of the script is considerably reduced. There is a tendency to write words out more fully, with a greater use of phonetic complements. Many elaborate pictorial hieroglyphs were not standardized: for example, in hieroglyphs and cursive hieroglyphs 'cat' was written with a pictorial determinative representing a cat (\mathcal{Y}), while in hieratic, the sign is replaced with a more generalized and simpler sign of an animal-skin (\mathcal{T}) that acts as the determinative of many words for mammals. Complex determinatives were even replaced by a simple diagonal stroke (\setminus) that derived from a stroke used in Old Kingdom funerary inscriptions to replace signs that were considered dangerous in magically potent contexts (cf. cat. 53). By the 18th Dynasty this cursive sign had worked its way into hieroglyphic inscriptions, occasionally substituting for complicated signs. Most texts and inscriptions were composed and drafted in cursive script, which was the normal medium for reading.

13

13 P. Abu Sir: temple records

EA 10735.10
H. 20.5 cm, W. 21 cm
5th Dynasty, c. 2360 BC
From Abu Sir, pyramid complex of
Neferirkare Kakai
Purchased from the estate of Prof. Ludwig
Borchardt; previous owner: Henri Edouard
Naville; acquired in 1950

Fragment of papyrus from the papyrus archive in the funerary temple dedicated to the cult of King Neferirkare Kakai (2446–2426 BC) in his pyramid complex at Abu Sir, meticulously recording the temple's goods. This fragment comes from the beginning of the roll. The opening heading is written in carefully delineated hieroglyphs.

The year a[fter] the 14th occasion of counting all the great and small herds [. . . In this instance only the date is preserved, but the headings to other rolls provide the king's name and the subject matter of the roll. The date can be reconstructed as Year 27 or 28 of Djedkare Isesi (i.e. around sixty-five years after King Neferirkare Kakai died). Shortly afterwards another scribe added an account on the margin of the roll, in more cursive hieratic script:

1st month of Shemu, last day: Giving the [. . .] gallons of grain issued to Tjesemy and Nefernemtet: THIS IS WHAT IS MEASURED EVERY DAY.

2nd month of Shemu, day 2: Giving the [. . .] gallons of grain issued to Tjesemy; day 6: Giving the 5½ gallons of grain issued to Tjesemi: THIS IS [WHAT IS MEASURED EVERY DAY].

BIBLIOGRAPHY: P. Posener-Kriéger and J.L. de Cenival, *Hieratic Papyri in the British Museum, 5th series: The Abu Sir Papyri* (London, 1968), pl. 2a; P. Posener-Kriéger, *Les archives du temple funéraire de Néferirkarê-Kakaï (les papyrus d'Abousir)*, BdE 65 (Cairo, 1976), 3–13, 324–7; see also B.J. Kemp, *Ancient Egypt: Anatomy of a Civilization* (London and New York, 1989), 112–19; M. Verner, *Forgotten Pharaohs, Lost Pyramids: Abusir* (Prague, 1994), 157–70.

14 Statue of the priest Amenhotep

EA 2295
H. 39 cm, W. 11.7 cm, D. 17.5 cm
12th Dynasty
Provenance unrecorded
Purchased from Giovanni Anastasi;
acquired in 1839

A finely carved limestone statue of a man wearing a triangular kilt. The stone is un-painted apart from the black eye detail, and the white in the eyes and on the finger and toenails. A dedicatory inscription was usually carved in hieroglyphs at the top front of a statue plinth, but here the text consists of two lines of hieratic text in black ink (reading right to left). This identifies the man as:

> The one revered before Montu in
> Medamud, the priest Amenhotep.

The inscription suggests that the statue may have come from near Thebes, since Montu in Medamud is a Theban deity. The reason – perhaps of time or expense – why the text was written in ink rather than carved can now only be guessed at.

BIBLIOGRAPHY: hitherto unpublished;
cf. S. Quirke, *The Administration of Egypt in the Late Middle Kingdom* (New Malden, 1990), 28–9, n. 21.

14 (detail)

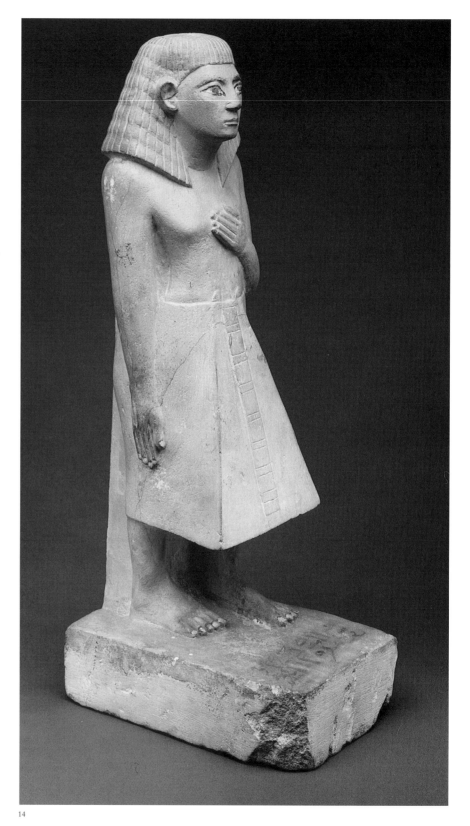

14

15 P. Ramesseum VI: hymns to Sobek

EA 10759.3

H. 13 cm, W. 18.4 cm

Late 12th Dynasty to 13th Dynasty

From a 13th Dynasty tomb beneath the later Ramesseum, western Thebes

Donated by Sir Alan Henderson Gardiner; acquired in 1956

Section of a papyrus roll written in cursive hieroglyphs, containing eighteen vertical lines of text, between ruled lines; the hieroglyphs are retrograde, that is, although the signs face right, the lines are read from left to right and not right to left (see p. 57). A horizontal line of writing running above the text gives the title as 'Speaking words: praising Sobek'; these signs are again to be read retrograde from left to right. Over 140 lines of a Middle Egyptian hymn cycle are preserved on the roll, which is not complete; this section comprises ll.40–58:

> . . . exulting in incense! May you be gracious to King (Amenemhat)|, through whom your face is happy on this day. Speaking words: praising Sobek. Hail to Sobek of Shedet (a cult centre in the Faiyum)! Open be the face of Rahes the gracious, Horus who is in the midst of Shedet! O appear Horus upon the rivers! Rise high, Sobek who is in Shedet, Re-Horus, mighty god! Hail to you Sobek of Shedet! Hail to you, who rise from the Flood, Horus chief of the Two Lands, bull of bulls, great male, lord of the island-lands! Geb has provided you with your sight, he has united you with your eyes. Strong one, your strength is great! May you go through the Lake-land (the Faiyum), traverse the Great-Green, and seek out your father Osiris. Now you have found him, and made him live, and said: This cleans the mouth (sk-r3) of his father in his name of Sokar (Skr)! You have commanded your children to proceed and care for your father – that is, him (Sokar) – in their name of 'Carers of Sokar'; you have pressed upon the mouth of your father Osiris; you have opened his mouth for him. You are his Beloved Son; you have saved your father Osiris; you have protected . . .

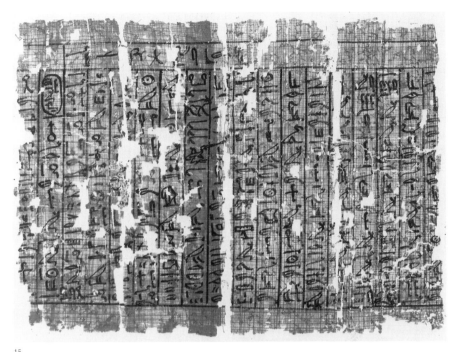

15

Although the manuscript came from a known archaeological context, the nature of the hymns is uncertain. They were probably composed originally for liturgical use at a particular festival ('this day') in the state cult. They have a strongly poetical character, while the use of glosses and mythopoeic wordplay (between *sk-r3* and *Skr*) is frequent in Egyptian ritual and religious writings.

The papyrus was found as part of a 13th Dynasty individual's archive which had been deposited in his tomb beneath the later cult temple of Ramses II (the 'Ramesseum'). The tomb, which contained magical papyri and equipment, may have belonged to a lector priest (the main ritual practitioner of a temple). The script of the papyrus suggests that it was copied in a temple scriptorium. Exactly how it moved from the temple context into the possession of the tomb's occupant is uncertain, and scholars have proposed various speculative, sometimes rather dramatic, scenarios. The appropriation of institutional texts by persons that the modern reader would consider private individuals is, however, well attested from Egyptian (and there is no reason to suppose that it constituted misappropriation; cf. cat. 78).

BIBLIOGRAPHY: A.H. Gardiner, 'Hymns to Sobk in a Ramesseum papyrus', *RdE* 11 (1957), 43–56; L.D. Morenz, *Beiträge zur ägyptischen Schriftlichkeitskultur des Mittleren Reiches und der Zweiten Zwischenzeit*, ÄUAT 29 (Wiesbaden, 1996), 147–54.

16 'Graffiti' from a temple at Deir el-Bahri

Graffiti were an integral part of Egyptian writing practice and of official culture:[23] as used by Egyptologists, the term can include any commemorative inscription incised into natural rock faces. For modern tastes, less formal 'graffiti' scratched in cursive scripts or written in pen on monuments are more revealing, but even these are rarely subversive, since only the literate elite and sub-elite could inscribe them. These texts sometimes record a pilgrimage to a religious site, such as the temples of Deir el-Bahri, with prayers and requests to the god of the sanctuary to do good.[24] 'Graffiti' are also found in tombs, where they may record cultic visits to the necropolis or visits to see the monuments of personal ancestors. They often refer to the aesthetic impression the site made on the visitor, a common formula being 'he found it like heaven in its interior'. One graffito dated to Year 47 of Ramses II (*c.* 1243 BC) at the Step Pyramid at Saqqara specifically says that the Treasury scribe Hednakht was 'strolling and taking recreation in the west of Memphis with his brother' when he made the 'graffito'. The modern concept of recreational tourism is relevant to some extent here; however, recreational and cultic visits are not necessarily mutually exclusive.

The following 'graffiti' on fragments of relief found detached from their original contexts are from the temples at Deir el-Bahri, and were donated by the Egypt Exploration Fund in 1907, from the excavations by Henri Edouard Naville and H.R. Hall. They derive from the 11th Dynasty funerary temple of Montuhotep (2061–2010 BC), but some have no exact provenance recorded and may derive from later temples near by.

EA 1419
H. 23 cm, W. 15 cm, D. 11.5 cm

Fragment of painted limestone relief showing a man slaying a cow, with some New Kingdom 'graffiti' beside the body of the bovine.

BIBLIOGRAPHY: hitherto unpublished.

16a EA 1419

16b EA 47962

16c EA 47963

16d EA 47971

EA 47962
H. 7.5 cm, W. 6.5 cm, D. 1.6 cm

Fragment of a painted limestone relief showing the toes of a male figure, and a register line. There are two lines of a New Kingdom 'graffito' in black.

BIBLIOGRAPHY: hitherto unpublished.

EA 47963 (pl. 16)
H. 9.5 cm, W. 19.5 cm, D. 8.6 cm

Fragment of a painted limestone temple relief. A register line and fragments of bird wings painted yellow survive. One line of a 'graffito' is written in red ink.

BIBLIOGRAPHY: hitherto unpublished.

EA 47971
L. 47 cm, W. 34 cm, D. 20 cm

Fragment of the sandstone floor from the lower colonnade of the funerary temple of Montuhotep bearing an incised 'graffito' showing a foot – evoking the physical presence of the visitor – and inside it the name of the visitor, 'the attendant Huia'. Across this has been hammered another 'graffito' belonging to a priest. Another smaller foot is incised to the right of the main foot.

BIBLIOGRAPHY: E. Naville and H.R. Hall, *Deir El-Bahari* III, EES 32 (London, 1913), 24, pl. 16; cf. id., *Deir El-Bahari* I, EEF 28 (London, 1907), 25.

ABBREVIATIONS, OWNERSHIP-MARKS AND 'FUNNY SIGNS'

Written records of ownership are found from the earliest times. Cursive signs are often notes recording information for practical purposes and are generally rather scribbled and abbreviated, but in religious contexts (such as cat. 18, 21) these could be formally composed and fully written texts.

Abbreviated writings of common words or phrases, especially titles and epithets, occur in hieroglyphic inscriptions, often for aesthetic reasons: thus the ubiquitous funerary epithet 'true-of-voice' is written with just two signs, aesthetically grouped: ⊻. Other abbreviations are found in administrative texts; one Middle Kingdom onomasticon includes a list of abbreviations for types of cows to be used in inventories with their meanings:

 ꜣꜣꜣ𓏭 A mottled red ox with white on its face.

 ▭ This is a red ox whose skin is mottled.[25]

Stone carvers placed similar signs on blocks, indicating dates, who did the work and the planned locations (cat. 31). These do not necessarily show that the workmen who wrote or read them were fully literate: their understanding may have been limited to a dozen or so signs. While some of these are abbreviated from hieroglyphs, many are randomly chosen shapes. Although they can appear linear like 'letters' of the alphabet, they are not a step towards the alphabet, as was once thought for marks placed on pots during manufacture.[26]

'Funny signs' are eccentric sign forms known from the New Kingdom community of Deir el-Medina and include hieroglyphic signs as well as other shapes. They occur as personal marks on objects owned by someone, and they can also occur in lists, where they were used as abbreviations of people's names in administrative records (cat. 20). Their exact usage and significance, however, is as yet uncertain.

17 (front)

17 (back)

17 Glazed composition tile from the Step Pyramid of Djoser

EA 66830
H. 6 cm, W. 3.6 cm, D. 1.3 cm
3rd Dynasty, temp. Djoser (2630–2611 BC)
From Saqqara, the Step Pyramid of Djoser
Purchased from Capt. Edward G. Spencer Churchill (Trustees of); acquired in 1966

Rectangular blue glazed composition ('Egyptian faience') tile from the underground funerary chambers of the Step Pyramid complex. There is a rectangular projection on the back with a hole to secure its attachment to the wall. On the back is an incised hieroglyphic sign 𓋹, the exact significance of which is uncertain. It may relate to the tile's maker or to its intended destination.

BIBLIOGRAPHY: A.J. Spencer, *Catalogue of Egyptian Antiquities in the British Museum* V, *Early Dynastic Objects* (London, 1980), no. 520. See also, F.D. Friedman (ed.), *Gifts of the Nile: Ancient Egyptian Faience* (Rhode Island, 1998), nos 17–20 (similar examples).

18 Pottery vase of Ukhhotep

EA 59776

H. 28.2 cm, Diam. 10.6 cm

From Meir

Purchased through Sotheby's and Co.,
from Laebdjian; acquired in 1930

A Middle Kingdom vase in red ware, with red slip. The rim is lost; the base is flat. This shape of vase was used for libations. The term for the vase was *ḥst* and the shape was used as a hieroglyph for the consonants *ḥs*, a stem meaning 'favour'. A single vertical line of text is written down the side; some of the ink has rubbed off the smooth surface. The text is a funerary dedication in Middle Egyptian, reading:

> The blessed one, Osiris Ukhhotep true-of-voice, born of Hentib true-of-voice.

The hieratic is written in a formal hand, whose style suggests a date early in the 12th Dynasty, or it may be an archaizing hand from slightly later. The name of the lady, Ukhhotep, is characteristic of the site of Meir, the necropolis of the provincial capital of Cusae. The hand and name are the same as are found on a series of five bowls of three different types now in Moscow; together they would have formed a funerary service of offering vessels, placed in Ukhhotep's tomb.

BIBLIOGRAPHY: PM IV, 251; H.R. Hall, 'Recent Egyptian and Assyrian purchases', *BMQ* 5 (1930), 50, pl. 22; S. Hodjash and O. Berlev, 'An early Dynasty XII offering service from Meir (Moscow and London)', in *Warsaw Egyptological Studies*, I: *Essays in Honour of Prof. Dr Jadwiga Lipinska* (Warsaw, 1997), 283–90.

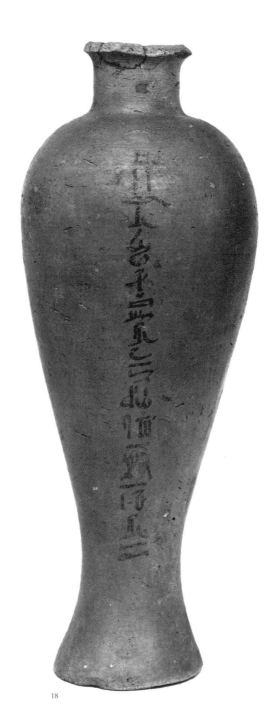

18

19 Wine amphora with hieratic docket

EA 4947

H. 49.3 cm, Diam. 17.1 cm (including handles)

New Kingdom

Provenance unrecorded

Donated by Somerset Lowry-Corry,
2nd Earl of Belmore

Pottery amphora with a pointed base and convex sides, with two handles near the top; the neck is incomplete. One side is inscribed with hieratic script in black paint, describing the contents of the amphora as 'Year 4 wine' and giving its place of origin. On the other side the hieroglyph 𓏶 is incised; this is a notation in connection with the word 'bring' (*jn*), marking the vessel either as something to be brought, as having been brought, or as an official gift (*jnw*).

BIBLIOGRAPHY: hitherto unpublished.

19 (detail)

19

20 Ostracon with 'funny signs'

EA 50716

H. 11 cm, W. 18.9 cm, D. 2.8 cm

19th Dynasty

From Thebes

Purchased from Mohammed Mohassib;

acquired in 1912

A limestone ostracon with sketch of a bull in red pigment on the front, with a hieratic text in red above it (two lines), and three horizontal lines of hieratic text in black to one side, at right angles to the sketch. On the other side there are 3 vertical lines of personal check marks in red. The ostracon presumably comes from the village of Deir el-Medina, and records a list of villagers for some purpose, now unknown.

BIBLIOGRAPHY: hitherto unpublished.

20 (front)

50716

20 (back)

21 Votive textile with label

EA 6640

H. 88 cm, W. 73 cm

25th Dynasty, temp. Piye (750–712 BC)

From Thebes

Donated by Anthony Charles Harris (1790–1869)

A fragment of textile with a fringe. A single right-facing vertical line of hieroglyphic text written in ink along the right edge records the dedication of the cloth. Although fragmentary, the neo-Middle Egyptian text can be restored from better preserved parallels as follows:

> [The Dual] King, Lord of the Two Lands: (Sneferre)| ; Son of the sun-god, Lord of Diadems: (Piye)| [beloved of] his father [Amun-Re Lord of the Thrones of the Two Lands(?)] Foremost in Ipet-sut (Karnak in Thebes) that [he might] act given-life for all time. (small space) Year [. . .]

The date is broken; two ∩ signs survive (each writing '10'), showing that the original figure was higher than 20. The most likely reading is 'Year 30'; possible traces of a sign to the right are partially obscured by earlier modern conservation, while a blank space below argues against restoring a fourth ∩ sign and reading 'Year 40'. Such uncertainty has rendered the cloth notorious, since whether the date is read as 30 or 40, it is the highest recorded regnal year known for the king, assuming that the date is related to the titulary.

The Napatan king Piye was buried at el-Kurru in Sudan around 712 BC, so this linen, which was acquired at Thebes, cannot come from his burial. It was donated by him to a temple of Amun-Re, perhaps Karnak or the temple of Medinet Habu on the Theban West Bank, but its comparatively good state of preservation suggests that it was subsequently placed in a tomb, having been used in the burial of a priest.

BIBLIOGRAPHY: J.B. Greene, *Fouilles exécutées à Thèbes dans l'année 1855* (Paris, 1855), 10, pl. 8: 3, 3a; K. Baer, 'The Libyan and Nubian kings of Egypt: notes on the chronology of Dynasties XXII to XXVI', *JNES* 32 (1973), 4–25, esp. 7–8 n. 1; J. Leclant, 'Pi(anchi)', *LÄ* IV (Wiesbaden, 1982), 1045–52, esp. n. 17; D.B. Redford, 'Sais and the Kushite invastions of the eighth century BC', *JARCE* 22 (1985), 5–15 (esp. 9–11).

K.A. Kitchen, *The Third Intermediate Period in Egypt (1100–650 B.C.)* (Warminster, 1986 [1st edn 1973]), 152 n. 292, 370 n. 732, *Supplement* (Warminster, 1986), 559.

21 (detail)

DEMOTIC

The demotic script[27] is essentially a more cursive development of the hieratic script. In the first half of the first millennium BC hieratic evolved in the two different directions of 'abnormal hieratic', the chancery style of the south, and a business hand in the north that was the forerunner of demotic. Demotic is characterized by many ligatures; like hieratic, it is written from right to left, but only in horizontal lines. The script is recognized as a separate script from the middle of the reign of Psammetichus I (664–610 BC), and by the end of the 26th Dynasty (525 BC) it was the standard script for business and legal affairs throughout the country. A calligraphic hieratic hand was retained for writing religious texts, but the more cursive hieratic hands fell out of use. Demotic could still be notionally transcribed into hieratic, and thence into hieroglyphic script, but by the Ptolemaic Period it was developing as an independent orthographic system. Modern transcriptions of Ptolemaic and later demotic into hieroglyphs become increasingly artificial. The later stages of the language written in demotic script are close to Coptic (see chapter 2).

Demotic varies with region and by period, and three phases can be distinguished: early, Ptolemaic and Roman. The Roman Period script uses more alphabetic spellings than earlier periods. Demotic declines from the late first century AD in both the private and public sphere, and by the second half of the second century AD its use had become mainly learned. This change was probably due largely to the dominance of Greek in political and economic affairs, and may reflect the Roman government's policies disfavouring the native elite.

22 Early demotic loan agreement

EA 10113
H. 24 cm, W. 42 cm
26th Dynasty, 570 BC
From Thebes

A loan agreement for a period of six months, presumably from a family archive. Such documents were kept in dossiers by those concerned, often over several generations. The text is formulaic; some of the formulae belong to the stage of the script known as abnormal hieratic, and some to demotic.

Year 20, Month 2 of Shemu, Day 10 of the Pharaoh Wahibre (Apries). The embalmer Hapiu son of Djedher, his mother being Dimutpaankh, says to the libation-priest of the Valley, Djedkhy son of Dismonth, his mother being Khausisis: I've received from you one deben of silver of the treasury of Thebes i.e. 9 2/3 1/6 1/10 1/20 1/60 kite of the treasury, making one deben of silver of the treasury of Thebes. I will give it back to you in Year 21, Month 4 of Akhet. If I do

22 (recto)

not give it back in Year 21, Month 4 of Akhet, it will bear interest at 1/3 kite per deben of silver each month without interruption for every month and every year during which it is still with me. It can be exacted from any guarantees that you want from me – house, servant, serving girl, son, daughter, silver, copper, clothing , oil, emmer, any chattels at all that I have – anywhere, and you will take them in recompense, without citing any document. Written by Horkhons son of Neithemheb (son of) Iby.

22 (verso, detail)

On the verso are the names of two witnesses:

Djedhor son of Khonsuirdis
Ptahirdis son of Iirawu

BIBLIOGRAPHY: M. Malinine, *Choix de textes juridiques en hiératique 'anormal' et en démotique (XXVᵉ–XXVIIᵉ dynasties)* (Paris, 1953), 15–19; K. Donker van Heel, *Abnormal Hieratic and Early Demotic Texts Collected by the Theban Choachytes in the Reign of Amasis: Papyri from the Louvre Eisenlohr Lot* (Leiden, 1995), no. 23.

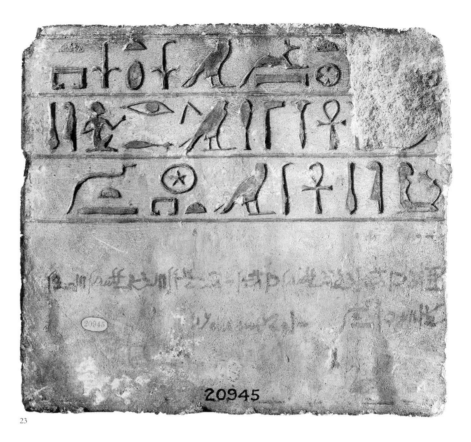

23

23 Fragment of the stela of Horiraa

EA 20945
H. 19.5 cm, W. 22 cm, D. 6.3 cm
30th Dynasty to early Ptolemaic Period
From Memphis
Purchased from Revd Greville J. Chester; acquired in 1886

A fragment from the lower left corner of a limestone funerary stela of Horiraa, a high-ranking Memphite priest. The ends survive of a funerary inscription of three horizontal lines of incised hieroglyphs, painted black, and reading right to left. This inscription contains the deceased's name, titles and filiation:

> . . .] Master of the Mysteries in Tanenet (a sanctuary at Memphis)
> . . . Lord/Lady of(?)] Ankhtawy (north Memphis), the priest Horiraa, true-of-voice
> . . .] true-of-voice, may she live in the Otherworld for all time!

Below this are two horizontal lines of black-painted cursive script, providing additional titles:

> . . .] White Walls (Memphis), Master of the Mysteries of the Foremost in Tanenet, Master of the Mysteries of the Temple of Ptah, priest of the Foremost in Tanenet, priest of Bastet
> . . .]al(?) living for all-time. Year 4, Month 4 of Akhet, Day 27(?)

Demotic subscriptions to hieroglyphic texts are common, and such usages of several forms of script on private monuments parallel the state multi-script decree of the Rosetta Stone. Here the cursive script is written very formally with a mixture of late hieratic and early demotic forms; the form of the final word of the cursive text before the date is very similar to that of the hieroglyphic text.

BIBLIOGRAPHY: hitherto unpublished.

24 Funerary stela of Didymos

EA 838

H. 55 cm, W. 32.5 cm, D. 8.5 cm

Late Ptolemaic to Roman Period

From Abydos(?)

Purchased from Giovanni Anastasi (executors of);
acquired in 1857

A round-topped limestone funerary stela of
'D[id]ymos'. The stela is divided into two
registers, topped by a winged sun-disk with
pendant uraei. Below this is a scene of the
deceased being led by Anubis before Osiris
and Isis, whose names are written in hiero-
glyphs beside them; the hieroglyphic script
is, significantly, used only in the pictorial
space depicting the gods. The deceased has
no name, but the formula 'may he live for all
time', beside him. In the bottom register are
two horizontal lines of incised Greek text
above two lines of incised demotic, crudely
incised and virtually unintelligible. The
Greek reads (left to right):

> D[id]ymos (son) of Hierakon, twenty-
> seven years (old), before his time.

BIBLIOGRAPHY: A. Abdalla, *Graeco-Roman Funerary
Stelae from Upper Egypt* (Liverpool, 1992), no. 187.

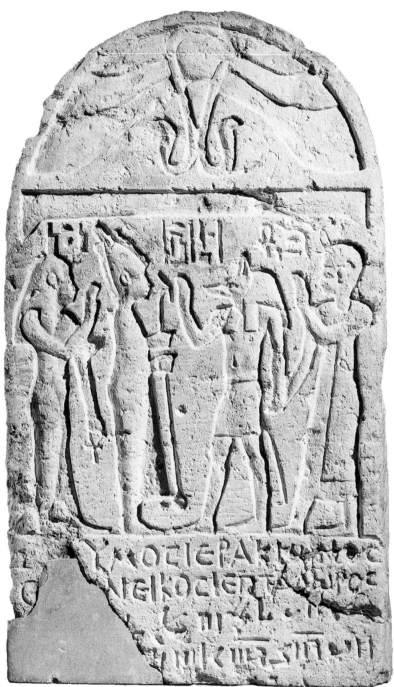

24

25

25 P. London/Leiden: a magical papyrus

EA 10070.2

L. 85.4 cm, H. 23.9 cm

Roman Period, third century AD

From Thebes

Purchased from Giovanni d'Athanasi; acquired in 1857

This very late demotic papyrus was sold in two parts in Thebes, the first part going to London and the second to Leiden, where it proved important in deciphering the demotic script, since the text contains glosses in a mixture of Greek and demotic characters now known as Old Coptic. The entire roll measured some 5 m. On the recto are a series of spells and recipes arranged in twenty-nine columns written between ruled lines. These include spells for divination, love spells, poisons and spells of healing. On the verso are apparently discontinuous memoranda, prescriptions and short invocations. The spells are typical products of the syncretistic culture of Late Antiquity.

This section comprises columns 4–7. Column 4 contains a spell for a revelation, including a recitation written in Greek that is to be read in the opposite direction to the demotic (4.9–18). This is followed by two further spells for visions. Column 5 contains a spell for 'A TESTED god's arrival', that is, for a vision in a dream. Lines 6–8 read:

> If you put frankincense up in front of the lamp and look at the lamp, you see the god near the lamp; you sleep on a reed mat without having spoken to anyone on earth, and he tells you the answer in a dream. HERE IS ITS INVOCATION: FORMULAE: Here are the writings which you should write on the wick of the lamp: Bakhukhsikhukh

This last word is written in Old Coptic signs, and means 'Soul of darkness, son of darkness'. Then come some untranslatable hieroglyphic signs to be written on the wick. There follows a recitation in which the magician identifies himself with various magical names. Many of these are written phonetically in demotic characters, but with a gloss above them in Old Coptic letters (l. 9):

> Hail, I am Myrai Myyribi Babel Baoth Bamyi, the great Agathodaimon . . .

25 (detail of column 5)

The remainder of the spells in this section of the papyrus is another 'inquiry of the lamp'.

BIBLIOGRAPHY: F.Ll. Griffith and H. Thompson, *The Demotic Magical Papyrus of London and Leiden* (London, 1904); translation: J. Johnson in H.D. Betz (ed.), *The Greek Magical Papyri in Translation, Including the Demotic Spells* (Chicago and London, 1986), 195–251 (= PDM xiv; spells on this section = PDM xiv.93–219); J. Tait, 'Theban magic', in S.P. Vleeming (ed.), *Hundred-Gated Thebes: Acts of a Colloquium on Thebes and the Theban Area in the Graeco-Roman Period*, Papyrologica Luduno-Batatva 27 (Leiden, 1995), 169–82.

COPTIC

The first significant attempts to write the Egyptian language with Greek letters date from the second century AD. Inevitably an alphabet that had evolved for Greek phonology could not be used for a different language without some adaptation, and several letters were added, derived from demotic phonemic signs or groups of signs (fig. 38).

The original impulse for this change is debatable: a proto-Coptic script appears in magical texts, perhaps due to a desire to record the vowels of magical utterances (e.g. cat. 25), but its rise may also have been due to the fact that demotic was becoming more cursive and increasingly difficult to read, despite tendencies to use spellings foregrounding the phonetic value of words, including the usage of only uniliteral signs.[28] Coptic was developed in a thoroughly bilingual and educated setting, and many Greek words were imported into the language as well as the alphabetic letters. It provided a necessary means of recording the native language, since after the first century AD and the decline of demotic there was no commonly used written form of Egyptian. As Roger Bagnall remarks, the majority of the indigenous population had no way of recording its own language in writing until the mid-third century at the earliest.[29]

Initially Coptic was mostly used for biblical texts, but by the mid-fourth century, in 'a cultural event of major proportions',[30] it came to be used for Christian literary works and private letters. Apart from some minor features of demotic, dialects became visible in written form for the first time in the history of Egyptian.[31] It is uncertain how the dialects were located geographically, but what is now termed the Sahidic, after the Arabic for Upper Egyptian dialect, was chosen for the official translation of the Bible, and this consequently became the standard literary language. Sahidic, which despite its name is thought to have been the language of the region around Memphis, lasted from the fourth to the tenth century. Native Egyptian texts, as opposed to translations, include the writings of the monks Pachomius, Shenute and Besa (fig. 39). The Bohairic, or 'northern', dialect is well attested by the ninth century and became the principal language of the Coptic church in the tenth century.

Greek retained its importance in economic and official matters for several centuries after the appearance of Coptic. Contrary to what is often assumed, the two languages were not divided between poor country dwellers speaking Coptic and sophisticated town dwellers writing in Greek. The dominance of Greek in surviving manuscripts may well reflect the preservation of manuscripts and the importance attributed to Greek by earlier scholars and collectors, as with the desert town-site of Oxyrhynchus which is famous for the Greek papyri that it produced, despite other significant material (such as fig. 21).[32] Such factors produce the misleading impression that it was only after the Arab conquest of Egypt in AD 639–41 that Coptic began to replace Greek as a language of administrative affairs. A huge number of Arabic papyri survive from Egypt for the first few centuries after the Muslim conquest. Arab dominance over the native

hieroglyphs	demotic	Coptic	phonological value
		ⲁ	a
		ⲃ	b
		ⲅ	g
		ⲇ	d
		ⲉ	e
		ⲍ	z
		ⲏ	ē
		ⲑ	th
		ⲓ	i
		ⲕ	k
		ⲗ	l
		ⲙ	m
		ⲛ	n
		ⲝ	ks
		ⲟ	o
		ⲡ	p
		ⲣ	r
		ⲥ	s
		ⲧ	t
		ⲩ	u
		ⲫ	ph
		ⲭ	kh
		ⲯ	ps
		ⲱ	ō
𓄿	ϫ	ϣ	sh
		ϥ	f
		ϩ	h
		ϫ	j
		ϭ	c
		ϯ	ti

Fig. 38 The Coptic alphabet

Fig. 39 A limestone stela with a Coptic inscription of twenty-four lines surrounded by a border of plant motifs. From the Monastery of Apa Jeremias, Saqqara. H. 66.7 cm. EA 1623.

Egyptian population eventually caused Coptic to die out as a spoken language, probably by the fifteenth century. This marked the end of a language that had a continuous written tradition for over 4,500 years. Coptic continues as a liturgical language, but its present pronunciation is essentially that of Arabic and offers little evidence of how it was pronounced in medieval and earlier periods.

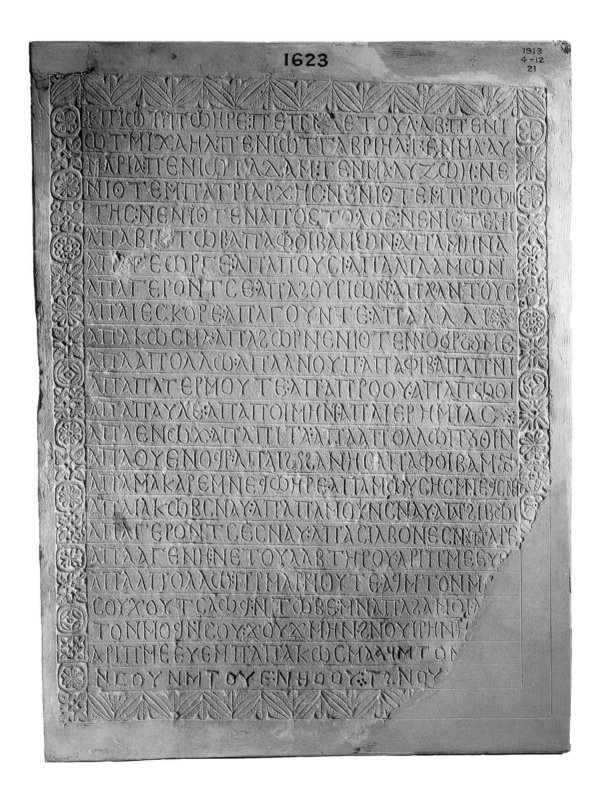

26 Page of a Coptic codex

EA 71005.3

H. 20.2 cm, W. 13.3 cm

Coptic Period, seventh century AD

Provenance unrecorded

Donated by Messrs Rutter and Marchant, from the collection of John Lee; acquired in 1935

A papyrus page from a Coptic codex, dated by the palaeography to the seventh century AD. The text is a entitled 'A [Discourse by our] Holy Father Shenute', and is written in the Sahidic dialect. Shenute (d. AD 466), the abbot of the White Monastery near Akhmim, was a passionate reformer and a persecutor of paganism. His writings display a 'highly individualistic and very powerful' style;[33] the style of the present text, however, suggests that it was written later and only attributed to Shenute. This page (no. 11) contains an account of a miraculous supply of grain:

> . . . Now when we had finished praying, look, someone touched me. I thought that it was the hand of the Son of God. He said to me: 'Shenute, do not fear, but trust in the Lord. It is he who will take care for you and he will never abandon you.' He said to me: 'Send the brother to bring bread for the men so they may eat.' I turned round, but I did not see him. We prayed and sent the brother. When he opened the door, we found one hundred artabae (a measure of grain volume, equivalent to *c.* 30 kg) pouring on us. We were very happy and we blessed Jesus, who is always beneficent to his servants. We brought five artabae [from there].

BIBLIOGRAPHY: H. Behlmer and A. Alcock, *A Piece of Shenoutiana from the Department of Egyptian Antiquities (EA 71005)*, BM Occasional Paper 119 (London, 1996), esp. 13, pl. 11.

26

27 Ostracon with ecclesiastical letter

EA 32782

H. 12.7 cm, W. 17.2 cm, D. 2 cm

Coptic Period, seventh century AD

From Deir el-Bahri

Donated by the Egypt Exploration Fund;
acquired in 1900

A limestone ostracon with text on both sides in Coptic, from the archives of the monastery of Apa Phoibammon, built on the upper terrace of the temple of Hatshepsut at Deir el-Bahri. Such pieces of stone or pottery were used for brief notes and memoranda throughout Egyptian history. There are twenty lines in black pigment on the front, and a further sixteen on the back. The text is a copy of an ecclesiastical letter, probably from the monastery's founding abbot Bishop Abraham (AD 590–620), to judge by the provenance and other related documents. The letter begins:

> Now I have been informed that Psate is
> maltreating the poor, and they have told
> me saying, 'He is maltreating us, [and
> leaving] us poor and wretched.' He who
> maltreats his neighbour is excluded from
> the feast, and he is like Judas – he who
> arose from supper with his Lord and
> betrayed him, as is written: 'He who
> ate my bread has lifted his heel against
> me . . . ' (ll. 1–7)

BIBLIOGRAPHY: W.E. Crum, *Coptic Ostraca from the Collections of the Egypt Exploration Fund, the Cairo Museum and Others* (London, 1902), no. 71; W. Godlewski, *Deir el-Bahari: le monastère de St Phoibammon* (Warsaw, 1986), 154 (no. 56, misnumbered); W. Godlewski, 'Dayr Apa Phoibammon', in A.S. Atiya (ed.), *The Coptic Encyclopedia* III (New York and Toronto, 1991), 779–81.

27 (front)

27 (back)

28 Grammatical ostracon

EA 14222

H. 13.8 cm, W. 12 cm, D. 0.7 cm

Coptic Period

Provenance unrecorded

Donated by Revd Greville J. Chester;

acquired in 1879

Red pottery ostracon with text written in black pigment on both sides. On the front are seventeen lines of grammatical exercises: the tenses of the verb 'to teach' are written first in Greek and then in Coptic. At the top is the future tense ('I will teach', 'You will teach'), followed by the perfect tense ('I taught'); then the future is repeated again (the Greek version is broken away). At the bottom are 'Swear to me' and 'I will swear'. On the other side are eleven lines of a Coptic letter mentioning one Horsiesious (a name derived from the Pharaonic name, 'Horus-son-of-Isis'), giving greetings to a most holy father.

BIBLIOGRAPHY: H.R. Hall, *Coptic and Greek Texts of the Christian Period* (London, 1904), 38.

28 (front)

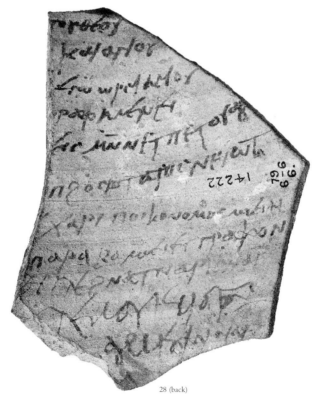

28 (back)

DECORATIVE HIEROGLYPHS

Aesthetic considerations were a determining factor in the layout of hieroglyphic inscriptions, in which signs were organized into square spaces ('quadrants') and sometimes transposed so they fitted together in a pleasing manner; occasionally space-filler signs were used. One example is the word for lector priest, ḫrj-ḥbt, which is written in cursive scripts as ⌷⌷⌷⌷⌷, but in hieroglyphs in a square arrangement as ⌷⌷. Many writings in hieroglyphic inscriptions are also abbreviated for aesthetic reasons, such as ⌷ for ḫrj-ḥbt, and there is also a preference for placing a tall thin vertical sign before a bird hieroglyph that it might otherwise follow: thus ⌷ is to be read wḏȝ ('prosperity'), not ḏȝw. For decorative reasons this word is often abbreviation into the single sign ⌷.

Hieroglyphs were not only arranged decoratively, but were a principal vehicle of decoration. From the late 0th Dynasty, there is a tendency to use hieroglyphs in emblematic and iconographic groups. Like cryptography, this practice relies on the close association of a pictorial shape of a sign and its semantic meaning, which is often very different from what the sign represents. For example, the ꜥnḫ sign, which shows a penis sheath or sandal strap, is used as the emblem for the word it writes phonetically, 'life'. The Rosetta Stone contains instructions for building the shrines of the royal cult and decorating them with emblematic hieroglyphs:

> A uraeus should be placed on a basket with a 'sedge' under it on the right of the side on the top of the shrine, and a uraeus with a basket under it should be placed on a papyrus on the left, the meaning of which is 'The King who has illumined Upper and Lower Egypt'. (Demotic text, l. 27)

Texts were also laid out in decorative bands on artefacts ranging from cosmetic instruments to monumental gateways, all being expressive of elite, often royal, power. Many such inscriptions are formulaic and comprise simply names and epithets.

29 Pendant with the name of Senwosret II (pl. 17)

EA 54460
H. 1.5 cm, W. 3.5 cm, D. 0.3 cm
12th Dynasty, temp. Senwosret II (1897–1878 BC)
Provenance unrecorded
Purchased from Mohammed Mohassib;
acquired in 1919

A winged scarab of electrum, inlaid with red cornelian, blue lapis lazuli and green feldspar. The ornament would have been suspended from a wire or thread passing through tubes on the underside of the wings. The underside is not inlaid. A scarab with a blue body holds a red sun-disk in its front legs, as if bearing it across the sky. Its wings are formed of bands of red, blue and green. It rises from a hieroglyph representing a red hill over which the rising sun's blue and green rays are visible; from this spring two green plants, perhaps representing Upper and Lower Egypt. Together the scarab (ḫpr), hill (ḫꜥ), and sun (rꜥ) write the throne name of Senwosret II, Khakheperre (Ḫꜥ-ḫpr-rꜥ); the inscription is exactly symmetrical. The outspread wings are a protective device.

BIBLIOGRAPHY: C. Andrews, *Catalogue of Egyptian Antiquities in the British Museum, VI: Jewellery, I: From the Earliest Times to the Seventeenth Dynasty* (London, 1981), no. 554; C. Andrews, *Ancient Egyptian Jewellery* (London, 1990), 130, fig. 113.

29

30 Inscribed bronze fitting of Amenhotep IV (pl. 18)

EA 41643

H. 38 cm, W. 8.9 cm, D. 0.3 cm

18th Dynasty, temp. Amenhotep IV

(1353–1348 BC)

Provenance unrecorded

Donated by Frederick George Hilton Price;

acquired in 1905

A plate of bronze with fourteen holes, five of them still containing nails. The front is inscribed with a single line of finely incised left-facing hieroglyphs recording the name and epithets of an Amenhotep, probably Amenhotep IV, in Middle Egyptian:

> There exists the Son of the sun-god,
> whom he loves: (Amenhotep, Divine
> Ruler of Thebes) [...

This piece was probably a decorative element attached to a wooden door, presumably in a temple or palace building; the phraseology is characteristic of a column of text framing a figured scene, so was presumably part of a larger composition on the door.

BIBLIOGRAPHY: hitherto unpublished; for text see J. Baines, 'King, temple, and cosmos: an earlier model for framing columns in temple scenes of the Graeco-Roman Period', in M. Minas and J. Zeidler (eds), *Aspekte spätägyptischer Kultur: Festschrift für Erich Winter zum 65. Geburtstag,* Aegyptiaca Treverensia 7 (Mainz, 1994), 23–33.

30

31 Glazed composition plaques and hieroglyphs

Glazed tiles survive from several New Kingdom palaces, including those of Sety I at Qantir and Ramses III at Tell el-Yahudiya, and in the cultic palace complex of Medinet Habu at western Thebes. These brightly decorated tiles were part of the iconographic programme of a palace, and are most likely to come from doorways and the throne dais.[34] Such a dais would have created an iconographic context for the king's appearance at the very centre of art, prestige and writing. They give a sense of the vivid colours that once decorated sculpture, architectural surfaces and most inscriptions. The exact provenance of most of these examples is unknown; they vary in elaboration and costliness.

EA 58953 (pl. 19)

H. 18.5, 19.7, 22.5, 18.6 cm; W. 7.7 cm

18th Dynasty, temp. Amenhotep III

(1391–1353 BC)

Provenance unrecorded

Donated by C. W. Scott; acquired in 1928

Four blue glazed composition rectangular tiles; a further seven fragments are in the collection. The blue tiles will have formed a vertical band, with a vertical line of gilded hieroglyphs, modelled in delicate raised gesso relief, in which linen inclusions can be detected (as supports for the gesso). The hieroglyphs are decorated with fine incised detail, somewhat obscured by the cracks in the gilding. In places the gesso has flaked off, leaving only a faint outline, or a damaged area, on the glazed surface. The left-facing line of inscription records the titulary of Amenhotep III:

> Horus: Strong Bull Appearing in Thebes;
> Perfected God, Lord of Joy, Lord of
> Crowns, who takes the Fair Crown (of
> Upper Egypt), Dual King: [...

The tiles were probably inlaid into an architectural element, perhaps a doorway; similar examples survive from the palace city of Amenhotep III at Malqata in western Thebes.

BIBLIOGRAPHY: hitherto unpublished.

31a (EA 58953)

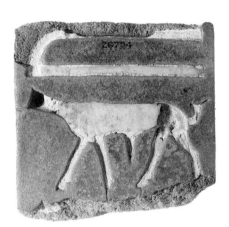

31b (EA 26794)

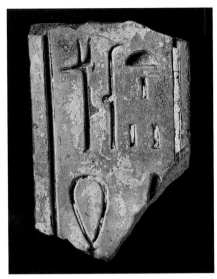

31c (EA 12896 [front])

31c (EA 12896 [back])

31d (EA 13714)

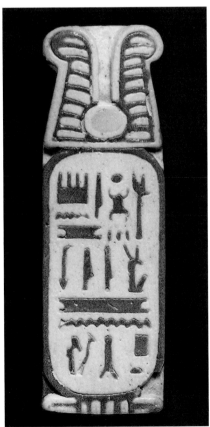

31e (EA 67970)

EA 26794
H. 9.41 cm, W. 8.93 cm, D. 1.9 cm
Ramesside Period
From Tell Basta
Purchased from Revd Greville J. Chester;
acquired in 1891

Part of a blue glazed composition tile from a decorative line of text bearing inlaid hieroglyphs of very high quality. The lower sign, which shows a headless animal-skin (facing left), has an inlaid body of calcite, while the legs and tail are of white gypsum. The signs write the preposition *m-ḥnw*, 'within'. The side edges are original.

BIBLIOGRAPHY: hitherto unpublished.

EA 12896
H. 12.6 cm, W. 8.3 cm, D. 2.9 cm
20th Dynasty, temp. Ramses III (1194–1163 BC)
Provenance and acquisition details unrecorded

Part of a tile made of glazed composition, with hieroglyphs inlaid in a white material (much of it lost), on a blue background. The left-facing text comprises part of the 'Golden Horus' name of Ramses III:

Powerful of years like [. . .
On the reverse is a mark like a modern H in black pigment, with five incised horizontal lines below it. The incised marks were presumably made by the manufacturer, while the written mark was added later, perhaps giving information relating to the tile's delivery or intended position.

BIBLIOGRAPHY: hitherto unpublished.

EA 13714
H. 7.29 cm, W. 2.43 cm, D. 0.7 cm
Ramesside Period
Provenance unrecorded
Donated by Major-General Augustus
W.H. Meyrick; acquired in 1878

Light blue glazed composition inlay in the form of a basket sign (*nb*); the dark blue chequer-board pattern represents the fibres of the woven basket, with a border along the top edge. The under-surface is flat and smooth, with some staining. An entire inscription made up of such large decorative hieroglyphs would have been a striking sight.

BIBLIOGRAPHY: hitherto unpublished.

EA 67970
H. 13.84 cm, W. 4.59 cm, D. 1.2 cm
19th Dynasty, temp. Sety II (1214–1204 BC)
Provenance unrecorded
Purchased from R. Symes; acquired in 1973

Inlaid glazed composition tile in the form of a plumed cartouche containing the throne and birth names of Sety II. This royal cartouche is a decorative element, not part of an inscription. It is in blue on a white background and wears a headdress of two plumes and a sun-disk in yellow. The right-facing cartouche reads:

(Userkheprure, beloved of Amun; Sety, beloved of Ptah)| .
The back is flat and in part unglazed.

BIBLIOGRAPHY: I. Freestone and D. Gaimster (eds), *Pottery in the Making: World Ceramic Traditions* (London, 1997), 106, fig. 2.

32 Sculptor's trial piece

EA 38276

H. 15.8 cm, W. 13.5 cm, D. 2.45 cm

Ptolemaic Period

Provenance unrecorded

Purchased from Revd Greville J. Chester; acquired in 1871

A limestone trial piece depicting an owl-hieroglyph (facing right), the uniconsonantal sign for *m*, in elaborately detailed raised relief; the left side is lost. Such pieces by sculptors show the level of detail that could be incorporated into a single very common sign.

BIBLIOGRAPHY: hitherto unpublished.

Some similar pieces are probably votive offerings: R.S. Bianchi, 'Ex-votos of Dynasty XXVI', *MDAIK* 35 (1979), 15–22; id., 'Two ex-votos from the Sebennityc Group', *JSSEA* 11 (1981), 31–6. See also K. Myśliwìec, 'Towards a definition of the "Sculptor's Model" in Egyptian art', *Etudes et Travaux* 5 (1972), 71–5.

38276

32

COLOUR PLATES

Plate 2 The fort of St Julien at Rosetta, showing an ancient Egyptian block inscribed with hieroglyphs built into the wall, upside down. The inscription contains the cartouche with the throne name (Haaibre) of Apries (589–570 BC), and probably originally came from Sais.
Courtesy C. Andrews.

Plate 3 Detail of the incised hieroglyphs, showing traces of the savants' ink, and the pink infill.

Plate 4 View of the second court in the temple complex of Philae, showing the rounded granite stela of Ptolemy VI Philometor against the second pylon of the temple of Isis. A scene showing the king and queen offering to gods occupies the top of the stela, with six lines of hieroglyphic text below.
Courtesy C. Andrews.

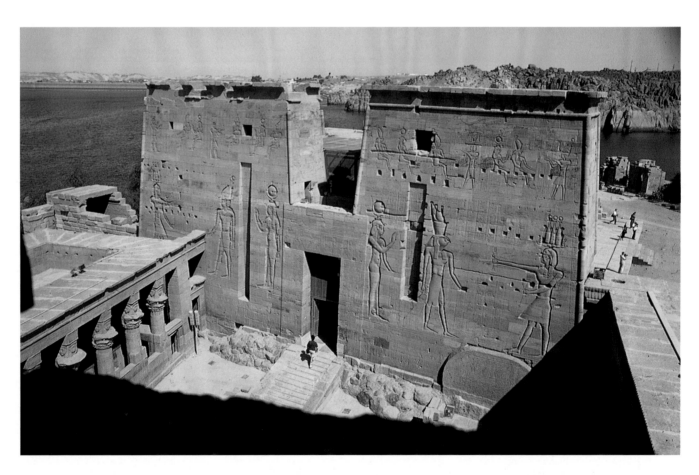

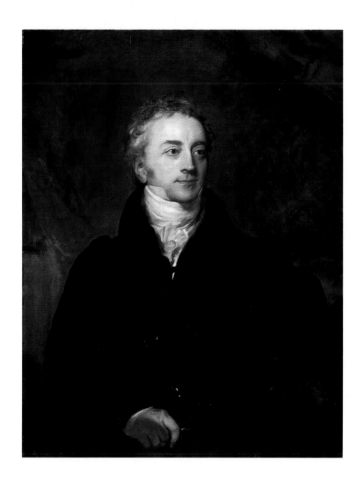

Plate 5 A portrait of Thomas Young, apparently an early copy by an unknown artist of the portrait by Sir Thomas Lawrence; now in the possession of Thomas Young's descendants.
H. 91 cm. Courtesy Mr and Mrs S.Z. Young (all rights reserved).

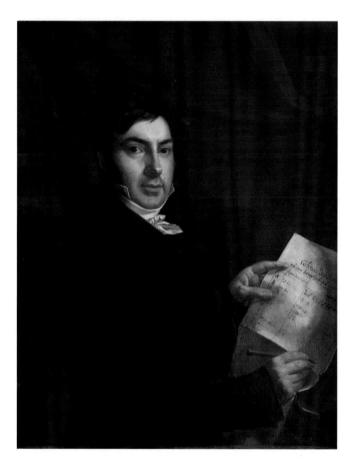

Plate 6 Portrait of Jean-François Champollion holding the hieroglyphic 'alphabet' from the *Lettre à M. Dacier*, attributed to Mme de Rumilly, *c.* 1823.
H. 81 cm. Courtesy the Musée Champollion (all rights reserved); by kind permission of M. and Mme Chateauminois.

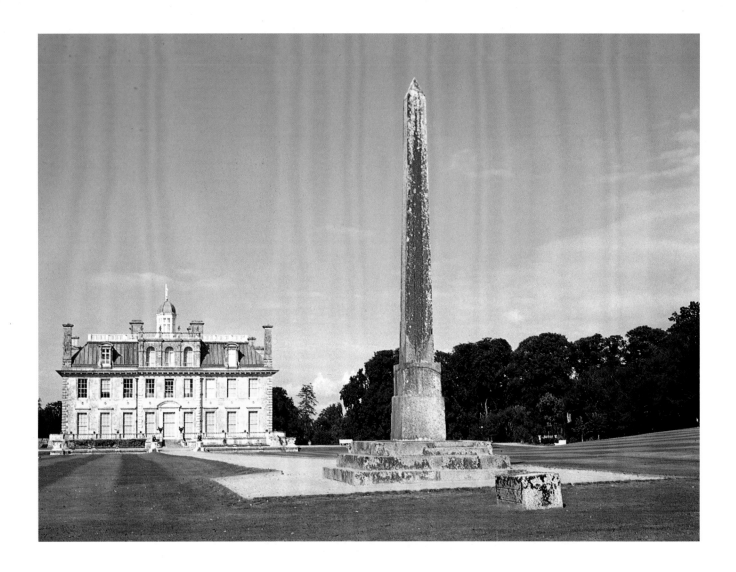

Plate 7 The Bankes obelisk at Kingston Lacy, Dorset, in the position facing the house that was chosen by Bankes' friend the Duke of Wellington. In front of it lies a fragment of another obelisk from Philae; the two originally stood in front of the first pylon of the temple of Isis, flanking the central doorway. H. 7 m. Courtesy T.G.H. James.

Plate 8 P. Sallier II containing the first column of a Ramesside copy of the poem *The Teaching of King Amenemhat*; the notes written on the mounting state that the papyrus was 'stuck onto fourteen squared sheets by Champollion at M. Sallier's in the month of February 1830', on his return from Egypt and two years after he first saw the papyrus. The red dots mark the ends of lines of verse, and the red phrases are the opening lines of stanzas. H. 21.2 cm. EA 10182.1.

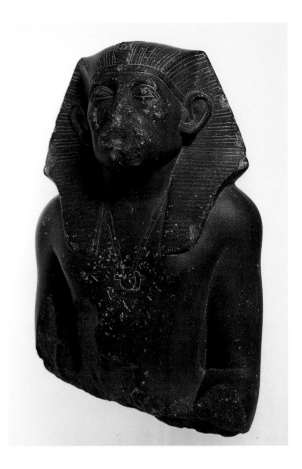

Plate 9 A 12th Dynasty statue of King
Senwosret III wearing the *nemes* crown
and an amulet. The prominent ears
represent the king's ability to hear.
H. 22 cm. EA 36298.

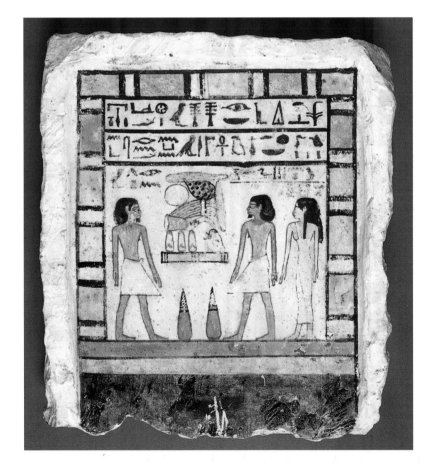

Plate 10 Funerary stela of
Renefseneb. EA 636; cat. 3.

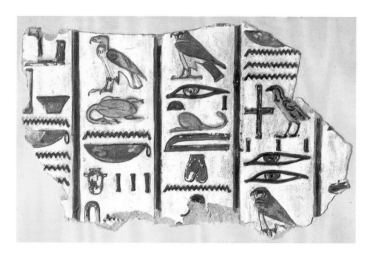

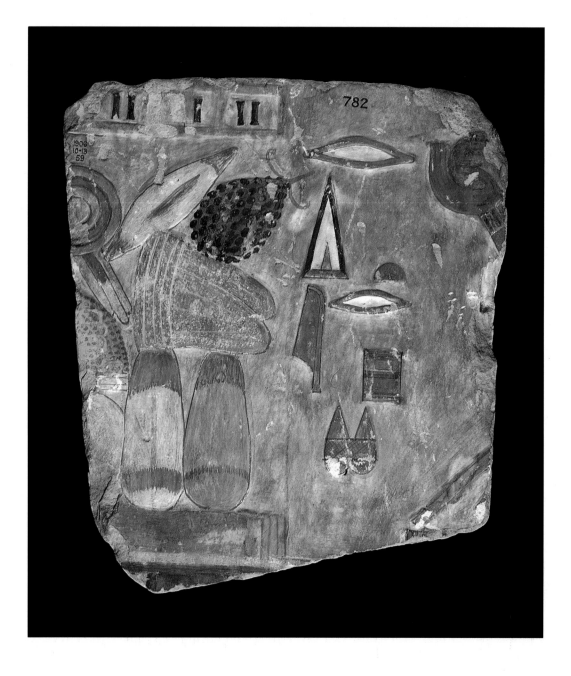

Plate 11 (above left) Fragment of a tomb chapel inscription from Deir el-Bersha. EA 71539; cat. 4.

Plate 12 (above right) Fragment of an inscription from the tomb of Sety I. EA 5610; cat. 5.

Plate 13 A royal temple inscription from Deir el-Bahri. EA 782; cat. 6.

Plates 14 and 15
Part of a coffin of Tanetaa
(inner and outer sides).
EA 30360; cat. 7.

Plate 16 'Graffito' from a
temple at Deir el-Bahri.
EA 47963; cat. 16c.

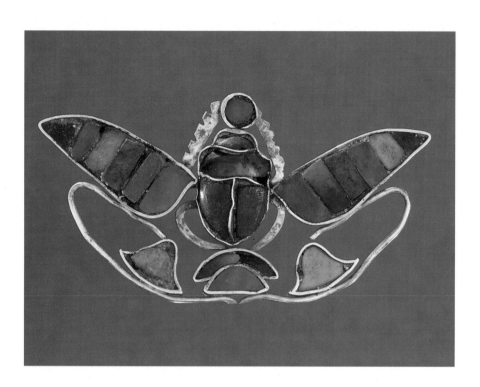

Plate 17 Pendant with the name of Senwosret II.
EA 54460; cat. 29.

Plate 18 Inscribed bronze fitting of
Amenhotep IV. EA 41643; cat. 30.

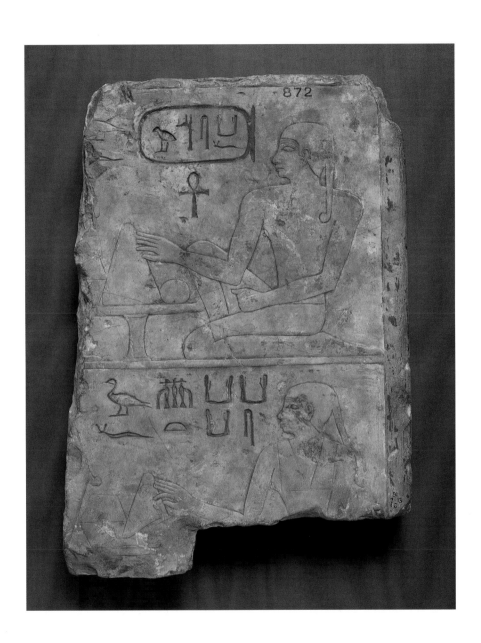

Plate 19 Blue glazed composition tiles.
EA 58953; cat. 31a.

Plate 20 5th Dynasty tomb relief from Saqqara.
EA 872; cat. 33.

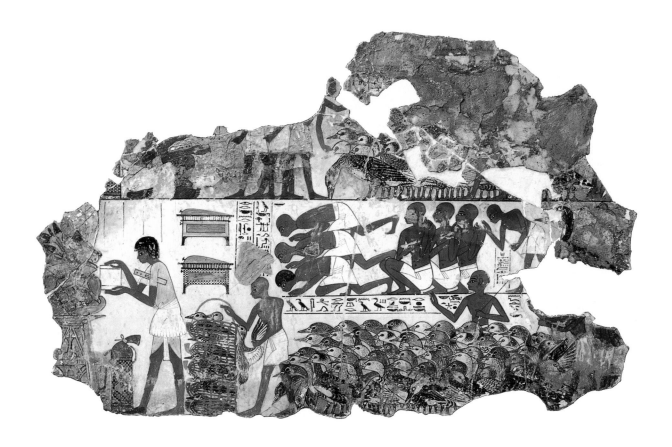

Plates 21 and 22 Paintings from the tomb chapel of Nebamen. EA 37976, 37978; cat. 38.

Plate 23 Wooden funerary model of a granary. EA 41573; cat. 42.

Plate 24a and b A *was* staff in glazed composition decorated with the titulary of Amenhotep II (1427–1401 BC) in black, in a vertical column down the front of the staff. The staff has arms (now broken). From the temple of Seth at Tukh. H. 216 cm. Victoria and Albert Museum 437.1895; courtesy the Victoria and Albert Museum.

a (detail)

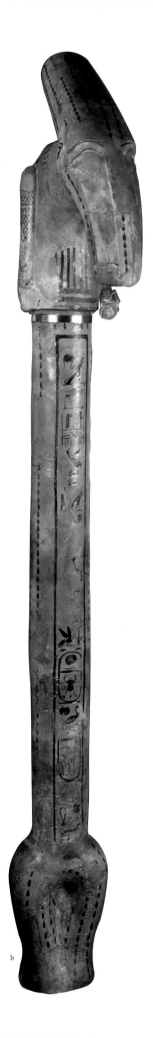

b

Plate 25 Model of a scribe's writing box.
EA 35878; cat. 56. The base is modern.

Plate 26 Tomb wall-painting of scribes
from Thebes. EA 43468; cat. 57.

Plate 27 Painted limestone shabti of Qenherkhepshef, showing a mummiform figure holding agricultural implements. EA 33940; cat. 70.

Plate 28 Limestone ostracon with the concluding stanzas of *The Tale of Sinuhe* written in hieratic on one side. EA 5629; cat. 79.

Plate 30 The bark stand from Wad Ban Naqa. H. 118 cm. Berlin, Ägyptisches Museum und Papyrussammlung 7261. Courtesy Staatliche Museen zu Berlin – Preussischer Kulturbesitz: Ägyptisches Museum und Papyrussammlung.

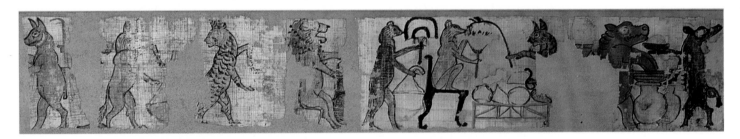

Plate 29 Fragments of an illustrated papyrus showing animals engaged in human activities. EA 10016.2; cat. 81.

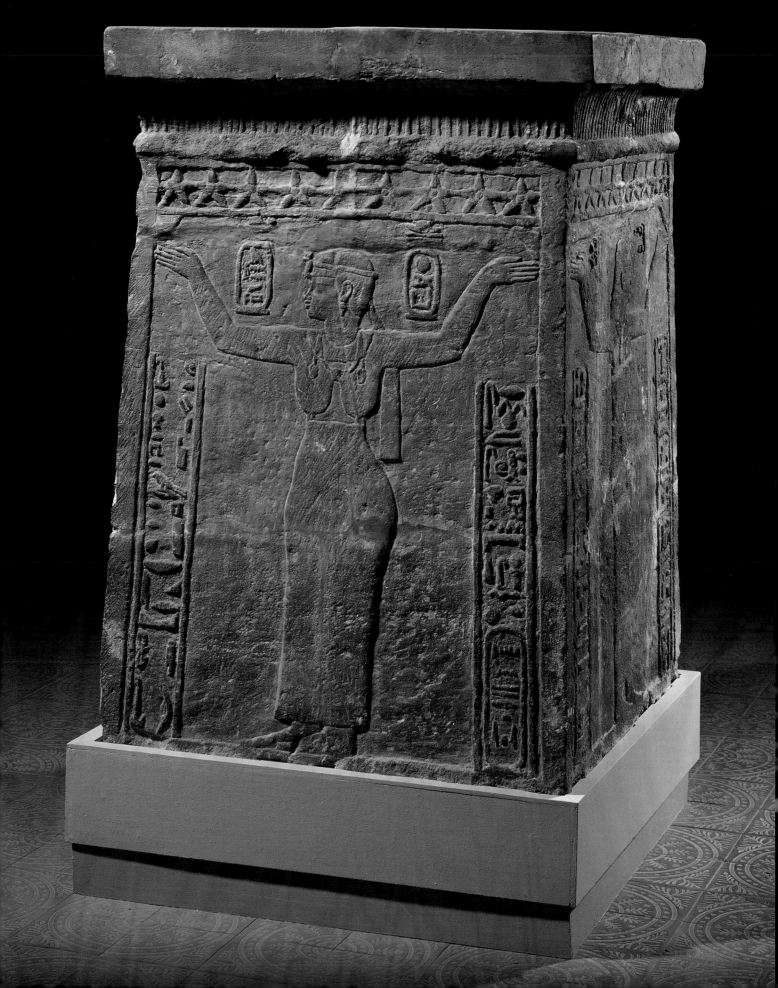

Plate 31 A red sandstone sphinx from the Middle
Kingdom temple at Serabit el-Khadim with
inscriptions in Egyptian hieroglyphs and in the
Proto-Sinaitic script. L. 23.7 cm. EA 41748.

MONUMENTAL ART: CULTURAL DISPLAY

The relationship between hieroglyphs and representational art is intimate, and is both complementary and fundamental to the script.[35] In the Old Kingdom, inscriptions which included a determinative sign that could be supplied by an adjacent representation omitted the determinative. This was especially common in texts comprising names where the final determinative of a human figure was supplied by the figure of the person concerned, to which the name was the caption (e.g. cat. 33, 34). By the Middle Kingdom the captions generally included the determinatives, and representation and caption were more discrete. The gradual lessening of the prestige of representation over text can also be seen in the way in which inscriptions were added to statues. In the Old Kingdom short inscriptions were added to spaces such as a figure's belt, while later longer inscriptions spread onto spaces such as thrones or the back pillars of statues, and subsequently also onto areas of clothing (e.g. cat. 37, 39, 51). From the 18th Dynasty on, even areas of the statue representing unclothed flesh were inscribed (e.g. cat. 37, 46). Some types of stelophorous statues (i.e. statues with a stela) also display a tendency for the statue itself to become more abbreviated, without affecting the text on the stela (e.g. cat. 40, 41). This tendency may reflect a gradual increase in the uses of writing apart from monumental display, and for continuous texts, giving texts a certain autonomy.

Hieroglyphs nevertheless almost always obey the rules of iconography and scene composition. Just as the most important figure takes precedence in a scene, so the hieroglyphic signs writing the words for 'king' or 'god' precede the word with which they are associated, regardless of their linguistic order; thus *sḫ-njswt*, 'scribe (*sḫ*) of the king (*njswt*)', is written as if it were *njswt-sḫ*: . This tendency to 'honorific transposition' is stronger in hieroglyphic script than in cursive scripts (and also with logograms than with phonograms). The orientation and extent of a hieroglyphic text was always determined by the context and artistic or architectural considerations. Wherever possible, a symmetrical arrangement of script was preferred. The captions to a figure were aligned to face in the same direction as the figure that they accompanied: two figures facing each other can have their captions facing accordingly. Scenes have to be read as a whole, since much semantic and symbolic information is conveyed not by text but by iconography. An explicit articulation of this integrated way of reading a monument is provided by a neo-Middle Egyptian text in the tomb of Ibi at Thebes, from the time of Psammetichus I (664–610 BC), which evokes the experience desired of a pious tomb visitor:

> As you descend to the stela of this tomb-chamber,
> and understand the writings which are in it,
> you will see the Beatifications of the ancestors
> who are on their seats with inimitable richness;
> you will hear the dispute of those who are speaking loudly
> to their companions;

you will hear the singing of the musicians,
the laments of those who are mourning;
you will find the name of every man above him
in every office by its name,
the cattle, tree<s> and herbs,
with their names above them,
with their throats turning(?), the tree in the earth growing,
with its branch and its fruit(?) . . .[36]

The art of such monuments is often said to be bound to their function and to be magical far more than aesthetic, but that assumption has been challenged.[37] Although tomb chapels such as Ibi's or Nebamen's (cat. 38) are ritual spaces, that is just as true of the funerary chapel of the Scrovegni family at Padua, decorated by Giotto around AD 1304–13, or the liturgical spaces decorated by Michelangelo in the Vatican in 1508–12 and 1536–50. Aesthetics and ritual do not have to exclude each other. The aesthetic, virtuosic and 'playful' nature of the hieroglyphic script and its capacity to evoke aesthetic wonder should not be underestimated; the Greco-Roman usage of 'figurative' hieroglyphs is only an elaboration of features that were always implicit in the script.

An entity such as a cat is often represented in the same way in the hieroglyphic script and in representational art, but this is due to the pictorial nature of the hieroglyphic signs rather than the hieroglyphic nature of representational art. It is easy for the modern viewer to overestimate the 'hieroglyphic' aspects of Egyptian art[38] and forget that most Western art draws similarly on the culturally determined iconography and significance of represented entities.

Hieroglyphic signs could become amulets and emblems, not because of what they represented but because of what they meant. Emblematic hieroglyphs and other symbols are an intermediary level between writing and representation. In royal and sacred iconography such emblems act as framing elements for pictorial space, providing representations of heaven and earth at the top and bottom of scenes, but can also participate in the action: *ankh* ('life') signs can be attendants on the king.

Hieroglyphs are occasionally transposed into three dimensions, especially when acting as emblems (see p. 138 and pl. 24). There are also rebus statues, such as the statue in the Cairo Museum where a sun-disk (*R'*) is worn by the king as a child (*ms*) who holds a reed (*sw*), writing *R'-ms-s(w)*: Ramses (II).[39]

33 5th Dynasty
tomb relief (pl. 20)

EA 872

H. 31.2 cm, W. 22.5 cm, D. 6 cm

Early 5th Dynasty, *c.* 2460 BC

From Saqqara (on stylistic grounds);
acquired in 1891

Part of a limestone raised relief from the
tomb chapel of an unknown official, show-
ing banqueters with their names in incised
hieroglyphs (reading left to right). The upper
register depicts 'his son Userkafankh' sitting
by an offering-table; the lower register
depicts 'his son (*sic*) Khentkaues' in a similar
scene; the caption should read 'his daughter',
but the feminine ending was omitted. There
are some remains of red and yellow pigment
on the figures, and a discoloured blue in the
hieroglyphs. The name of the son means
'(King)-(Userkaf)|-lives': the king's name is
written inside the royal cartouche, and the
ankh sign writing '-lives' is centred under the
cartouche. The children's names have no
determinative in the inscription: the figures
fulfil its role.

BIBLIOGRAPHY: PM III², 579; T.G.H. James,
Hieroglyphic Texts 1² (London, 1961), 19, pl. 20;
Y. Harpur, 'The identity and positions of relief
fragments in museums and private collections',
JEA 71 (1985), 36.

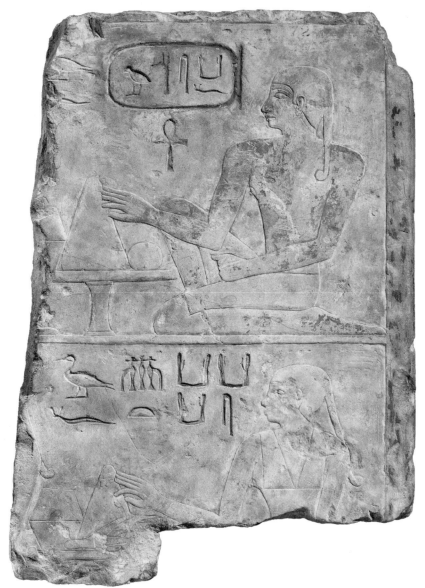

33

34 False door panel of Niankhre

EA 1429a

H. 21 cm, W. 29.2 cm, D. 3.5 cm

Mid-5th Dynasty

From Saqqara

Purchased from Panayotis Kyticas;
acquired in 1908

Part of the limestone false door from the 5th Dynasty mastaba of the Superintendent of the Hairdressers of the Palace, Niankhre, at Saqqara, east of the Step Pyramid. Other fragments from his tomb are in the British Museum, the Egyptian Museum, Cairo, Macquarie University, Sydney, and the Field Museum of Natural History, Chicago. In the central panel Niankhre is shown in sunk relief seated before an offering table. This type of scene represents the practice of the funerary cult, where food offerings were invoked for the dead before the false door of the tomb chapel. The caption for the offering table is presented as if part of the pictorial scene, and reads in vertical lines (from right to left):

> A thousand ($\stackrel{\circ}{\underset{\perp}{}}$) of fowl; a thousand of
> flesh; a thousand of bread; a thousand
> of beer.

The hieroglyphs for the items are piled up under the offering table, and the word for 'fowl' is written with an usually full representation of the hieroglyph; usually only the head of a bird (\natural) is portrayed, rather than the body. Beside Niankhre his name is written in a vertical line in the same direction as his figure, which is the determinative to his

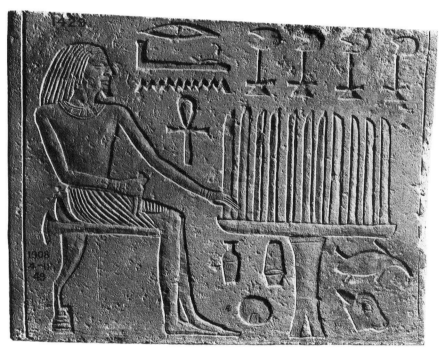

34

name (see above). A noteworthy point of decorum is that in his name, which means 'Life-Belongs-to-the-sun-god', the element 'sun-god' (r') is written with uniconsonantal signs, not the logogram that generally wrote the god's name (\odot). In this period, such logographic writings of names of gods were reserved for use in royal contexts.[40]

BIBLIOGRAPHY: PM III², 586; T.G.H. James *Hieroglyphic Texts* 1² (London, 1961), pl. 26; N. Kanawati, 'An unpublished door jamb from Dynasty 5', *GM* 100 (1987), 41–3.

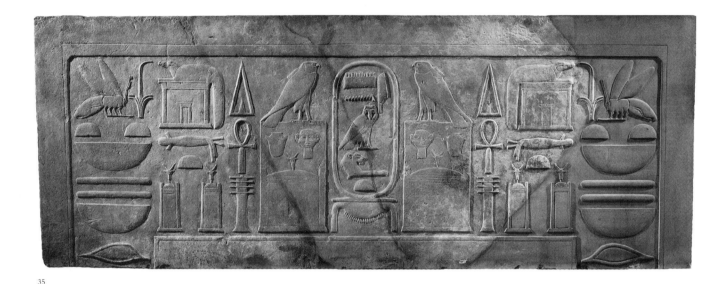

35

35 Royal temple lintel of Amenemhat III

EA 1072

H. 88 cm, W. 234.5 cm, D. 8 cm

12th Dynasty, temp. Amenemhat III

(1844–1797 BC)

From Faiyum, Middle Egypt

Purchased from Maurice Nahman; acquired in 1907

A rectangular limestone raised relief from a temple door lintel. The exact provenance is unrecorded, but the piece comes either from a temple to Sobek at Medinet el-Faiyum (ancient Shedet) or from the nearby funerary temple of Amenemhat III at Hawara, famous to classical authors as the Egyptian 'Labyrinth'. The text is arranged symmetrically, with the central cartouche placed over the axis of the doorway. The text cannot be deciphered into a single sentence, since the elements are arranged according to heraldic rather than linguistic principles.

In the centre, the right-facing cartouche of Amenemhat III rests on the sign for gold; this is flanked by the name of the god 'Horus who is in Shedet', which is written similarly to the Horus name of the king, with a falcon ('Horus') perched on a enclosure including a sacred building associated with Shedet. Flanking this are the royal epithets 'given life and stability'. Next is the name of the god, 'Sobek, the Shedetite' (cf. cat. 15), facing vertical lines of text which originally ran down the sides of the doorway (now lost), and contained the titles of Amenemhat III:

Dual King, Lord of the Two Lands, Lord of [Ritual] Action [. . .

The names of the gods face that of the king, forming a graphic version of scenes where the king worships, or is embraced by, the gods who give him life and power. The right end is restored.

BIBLIOGRAPHY: PM IV, 101; H.R. Hall *Hieroglyphic Texts* 4 (London, 1913), pl. 15; Ingrid Blom, 'Sculpture fragments and relief fragments from the Labyrinth at Hawara in the Rijksmuseum van Oudheden, Leiden', *OMRO* 69 (1989), 25–50, esp. 40; R. Krauss and C.E. Loeben, 'Die Berliner "Zierinschrift" Amenemhets III. als Beispiel für gebrochene Symmetrie', *Jahrbuch Preussischer Kulturbesitz* 33 (1996), 159–72, esp. 170 n. 4; cf. H. Schäfer, *Principles of Egyptian Art*, trans. J. Baines (Oxford, 1974 [1st edn, German, 1919]), 352–5, pl. 36 for similar piece.

36 Funerary stela of Senitef

EA 576

H. 66 cm, W. 42 cm, D. 6.2 cm

12th Dynasty, temp. Amenemhat II

(1929–1892 BC) or later

Provenance and acquisition details unrecorded

A limestone Middle Kingdom funerary stela, in sunk relief, probably from the necropolis at Abydos. The stela exemplifies the orientation of hieroglyphic text in relation to the scene that it accompanies. The top horizontal line describes the dedicator of the stela in Middle Egyptian, reading from right to left, and continuing down the left side of the scene in a vertical line:

> The Blessed One before the Foremost of Westerners, the Lord of Abydos, the Chamberlain Senitef, born of Rehutankh true-of-voice

The text, still reading right to left, continues above the scene which shows offerings being made to a royal statue, which also faces right. This gives a brief autobiographical statement:

> he says: 'I was one who controlled the First Mansion (= the cult-chapel) of the Person of the Dual King: Nubkaure.'

> Unusually, there is no figure of Senitef receiving offerings on the stela, but he is represented by a scene of other individuals fulfilling his cultic role. The final words of his speech, comprising Amenemhat II's throne name, Nubkaure, are cleverly aligned so that they also form a caption identifying the royal statue in the scene. The two figures facing the statue are labelled as:

> His brother whom he loves, Hetepi born of Rehutankh

and

> his brother whom he loves, Senbebu true-of-voice.

These hieroglyphs face the same direction as their figures, as does the caption describing their actions:

> Bringing choice cuts of meat.

> Below the scene is a row of Senitef's relatives, who face in the same direction as the

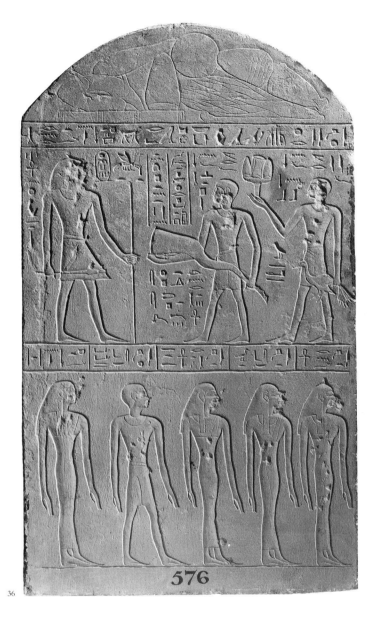

36

statue. Their names are written in a horizontal line above them, subdivided into sections:

> The Blessed One Renefankh. The Blessed One Satsebek. The Blessed One Rehutankh true-of-voice (his mother). The Blessed One Dedsebek true-of-voice. His wife Seni true-of-voice.

The lunette at the top of stelae with royal figures is often occupied by a protective winged sun-disk, but here it is occupied by a pile of offerings, representing Senitef's duty and his hope for recompense; a large circular loaf is wittily placed in the position usually occupied by the sun-disk and other heraldic devices.

BIBLIOGRAPHY: P.D. Scott-Moncrieff *et al.*, *Hieroglyphic Texts* 2 (London, 1912), pl. 10; discussed in: H.G. Fischer, 'Offering stands from the pyramid of Amenemhet I', *Metropolitan Museum Journal* 7 (1973), 123–6.

37 Block statue of Teti

EA 888

H. 59 cm, W. 27 cm, D. 39 cm

18th Dynasty, temp. Tuthmosis III (1479–1425 BC)

From Karnak

Purchased from Mohamed Mohassib;
acquired in 1909

A red quartzite block statue of Teti, Viceroy of Kush. The statue is finely carved, and the features of the squatting body and the plinth are modelled, in contrast with more schematically modelled styles of block statue. Teti is dressed in a leopard skin, whose tail falls over the plinth beside his right foot, and wears sandals. Around his neck he wears a pendant formed of the *ankh* (life) sign and the *hetep* ('peace') sign, which can be read '*nḫ ḥtp* ('Life and peace!'). On his upper arm is inscribed the cartouche of his sovereign, Tuthmosis III; this does not represent a tattoo, but is a graphic declaration of loyalty first attested in this period (cf. cat. 46). He holds a lotus flower in his left hand. Emblematic hieroglyphs are inscribed on his hands: on the left hand are signs showing the red crown of Lower Egypt and the moon, and on the right hand signs showing the white crown of Upper Egypt and the sun. These combine to suggest that the kingship of Tuthmosis is synonymous with all that the sun and moon encircle.

Two horizontal lines and nine vertical lines of Middle Egyptian hieroglyphic text are carved at the front, and one horizontal line and three vertical lines on the back pillar; all read right to left. The horizontal text at the top of the front reads:

An offering which the King gives to Amun[-Re and] Re-Horakhty, that they may give beatification, power, justification, joy and fair blessedness.

Each vertical line then begins 'to the spirit of', with a series of titles; each line ends with 'Teti true-of-voice' at the bottom (with slight variations in the name: ll. 7–9 read 'Tetity'). The bottom horizontal line gives the name of the person who probably dedicated the statue:

His son, the Scribe of Divine Offerings, Hori, born of the Lady of the House, Mutnesut.

On the back the horizontal line reads:

The King's Scribe, Chief Lector Priest and Craftsman (? a 'cryptographic' sign), Teti.

Under this are three vertical lines (reading right to left) giving his filiation, arranged so that each line's top and bottom have the same signs:

Son of the Scribe of the Divine Offerings of Amun, Ahmes Petjena true-of-voice;

son of the King's Son and Overseer of Southern Foreign Lands, Ahmes Turo true-of-voice;

37 (detail)

son of the King's Son and Overseer of Southern Foreign Lands, Ahmes Sataiit true-of-voice.

As this genealogy makes clear, in this period the title 'King's Son' was awarded to people who were not children of the king. The statue was placed in a chapel in the temple enclosure at Karnak.[41]

BIBLIOGRAPHY: PM II², 279; H.R. Hall *Hieroglyphic Texts* 5 (London, 1914), pl. 25; L. Habachi, 'The first two viceroys of Kush and their family', *Kush* 7 (1959), 44–62; J. Vandier, *Manuel d'archéologie égyptienne* 3 (Paris, 1958), 456–7; H.G. Fischer, 'More emblematic uses from ancient Egypt', *Metropolitan Museum Journal* 11 (1976), 125–8; R. Schulz, *Die Entwicklung und Bedeutung des kuboiden Statuentypus: eine Untersuchung zu den sogenannten 'Würfelhockern'*, HÄB 33 (Hildesheim, 1992), no. 218.

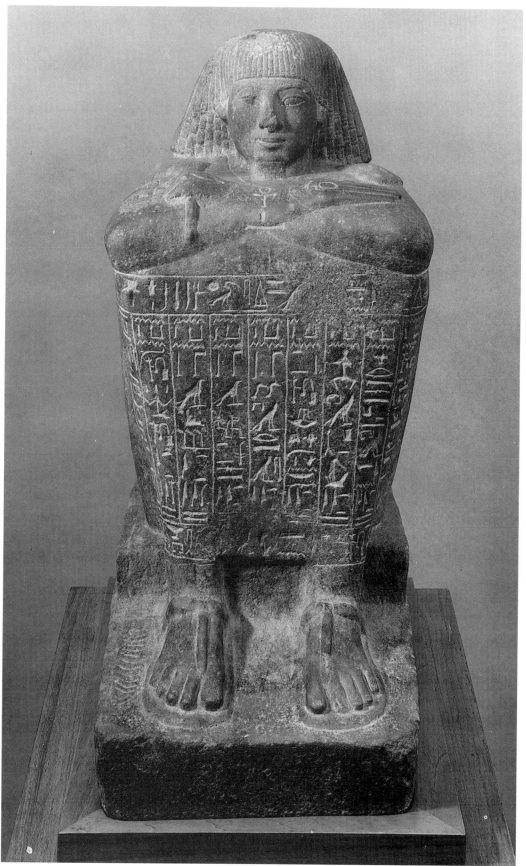

37 (the base is modern)

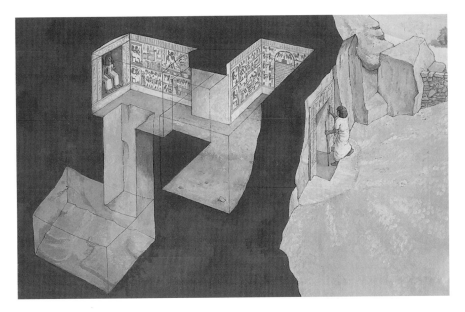

Fig. 40 A reconstruction drawing of
the lost tomb of Nebamen on the West Bank at
Thebes; based on the research of L. Manniche.
By R.B. Parkinson.

38 Paintings from the tomb chapel of Nebamen (pls 21–2)

EA 37976,8

Eleven large fragments from the tomb chapel of the Scribe and Counter of Grain, Nebamen, are in the British Museum, which can be dated on art historical grounds to the 18th Dynasty, temp. of Tuthmosis IV and Amenhotep III (*c.* 1390 BC); ten of the eleven fragments were purchased from Henry Salt, having arrived in England in 1821. The exact location of the magnificently decorated tomb on the west bank at Thebes is now lost, but Lise Manniche has proposed that these two scenes were part of a single wall to the right of the tomb entrance, showing produce being brought before a figure of the tomb owner (fig. 40).

EA 37976: H. 58.5 cm, W. 106 cm
EA 37978: H. 71 cm, W. 117.8 cm

The fragmentary top register shows workers standing in front of a gaggle of geese and presenting a basket of eggs to two seated scribes, who record the produce. In the lower register workers come with a flock of geese, and a man presents birds in baskets. A scribe stands reading out the list of produce to a large seated figure of the tomb owner, towards whom both upper registers were oriented (EA 37979; not displayed). The painted hieroglyphic texts face the same way as the people who speak what is written. The texts are not quite written in classical Middle Egyptian like the formal texts in the tomb chapel, but they are still very remote from what such workers would actually have spoken.

In the lower register the man bending forward and holding a stick speaks to the men squatting in front of him:

Sit, and don't talk!

The man who is herding the gaggle of geese tells the man in front of him:

Do not hurry your feet, carrying these
geese – until you hear for yourself. You
don't know (if there will be) another
chance for what you will say!

This seems to be a sarcastic comment that he should not be too eager, and wait until he is summoned: he must not misuse his opportunity to speak to the master. Above the man with the basket of birds is a sarcastic reply:

You too should take your time, take your
time! [. . .] You are conducting the Young
Troops [of . . .]

The man's supposed 'Troops' are the geese.

The cattle scene is also divided into two registers. It probably occupied the lower half of the same wall as the goose count, although the hieroglyphs in the two fragments are painted in different colours (black and blue). In the upper register a herd of cattle is brought to Nebamen; in front of the cattle the herdsmen bow down to a standing scribe who records the produce. The hieroglyphic caption is damaged, and only a few phrases can be read:

. . .] boasting of
. . .] an instance of what people say.

In the lower register a man drives cattle towards some seated scribes. He says to his colleague in front who is bowing to Nebamen's scribe:

Come on! Move off! Don't speak in front
of this favoured one (Nebamen). People
who talk are his horror! He does what is
true; he will not pass over any complaint.
Pass on (?) quietly, truly! He will not just
do the bidding of people – he knows
everything, does the Scribe and Counter
of Grain of [Amun] Neb[amen]!

In this passage, the name of the god Amun/Amen has been removed, presumably as part of Akhenaten's reforms when monuments had the divine names of the old regime erased (cf. cat. 40, 41, 54). The tomb chapel must thus have been accessible during his reign.

BIBLIOGRAPHY: PM I.2², 817–18; L. Manniche, *Lost Tombs: A Study of Certain Eighteenth Dynasty Monuments in the Theban Necropolis*, Studies in Egyptology (London and New York, 1988), 136–57, esp. 144–5.

38a

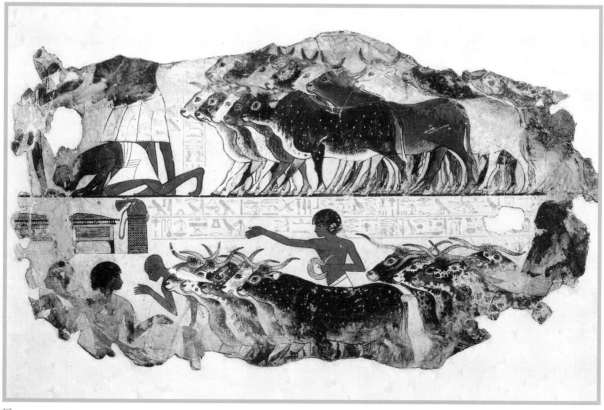

38b

39 Statue of Amenmes

EA 137

H. 49 cm, W. 22 cm, D. 33.5 cm

19th Dynasty, temp. Ramses II (1290–1224 BC)

Provenance unrecorded, perhaps from Upper Egypt

Donated by King George III, acquired in 1802

This was one of the antiquities acquired from the French together with the Rosetta Stone. It is a granite figure of the King's Scribe Amenmes, clad in a long garment, kneeling and holding a cultic object, now lost. Amenmes was buried in Theban Tomb 373; a bust of his mother is also in the British Museum (EA 1198). He dedicated several other statues in various temples, which he may have been able to do because of his position as a temple inspector. This statue, however, may come from his tomb. He was an important official and was devoted to the goddess Neith.

Four vertical lines of inscription run down the front of his garment on the statue; these are arranged in two pairs with their signs facing outwards, and contain funerary prayers in Middle Egyptian, reading (the first pair right to left, the second left to right):

[Neith lady of Sai]s – may she give a
good lifetime joined with health; may I
join the earth in peace on the west of
Thebes, all my limbs whole, well and
prosperous;
for the spirit of the King's Scribe
Amenmes, begotten of Inyt.
[. . .] Lord of the Two Great Plumes, that
he may let me follow his Person in the
daytime to see [his] beauty without
ceasing;
for the spirit of the King's Scribe
Amenmes, son of the Dignitary Pendjerti.
The three vertical lines on the back pillar of the statue contain funerary prayers, reading (right to left):

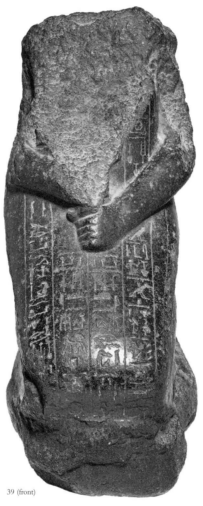

39 (front)

39 (back)

. . .] with the King's Scribe Amenmes, son
of the Dignitary Pendjerti; to him
belongs the worm, your corpse
. . .] the King's Scribe Amenmes, begotten
of Inyt, weeping for him who is in the
Otherworld.
. . .] sad for him who is against him,
Amenmes, son of Pendjerti of Esna,
whose mother was Inyt.

BIBLIOGRAPHY: T.G.H. James, *Hieroglyphic Texts* 9 (London, 1970), pl. 45.2; L. Habachi, 'The royal scribe Amenmose, son of Penzerti and Mutemonet: his monuments in Egypt and abroad', in J. Johnson and E. Wente (eds), *Studies in Honor of George R. Hughes* (Chicago, 1977), 83–103, esp. 90.

40 Statue with a stela

EA 24430

H. 26 cm, W. 11.5 cm, D. 18 cm

Late 18th Dynasty, temp. Amenhotep III

(1391–1353 BC)

Purchased from Revd Chauncey Murch;
acquired in 1891.

Limestone kneeling stelophorous male figure,
with remains of red and black paint on the
figure. On the stela is carved a short Middle
Egyptian hymn to the sun-god (one of those
now designated Spell 15 of the funerary
Book of the Dead), in eight lines of incised
hieroglyphs, beneath two *wedjat* eyes flank-
ing a *shen* sign, a cup and three lines of
water. The eyes in this emblematic group are
symbolic of wholeness; the *shen* sign (◯)
represents the totality of the sun's circuit; the
vase and water (≋) are suggestive of the
libations desired by the dedicator. It may be
possible to read the group more literally, as a
wish for the deceased to 'see' (written with
two eyes) the solar cycle and the water.[42] An
offering table is carved on top of the stela.
The hieroglyphs are unpainted. The dedica-
tor's name has been erased, presumably
because it contained the name of the god
Amun, and was removed in the reign of
Akhenaten as part of that king's religious
reforms (cf. cat. 38, 41 and 54); the statue
can be dated to the immediately preceding
reign from its style. The hymn on the stela
forms a speech of the figure and reads (right
to left):

> Praising Re when he rises, until it happens
> that he sets in life, by the cup-bearer [. . .],
> he says: 'Hail to you Re at your rising,
> Atum at your perfect setting. I shall give
> you adorations at your perfect setting.
> Exalted be Re in the Solar Day-barque,
> who rises in the eastern horizon, who sets
> in the west, who fells <his> enemy.'

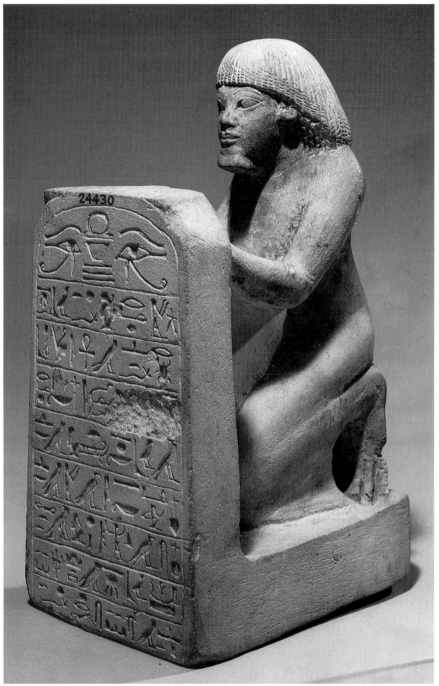

40

The statue was probably placed in the owner's
tomb, possibly in a niche in a pyramidion
above the tomb chapel, where it would face
the rising sun. In earlier statues of this type, the
text is is inscribed directly on the area between
the worshipper's hands and on his kilt.

BIBLIOGRAPHY: I.E.S. Edwards, *Hieroglyphic Texts* 8
(London, 1939), pl. 32; J. Vandier, *Manuel
d'archéologie égyptienne* 3 (Paris, 1958), 471–4, esp.
2; W. Seipel, *Gott Mensch Pharao* (Vienna, 1992),
no. 124; cf. H.M. Stewart, 'Stelophorous statuettes
in the British Museum', *JEA* 53 (1967), 34–8.

41 The shrine-stela of Ineny

EA 467

H. 49 cm, W. 24 cm, D. 25.5 cm

Late 18th Dynasty

From Thebes

Purchased from Giovanni Anastasi;

acquired in 1839

A limestone shrine-stela of Ineny with a pyramidion, presumably from his tomb. On each side is a recess, similar to niches in large New Kingdom pyramidions in which stelophorous statues such as cat. 40 were placed. In each recess is a reduced version of such a statue, abbreviated to a stela with the face and hands of the worshipper above it. As with cat. 40, the name of the god Amun has been erased, presumably during the Amarna Period. Each niche is framed by symmetrically arranged lines of incised hieroglyphs recording the traditional offering formula. The hieroglyphs are noticeably more tightly spaced at the end of each line, as if the carver had misjudged the space available. On one face the text on the right side reads (left to right):

> An offering which the King gives to Re-Horakhty who crosses the heaven in peace, so that he may let the sun-disk to be seen each day by the Porter of [Amun], Ineny.

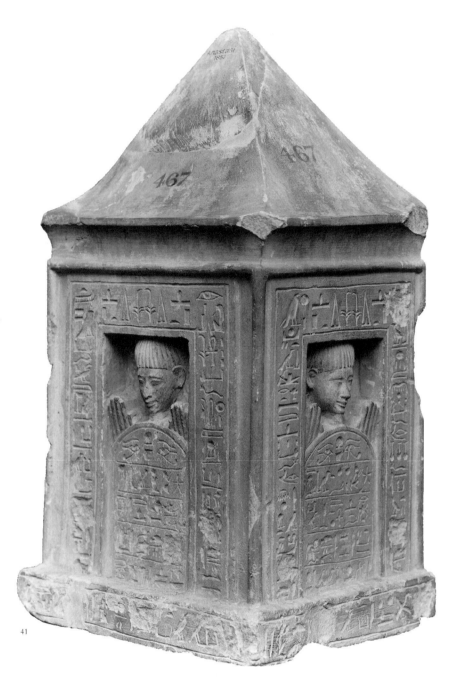

41

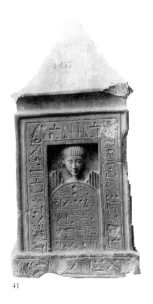

41

The text on the left side reads (right to left):

> An offering which the King gives to [Amun-Re] who shines in gold that he may let his perfection be seen by the Porter of [Amun] Ineny

The text on the stela itself is inscribed in four lines of incised hieroglyphs, presenting a summary of Ineny's hymn (right to left):

> Praising Re when he rises, until it happens that he sets in life, by the Porter of [Amun] Ineny. He says: 'Hail to you: how beautiful is your rising!'

On the plinth is a horizontal line reading:

> . . .] Primeval one of the Two Lands, by the Por[ter of Amun], Ineny true-of-voice.

BIBLIOGRAPHY: H.R. Hall *Hieroglyphic Texts* 7 (London, 1925), pls 1–4; E. Brovarski, 'The singer with the glorious harp of Amen, Amenemheb Mehu', *Serapis* 6 (1980), 31 n. 10; M. Dewachter, 'Les "premiers fils royaux d'Amon" compléments et remarques', *RdE* 35 (1984), 88 n. 34.

LITERACY AND THE SOCIAL POWER OF WRITING

Modern attempts to calculate a figure for the extent of full literacy in ancient Egypt have produced figures of around 1%;[43] this figure has been much disputed on the basis of the vast quantities of texts found at Deir el-Medina (see cat. 68–73) and el-Lahun, but these may have been exceptional sites, both being state foundations. Such arguments may also reflect the modern feeling that sophisticated people and civilizations must be fully literate; yet some civilizations, such as that of India, give primacy to oral transmission. In Egypt writing implied cultural centrality: an inscription of Ramses IV (1163–1156 BC) at Abydos describes a matter proudly as 'in writing, and not from mouth to mouth'.[44] Moreover, full literacy is not the whole picture: some people could have read but not written, and many more would have been able to read or write a limited amount of information, or limited types of text. The extent of full literacy among women is very uncertain, but was probably extremely restricted.

Depictions of scribes in tombs and descriptions of them in literary texts give the impression of an Egypt run by a very prestigious bureaucratic sub-elite. Such a favourable image is not surprising since the literary texts were composed among that sub-elite, but it nevertheless probably reflects a social reality. In the Old Kingdom, elite tomb owners were depicted in statues as scribes writing, as if acting as a scribe to the king or gods, a position that is invoked in funerary texts. But although literacy was a prerequisite to office, they were of too high a status to have acted as scribes in real life, and their role is a symbolic lowly travesty. Scribal equipment, and sometimes even manuscripts (regardless of their content), were placed in tombs to display the literacy, and thus prestige, of the tomb owner. Statues showing an official as a scribe were also later dedicated in temples, where they could act both as intermediaries to the gods and secure their owner's perpetual participation in the cult. Unlike in Mesopotamia, kings were portrayed as being literate.

42 Wooden funerary model of a granary (pl. 23)

EA 41573

H. 21 cm, W. 30 cm, D. 35.8 cm

Middle Kingdom

From Beni Hasan, Tomb 723

Purchased from Frederick George Hilton Price; excavated by John Garstang; acquired in 1905

A model made of painted wood and grain, comprising a granary and five figures, from the tomb of the official Sebekhotep (see fig. 41). The model building has a doorway painted red and yellow; a ladder leads between two levels (its original position is not certain). The granary is filled with grain and juniper berries. Workmen on the lower level handle grain, one of them carrying a sack. A scribe sits on the upper level recording on a writing board the amounts of grain being stored or issued; a representation of his palette is painted onto the writing board beside his hand. Beside him sits a figure apparently directing the workmen below. Hieratic jottings on the walls of the granary perhaps recorded different amounts and types of grain, but are now illegible.

BIBLIOGRAPHY: R. Parkinson and S. Quirke, *Papyrus* (London, 1995), 37.

42

Fig. 41 Reconstruction drawing of the tomb of Sebekhotep at Beni Hasan. The tomb chamber is cut into the hillside and contains a coffin decorated with two eyes and bands of hieroglyphic text. On top of the coffin are various funerary models, including two boats, the granary and a group of bread and beer makers. By C. Thorne.

43 Scribe statue of Nikheftek

EA 29562

H. 35 cm, W. 33 cm, D. 23 cm

Late 5th Dynasty

From Dishasha

Donated by the Egypt Exploration Fund;
acquired in 1897

A painted limestone statue showing the official Nikheftek as a scribe, sitting cross-legged with a papyrus unrolled on his lap. There are remains of red paint on the body; the head is lost, and part of the left shoulder has been detached, apparently in an ancient repair to make good a faulty area of stone. The areas of 'negative space' under the arms are painted black. On the roll is a damaged line of hieroglyphs, written for the statue, and not the viewer, to read (right to left):

> The King's Acquaintance, the Overseer of [Commissioning, . . . Ni]kheftek.

This is one of a series of at least five statues of Nikheftek found by Flinders Petrie in the serdab chamber of his father's mastaba at Dishasha; Nikheftek himself was buried near by. The British Museum also contains one of the statues of his father, Nikheftka (EA 1239), from the same chamber. The statues show evidence of deliberate breakage (see cat. 53–5).

BIBLIOGRAPHY: PM IV, 123; W.M.F. Petrie, *Deshasheh 1897*, MEEF 15 (London, 1898), 13(c), pl. 33.30.

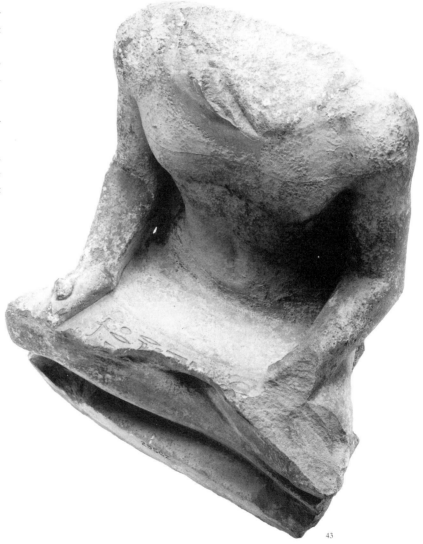

43

44 Wooden scribe

EA 2331

H. 10.24 cm, W. 7 cm, D. 5.41 cm

Late 18th Dynasty

Provenance and acquisition details unrecorded

A wooden figure of a scribe squatting cross-legged; much of the leg area is lost. The scribe is writing with his right hand on a roll stretched out over his leg. Rolls of fat are indicated on his abdomen, signifying the prosperity his office has brought him. The figure is finely carved, although rather worn and abraded. It may originally have been part of a small group statue showing the dedicator acting as a scribe in front of the baboon of Thoth, seated on a pedestal.

BIBLIOGRAPHY: H.R. Hall, 'Some wooden figures of the eighteenth and nineteenth Dynasties in the British Museum. Part II', *JEA* 16 (1930), 40, pl. 14.1–2; J. Vandier, *Manuel d'archéologie égyptienne* 3 (Paris, 1958), 448.

44

45 Pottery scribe

EA 24653

H. 15.3 cm, W. 9.3 cm, D. 10 cm

New Kingdom, 18th Dynasty(?)

Provenance unrecorded

Purchased from R.J. Moss and Co.;

acquired in 1893

A terracotta flask in the form of a squatting scribe, with a papyrus unrolled over his lap. Black paint decorates the wig and the eyes. He is writing with his right hand, while his left originally held the papyrus roll. The figure is largely hollow, but it seems not to have acted as a container for ink, as the scribal shape might suggest. Instead it belongs to a type of decorative vessel shaped into figures of servants, most often women nursing children. This example is unparalleled.

BIBLIOGRAPHY: E.A.W. Budge, *The Mummy* (Cambridge, 1925 [2nd edn]), pl. 27. In general see J. Bourriau, 'Pottery figure vases of the New Kingdom', *Cahiers de la céramique égyptienne* I (1987), 81–96.

45

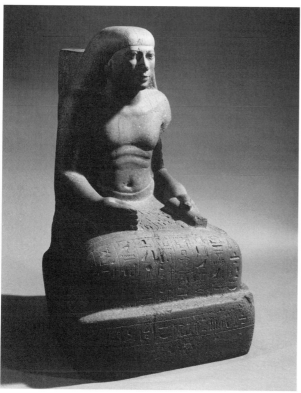

46

46 Scribal statue of Pesshuper

EA 1514

H. 54.9 cm, W. 33 cm, D. 37 cm

25th Dynasty, temp. Piye (750–712 BC)

From Karnak, Thebes

Purchased from Mohamed Mohassib;
acquired in 1911

A red quartzite statue of the Theban high official Pesshuper as a scribe. Hieroglyphic texts are incised on the plinth, on the papyrus roll on Pesshuper's lap, and on the back pillar of the statue. Pesshuper's left arm, which holds the roll, is damaged. On his knee is a shell-shaped container with inkwells, and over his left shoulder is slung the hieroglyph representing scribal equipment.

On the roll the traditional funerary invocation is inscribed in vertical lines so as to be read by the statue, not the spectator. It reads from right to left:

> An offering which the King gives to Osiris Lord of Restau, that you (*sic*) may let there be received presents of good things and of offerings of the Field of Reeds for the spirit of the scribe and Chamberlain of the God's Wife, Pesshuper.

On the right arm is written the cartouche of his patroness,

(The Divine Adoratrice Amenirdis)|

Further funerary invocations are written on his kilt in eight vertical lines (reading right to left), and around the plinth, in a single horizontal line. Three more vertical lines (right to left) are inscribed on the back pillar.

The statue probably came, like others of this official, from a chapel in the temple enclosure of Karnak (as did cat. 37), and may have been modelled on earlier statues of the sage Amenhotep son of Hapu (cf. cat. 51). It represents him with two rolls of fat in his abdomen, a sign of his prosperity.

BIBLIOGRAPHY: PM II², 279; J. Leclant, *Enquêtes sur les sacerdoces et les sanctuaires égyptiens à l'époque dite 'éthiopienne' (XXVᵉ dynastie)* (Cairo, 1954), 78–83; cf. E. Graefe, *Untersuchungen zur Zerwaltung und Geschichte der Institution der Gottesgemahlinnen des Amun vom Beginn des Neuen Reiches bis zur Spätzeit*, ÄA 37 (Wiesbaden, 1981) I, 85–6.

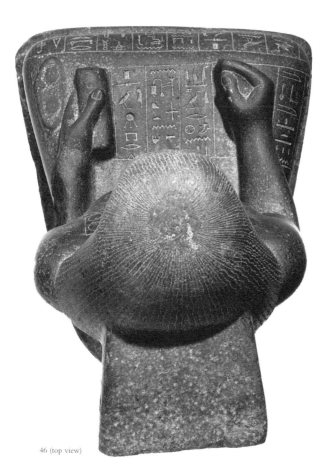

46 (top view)

THE GODS AND SAINTS OF WRITING

Thoth, the lord of Hermopolis, was the major deity of writing. Scribes seem to have owned figures of him in the form of a baboon (see cat. 49), and, in one Ramesside representation of a scribal office, baboon statues are shown on pedestals with offerings in front of them.[45] Thoth was usually represented in human form with an ibis head and a lunar disk on his head, or as a baboon. As a lunar god he was associated with dates and the measurement of time, and thus was an embodiment of the roles of writing in society. A hymn in Middle Egyptian inscribed on a scribal statue of General Horemheb records the cultural powers of writing as a series of epithets extolling the god:

> Who knows the mysteries, and sets the gods' utterances firm,
> who distinguishes a legal report from its fellow . . .
> he cannot forget yesterday's report . . .
> A vizier who judges matters,
> who calms tumult peacefully.
> A scribe of the mat, who establishes the roll,
> who attacks wrong, who receives what is under
> the shoulder (the scribal palette?)
> sound of arm, wise within the Company of gods,
> who proclaims all that is forgotten,
> intelligent for him who errs,
> who remembers the moment and the ends of time,
> who reports the hours of the night,
> whose words last for all time,
> who enters the Underworld, and knows who is in it,
> and records them in a list.[46]

Fig. 42 Temple relief from the 11th Dynasty temple of Montuhotep at Deir el-Bahri. The scene shows the upper part of a female figure below a row of stars on a heaven sign (⚊), which acts as a top border to the scene. The three vertical lines of hieroglyphs (reading left to right) describe a figure of Seshat (now lost) as 'Foremost of the House of the Book, Lady of Hieroglyphs, Lady of Writings'. H. 56 cm. EA 1542.

Another deity related to writing was Seshat (see cat. 48, fig. 42), a goddess who is known to have personified it from the late Old Kingdom onwards, although she is attested from earlier in other roles. She is associated with the recording of royal deeds, such as recording tribute or the length of years granted to a king by the gods; she also lays out foundation plans of temples together with the king. Thoth and Seshat are sometimes accompanied by personifications of the faculties of 'Seeing' and 'Hearing' in temple reliefs; for example, in a Ptolemaic relief in the temple of Edfu a scribal palette is surrounded by divine figures of Utterance, Perception, Seeing and Hearing.[47]

Beside these divinities, there was also a group of deified culture heroes, such as the high officials Amenhotep son of Hapu, the King's Scribe and Scribe of Elite Troops of Amenhotep III (1391–1353 BC), and Imhotep, the Vizier of Djoser (2630–2611 BC). These two were associated especially with written wisdom; their cults flourished in the Ptolemaic Period, when both were associated with the Greek god of healing Asclepius. Other more minor deified officials included the Vizier Ptahhotep of the 5th Dynasty, who had a short-lived cult around his tomb and featured as the culture hero protagonist in a later literary wisdom text, *The Teaching of the Lord Vizier Ptahhotep*.[48] These heroes and divinities permeated all aspects of scribal life, from official cultic activity to idle doodles.

47

47 P. Lansing: a scribal manuscript

EA 9994.7
H. 20.6 cm; W. 45.3 cm
Late 20th Dynasty
From Thebes (on internal evidence)
Purchased from Revd Gulian Lansing;
acquired in 1886

P. Lansing is a 'Letter-Teaching made by the King's Scribe, Overseer of the Cattle of Amun-Re King of the Gods, Nebmaatre-nakht, for his apprentice the scribe Wenem-diamen' which the apprentice copied in fifteen columns of literary hieratic. It is a New Egyptian 'Miscellany', or anthology of texts, praising the profession of the scribe, and it includes praises of Wenmediamen's teacher. On this section of the manuscript, at the end of the verso, the apprentice drew calligraphic sketches of Thoth shown both as a baboon with a lunar disk, holding scribal equipment in his paw, and as a figure with an ibis head, wearing a lunar disk, and with an elongated *ankh* sign in front of him. Elsewhere on this section there are palimpsest traces of jottings and doodles by Wenmediamen.

BIBLIOGRAPHY: E.A.W. Budge, *Egyptian Hieratic Papyri in the British Museum*, Second Series (London, 1923), pls 15–30; A.H. Gardiner, *Late Egyptian Miscellanies*, BAe 7 (Brussels, 1937), xviii, 99–116; R.A. Caminos, *Late Egyptian Miscellanies* (London, 1954), 373–428; M. Lichtheim, *Ancient Egyptian Literature: A Book of Readings*, II: *The New Kingdom* (Berkeley, 1974), 168–75.

48 Scribal palette showing the goddess Seshat

EA 54829
H. 7 cm, W. 7.2 cm, D. 2 cm
Late Period
Provenance unrecorded
Donated by Walter Llewellyn Nash (Trustees of);
acquired in 1920

Part of a limestone funerary scribal palette (cf. cat. 60). At the top are the remains of an inkwell; the slot for pens, which contains traces of red paint, is partly preserved. No inscription survives, but a figure of Seshat is incised on the right side of the upper surface. The goddess holds a papyrus staff and has on her head her usual insignia of a rosette surmounted by upside-down horns, of uncertain significance.

BIBLIOGRAPHY: hitherto unpublished.

48

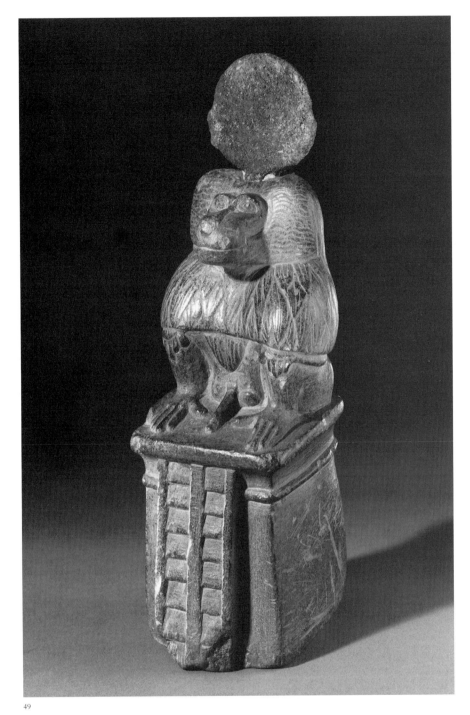

49

50 Statue of Huy holding a baboon

EA 13355

H. 17.2 cm, W. 9 cm, D. 10.3 cm

Ramesside Period

Provenance unrecorded

Purchased from Revd Greville J. Chester;
acquired in 1881

The lower half of a grey steatite kneeling figure carrying a figure of a baboon on a pedestal. Statues of this type were probably placed in temples, perhaps with royal permission. The upper body of the main figure and the baboon's headdress are lost. On the back pillar a single right-facing vertical line of incised hieroglyphs reads:

> . . .] his [Person(?)] l.p.h., a favour to the King's Scribe, the Overseer of Elite Troops Huy true-of-voice.

BIBLIOGRAPHY: hitherto unpublished.

49 Statuette of the baboon of Thoth

EA 35401

H. 18 cm, W. 5.64 cm, D. 8.03 cm

Ramesside Period(?)

Provenance unrecorded

Purchased from R.J. Moss and Co. (Alexandria);
acquired in 1901

A steatite baboon, seated on a high pedestal with a double flight of steps. The pedestal has a curved back. The baboon sits with his paws on his knees; on his head is a lunar disk in bronze, now somewhat corroded. It is uncertain whether this type of statue comes from a funerary or state temple context, or was made for the private cultic activity of a scribe.

BIBLIOGRAPHY: hitherto unpublished.

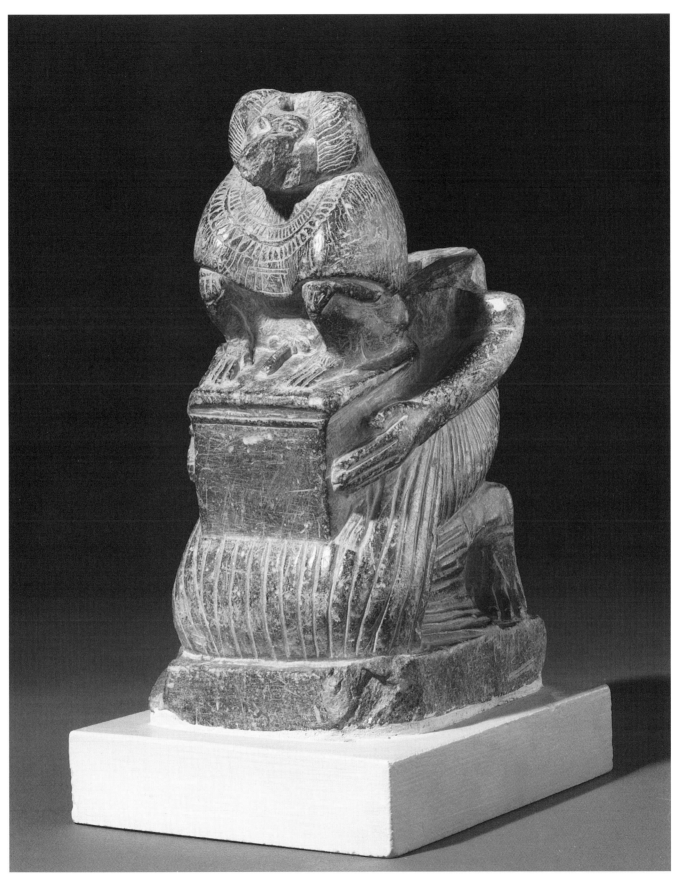

50 (the base is modern)

51 Scribal statue of Amenhotep son of Hapu

EA 103

H. 33 cm, W. 55 cm, D. 60 cm

18th Dynasty, temp. Amenhotep III

(1391–1353 BC)

From Karnak, Thebes

Acquisition details unrecorded

A black grano-diorite statue of Amenhotep son of Hapu as a scribe. Hieroglyphic texts are inscribed on the papyrus unrolled on his lap and on the statue plinth. His right hand, now broken, held a pen, as if writing, while his left hand holds the papyrus roll. On his left knee sits an ink container, with two cakes of ink.

The inscriptions indicate that this is one of a series of statues given by the king and placed in the temple at Karnak (others are in the Egyptian Museum, Cairo, and the Luxor Museum). In style the statue is modelled on Middle Kingdom forerunners. The statue acted as an intermediary between worshippers and the god: on another statue Amenhotep calls himself the 'herald of the god Amun'. The Middle Egyptian text on the papyrus roll is written in vertical lines as if to be read by Amenhotep himself rather than by the actual reader standing in front of the statue. The text reads (right to left):

> Placed as a favour of the king in the temple of Amun in Ipetsut for the Prince and Count, Chief of Upper and Lower Egypt, Great of Favours from his Person, the King's Scribe, Scribe of the Elite Troops, Steward of the King's Eldest Daughter, Amenhotep true-of-voice; he says: 'I have come to you, lord of the gods, Amun Lord of [the Thrones of the] Two Lands . . .

On the top of the plinth is carved a wish (reading right to left) to be read by the viewer:

> Satisfaction with the daily provisions at the festivals of A{n}mun in Ipetsut, for the spirit of the King's Scribe Amenhotep true-of-voice.

This wish involves wordplay, since *ḥtp* is 'to be satisfied', but also 'to offer'; this is the surface on which temple visitors could notionally place their offerings to Amenhotep. Even on this prestigious statue there is a corrected error in the carving: Anmun for Amun.

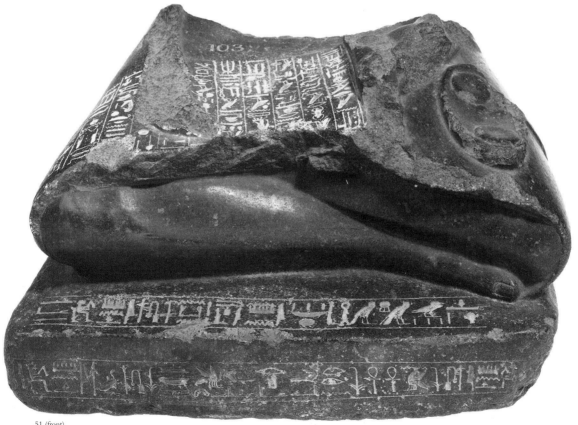

51 (front)

Around the base is a single line of inscription, formed of two texts spreading out from the initial word of both parts ('The Prince') which is written only once, and meeting in the middle at the back. These record the statue's purpose in allowing Amenhotep to partake perpetually in the god's cult at Karnak. The right-hand half of the line, running from right to left, reads:

> The Prince and Count, Seal-bearer of the King, whom the Lord of the Two Lands loves, the Standard-bearer Amenhotep true-of-voice, (corner of the pedestal) he says: I have come to see your perfection, Lord of the Gods, Atum Lord of Thebes, King of the Two Lands, so that you may place me in your temple-estate, so that I may be nourished by your spirit, you may make green my years, and I may be in your following and kiss the earth in your temple every day.

BIBLIOGRAPHY: PM II², 288; S.R.K. Glanville, 'Some notes on material for the reign of Amenophis III', *JEA* 15 (1929), 2–8, esp. 2–5; I.E.S. Edwards, *Hieroglyphic Texts* 8 (London, 1939), pl. 12; cf. A. Kozloff *et al.*, *Egypt's Dazzling Sun: Amenhotep III and his World* (Bloomington, 1992), no. 44 (similar examples); H. Sourouzian, 'La statue d'Amenhotep fils de Hapou, âgé, un chef-d'oeuvre de la XVIIIè dynastie', *MDAIK* 47 (1997), 341–55.

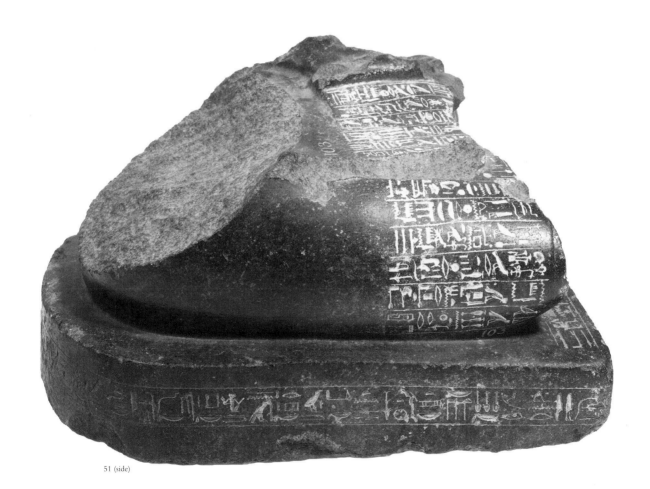

51 (side)

GOD'S WORDS

Hieroglyphs were called the 'writing of god's words', or just the 'god's words' (*mdw-nṯr*) from the Old Kingdom, a term parallel to the Greek 'hieroglyphic' ('sacred incised letters'). Thoth was the god who was believed to have invented writing, although no myth narrating its invention is preserved from the pharaonic period.[49] The term 'god's words' brings out the association between the script and the display of the gods' and the king's power, and expressed a mythical pedigree going back to the gods. Sometimes it denotes the cultural centrality of documents that were not even written in hieroglyphs. The term also presents the script as a form of language: 'words'. Speech and language were important in ritual and magic: the cosmos had been created by the utterance of the creator god. Many etiological myths explained the origin of phenomena with wordplay: for example, the creator's 'tears' (*rmjjt*) were the origin of mankind (*rmṯ*). The Memphite creation myth preserved on the Shabako Stone (EA 498) of *c.* 700 BC summarizes the creation of the world as consisting of 'everything and all god's words'. As Jan Assmann has noted, 'Writing only carries out what is already implicit in the structure of reality. The Egyptians interpreted the visible world as a kind of infinitely ongoing series production which very faithfully follows an original finite set of types or models. And this same set is also represented by the hieroglyphic system.'[50] The signs themselves thus can have a numinous power: in the 4th Dynasty tomb of Nefermaat and Itet at Medum, Nefermaat describes himself as 'one who fashions his gods in writing which does not rub off', implying that the signs themselves are 'gods'.[51]

Hieroglyphic signs could also act as emblems and amulets. The animal-headed *was* staff shown in the hands of gods was a symbol of might, and the sign showing the staff (𓌂) wrote the phonemes *w3s* ('power'). The object and sign also occur as an iconographic emblem and as an amulet of power that could be worn. In certain contexts, usually in relief, the staff itself has hands and arms. The staff is also represented in three dimensions, as in the glazed composition example (pl. 24), some 216 cm high, decorated with the titulary of Amenhotep II, which Flinders Petrie discovered in a chamber of the temple of Seth at Tukh (ancient Nubt).[52]

The numinous power of writing can also be seen in stelae inscribed with magical texts that were designed to have water poured over them and then drunk to ingest protection of the texts. Amulets in the shape of writing boards, many of which are uninscribed, were another way of appropriating the power of text. Texts could have the same power in cursive script as in hieroglyphs, as in the case of the scribe Qenherkhepshef (cat. 68–70), who had an amulet of a small sheet of papyrus with a hieratic spell against a demon of nightmares called Sehaqeq. This was folded up, tied with a string, and presumably worn (fig. 43).

Fig. 43 The papyrus charm of Qenherkhepshef, written in his distinctive hieratic hand. The sheet is rather worn from having been folded. The text reads, 'You will go back, Sehaqeq, who came forth from heaven and earth, whose eyes are in his head, whose tongue is in his backside; who eats faeces …'. H. 18.9 cm. EA 10731.

52 Heart-scarab of Iuy

EA 7925

H. 9.5 cm, W. 4.1 cm, D. 2.7 cm

New Kingdom

From Thebes

Purchased from Henry Salt; acquired in 1835

A green feldspar 'heart-scarab', to be placed on the mummy as its heart. On the underside is a funerary spell in Middle Egyptian that conjures the deceased's heart to 'not stand up against me as a witness' (ll. 3–4) when he/she is judged after death. This could be written on an amulet shaped like the heart, but the scarab is attested from the 13th Dynasty on as a symbolic representation of the heart. In this case, a scarab sits upon a base formed from the hieroglyph for 'heart' (♡); the amulet is thus formed of two complementary signs.

The twelve right-facing horizontal lines of hieroglyphic text on the underside were first carved leaving a blank space for the name: later the name of the lady Iuy was added in a less accomplished manner than the rest of the inscription, when she or her heirs acquired the scarab (l. 1). On the front of the scarab's body are four right-facing lines of additional prayers, and on the heart-shaped base is a row of decorative and emblematic hieroglyphs: the *djed* pillar, writing 'stability', and associated with Osiris, is flanked by the sign for 'life' and by the amuletic 'Isis knot' (which does not have a regular reading as a specific word). The amulet is pierced by two transverse drilled holes for attachment to the mummy.

BIBLIOGRAPHY: C. Andrews, *Amulets of Ancient Egypt* (London, 1994), fig. 56.

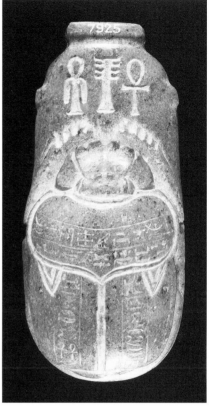

52 (front)

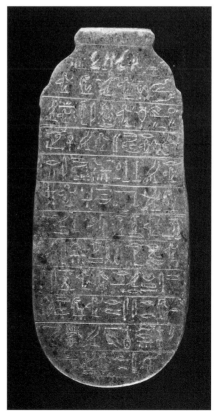

52 (back)

MUTILATED HIEROGLYPHS
AND 'DAMNATIO MEMORIAE'

The power of hieroglyphs is also manifest in measures taken to restrict their effi-
cacy. In the royal burials of the late Old Kingdom, the hieroglyphic signs of
human and animal figures in the texts on the walls were omitted or truncated in
order to lessen their potential threat to the deceased. This practice was revived in
the late Middle Kingdom, when cuts were also inserted through such signs in
some funerary contexts (see cat. 53). Another more common method was to
show dangerous animal signs transfixed with knives, as in the 19th Dynasty
funerary papyrus of Ani (EA 10470.22), where the name of the demon serpent
Apep/Apopis is written in the unlucky colour red and the determinative sign is
speared (fig. 44).

Names were particularly potent written features and were quite frequently
damaged or erased. King Akhenaten (1353–1335
BC) practised systematic erasure as part of his
religious reforms, and his own name was subse-
quently erased on the monuments and from
state records as part of the reaction to those
reforms (see also cat. 38, 40, 41, 54). This
'damnatio memoriae' is best attested in funerary
and commemorative inscriptions, but was also
carried out on papyrus records. Similar attitudes
underlie the 'execration rituals', in which figures
and vessels were inscribed with the names of the
state's enemies, and then were cursed and
destroyed. Images of people could also be a

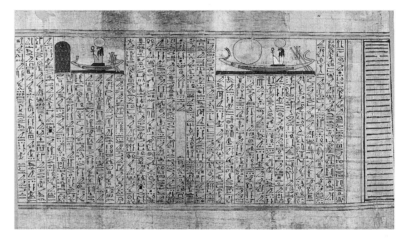

mutilated in a personal vendetta, as is expressed in the 6th Dynasty tomb of
Niankhpepy at Saqqara, where the relief is erased especially around the head of
the tomb owner in one scene, and a text is incised near by, in a cruder style than
the tomb's original inscriptions:

> You enchained me! You beat my father! Now I shall be satisfied, for what can
> you do to escape my hand? My father shall be satisfied![53]

The translation here is uncertain, but it seems clear that the graffito records the
sentiments of the person who erased the image.

A similar practice is the royal usurpation of monuments. This, however, does
not necessarily indicate any hostility, but was a practical measure to save expendi-
ture,[54] and occurs in many cultures. Nonetheless, a literary text from the 12th
Dynasty warns that it is reprehensible:

> Destroy not the monuments of another;
> you should hew stone in Tura!
> Build not your tomb chamber from ruins,
> for what is done will be what will be done![55]

Fig. 44 Detail from the 19th Dynasty funerary
papyrus of Ani, written in a fine cursive
hieroglyphic hand. The name of the demon
serpent Apep/Apopis () is written in the
unlucky colour red (fourteenth line from left);
the determinative shows a serpent lying flat with
its head curled under its body, which is transfixed
with knives drawn in black. W. of column 1.9 cm.
P. BM EA 10470.22.

53 Shabti of Renseneb

EA 49343

H. 22.6 cm, W. 6.8 cm, D. 6.4 cm

13th Dynasty, temp. Sobekhotep IV
(1730–1720 BC)

From Abydos, Tomb B13

Donated by the Egypt Exploration Fund;
acquired in 1910

Limestone shabti of the retainer Renseneb. Eight right-facing horizontal lines of blue-painted hieroglyphs are inscribed around the front of the body. The so-called 'shabti spell' is first attested on coffins of the early 12th Dynasty, and from the middle of the dynasty it is found on mummiform statuettes of the deceased ('shabtis'). The spell allows the deceased to produce a substitute for the labour duties he might be called upon to provide in the Otherworld, reflecting the actual practice of corvee labour.

This shabti is from a 13th Dynasty shaft tomb at Abydos that contained at least five burials. Blue paint survives on the wig, and black and red details on the eyes and flesh. Renseneb holds an *ankh* sign ('life') in one hand, and in the other a vase (*ḥs*) that can be read as 'favour' (see cat. 18). The hieroglyphs are mutilated: the birds and figures lack their lower parts and legs.

BIBLIOGRAPHY: T.E. Peet, *Cemeteries of Abydos 1911–1912* II, MEEF 34 (London, 1914), 57, 113, pl. 13.3; D. Franke, *Personendaten aus dem Mittleren Reich (20–16. Jahrhundert v. Chr)*, ÄA 4 (Wiesbaden, 1984), no. 241; J. Bourriau, *Pharaohs and Mortals: Egyptian Art in the Middle Kingdom* (Cambridge, 1988), no. 83.

53

54

54 Statue base from el-Amarna

EA 1000

H. 31 cm, W. 90 cm, D. 52 cm

18th Dynasty, temp. Akhenaten (1353–1335 BC)

From el-Amarna

Purchased from Selima Harris; acquired in 1875

Rectangular grey granite plinth of a royal statue discovered in a garden in Cairo; the statue, now lost, was presumably of Princess Meretaten, and was originally erected in a chapel to her at Akhenaten's royal city of Akhetaten at el-Amarna. Two lines of incised left-facing hieroglyphic text run around the sides, including the names of Akhenaten's god, the Aten ('sun-disk'), which were issued in two different formulations at different periods of the reign as programmatic statements of the king's religious reforms. They embody the dogmatic importance of names, and are placed in royal cartouches. The first is present here, dating the piece to no later than Akhenaten's Year 8.

The dedicatory inscription in formal New Egyptian also includes the cartouches of Akhenaten's queen, Nefertiti, which have been erased (erasures underlined below). The reasons for this (and the date) are uncertain, and it need not reflect Nefertiti's fall from royal favour, despite some scholars' theories. The first cartouche of the Aten open with an *ankh* sign, which can be read as 'May live . . .', but which is probably a heraldic device, and is not to be read linguistically.

> May live my father (Harakhte rejoicing in his horizon)‖ (in his name of Shu who is in the sun-disk)‖ given life for all time and eternity! The Dual King, who lives on Truth, Lord of the Two Lands: (Neferkheperure waenre)‖ given life [. . .] (Akhenaten)‖, great in his lifetime; the King's Bodily Daughter whom he loves, Meretaten, born of the Great Royal Wife (<u>Neferneferuaten Nefertiti</u>)‖ may she live for all time and eternity!

> Living Aten, great one who is in the jubilee shrine, lord of all the Aten encircles, lord of heaven, lord of earth in the Sunshade-of-Re (a solar shrine) of the King's Bodily Daughter whom he loves, Meretaten, born of the royal wife great of love, lady of the Two Lands, (<u>Neferneferuaten Nefertiti</u>)‖, may she live and be healthy for all time and eternity, in the House of Rejoicing of the Aten in the temple of the Aten in Akhetaten.

BIBLIOGRAPHY: PM IV, 70; T.E. Peet and C.L. Wooley, *City of Akhenaten* I, MEES 38 (London, 1923), 155; J.D.S. Pendlebury, *City of Akhenaten* III, MEES 44 (London, 1951), 193; G. Roeder, *Amarna-Reliefs aus Hermopolis* (Hildesheim, 1969), 352; I.E.S. Edwards *Hieroglyphic Texts* 8 (London, 1939), pl. 24; B.J. Kemp and S. Garfi, *A Survey of the Ancient City of el-'Amarna* (London, 1993), 78.

55 Temple inscription usurped by Ramses II

EA 1102

H. 97.5 cm, W. 100 cm, D. 16 cm

12th Dynasty, temp. Senwosret III
(1878–1841 BC), reinscribed in the 19th Dynasty,
temp. Ramses II (1290–1224 BC)

From Tell Basta

Donated by the Egypt Exploration Fund;
acquired in 1891

A red granite temple relief, perhaps an architectural element, inscribed with a text containing the cartouche of Ramses II directly superimposed upon an earlier (by six centuries) inscription with the cartouche of the 12th Dynasty king Senwosret III: '(Khakheperre)|'. Both are carved in sunk relief, but the later inscription is slightly larger and more crudely executed than the earlier. In this case, the usurpation is almost certainly not a sign of hostility to the earlier monarch, but done to save expenditure, since hard stone was not locally available in the Delta. The red infill is modern.

BIBLIOGRAPHY: PM IV, 30; E. Naville, *Bubastis*, MEEF 8 (London, 1891), pls 26c, 33e; M. Bierbrier, *Hieroglyphic Texts* 10 (London, 1982), pl. 13.

55

SCRIBES' EQUIPMENT

The cultural centrality of literacy has ensured the presence of much scribal equipment in representations, texts and artefacts. Scribal palettes were the tools and badges of office, and surviving examples range from small crude palettes to ones in prestigious materials such as ivory, as well as stone funerary ones. Palettes were often placed in tombs, and were sometimes the ones the tomb owner had used in life, as with the palette of the official Merire (EA 5512) from the reign of Tuthmosis IV (1401–1391 BC). This shows clear signs of use, but it was inscribed with a funerary invocation in Middle Egyptian for Merire by his scribe Tenen:

> An offering which the King gives to Thoth lord of god's words, that he may give him knowledge of writings and of what comes forth from him, and understanding of gods' words, to the spirit of the Prince and Count, the Official at the Head of the King's Nobles, the High Steward, Merire.
>
> The scribe of the High Steward [Merire], Tenen.[56]

This section presents a few examples of surviving equipment and a sample of the various writing surfaces and tools that were employed. The principal writing surface was papyrus, but wooden writing boards were reusable, and so were often used for notes or for exercises by apprentice scribes, as were stone or pottery ostraca. Leather was a prestigious and expensive writing surface. Mud or textiles were used occasionally in particular circumstances: mud was sometimes used for ritual reasons (e.g. cat. 63), or in places where there was a shortage of papyrus, such as the Kharga and Dakhla oases. Metal objects were often inscribed, and metal was used as an ostentatiously expensive writing surface, for example in the treaty between Ramses II and the Hittites in *c.* 1258 BC.

56 Model of scribe's writing box (pl. 25)

EA 35878
H. 3.1 cm, W. 4.7 cm, D. 9.1 cm
First Intermediate Period to
early Middle Kingdom
Provenance unrecorded
Purchased from R.J. Hay; acquired in 1868

Model of a scribe's chest made of wood, slightly worn and abraded. The rectangular chest has two feet, and is painted white, with red and black bands. The sliding lid of the chest is white with red bands at the two ends, and is shown open to reveal five papyrus rolls laid lengthways inside. This is a unique depiction of how rolls were placed in chests for storage. On the open lid is the scribe's palette, painted in red and black. Beside it are the remains of a peg with which a circular object, perhaps a pot or another container, was attached. The chest was presumably part of an elaborate model manufactured to be placed in an official's tomb (similar to cat. 38), showing the tomb owner's scribes at work.

BIBLIOGRAPHY: hitherto unpublished.

56 (the base is modern)

57 Tomb wall-painting of scribes (pl. 26)

EA 43468

H. 30 cm, W. 36.5 cm

18th Dynasty, *c.* 1390 BC

From Thebes

Purchased from William Talbot Ready; acquired in 1907 (Lot 401, Rustafjaell sale)

A fragmentary tomb-painting on plaster. Comparison with other tomb-paintings indicates that this is part of a harvest scene, showing scribes assessing and recording the harvest. At the top and down the right-hand edge a green border is visible. To the left is the figure of a squatting scribe taking records of the harvest. Above him is his scribal chest, painted with a black and white design. On top of its sloping lid is a white roll of papyrus, and above this a wooden palette with reed pens in the slot, painted yellow to indicate wood. Behind the scribe an inspector sits on a pile of grain, now lost; he holds a staff and a bouquet of greenery as he watches his subordinates work. The scribes' linen costumes distinguish them from the workers in such scenes, who are shown as wearing only loin-cloths.

The painting comes from the walls of an unknown Theban tomb, similar in style to, though not identical with, the mid–18th Dynasty tomb of Nebamen (cat. 38). It is

57

generally well preserved, although the black paint has flaked off in several places.

BIBLIOGRAPHY: L. Manniche, *Lost Tombs: A Study of Certain Eighteenth Dynasty Monuments of the Theban Necropolis* (London, 1988), 196 (location in the British Museum not then known to author).

58 Scribal palette

EA 12784

H. 28.8 cm, W. 3.5 cm, D. 0.7 cm

18th Dynasty, temp. Ahmose I (1550–1525 BC)

Provenance unrecorded, presumably Thebes

Purchased from Giovanni Anastasi;
acquired in 1857

A wooden scribal palette, with two wells containing red and black pigment. On the cover of the slot for pens (partly broken away) is a line of right-facing hieroglyphs in raised relief recording the throne name and epithets of Ahmose I:

> The Perfected God, Lord of the Two Lands, (Nebpehtire)‖ [. . .

Palettes inscribed with royal names may have been particularly significant badges of office, representing the official's status as a 'King's Scribe' and delegate; such palettes might even have been awarded by the king himself.[57] A wooden mixing-stick and four rush pens were acquired with this palette; two of the pens have traces of red and black pigment on the end, and two have red on one end and black on the other.

BIBLIOGRAPHY: S.R.K. Glanville, 'Scribe's palettes in the British Museum. Part I', *JEA* 18 (1932), 53–61, esp. 55.

59 Scribal palette

EA 5521

H. 27.5 cm, W. 3.4 cm, D. 1.1 cm

New Kingdom

Provenance unrecorded

Probably purchased from Henry Salt;
marked in ink 'S.653'.

A small simple scribal palette, made of wood; it is undecorated apart from a sky sign (⎓) at the top of the reed slot. There are no inkwells, but there are extensive traces of black and red pigment at the top. The rectangular slot in the centre for reed pens has a cover; the slot was cut in from the side of the palette, and the piece of wood closing this slot is now lost.

BIBLIOGRAPHY: hitherto unpublished.

60 Funerary scribal palette of Amenmes

EA 12778

H. 40.8 cm, W. 6.4 cm, D. 0.85 cm

Ramesside Period, post Sety I (1306–1290 BC)

Provenance unrecorded

Purchased from R.J. Hay; acquired in 1868

A mudstone model of a scribal palette, with two imitation inkwells lightly incised on the surface, in the form of *shen* signs (⚬), an emblem of encirclement representing protection and totality. This is an elaborate and prestigious piece of work, although even finer examples of stone palettes are known, with inlays of semi-precious stones in the inkwells. The slot for reeds contains ten glass model pens attached with stucco. At the top of the palette is a scene of Amenmes adoring Osiris, Isis(?) and Thoth. An incised caption above the figure of Osiris reads 'Osiris Lord of Eternity', and above the owner, 'made for the official(?) Amenmes'. Two vertical lines of hieroglyphs flank the slot, with the signs facing inwards towards each other. The texts are dedications to Thoth and Osiris in Middle Egyptian. The right side reads:

> An offering which the King gives to Thoth lord of god's [word]s, chief of all the gods, that he may give entry and exit in the necropolis, and no turning back of the soul, to the spirit of the Chief Scribe of the Waters of The Mansion of Menmaatre (a temple of Sety I) in the temple-estate of Amun, Amenmes, true-of-voice before Osiris Lord of Eternity.

The palette was either placed in the tomb of Amenmes, probably at Thebes, or perhaps in a temple as a votive offering. It is a monumental, enduring alternative for the more usual practice of adapting palettes from daily life to funerary ends.

BIBLIOGRAPHY: S.R.K. Glanville, 'Scribe's palettes in the British Museum. Part I', *JEA* 18 (1932), 53–61, esp. 58.

12778.

68.11.2.426

60

61

61 Pigment grinder and stone

EA 5547

Stone: H. 2.6 cm, W. 7.2 cm, D. 11.9 cm; grinder: H. 3.1 cm, Diam. 2.5 cm

New Kingdom

From Thebes

Purchased from Joseph Sams; acquired in 1834

A rectangular basalt slab with an oval depression for grinding pigment. The oval is surrounded by a lightly incised cartouche (cf. cat. 60). The slab was acquired together with a basalt grinding stone.

BIBLIOGRAPHY: T.G.H. James, *Egyptian Painting and Drawing in the British Museum* (London, 1985), 11.

62 Inscribed metal plaque from Dendera

EA 57372

H. 31.8 cm, W. 25.9 cm, D. 0.4 cm

Roman Period, temp. Augustus (30 BC–AD 14)

From Dendera

Purchased from Denis P. Kyticas; acquired in 1924

Part of a bronze writing tablet, said to have been discovered in a cache of similar material near the sacred lake of the temple of Hathor at Dendera. It is inscribed on both sides, with thirty-one lines of incised hieroglyphic text in neo-Middle Egyptian on one, and sixteen surviving lines of incised demotic on the other. The tablet was dedicated in the temple by the son of a man whose Egyptian name was Pasherpakhy, and whose Greek name was Ptolemaios. The text comprises a list of his titles, including '[scribe] of Greek writings' (l. x + 9) and:

> . . .] Scribe of God's Words, Scribe of the Temple, Scribe of the Priests, Scribe of the Chest, Chief of Burnt-offerings, Chief [. . . (l. x + 13).

In these titles, the word for 'scribe' is sometimes written not with the usual sign (▨), but 'cryptographically' with the sign showing a baboon of the god of writing Thoth (▨). Another similar tablet (EA 57371) contains a duplicate of the same text in demotic only with a continuation that records the dedicator's good works for the temple. The tablet was a votive offering, a dedication of precious metal and a permanent record of the donor's piety. It seems to have been damaged by fire, perhaps in a deliberate attempt to melt it down.

BIBLIOGRAPHY: A.F. Shore, 'Votive offerings from Dendera in the Graeco-Roman Period', in J. Ruffle *et al.* (eds), *Glimpses from Ancient Egypt: Studies in Honour of H.W. Fairman* (Warminster, 1979), 138–60; F. von Känel, *Les prêtres-ouâb de Sekhmet et les conjurateurs de Serket* (Paris, 1984), 149–50.

62 (front)

62 (back)

63 Inscribed brick of Amenemopet

EA 29547

H. 4 cm; W. 9 cm; L. 18.6 cm

New Kingdom

Provenance unrecorded

Purchased from Selima Harris; acquired in 1875

A mud magical brick, with an inscription in seven lines of hieratic, incised when the clay was still damp. The use of mud as a writing surface is rare (see p. 143 above), and is here determined by magical considerations: the brick comes from a set of four that was placed in New Kingdom tomb chambers with amulets attached, to act as a protection for the tomb owner. This practice is recorded in Book of the Dead spell 151, which gives instructions for making the unbaked bricks and sealing them in niches. The invocation in Middle Egyptian reads:

> You who come to disturb, I shall not let you disturb! You who come to strike, I shall not let you strike! I will disturb you! I will strike you! I am the protection of the Osiris of [. . .] Amenem[opet]

This is the spell on the brick which was to be placed in the niche in the north wall of a burial chamber, and which was to be inset with an amulet in the form of a human mummy (here the end to be inset has broken away). In royal tombs such bricks were inscribed in hieroglyphs, while those from non-royal burials use hieratic, as here.

BIBLIOGRAPHY: J. Monnet, 'Les briques magiques du Musée du Louvre', *RdE* 8 (1951), 151–62, esp. 156–60; C.N. Reeves, 'Excavations in the Valley of the Kings, 1905/6: A photographic record', *MDAIK* 40 (1984), 227–35, esp. 232 n. 34.

63

64 Wooden writing board

EA 5646

H. 26.7 cm, W. 44.4 cm, D. 0.7 cm

Early 18th Dynasty

From Thebes

Purchased from Henry Salt, acquired in 1835

A stuccoed and painted rectangular wooden writing board; it is broken away at the top and slightly cracked. There is a hole to suspend the board when not in use. On the front are ten horizontal lines of hieratic; the back has eight lines with an inventory of goods (not translated here). On the front is a hymn to Thoth in Middle Egyptian; it is written in black ink, with verse-points marking the ends of metrical verses in red. The text opens with an introduction urging deities to worship the god of writing. After a punctuation mark in red, the hymn itself then follows. The handwriting is slightly smudged in places, and in one place a correction has been inserted in red (in SMALL CAPITALS in the translation below):

> Praising Thoth in the course of every day:
> O gods who are in heaven,
> O gods who [are in earth]
> [. . .] easterners,
> come, that you may see Thoth crowned
> with his uraeus,
> when the Two-Lords (= the double
> crown of Egypt) are established for
> him in Hermopolis,
> that he may govern the people!
> Rejoice in the Hall of Geb at what he has
> done!
> Praise him, extol him, give him hymns!
> – this god is the lord of kind-heartedness,
> the governor of entire multitudes.
> Now every god and every goddess,
> who shall give praises to Thoth on this
> day –
> he shall found their seats, and their offices
> in their temples
> in the Island of Fire!

64

Hail to you Thoth!
I am the one who praises you,
so may you give me house and property!
May you establish ME, create my
 livelihood,
in the land of the living,
as you have made them to live in the
 Island of Fire!
May you give me love, favours,
[. . .], sweetness, protection,
in the bodies, hearts, breasts of all
 mankind,
all patricians, all folk, all sunfolk!

The final line of the hymn is short, perhaps to avoid writing too close to the suspension hole. A spell follows, suggesting that the hymn was to be used for practical purposes as well as an act of daily worship by the scribe:

Spell:
May you strike down my male and
 female enemies,
dead and living.
These are to be spoken by a man when
 he has offered to Thoth,
– justifying a man against my (*sic*)
 enemies
in the council of every god and every
 goddess!

A further line that follows after a space contains a couplet which may be part of another hymn, left incomplete by the apprentice scribe:

For he is the chief of every god and every
 goddess,
this being what the great Company of
 gods has decreed for him . . .

The board is well preserved, and was presumably placed in a tomb.

BIBLIOGRAPHY: B. von Turajeff, 'Zwei Hymnen an Thoth', *ZÄS* 33 (1895), 120–5, esp. 120–3; R. Parkinson and S. Quirke, *Papyrus* (London, 1995), 20, fig. 8; R.B. Parkinson, 'The text of *Khakheperreseneb*: new readings of EA 5645, and an unpublished ostracon', *JEA* 83 (1996), 55–68, esp. 60.

SCRIBAL EDUCATION AND ERRORS

Schools seem to have existed at least from the late Old Kingdom, but most of the surviving evidence for educational practices and training comes from New Kingdom manuscripts and ostraca of apprentice scribes.[58] It is, however, difficult to tell which pieces are exercises and which were handy notes that might either have been kept or thrown away. Only one text, called *Kemyt*, was almost certainly written primarily as a school book (cat. 67). Other literary texts, especially 'Teachings', were used as copying exercises, but it is doubtful whether these were primarily educational texts, any more than Shakespeare's plays were, although they are now used as school texts.

It seems that most scribes learnt holistically, rather than analytically, and learnt cursively written word groups rather than individual signs. There are examples of scribes who could write graffiti on tombs they visited but were unable to read the monumental hieroglyphs correctly. Despite the prestige of being a scribe, training was recorded as involving being beaten, while the boredom of trainees is suggested by their occasional doodles on their manuscripts, sometimes with slightly satiric intent against the master (fig. 45). The copying on such manuscripts is often erratic (e.g. cat. 79), and approximately homophonous words are

Fig. 45 A sheet of P. Lansing (see cat. 47). In the midst of a eulogy of his teacher, the apprentice Wenemdiamen has drawn in red and black a picture of a disreputable-looking baboon, the animal of the god of writing. Given its position, it may be intended as a caricature of the teacher. H. 20.1 cm. EA 9994.5.

often confused regardless of the sense: thus in copies of one 'Miscellany' text, 'he stops' (*wḥʿ:f*) becomes 'he catches fish' (*wḥʿ:f*), and even 'he is laid down' (*w3ḥ.tw:f*).[59]

Many craftsmen and artists were probably partially literate, being able to copy texts correctly but not fully able to read them. Many could transfer a text on a hieratic manuscript into hieroglyphs on a wall, although from as early as the Old Kingdom there are examples where someone carving hieroglyphs either mistranscribed a hieratic sign or simply copied its shape blindly.[60] Poor workmanship is usually a sign of activity away from the centres of society, but mistakes are common to all humanity, and even the exceptionally fine reliefs in the temple of Sety I (1306–1290 BC) at Abydos include wrong signs, where the carvers had carved one bird instead of another. Even manuscripts by highly accomplished scribes from royal institutions who praised their own skills in the colophon are far from perfect. Such mistakes, like the repair patches on papyri and the blotches from faulty reed pens, are eloquent testimony for ancient individual experience, and their immediacy can be appealing for a modern viewer.

65

65 Funerary stela of Hepu

EA 205

H. 45.5 cm, W. 29 cm, D. 8 cm

Late Middle Kingdom

Provenance unrecorded

Purchased from Joseph Sams; acquired in 1834

Limestone stela with a cavetto cornice. A crudely incised scene shows the deceased seated before an offering table with a figure on the other side offering bread. The hieroglyphic text contains the offering formula and gives his name as 'Hepu, begotten of . . .', but the name of his parent is illegible due to the clumsy carving. Below is a Middle Egyptian offering formula for his relatives. There are traces of pigment (blue and black) in the incised signs, and on the figure (red). The poor workmanship of scene and text is presumably due to a factor such as comparative poverty or provincialism.

BIBLIOGRAPHY: P.D. Scott Moncrieff, *Hieroglyphic Texts* 2 (London, 1912), pl. 48.

Fig. 46 A cartoon by Ronald Searle, by kind permission of the artist. © Ronald Searle 1945.

"*Do you know, I can never remember whether to spell* 🐍〰️🦅 *with an* 🐍 *or an* 🦅."

66 Name stone of Hatshepsut

EA 52882

H. 29.5 cm, W. 18.5 cm, D. 7.2 cm

18th Dynasty, temp. Hatshepsut (1473–1458 BC)

From Deir el-Bahri, the temple of Hatshepsut

Donated by G.E.S.M. Herbert, 5th Earl of

Carnarvon; acquired in 1913

Limestone name stone from the temple of
Hatshepsut. The stone bears the throne
name of Hatshepsut, (Maatkare) |, and was
one of several placed in the foundations and
enclosure walls. Such name stones seem to
have been votive offerings placed by people
involved in the construction of the temple.
The hieroglyphs are unevenly incised and
badly proportioned; the cartouche ring is
spindly. There is no colour. Comparison
with another name stone from the site (EA
52883; fig. 47) suggests that it is an appren-
tice's work.

A hieratic graffito along the left side of
the cartouche (now almost invisible) is dated
'Month 2 of Akhet, day 10' and dedicates the
stone to Hatshepsut's Overseer of Works, the
'Steward of Amun, Senenmut'.

BIBLIOGRAPHY: PM II², 424; H.R. Hall
Hieroglyphic Texts 5 (London, 1914), pl. 28;
P.F. Dorman, *The Monuments of Senenmut: Problems
in Historical Methodology* (London and New York,
1988), 205; C.N. Reeves and J.H. Taylor, *Howard
Carter Before Tutankhamun* (London, 1992), 95;
G. Robins, *Reflections of Women in the New
Kingdom: Ancient Egyptian Art from the British
Museum* (San Antonio, TX, 1995), no. 23.

66

Fig. 47 EA 52883.

67 Ostracon with part of *Kemyt*

EA 5640

H. 14.5 cm, W. 19 cm, D. 3 cm

Ramesside Period

Provenance unrecorded, but possibly from
Deir el-Medina

Purchased from Joseph Sams; acquired in 1834

A limestone ostracon with four vertical lines
of text in cursive hieroglyphs. The top edge
is original, but the bottom edges are
chipped. The text is written in black
between red ruled lines, and the metrical
verses of the text are marked by horizontal
red lines. The style of script and the layout of
the text are characteristic of the composition
entitled *Kemyt* ('The Compendium'). This is
an elaborate model letter with a narrative,
probably composed in the early Middle
Kingdom in Middle Egyptian, which was
used as an educational text for training
scribes; the signs on this ostracon are rather
clumsily written. The extract comprises the
opening greetings of the letter (reading right
to left):

> Your state is like living a million times!
> May Montu lord of Thebes act for you,
> Even as this servant desires!
>
> May Ptah South of his Wall sweeten your
> heart
> with [life], very [much]!

BIBLIOGRAPHY: hitherto unpublished; equivalent
to §§3–4 in G. Posener, *Catalogue des ostraca
hiératiques littéraires de Deir el Médineh* II, DFIFAO
18 (Cairo, 1951), pls 1–21; translation: E.F. Wente,
Letters from Ancient Egypt (Atlanta, GA, 1990),
15–16; cf. also examples in A.M. Donadoni
Roveri (ed.), *La scuola nell'antico Egitto* (Turin,
1997), 67–75.

67

INDIVIDUAL SCRIBES AT DEIR EL-MEDINA

Deir el-Medina (fig. 48) is the remains of a walled village for the craftsmen who built and decorated the New Kingdom tombs in the Valley of the Kings; it lies in a small side valley, in the shadow of the Theban Peak, some thirty minutes' walk from the royal valley.[61] It has provided a unique combination of a well preserved archaeological settlement site with a mass of texts. The village was built in *c.* 1500 BC and abandoned towards the end of the 20th Dynasty, *c.* 1100 BC. It is unsure how representative this artist/craftsmen's community was of Egyptian society as a whole. Levels of literacy in the village were probably significantly higher than in most places of comparable size. The difficulty of historical construction and interpretation can be exemplified by the question of how isolated the village was: one scholar has suggested that the inhabitants were strictly segregated in order to keep the site of the royal tomb secret, but others consider this Hollywood-style image to be unfounded.[62] Nevertheless, it provides a unique insight into the lives of the court's workmen, the cultural ancestors of the inscribers of the Rosetta Stone.

The site was excavated principally by Bernard Bruyère (1879–1971), and provided a wealth of archaeological material (fig. 49), although the texts have tended to dominate in subsequent studies. The quantity of texts allows a sense of individual personalities. Jaroslav Černý (1898–1970), one of the outstanding experts

Fig. 48 View of the village of Deir el-Medina from the hillside cemetery to the west. A reconstructed pyramidion is visible to the left. Courtesy C. Andrews.

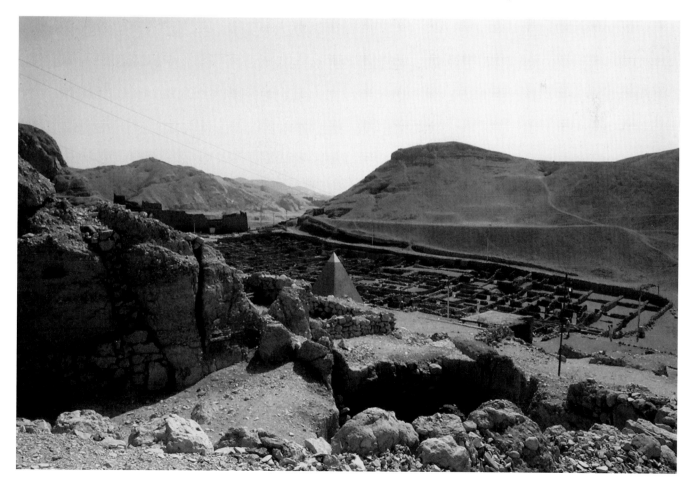

on the village, developed an almost instinctive ability to recognize the handwriting of particular individuals. While artistic groups can be detected in many painted Theban tombs, at Deir el-Medina scholars such as Cathleen Keller can put names to the signs and paintings. One also has evidence of actual local authors, composing literary works and circulating them among their apprentices (e.g. cat. 71). Such familiarity, while very appealing, has produced a slight tendency to treat the village as if it were a Western suburb.[63]

QENHERKHEPSHEF

Qenherkhepshef, a 'Scribe of the (Royal) Tomb', is attested from Year 40 of Ramses II (cat. 76; 1250 BC) until Year 6 of Sety II (1208 BC), about forty years later.[64] Attempts to assess his character inevitably reveal the assumptions of modern scholars. The fact that he married late in life a woman some forty years younger than himself, and that he used the workmen under his command to do work for him rather than on the royal tomb (cf. cat. 76), will not have had the same significance for his contemporaries that they may have for us. He was, however, accused of bribery, and a letter to him from a draughtsman Prehotep complains of 'this bad way in which you behave to me'; his own letters sound confident and self-assertive. Texts, including ones from his extensive archive that has largely survived, suggest that he was a man of considerable learning, with an interest in historical matters. They also suggest a particular concern with matters to do with sleep, since they include his headrest (cat. 69), a 'Dream book' (cat. 68), and an amulet which seems to be against a demon who comes in sleep (see fig. 43, p. 138).

He was fond of writing his name in graffiti on the Theban hills. One graffito in a niche close to the tomb of Merenptah in the Valley of the Kings names the shady spot as 'the seat of the scribe Qenherkhepshef', presumably while supervising work on the tomb (see cat. 68).[65] The location of his tomb is not certainly identified, although some of its contents have survived (cat. 69–70); it may perhaps have been a now-ruined tomb in the southern cemetery beside the village.

Fig. 49 Scene from the tomb of Inherkhau in the cemetery to the west of the village of Deir el-Medina (Tomb 359). Inherkhau was the foreman of the village from Year 22 of Ramses III (=1173 BC), and a contemporary of Amennakht son of Ipuy. H. 25.5 cm. EA 1291.

68 Qenherkhepshef's handwriting (P. Chester Beatty III)

EA 10683.3

H. 34.4 cm, W. 60.3 cm

19th Dynasty, *c.* 1220 BC

From Deir el-Medina

Donated by Mrs Chester Beatty; acquired in 1930

The recto contains a copy of a manual for interpreting dreams written in Middle Egyptian, in a fine literary hand of an unknown scribe (this section is columns 8–11); the first entry is typical of the contents:

> If a man sees himself in a dream:
> seeing his penis erect (*nḫt*): BAD: this
> means victory (*nḫtw*) for his enemies.

Qenherkhepshef's instantly recognizable, bold and highly cursive handwriting is apparent on the verso of this papyrus, where he copied part of a recently composed poem (*c.* 1285 BC) – the literary New Egyptian (with many Middle Egyptian forms) celebration of Ramses II's exploits, *The Battle of Qadesh*. He also added a copy of a letter he had written to the vizier (columns 4–5, shown here) during the reign of Ramses II's successor Merenptah (*c.* 1224–1214 BC). The letter begins:

> The Scribe Qenherkhepshef of the Great
> Tomb of (Baenre beloved of Amun)|, Son
> of the sun-god: (Merenptah satisfied with
> Truth)| (= Valley of the Kings Tomb no. 8)
> in the Estate of Amun, greets his lord, the
> Standard-bearer on the King's Right
> Hand, the Lord Vizier of Upper and Lower
> Egypt, Panehsy. In life, prosperity, health! . . .

The papyrus was later owned by his young wife's second husband Khaemamen, and then his son Amennakht, both of whom added their names to the recto in handwriting that is less neat than that of the original copyist of the Dream book, but much less cursive than Qenherkhepshef's (under column 10).

68 (recto)

68 (verso)

BIBLIOGRAPHY: A.H. Gardiner, *Hieratic Papyri in the British Museum, 3rd Series: Chester Beatty Gift* (London, 1935), 9–27, pls 5–12; P.W. Pestman, 'Who were the owners, in the "community of workmen", of the Chester Beatty Papyri?', in R.J. Demarée and J.J. Janssen (eds) *Gleanings from Deir el-Medina* (Leiden, 1982), 155–72.

69 Qenherkhepshef's funerary headrest

EA 63783

H. 18.8 cm, W. 23 cm, D. 9.7 cm

19th Dynasty, *c.* 1210 BC

From Deir el-Medina

Purchased from Maurice Nahman;
acquired in 1933

The limestone headrest of Qenherkhepshef,
decorated with incised apotropaic figures of
mythical animals and the domestic deity
Bes. It is inscribed with incised hieroglyphs,
originally painted blue, recording prayers in
Middle Egyptian for:

> a good sleep within the West, the
> necropolis of the righteous, by the King's
> Scribe Qenherkhepshef.

One end is damaged. The material and
inscription indicate that it is a funerary item,
rather than a headrest that was used by Qen-
herkhepshef in life.

BIBLIOGRAPHY: PM I.2², 748; K.A. Kitchen
Ramesside Inscriptions 7 (Oxford, 1989), 200; M.
Bierbrier and R.B. Parkinson, *Hieroglyphic Texts* 12
(1993) pl. 43.

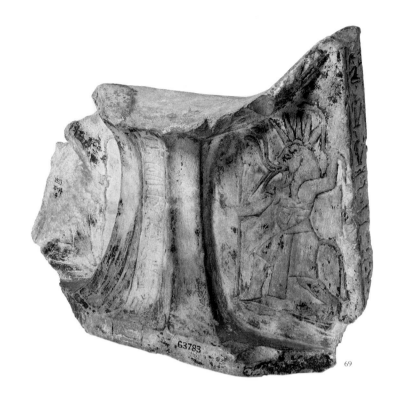

69

70 Qenherkhepshef's shabti (pl. 27)

EA 33940

H. 29.3 cm, W. 8.7 cm, D. 5.3 cm

19th Dynasty, *c.* 1210 BC

From Deir el-Medina

Purchased from R.J. Hay; acquired in 1868

Painted limestone shabti of Qenherkhep-
shef, showing a mummiform figure holding
agricultural implements. The hieroglyphic
text gives his title 'Scribe in the Place of
Truth' (Deir el-Medina) and his name, fol-
lowed by the shabti spell in Middle Egyptian
(see cat. 53), skilfully painted in horizontal
lines of black around the mummiform body.
As shabtis were substitutes for the deceased,
they also act as representations of the person,
but the features of the figurine are so stan-
dardized that they cannot be considered a
portrait. Nevertheless this is the only known
representation of the well-known scribe. The
nose is chipped and some paint has been lost
from the face.

BIBLIOGRAPHY: M. Bierbrier, *The Tomb-builders of
the Pharaohs* (Cairo, 1989 [1st edn 1982]), 12, fig. 3.

70

AMENNAKHT, SON OF IPUY

Amennakht, son of Ipuy, was initially a draughtsman, who was promoted to the rank of 'Scribe of the (Royal) Tomb' in Year 16 of Ramses III (1178 BC), thanks to the Vizier Taa (after whom he later named one of his sons).[66] He held this office together with other administrative and religious posts for thirty years. Amennakht was well placed to create and circulate written literature, being both a 'Scribe of the House of Life' (the temple scriptorium) and 'Scribe of the Elite Workers in the Horizon of Eternity' (the royal tomb). He is known as the copyist of many legal and administrative texts from Deir el-Medina, including the will of Naunakhte, the widow of Qen-herkhepshef (fig. 50; see also cat. 68). He also seems to be the author of five literary works, including a Teaching, a lyrical poem on the neighbouring metropolis of Thebes (fig. 51), a satiric poem and three hymns. His lyrical poem on Thebes in literary New Egyptian begins:

> What do they say in their hearts daily,
>
> those who are far from Thebes?
>
> They spend their days sorrowfully invoking Her . . .[67]

Although the village was a good walk away from the city and on the other side of the river, this is literary hyperbole; but Amennakht, as a highly cultured man, could have felt slightly isolated dwelling in the desert hills away from the metropolis. He has been described as an 'upright, able and influential scribe who was always very loyal to his superiors and society',[68] managing to control the revolting work-crew in the strike of Year 29 of Ramses III (1165 BC).

Fig. 50 Column 5 of the will of Naunakhte, from Year 3 of Ramses III (1192 BC), in which she disinherits her son Neferhotep. The document is described in l.8 as 'made by the Scribe of the (Royal) Tomb Amennakht'. After this a postscript is added in another, less neat, hand, confirming her second husband's agreement to the document. From Deir el-Medina. H. 43 cm. Ashmolean Museum, 1945.97. Courtesy the Visitors of the Ashmolean Museum, University of Oxford.

Fig. 51 An ostracon from Deir el-Medina, with Amennakht's poem, expressing longing for Thebes, written in black ink with red verse-points by Amennakt himself. H. 18 cm. Ashmolean Hieratic Ostracon 25. Courtesy the Visitors of the Ashmolean Museum, University of Oxford.

71 Ostracon with
The Instruction of Amennakht

EA 41541

H. 20 cm, W. 15.7 cm, D. 2.5 cm

20th Dynasty, *c.* 1170 BC

Purchased from Mohamed Mohassib;
acquired in 1905

Limestone ostracon painted with twelve
lines of hieratic. Its provenance is
unrecorded, but can be deduced to be Deir
el-Medina. The hieratic is a copy of *The
Instruction of Amennakht*, written in literary
New Egyptian, a rare example of a literary
work composed by a known historical indi-
vidual. His apprentice Hormin was the son
of his colleague Hori and friend of his own
son Amenhotep. The *Teaching* was probably
circulated locally among the litterateurs of
the village, as well as being used as a copying
exercise for Amennakht's apprentices. Some
seven copies on ostraca are known, but all
the others contain a shorter extract than this
one. This copy is well written on a carefully
chosen ostracon and the scribe's hand-
writing seems modelled on Amennakht's
own. It was certainly an exercise, since the
date is written in red under the final line, as
was a common practice of apprentices. The
red points mark the ends of lines of verse; in
ll. 9–10 a mistake has been made, and there
is one point too many (similar mistakes
occurs in ll. 5 and 6). The text reads:

71

Beginning of the Instruction,
the verses for the way of life,
made by the scribe Amennakht
⟨for⟩ his apprentice Hormin;
he says: You are a man who listens to a
speech
to separate good from bad
– attend and hear my speech!
Do not neglect what I say!
Very sweet it is for a man to be
recognized
as someone [competent] in every work.
Let your heart become like a great dyke,
beside which the flood is mighty.
Receive my utterance in all its matter;
do not be recalcitrant [so as to] overthrow
[it]!

Let your eyes see every trade,
and all that is done by writing,
and you will realize the fact [that they
are] excellent,
the observations I have spoken.
Do not neglect the matter!
I shall reject a long report as
inappropriate.
Make great your heart (be patient?) in its
haste
and speak only when you have been
summoned.
You shall be a scribe and go around the
House of Life
– this is how to become like a chest of
writings!

BIBLIOGRAPHY: G. Posener, 'L'exorde de
l'instruction éducative d'Amennakhte
(Recherches littéraires, v)', *RdE* 10 (1955), 61–72;
S. Bickel and B. Matthieu, 'L'écrivain Amennakht
et son *Enseignement*', *BIFAO* 93 (1993), 31–51 (the
translation here differs slightly in l. 10 from that of
Bickel and Matthieu, having been recollated with
the original).

72 Amennakht's votive stela

EA 374

H. 20.6 cm, W. 14.3 cm, D. 4 cm

20th Dynasty, *c.* 1170 BC

From Deir el-Medina; acquisition details
unrecorded

This round-topped limestone stela was dedi-
cated by the Scribe of the Place of Truth,
Amennakht, and depicts him kneeling in
adoration before the enthroned figure of the
goddess of the Theban Peak, Meretseger,
holding a lotus-flower and *ankh* sign. The
stela has some painted detail. Neither figure
has eyes, which may be an oversight, or may
relate to the substance of the text. The donor
is possibly the Amennakht who was the
author of *The Teaching of Amennakht*, but the
name was common at Deir el-Medina. It is
uncertain where the stela was set up, but it
was presumably in a sacred context, where it
could be dedicated to the goddess.

Seven vertical lines of hieroglyphic text
(painted yellow) at the top express the
donor's personal piety in Middle Egyptian.
Such hymns and prayers are characteristic of
the Ramesside Period, but the phenomenon
can be traced back to the Middle Kingdom
and was not necessarily a religious innova-
tion of the New Kingdom. The text is a
penitential prayer to the local goddess; other
stelae record instances of divine grace where
penitence was rewarded, but here only the
donor's request is recorded. The text men-
tions 'darkness by day'; this may refer to lit-
eral blindness (a common affliction in
Egypt, and one dreaded by visual artists such
as the inhabitants of Deir el-Medina), but it
is more likely to be a metaphor for some
other affliction:

> Praises for your spirit, Meretseger,
> Mistress of the West, by the Scribe of the
> Place of Truth, Amennakht true-of-voice;
> he says: 'Be praised in peace, O Lady of
> the West, Mistress who turns herself to
> grace! You made me see darkness in the
> day. I shall declare your power to other
> people. Be gracious to me in your grace!'

BIBLIOGRAPHY: PM I², 716; B. Gunn, 'The religion
of the poor in ancient Egypt', *JEA* 3 (1916),
81–94, esp. 87; K.A. Kitchen, *Ramesside Inscriptions*
5 (Oxford, 1983), 645; A.I. Sadek, *Popular Religion
in Egypt during the New Kingdom*, HÄB 27
(Hildesheim, 1987), 201, 203, 205; M. Bierbrier
and R.B. Parkinson, *Hieroglyphic Texts* 12 (London,
1993), pls 50–1.

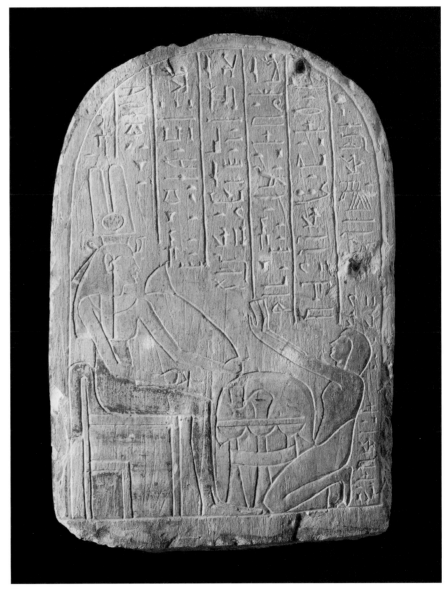

72

TJAROY

Tjaroy, the great-grandson of Amennakht, is first attested from Year 17 of Ramses IX (1114 BC), and as 'Scribe of the (Royal) Tomb' from Year 8 of Ramses XI (1092 BC).[69] During his life the villagers moved from the hills inside the enclosure walls of the eighty-year-old funerary cult temple of Ramses III at Medinet Habu, due to fear of attacks from the desert. He is known principally from a cache of New Egyptian letters discovered in the 1810s, now known as the 'Late Ramesside Letters'. His full name was Djehutymes, shortened to Tjaroy. His character and human frailties are well documented, and in one of the letters he alludes to his reputation for telling jokes:

> I've heard that you are angry and that you have caused me to be maligned through slander on account of that joke which I told the chief taxing master in that letter, although it was Henuttawy (his wife) who urged me to tell him some jokes in my letter. You are just like the wife blind in one eye who had been married to a man for twenty years, and when he found another woman he said to her, 'I shall divorce you because you are said to be blind in one eye.' And she answered 'Have you just discovered that after twenty years of our marriage?' Such am I and such is my joking with you . . .[70]

He was closely acquainted with General Payankh who controlled Thebes and was sent on several missions, including at least one with the army to the south, accompanying army supplies, and another to the north. Many letters express his anxieties for his family, including a wish that his wife was with him in the south, and there are references to his illnesses during his journeys. Although he presumably returned to Egypt from the expedition, he seems not to have enjoyed a good old age, since a graffito of his son Butehamen records the prayer to a god:

> Let ⟨me⟩ reach blessedness. Act not as you did to ⟨my⟩ father, the King's Scribe in the Place of Truth, Djehutymes.

73 Letter from Tjaroy's son

EA 10284
H. 15.5 cm, W. 18.3 cm
20th Dynasty, Year 10 of the 'Renaissance Era'
(= Year 28 of Ramses XI), 1072 BC
From Thebes; acquisition details unrecorded

In this letter Butehamen writes to the Priest of Hathor and Troop-Commander Shedsuhor, expressing his concern about his father, who is with Shedsuhor in Nubia. The letter comprises eleven lines of hieratic on the recto and a further two on the verso. The address is written on the bottom of the verso as 'It is for the scribe Tjaroy and Shedsuhor'; this would have been visible when the letter was folded and sealed into a small package (the cracks in the papyrus are the result of the ancient folds). After the conventional greeting and wishes, which establish and reaffirm the relationship between the correspondents, Butehamen writes:

> Indeed you are good, and my father belongs to you. Be a pilot for the Scribe of the (Royal) Tomb Tjaroy! You know he is a man who has no courage(?) of his own at all, since he has never before made such journeys as now. Help him in the boat. Look after ⟨him⟩ with vigilance at evening as well, while he is in your hands, since you are journeying [. . .]. Now a man is wretched(?) when he has become troubled, when he has never before seen the face of fear (i.e. of a crocodile). Now your people are alive; no harm has come to them. I am writing to let you know.

BIBLIOGRAPHY: J. Černý, *Late Ramesside Letters*, BAe 9 (Brussels, 1939), no. 29; E.F. Wente, *Letters from Ancient Egypt* (Atlanta, GA, 1990), no. 317; J.J. Janssen, *Hieratic Papyri in the British Museum*, VI: *Late Ramesside Letters and Communications* (London, 1991), pls 33–4.

73 (recto)

73 (verso)

WHAT COULD BE WRITTEN: TYPES OF TEXT

The reading of both modern and ancient texts is governed by formal considerations relating to different genres and types. Every document needs to be interpreted within its genre and context which display different registers of language, diction and decorum. Thus, whereas ideology dominates ancient Egyptian commemorative texts, it is qualified and challenged in many literary texts. In letters, where practical considerations are more pressing, it is sometimes even dismissed explicitly. Thus, the general Payankh wrote in response to the apprehensions of Tjaroy about some political murders: 'As for pharaoh l.p.h., whose master is he, in any case?'[71] The scribe who wrote this letter for Payankh automatically added the formulaic wish for the pharaoh's 'life, prosperity, health' (l.p.h.) despite the letter's contents – so strong are the conventions of written discourse. For the historian of ancient Egypt, a history of discourses, as against a history of real events, is all that is possible. Because all the written record was produced within the elite, it only rarely records and accommodates dissident voices. Even administrative documents are seldom as transparent as might at first appear: the Turin Strike papyrus, which was compiled by Amennakht (cat. 71–2), is a partial account of events, and edits reality for the scribe's personal ends.[72]

A few examples are provided here, from across Egyptian history, to give an impression of the range and wealth of surviving material. Texts include those created primarily for official display and commemoration, such as monumental stelae like the Rosetta Stone, funerary biographies, which were a central Egyptian genre, as well as royal annals and narratives. Royal and funerary texts that survive on funerary monuments are also attested in papyrus copies. Technical treatises include magical and medical texts of healing, mathematical and botanical treatises, and works on fauna. Letters belong together with administrative texts and records. Fictional literature is attested from the Middle Kingdom onwards; this type of entertainment text is unique among Egyptian high-cultural materials for being written almost always in hieratic, on mobile media, and for always being unillustrated. This pattern of inscription suggests that it was primarily a poetry for verbal performance. Entertainment lyrics are recorded on tomb walls as well as papyri, but it is uncertain whether the tomb versions are transcripts or rather versions of what was actually sung that were recomposed for writing. A whole world of oral literature has been lost together with the spoken language.

74 Boundary stela

EA 59205
H. 23 cm, W. 9.5 cm, D. 5.5 cm
Middle Kingdom
Provenance unrecorded
Purchased from Denis P. Kyticas; acquired in 1929

A round-topped limestone stela incised with the words *Pr-Snt*, the 'estate of Senet', as if a boundary-stone. When the stela was set in the earth, only 15 cm or so of it would have been visible, so it probably did not stand alone at a boundary, but beside a wall or building (the back surface is less smoothly worked). Since Senet's name is written without a determinative, the presence of the actual person may have made this deficiency acceptable, so the stela may have marked Senet's house or domain. It is apparently from a private, non-cultic context: the front doors of elite houses often had an inscription recording the names of their owners.
BIBLIOGRAPHY: H.G. Fischer, 'Égypte pharaonique: deux steles villageoises du moyen empire', *CdE* 55 (1980), 13–16.

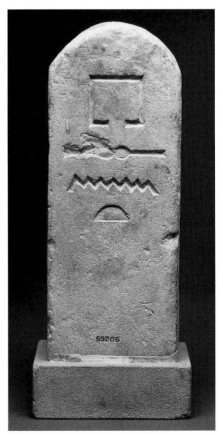

74 (the base is modern)

75 Stela and altar from Sinai

EA 694–5

H. 80 cm, W. 26 cm, D. 14 cm

12th Dynasty, Year 44 of Amenemhat III, 1800 BC

From Serabit el-Khadim

Donated by the Egypt Exploration Fund;
acquired in 1905

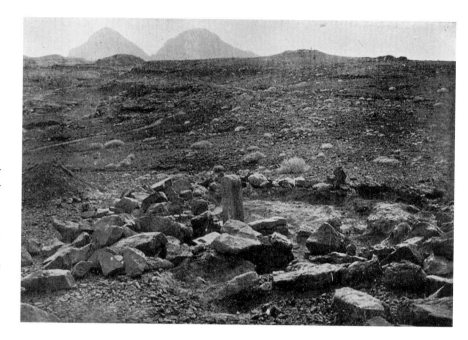

A round-topped sandstone stela with two vertical lines of sunk relief hieroglyphic text. It was discovered on a ridge south-west of the temple of Hathor at the mining site of Serabit el-Khadim, in Sinai. At its foot was an offering table, carved with vases, emblematic of desired libations, and troughs for the water. The stela and altar were surrounded by an approximately circular enclosure of rough stones that extended behind the stela (fig. 52). In the reigns of Amenemhat III and IV such enclosures for stelae were created as secondary private cult places clustering around the main temple. In the lunette, the inscription is dated to Year 44. Two vertical lines of Middle Egyptian read (right to left):

> An offering which the King ⟨gives⟩ to
> Hathor lady of Turquoise, for the spirit of
> the Chamberlain Sebekherheb, and for
> the spirit of the Assistant Seal-bearer of
> the Overseer of Seal-bearers, Kemn
> begotten of Qahotep.

These two officials are also known from an inscription of Year 40 of Amenemhat III (1804 BC), and in the same year as the stela Sebekherheb commemorated the opening of a new mining gallery with a rock-cut stela in mine B, in a valley to the south of the temple. The colonial context of the work is evident in the crudely shaped signs and the miscarving of the opening offering formula. Although the stela contains a funerary invocation, it is intended not to commemorate the officials' deaths, but their desire to have a permanent memorial beside the temple of the patroness of the mine.

BIBLIOGRAPHY: PM VII, 347; W.M.F. Petrie, *Researches in Sinai* (London, 1906), 63–71, pls 78–9; H.R. Hall, *Hieroglyphic Texts* 4 (London, 1913), pl. 17; A.H. Gardiner, T.E. Peet, and J. Černý, *The Inscriptions of Sinai* (London, 1952), no. 107; D. Valbelle and C. Bonnet, *Le sanctuaire d'Hathor maîtresse de la turquoise* (Paris, 1996), 29, 67, 70, passim.

Fig. 52 The stela and altar in situ in Sinai. From W.M.F. Petrie, *Researches in Sinai* (London, 1906), pl. 78.

75

76 Ostracon
with attendance register

EA 5634

H. 38.5 cm, W. 33 cm

19th Dynasty, Year 40 of Ramses II, 1250 BC

From Deir el-Medina (internal evidence)

Limestone ostracon labelled 'Year 40' of Ramses II on the top of the front side and providing a workmen's register for 280 days of the year. Although the list was compiled in Year 40, the information probably relates to the preceding year. There are twenty-four lines of New Egyptian hieratic on the front and twenty-one lines on the back. A list of forty names is arranged in columns on the right edge of each side, followed to the left by dates written in black in a horizontal line. Above most dates is a word or phrase in red, indicating the reason why this individual was absent from work on that date. The register was probably composed from a day-to-day rota kept as notes on smaller ostraca; only about 70 out of the 280 days covered by the register seem to have been full working days. Qenherkhepshef (cat. 68–70) is mentioned by name in l. 11 of the verso in a red entry, and is alluded to as 'the scribe' in several others. Sample entries are:

recto 1

Penduauu: month 1 of Akhet, day 24 DRINKING WITH KHONSU

recto 11

Pennub: month 3 of Akhet, day 21 WITH AAPEHTI; day 22 LIKEWISE; day 23 LIKEWISE; day 24 LIKEWISE; month 2 of Peret, day 7 CARRYING STONES FOR THE SCRIBE; month 2 of Peret, day 8 CARRYING STONES; day 23 WITH THE SCRIBE; day 24 LIKEWISE; month 3 of Peret, day 28 BREWING; month 4 of Peret, day 24 HIS MOTHER WAS ILL; day 25 LIKEWISE

recto 12

Aapehti: month 3 of Akhet, day 21 ILL; day 22 ILL; day 23 ILL; day 24 ILL; month 4 of Akhet, day 7, ILL; day 8 ILL; day 15 ILL; day 16 ILL; month 1 of Peret, day 14 OFFERING TO THE GOD; month 1 of Peret, day 15 ILL; month 1 of Peret, day 17 ILL; day 18 ILL

76 (recto)

verso 11

Iny: month 1 of Peret, day 24 CARRYING STONES FOR QENHERKHEPSHEF; month 2 of Peret, day 7, LIKEWISE; month 2 of Peret, day 17 ON LEAVE; month 2 of Peret, day 24 WITH THE SCRIBE

verso 15

Ramose: month 2 of Peret, day 14 ILL; day 15 ILL; month 2 of Shemu, day 2, MOURNING FOR HIS SON; day 3 ILL

On month 3 of Akhet, days 21–4, it seems that Pennub was off work because he was looking after the ill Aapehti. The most frequently recorded reason for absence is illness (over a hundred times), including 'eye trouble', and 'the scorpion stung him'; the next most frequent is being away with one's superior doing private work for him, a practice that was not forbidden if done in moderation.

76 (verso)

BIBLIOGRAPHY: J. Černý and A.H. Gardiner, *Hieratic Ostraca* I (Oxford, 1957), pls 83–4; J.J. Janssen 'Absence from work by the necropolis workmen of Thebes', *SAK* 8 (1980), 127–52; K.A. Kitchen, *Ramesside Inscriptions* 3 (Oxford, 1980), 515–25.

77 (detail)

77 P. Baldwin:
a record of grain transport

EA 10061

H. 20.7 cm; W. 203 cm

Mid–20th Dynasty

From Asyut

Donated by Edward T. Baldwin; acquired in 1882

This papyrus was acquired as half a roll in 1882, and only in 1994 was it realized that it was the bottom half of a roll, whose top half is now in Amiens (P. Amiens). The papyrus seems to have been discovered in the necropolis at Asyut by someone who then broke it into two (probably over their knee), so as to have two papyri to sell.

The recto contains a mid–20th Dynasty record of grain transport written in New Egyptian. It contains information about a fleet of twenty-one cargo ships belonging to the Domain of Amun and their being loaded. Each paragraph deals with a particular ship, with usually three ships in each column. Each entry is on a separate line, and the heading recording the name of the ship is written in red ink; a typical entry is as follows (recto 3.12–15)[73]:

SHIP OF the captain Bekenshed, son of Neban, of this house, under his authority:

Given to him on the Island of Amun Spirits-in-Thebes, on the threshing-floor of the controller Ashafeheryeb, being grain of the domain of the House of Ahhotep: 200 sacks

Given to him at this place, on this threshing floor, being grain of the domain of the baboon of Khonsu-who-was-a-child, under his authority: 75 sacks

Given to him at this place, on this threshing floor, being grain of the domain of the house of Nefertari-of-the-granary-of-the-House-of-Amun, under his authority: 25 sacks

The handwriting is very difficult to read, being written at speed with extremely abbreviated signs. The difficulties are compounded by the presence of many place names that are obscure to us because the papyrus records information about a region otherwise little known from documents.

BIBLIOGRAPHY: J.J. Janssen, 'Papyrus Baldwin rediscovered', *GM* 147 (1995), 53–60; full publication in preparation. For P. Amiens, see A.H. Gardiner, *Ramesside Administrative Documents* (Oxford, 1948), 1–13; A.H. Gardiner, 'Ramesside texts relating to the taxation of corn', *JEA* 27 (1941), 19–73, esp. 37–56.

78 Funerary Papyrus of Khay

EA 9953B.1

Ramesside Period

H. 31.1 cm, W. 30.6 cm

Provenance unrecorded

Purchased from R.J. Hay; acquired in 1868

A part of the funerary papyrus of Khay, 'Chief Keeper of the Writings of the Lord of the Two Lands'. This section includes a treatise in Middle Egyptian now known as 'The King as Sun-priest'. Earlier copies of this esoteric royal composition are from temples, but it was later taken over, as here, for private use. As a royal archivist, Khay would have had access to archival copies of the text. The original treatise is a description of the king's role in the solar cult; here it is adapted to form a preface for Khay's hymn to Amun-Re as sun-god, and the start of the original text is heavily truncated. The original text reads:

> Re has placed King X
> in the land of the living
> for eternity and all time;
> for judging men, for making the gods
> content,
> for creating Truth, for destroying evil.
> He gives offerings to the gods,
> and invocation offerings to the blessed
> spirits.

This becomes (ll. 6–8):

> The Osiris Khay true-of-voice is in the land of the living for eternity and all time; [for] judging men, [for making the gods content], [for] creating Truth, for destroying evil. The Osiris Khay gives offerings to the gods, and invocation offerings [to the blessed spirits].

As is usual for funerary papyri of this period, the text is written retrograde (see p. 57) in cursive hieroglyphs, between borders, with painted vignettes. On this section the text is flanked by two fragmentary vignettes. The one on the left shows the deceased before an offering table, while the one on the right must originally have shown the object of his veneration. The

78

royal version of this text in the temple of Luxor is accompanied by a scene of the king adoring the solar bark; here the remains of a sandy desert landscape suggest that the vignette showed sunrise, like vignettes to the solar hymns of the Book of the Dead.

BIBLIOGRAPHY: A. W. Shorter, *Catalogue of Egyptian Religious Papyri in the British Museum: Copies of the Book* Pr(t)-m-hrw I (London, 1938), 3; J. Assmann, *Der König als Sonnenpriester: ein kosmographischer Begleittext zur kultischen Sonnenhymnik in thebanischen Tempeln und Gräbern*, ADAIK 7 (Glückstadt, Hamburg and New York, 1970); I. Munro, *Untersuchungen zu den Totenbuch-Papyri der 18. Dynastie* (London and New York, 1988), 304 no. 44; S. Quirke, *Owners of Funerary Papyri in the British Museum*, British Museum Occasional Papers 92 (London, 1993), no. 106; J. Assmann, *Egyptian Solar Religion in the New Kingdom: Re, Amun and the Crisis of Polytheism* (London, 1995), 1–26.

79 Ostracon of
The Tale of Sinuhe (pl. 28)

EA 5629

H. 17 cm, W. 29.5 cm, D. 5.2 cm

19th Dynasty

Provenance unrecorded, probably Thebes

Purchased from Giovanni Anastasi; acquired in 1839

A limestone ostracon with the concluding stanzas of *The Tale of Sinuhe* written on one side in eight lines of hieratic (the other side is blank). The text is slightly corrupt, but this is an important manuscript for understanding and assessing the worth of the only other copy of this portion of the Middle Egyptian poem, a 12th Dynasty papyrus. The ostracon is probably an apprentice scribe's copy of the poem, which had been composed over seven centuries earlier. Verse-points in red ink mark the ends of metrical verses. The narrative poem has been the most widely acclaimed masterpiece of Egyptian literature in modern times. It inspired a much translated novel by Mika Waltari (1908–79), *Sinuhe the Egyptian* (1945), in which the *Tale* was moved from its original Middle Kingdom setting into the more glamorous Amarna Period; it was also subsequently further reshaped into a Hollywood epic, *The Egyptian* (dir. Michael Curtiz, 1954), one of whose stars, Peter Ustinov, described the experience as 'like being on the set of *Aida* and not being able to find the way out'[74] (fig. 53). The novel reflects the author's postwar disillusion with all ideologies, and ends with Sinuhe dying, not in Egypt, but in splendid and despairing isolation, proclaiming that he has 'lived alone, all the days of his life'. The final passage of the original is very different: the hero describes how he returned to Egypt after a life of adventures and misadventures abroad, and regained his position in Egyptian society, with a happy burial:

> My pyramid was built in stone,
> within the pyramid enclosure.
> The masons who construct the pyramid
> measured out its foundations;
> the draughtsman drew in it;
> the Overseer of Sculptors carved in it;
> the Overseer of the Works which are in
> the burial grounds busied himself
> with it.

> All the equipment to be put ⟨in⟩ a tomb –
> its share of these things was made for me.
> I was given funerary priests;
> a funerary demesne was ⟨made for me⟩,
> with fields and a garden in its proper
> place,
> as is done for a Chief Friend.
> My image was overlaid with gold,
> and its kilt with electrum,
> (The text here has the corrupt and
> garbled phrases:) for acting that I am
> King's sons
> I shall rejoice (the text should read:
> It is his Majesty who has caused this to be
> done.
> There is no other lowly man for whom
> it) was done in the entire land.
> I was in the favours of the king's giving,
> until the day of landing came {to him
> (*sic*) with it}.

SO IT ENDS, WELL AND IN PEACE

BIBLIOGRAPHY: R. Koch, *Die Erzählung des Sinuhe*, BAe 17 (Brussels, 1990), 80–1 (text L); R. Parkinson and S. Quirke, *Papyrus* (London, 1995), fig. 9; recent translation: R.B. Parkinson, *The Tale of Sinuhe and Other Ancient Egyptian Poems 1940–1640 BC* (Oxford, 1997), 21–53.

Fig. 53 All interpretation is appropriation: Edmond Purdom stars as Sinuhe in Twentieth Century Fox's version of *The Tale of Sinuhe*. The incident shown here does not derive from the original tale. The cat is unauthentically long-haired. Courtesy Twentieth Century Fox.

79

80

80 P. D'Orbiney:
The Tale of the Two Brothers

EA 10183.10

H. 19 cm, W. 64 cm

19th Dynasty, *c.* 1215 BC

From Memphis

Purchased from Elizabeth D'Orbiney;
acquired in 1857

This tale is one of the more famous of Egyptian compositions, variously interpreted in modern times as a fairy tale, a historical allegory and a political satire, among others. It is a highly entertaining but also sophisticated tale written in literary New Egyptian, telling of two semi-divine protagonists and their adventures, from which it derives its modern title *The Tale of the Two Brothers.* The only known copy of the *Tale* is this manuscript of nineteen columns, which was probably roughly contemporaneous with its composition. The manuscript ends with a colophon which includes a rare mention of the person who owned it (19.7–10, shown here; the rubrics are faded):

> SO IT ENDS, well and in peace. For the spirit of the treasury scribe Qageb of the Pharaoh's – l.p.h. – Treasury, the scribe Hori, and the scribe Meremopet. Made by the scribe Inena, the owner of this manuscript. As for anyone who maligns this manuscript, Thoth will fight with him.

The final line is written with a flamboyant calligraphic flourish. Despite the colophon's claims, the manuscript does contain inaccuracies. Although the papyrus was copied in honour of Inena's master Qageb, it was owned by the copyist. This papyrus can be linked with those acquired from Giovanni Anastasi (1780–1860) and François Sallier (1764–1831; see pl. 8) in the early nineteenth century; these include literary papyri written by the same scribe (P. Anastasi IV, VI and VII, and P. Sallier II) in his fine elegant literary hand;[75] others were written by scribes with titles of members of the same institution. This papyrus was written while Sety II (1214–1204 BC) was still crown prince, to judge by the jotting that occupies the space after the colophon:

> The Standard-bearer of the King, at the right hand of the Prince, the King's Scribe, and Overseer of the Army, the King's Elder Son, (Sety beloved of Ptah<|>).

Inena is thus a near-contemporary of the Theban Qenherkhepshef (cat. 68–70). The papyri probably all came from a single find at Saqqara, either from the tomb of Inena himself, or from a semi-official archive that had been stored in the necropolis.

BIBLIOGRAPHY: A.H. Gardiner, *Late Egyptian Stories*, BAe 1 (Brussels, 1932) ix–x, 11–29 (this section: 28–9); translation: M. Lichtheim, *Ancient Egyptian Literature: A Book of Readings,* II: *The New Kingdom* (Berkeley, 1974), 203–11; S. Hollis, *The Ancient Egyptian 'Tale of the Two Brothers': The Oldest Fairy Tale in the World* (Norman, OK, and London, 1990).

Textual information derives from only a small percentage of the population. Even for areas of life that are well documented the material is naturally not free from the concerns of the writers, displaying their prestige and expressing their common interests.[76] Texts are also archaeological artefacts and can be almost meaningless without their context, which only archaeology can provide. Archaeology alone can fill in the blanks left by the texts, but the relationship is mutual, since archaeology without texts can sometimes also be difficult to interpret. Cities, for example, feature rarely in Egyptian visual art and are seldom described in texts: cities and landscapes act as a means of representing ideology, rather than being themselves the objects of representation. In consequence, any assessment of urbanism in ancient Egypt, outside its very limited importance in official discourse, depends upon archaeology alone.

A more general phenomenon that can be illustrated to a limited extent with elite artefacts is the representations of sexual activity and sexuality. Although sexual activity may be a biological given, sexuality is, as Michel Foucault argued, a variable cultural artefact, a way of putting sex into discourse.[77] Although cultural assumptions are not often expressed explicitly, differences between modern and ancient Egyptian evidence for sexuality are immediately apparent. For example, explicitly sexual motifs seem to have had a relatively limited role in formal art and literature: both text and representations offer a high proportion of coded images or metaphors (fig. 54),[78] although direct representations and references to the gods' sexual acts and potency occur in sacred contexts. The self-sustaining fecundity of the earth-god Geb could be portrayed iconographically by showing him engaged in oral masturbation, as in the 21st Dynasty funerary papyrus of the Chantress of Amun Henuttawy (P. BM EA 10018.2; fig. 55).[79] Here, the ancient

Fig. 54 Detail from a Middle Kingdom stela, showing offerings being made to 'the Steward Saamen true-of-voice' and 'his wife whom he loves, Khuu'. Under her chair is a mirror in a case; this representation is not to be read literally, but is an allusion to the mirror's role in a woman's beautification, and thus metaphorically to her sexual vigour and fertility. W. 51 cm. EA 571 (detail).

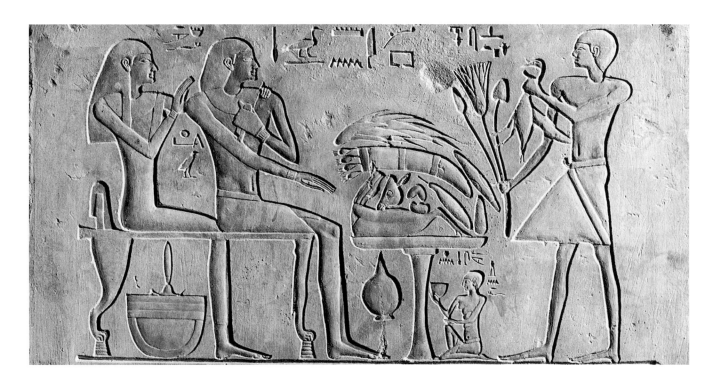

and modern decorums of what is appropriate for an official religious image and a piece of private pornography are exactly opposite. Sexual activity between humans is only represented directly on less formal artefacts (e.g. cat. 82), but these are often difficult to assess without their archaeological context. As Lynn Meskell has noted, 'sexuality suffused so many aspects of "ordinary life" from religion to child-rearing that it defies [modern] western definitions'.[80]

The following items cover a range of registers of discourse, including non-textual material that was probably produced in literate levels of society, to non-textual material whose social provenance is unknown. Such artefacts illustrate the limitations of writing and iconography in embodying a culture in its entirety.

Fig. 55 The Third Intermediate Period funerary papyrus of the Chantress of Amun Henuttawy. A polychrome vignette shows an image of the cosmos: the earth-god 'Geb father of the gods' is shown performing oral masturbation beneath an ithyphallic figure of Osiris representing the night sky. Both figures are painted yellow. H. 17.2 cm. P. BM EA 10018.2 (detail).

81

81 Illustrated papyrus (pl. 29)

EA 10016.2

H 8.3 cm, W. 52.8 cm

Ramesside Period

Provenance unrecorded

Purchased from Joseph Sams; acquired in 1834

Fragments of an illustrated papyrus showing animals engaged in human activities, including a hippopotamus making beer, a cat waiting on a mouse, a lion making beer and a canine carrying grain; other parts of the papyrus include a sexual motif. It is uncertain how the papyrus would have been 'read': the scenes do not represent a narrative sequence of successive events, and are thus unlikely to be a mnemonic summary or illustration of narrative tales, or to have been verbalized into a spoken narration.

Such papyri are often composed of parodies of types of scene from official and religious art, suggesting that the effect of the humour and the manner in which the papyrus was 'read' were purely visual. The sequence of images representing comic role-reversals is similar to the episodic textual images of social reversals in classic poems like the *Dialogue of Ipuur and the Lord of All*. It has been suggested that the papyrus images are social satire that mocked officials by portraying them as animals, but it is more likely that these scenes were not subversive or pro-grammatic social satire aimed at particular classes, but principally expressed a holiday mood.[81] The world turned upside down may be connected directly with the New Year feast and the drunkenness of religious festivals – which would explain why some similar types of scene occur on Greco-Roman Period temple walls. They are, however, also connected with relaxation of a less liturgical nature, constituting laughter pure and simple; this carnival atmosphere has left little trace in the monumental record. Although a modern audience's response is spontaneous, it is difficult to reconstruct the original cultural context and suggest a plausible interpretation. The provenance may have been the village of Deir el-Medina.

BIBLIOGRAPHY: E. Brunner-Traut, *Altägyptische Tiergeschichte und Fabel: Gestalt und Strahlkreft* (Darmstadt, 1968 [1st edn 1959]); J.A. Omlin, *Der Papyrus 55001 und seine satirisch-erotischen Zeichnungen und Inschriften* (Turin, 1968), esp. pl. 20a.

82 Ostracon with a scene of sex

EA 50714

H. 14.6 cm, W. 18.5 cm

Ramesside Period

From Thebes, possibly Deir el-Medina

Purchased from Mohamed Mohassib; acquired in 1912

Limestone ostracon with black-painted scene showing a man having sexual intercourse with a woman; the hieroglyphic caption in front of the woman reads:

Calm is the wish of my skin(?)!

The standing position of intercourse is the one most frequently represented in art, but this need not suggest that it was particularly popular; the woman's figure is slightly androgynous – presumably there was no need to indicate the sex strongly, since it would be assumed from the posture. The purpose of such scenes is uncertain: sexual activity was associated with religious festivity, but the nature of the 'Erotic Papyrus' in Turin and the sketchiness of this and other examples suggest a frivolous, throw-away quality, like doodles on papyri. The use of hieroglyphic as against hieratic script may suggest that the scene parodies more decorous representations (cf. cat. 81).

BIBLIOGRAPHY: L. Manniche, 'Some aspects of ancient Egyptian sexual life', *Acta Orientalia* 28 (1977), 10–23, fig. 3; W.H. Peck, *Drawings from Ancient Egypt* (London, 1978), no. 83; C. Johns, *Erotica*, British Museum Pocket Treasury (London, 1997), 12–13.

82

83 Clay figure of a woman with child

EA 23424

H. 7.8 cm, W. 4.3 cm, D. 13 cm

Second Intermediate Period

Provenance unrecorded

Purchased from Revd Greville J. Chester;
acquired in 1889

Terracotta figure of a naked woman suckling a child; the legs have been reattached in modern times. Such figures were once often thought to be children's toys, due to a superficial resemblance to modern dolls, but they have been shown to be fertility figurines. The woman's head has holes for attachments which would represent her hair and for earrings (sometimes added in metal). Although no provenance is recorded for this example, this type of statuette has been found in tombs, in domestic contexts, and as votive offerings, including at the Hathor temple at Deir el-Bahri. Such figurines seem to have a range of significance, from promoting fertility in this life and the next to evoking rebirth in the next. These artefacts also document a level of private cultic activity that is not represented in the elite textual record. The style is very different from that of formal art and may be deliberately non-standard or archaizing.

BIBLIOGRAPHY: G. Pinch, *Votive Offerings to Hathor* (Oxford, 1993), 201–3, pl. 48b (type 3); G. Robins, *Reflections of Women in the New Kingdom: Ancient Egyptian Art from the British Museum* (San Antonio, TX, 1995), no. 34.

83

84 (the base is modern)

84 Limestone figurine of a woman

EA 37925

H. 13 cm, W. 4.2 cm, D. 3 cm

Middle Kingdom

From Thebes

Purchased from Revd Greville J. Chester;
acquired in 1881

A limestone figure of a naked woman, shown only from the knees up. The hair, which is divided into three separate locks at the back, is painted black. Dots and crosses on the body represent tattoos or other skin decoration, ornaments and a girdle. Like the previous statuette, this is not a doll but a fertility figurine. This type of statuette was often assumed to represent Nubian dancing girls placed in the tomb to entertain the dead male owner, or 'concubine' figures for him to have intercourse with. They are, however, also found in women's burial equipment, suggesting a more diverse meaning. Most examples of this type date to the Middle Kingdom and Second Intermediate Period, and are from tombs.

BIBLIOGRAPHY: hitherto unpublished; similar example: J. Bourriau, *Pharaohs and Mortals: Egyptian Art in the Middle Kingdom* (Cambridge, 1988), no. 118; see G. Pinch, *Votive Offerings to Hathor* (Oxford, 1993), 198–9 (type 1).

85 Wooden votive phallus

EA 48109

H. 13.05 cm, Diam. 3.6 cm

New Kingdom, 20th Dynasty(?)

From Thebes, Deir el-Bahri

Donated by the Egypt Exploration Fund;
excavated by H.E. Naville and H.R. Hall;
acquired in 1907

85

86

An unpainted wooden votive phallus. Many votive phalli were found scattered on the floor in the chapel of Hathor constructed by Tuthmosis III at Deir el-Bahri, but their presence was not mentioned in the published reports. The base of this example is smoothed, suggesting that the phallus may have been placed upright in the shrine. Despite their known provenance, the exact purpose of these votive offerings is uncertain. One example is inscribed with a dedication by a man, but the text is obscure. It has been suggested that they were dedicated by men seeking a cure from impotence, or by men or women wanting children, or even as part of an agricultural rite evoking the fertility of the earth. The most plausible interpretation is perhaps that they were dedicated at a specific festival, celebrating the sexual union of the goddess Hathor and the creator god, to ensure both agricultural and personal fertility.

BIBLIOGRAPHY: G. Pinch, *Votive Offerings to Hathor* (Oxford, 1993), esp. 235–45.

86 A 'Naucratic' figure

EA 90380

H. 4.05 cm, W. 3.2 cm, D. 1.4 cm

Late Period(?)

Provenance and acquisition details unrecorded

Blue glazed composition figure of a squatting man with his phallus curved over his head. These figures are called 'Naucratic' because they were first discovered at the Greek settlement of Naucratis in the western Delta. Egyptologists have often considered them to be late, decadent and unworthy of Egyptian culture, but that is a false value judgement: they have been found in native Egyptian contexts on numerous sites. This figure has a hole for suspension at the back of the neck, and so was probably something worn as a amulet. Its purpose could have been to ensure potency, or perhaps to ward off evil: ithyphallic gods are often protective. The difficulties of interpretation have been hampered by modern reluctance to display and publish such material. The provenance is often unrecorded, although examples have been discovered in the cultic areas of the necropolis at Saqqara, where they were placed as votive offerings.[82] Many have apparently humorous aspects, with enormous phalli wrapped around their necks and the like.

BIBLIOGRAPHY: C. Johns, *Erotica*, British Museum Pocket Treasury (London, 1997), 20–21.

NOTES

1 C. Geertz, *The Interpretation of Cultures* (New York, 1973).

2 M.M. Bakhtin and P.N. Medvedev, *The Formal Method in Literary Scholarship* (Baltimore, 1978), 121.

3 See, for example, C. Sourvinou-Inwood, *'Reading' Greek Culture: Text and Images, Rituals and Myths* (Oxford, 1991), 5.

4 W.J. Ong, *Orality and Literacy: The Technologizing of the Word* (London, 1982).

5 A convenient account of this and other terms with reference to demotic is in M. Depauw, *A Companion to Demotic Studies* , Papyrologica Bruxellensia 28 (Brussels, 1997), 19–20.

6 P. Vernus, 'Les "espaces de l'écrit" dans l'Égypte pharaonique', *BSFE* 119 (1990), 35–56.

7 Louvre C 14, ll. 6–7: W. Barta, *Das Selbstzeugnis eines altägyptischen Künstlers (stele Louvre C 14*, MÄS 22 (Munich, 1970).

8 A summary is in 'Restricted knowledge, hierarchy, and decorum: modern perceptions and ancient institutions', *JARCE* 27 (1990), 1–23, esp. 17–21.

9 Ibid., 20.

10 See L.D. Morenz, *Beiträge zur ägyptischen Schriftlichkeitskultur des Mittleren Reiches und der Zweiten Zwischenzeit*, ÄUAT 29 (Wiesbaden, 1996), 13

11 J. Baines, in J. Sasson *et al.* (eds), *Civilizations of the Ancient Near East* (New York, 1995) IV, 2141.

12 The following account draws on the analysis of John Baines, including, for example, J. Baines, 'Literacy, social organisation and the archaeological record: the case of early Egypt', in J. Gledhill *et al.* (eds), *State and Society: The Emergence of Social Hierarchy and Political Centralisation* (London, 1988), 192–214.

13 J. Baines, review of J. Kahl, *Das System der ägyptischen Hieroglyphenschrift in der 0.–3. Dynastie* (Wiesbaden, 1994), *WdO* 27 (1997), 170–73. G. Dreyer, 'Recent discoveries at Abydos' Cemetery U', in C.M. Van den Brink (ed.), *The Nile Delta in Transition: 4th–3rd Millennium B.C.* (Tel Aviv, 1992), 23–99; G. Dreyer *et al.*, 'Umm el-Qaab: Nachuntersuchungen im frühzeitlichen Königsfriedhof 9./10. Vorbericht', *MDAIK* 54 (1998), 77–167; J. Görsdorf *et al.*, 'C14 dating results of the archaic royal necropolis Umm el-Qaab at Abydos', *MDAIK* 54 (1998), 169–75. Full publication: G. Dreyer, 'Umm el-Qaab I: Das prädynastische Königsgrab U-j und seine frühen Schriftzeugnisse', *Archäologische Veröffentlichungen* 86 (Mainz, 1998). Earlier cursive signs are attested on two Naqada II pots from the elite graves in the cemetery (G. Dreyer *et al.*, 'Umm el-Qaab: Nachuntersuchungen im frühzeitlichen Königsfriedhof 7./8. Vorbericht', *MDAIK* 52 (1996), 11–81, esp. 17, no. 17); sealings with proto-signs are now known from Naqada IId (U. Hartung, 'Prädynastische Siegelabrollungen aus dem Friedhof U in Abydos (Ummel-Qaab)', *MDAIK* 54 (1998), 187–217.

14 'Memory and literacy in ancient western Asia', in Sasson *et al.*, *Civilizations*, IV, 2184.

15 J. Scancarelli, 'Cherokee writing', in P.T. Daniels and W. Bright (eds), *The World's Writing Systems* (New York and London, 1996), 587–92; see also J. Goody, *The Interface Between the Written and the Oral* (Cambridge, 1987), 39–40.

16 B. Sass, *Studia Alphabetica: On the Origin and Early History of the Northwest Semitic, South Semitic and Greek Alphabets*, OBO 102 (Fribourg and Göttingen, 1991), 4–27.

17 A. Loprieno, *Ancient Egyptian: A Linguistic Introduction* (Cambridge 1995), 14–15; W. Schenkel, 'Syllabische Schreibung', in *LÄ* VI (Wiesbaden, 1986), 114–22.

18 E.g. É Drioton, 'Un rébus de l'ancien empire', in P. Jouguet (ed.), *Melanges Maspero*, I: *Orient ancien*, MIFAO 66 (Cairo, 1935–8), 697–704; S. Sauneron, *L'écriture figurative dans les textes d'Esna* (Cairo, 1982).

19 É. Drioton, 'Une figuration cryptographique sur une stèle du moyen empire', *RdE* 1 (1933), 203–29.

20 É. Drioton, 'Deux cryptogrammes de Senenmout', *ASAE* 38 (1938), 231–46, esp. 231–2. Another possible reference to 'cryptology' is F. Junge, 'Elephantine XI Funde und Bauteile: 1.–7. Kampagne, 1969–1976', *Archäologische Veröffentlichungen* 49 (Mainz, 1987), 77 (7.1.3), pl. 47g.

21 Loprieno, *Ancient Egyptian*, 23.

22 S. Sauneron, *Le temple d'Esna* II (Cairo, 1963), 203–4 (no. 103).

23 Overviews: K. Nordh, *Aspects of Ancient Egyptian Curses and Blessings: Conceptual Background and Transmission*, Boreas Uppsala Studies in Ancient Mediterranean and Near Eastern Civilizations 26 (Uppsala, 1996), 182–4; M. Negm, 'Tourist graffiti from the Ramesside Period', *DE* 40 (1998), 115–23.

24 See, e.g., A.I. Sadek, 'An attempt to translate the corpus of the Deir el-Bahri hieratic inscriptions', *GM* 71 (1984), 67–91; 72 (1984), 49–86.

25 P. Ramesseum D (P. Berlin 10495), ll. B.6–7; see A.H. Gardiner, *Ancient Egyptian Onomastica* (Oxford, 1955), 22–3, pl. 5.

26 See, e.g., E.C.M. van den Brink, 'Corpus and numerical evaluation of the "Thinite" potmarks', in R. Friedman and B. Adams (eds), *The Followers of Horus: Studies Dedicated to Michael Allen Hoffmann 1944–1990* (Oxford, 1992), 265–96.

27 See in general Depauw, *Companion*.

28 Ibid., 26.

29 R.S. Bagnall, *Egypt in Late Antiquity* (Princeton, 1993), 235.

30 See ibid., 238–40.

31 Heike Behlmer, 'Ancient Egyptian survivals in Coptic literature: an overview', in A. Loprieno (ed.), *Ancient Egyptian Literature: History and Forms* (Leiden 1996), 567–90.

32 See L.S.B. MacCoull, 'Further notes on interrelated Greek and Coptic documents of the sixth and seventh centuries', *CdE* 70 (1995), 341–53.

33 K.H. Kuhn, 'Shenute, Saint', in *The Coptic Encyclopedia* VII (New York and Toronto, 1991), 2131–3.

34 See, e.g., W.C. Hayes, *Glazed Tiles from a Palace of Ramesses II at Kantir*, Metropolitan Museum of Art Papers 3 (New York, 1937); H.W. Müller, 'Bermerkungen zu den Kacheln mit Inschriften aus Qantir und zu den Rekonstruktionen gekachelter Palasttore', *MDAIK* 37 (1981), 339–57; F.D. Friedman (ed.), *Gifts of the Nile: Ancient Egyptian Faience* (Rhode Island, 1998), 50–6. For a reconstruction of the palace at Medinet Habu see W.J. Murnane, *United with Eternity: A Concise Guide to the Monuments of Medinet Habu* (Chicago and Cairo, 1980), 69–73.

35 R. Tefnin, 'Discours et iconicité dans l'art égyptien', *GM* 79 (1984), 55–71. See also B.M. Bryan, 'The Disjunction of Text and Image in Egyptian Art', in P. Der Manuelian (ed.), *Studies in Honor of William Kelly Simpson* (Boston, 1996), 161–8.

36 K.P. Kuhlmann and W. Schenkel, *Das Grab des Ibi, Obergutsverwalters der Gottesgemahlin des Amun (Thebanisches Grab Nr 36)*, I: *Beschreibung der unterirdischen Kult- und Bestattungsanlage*, AV 15 (Mainz, 1983), pl. 23; K.P. Kuhlmann, 'Eine Beschreibung der Grabdekoration mit der Aufforderung zu kopieren und zum Hinterlassen von Besucherinschriften aus saitischer Zeit', *MDAIK* 29 (1973), 205–13; quoted in J. Assmann, 'Ancient Egypt and the materiality of the sign', in H.U. Gumbrecht and K.L. Pfeiffer (eds), *Materialities of Communication* (Stanford, 1994), 15–31.

37 See, for example, J. Baines, 'On the status and purposes of ancient Egyptian art', *Cambridge Archaeological Journal* 4 (1994), 67–94.

38 As illustrated by R. Wilkinson, *Reading Egyptian Art: A Hieroglyphic Guide to Ancient Egyptian Painting and Sculpture* (London, 1992).

39 E.g. H.G. Fischer, *L'écriture et l'art de l'Egypte ancienne* (Paris, 1986), 138, pl. 38.

40 H.G. Fischer, 'Some emblematic uses of hieroglyphs with particular reference to an archaic ritual vessel', *Metropolitan Museum Journal* 5 (1972), 5–23, esp. 19.

41 See now M. Eaton-Krauss, 'The fate of Sennefer and Senetnay at Karnak Temple and in the Valley of the Kings', in press.

42 See, e.g., R. Hölzl, *Die Giebelfelddekoration von Stelen des Mittleren Reichs*, Beiträge zur Ägyptologie 10 (Vienna, 1990), 13–47.

43 J. Baines and C.J. Eyre, 'Four notes on literacy', *GM* 61 (1983), 65–96.

44 K.A. Kitchen, *Ramesside Inscriptions* 6 (Oxford, 1983), 22 l.10.

45 R. Parkinson and S. Quirke, *Papyrus* (London, 1995), 61.

46 H.E. Winlock, 'A statue of Horemhab before his accession', *JEA* 10 (1924), 1–5, pl. 4; J. Assmann, *Ägyptische Hymnen und Gebete* (Zurich, 1975), no. 222.

47 E. Brunner-Traut, 'Der Sehgott und der Hörgott in Literatur und Theologie', in J. Assmann *et al.* (ed.), *Fragen an die altägyptische Literatur: Studien zum Gedenken an Eberhard Otto* (Wiesbaden, 1977), 125–45.

48 See in general, e.g., D. Wildung, *Egyptian Saints: Deification in Ancient Egypt* (New York, 1977).

49 See A.-A. Saleh, 'Plural sense and cultural aspects of the ancient Egyptian *mdw-ntr*', *BIFAO* 68 (1969), 15–38.

50 J. Assmann, *Egyptian Solar Religion in the New Kingdom: Re, Amun and the Crisis of Polytheism*, trans. A. Alcock (London and New York, 1995), 171–4, quote from 174.

51 W.M.F. Petrie, *Medum* (London, 1892), pl. 24; H.G. Fischer, *LÄ* II (Wiesbaden, 1977), 1198.

52 Now Victoria and Albert Museum, V&A 437.1895; W.M.F. Petrie and J.E. Quibell, *Naqada and Ballas 1895* (London, 1896), 68, pl. 78.

53 É. Drioton, 'Une mutilation d'image avec motif', *Archiv Orientalní* 20 (1952), 351–5.

54 See, e.g., C. Vandersleyen, 'Ramsès II admirait Sésostris Ier', in E. Goring *et al.* (eds), *Chief of Seers: Egyptian Studies in Memory of Cyril Aldred* (London and New York, 1997), 285–90.

55 *The Teaching for Merikare* (ed. Helck) 29b–e.

56 S.R.K. Glanville, 'Scribe's palettes in the British Museum. Part I', *JEA* 18 (1932), 53–61, esp. 56–7.

57 Morenz, *Beiträge zur ägyptischen Schriftlichkeitskultur*, 167 n. 737.

58 A.M. Donadoni Roveri (ed.), *La scuola nell'antico Egitto* (Turin, 1997).

59 A.H. Gardiner, *Late Egyptian Miscellanies*, BAe 7 (Brussels, 1937), xi.

60 Vernus, 'Les "espaces de l'écrit"', 35–56. esp. 39–41.

61 J. Černý, *A Community of Workmen at Thebes in the Ramesside Period* (Cairo, 1973); M. Bierbrier, *The Tomb-builders of the Pharaohs* (Cairo, 1989 [1st edn 1982]); D. Valbelle, *'Les ouvriers de la Tombe': Deir el-Medineh à l'époque Ramesside*, BdE 116 (Cairo, 1985); A.G. McDowell, *Village Life in Ancient Egypt: Laundry Lists and Love Songs* (Oxford, 1999); the 'Deir el Medina Database': www.leidenuniv.nl/nino/dmd/dmd.html.

62 A.G. McDowell, 'Contact with the outside world', in L.H. Lesko (ed.), *Pharaoh's Workers: The Villagers of Deir el Medina* (Ithaca, NY, 1994), 41–59.

63 Compare the approach of Lynn Meskell, 'An archaeology of social relations in an Egyptian village', *Journal of Archaeological Method and Theory* 5 (1998), 209–43.

64 Černý, *A Community of Workmen*, 329–37; K.A. Kitchen, *Ramesside Inscriptions* 3 (Oxford, 1980), 640–5; 4 (Oxford, 1982), 180–8, 239, 337.

65 J. Černý, *A Community of Workmen*, 334.

66 Ibid., 339–52; K.A. Kitchen *Ramesside Inscriptions* 5 (Oxford, 1983), 643–57; 6 (Oxford, 1983), 202–4, 376–9.

67 Ashmolean Hieratic Ostracon 25 (= O. Gardiner 25), recto: J. Černý and A.H. Gardiner, *Hieratic Ostraca* I (Oxford, 1957), pls 38–38a; S. Bickel and B. Matthieu, 'L'écrivain Amennakht et son *Enseignement*', *BIFAO* 93 (1993), 31–51, esp. 38–40.

68 P.J. Frandsen, 'Editing reality: the Turin Strike Papyrus', in S. Israelit-Groll (ed.), *Studies in Egyptology Presented to Miriam Lichtheim* (Jerusalem, 1990), 166–99, quote from 195.

69 Černý, *A Community of Workmen*, 357–82; K.A. Kitchen, *Ramesside Inscriptions* 7 (Oxford, 1989), 398–403.

70 J. Černý, *Late Ramesside Letters*, BAe 9 (Brussels, 1939), no. 46; E.F. Wente, *Letters from Ancient Egypt* (Atlanta, GA, 1990) no. 289; J.J. Janssen, *Hieratic Papyri in the British Museum*, VI: *Late Ramesside Letters and Communications* (London, 1991), pls 82–3.

71 Černý, *Late Ramesside Letters*, no. 21; Wente, *Letters*, no. 301; Janssen, *Hieratic Papyri*, VI, pl. 50.

72 Frandsen, 'Editing reality'.

73 Translation kindly provided by J.J. Janssen.

74 J.R. Nash and S.R. Ross, *The Motion Picture Guide* (Chicago, 1987), 749.

75 A.H. Gardiner, *Late-Egyptian Stories*, BAe 1 (Brussels, 1932), ix–x; id., *Late-Egyptian Miscellanies*, xiii.

76 To use the terms of M. Liverani, *Prestige and Interest: International Relations in the Near East ca. 1600–1100 B.C.* (Padua, 1990).

77 M. Foucault, *A History of Sexuality*, I: *An Introduction*, trans. R. Hurley (Harmondsworth, 1981 [1st edn 1976]).

78 See, for example, P. Derchain, 'Symbols and metaphors in literature and representations of private life', *Royal Anthropological Institute News* 15 (1976), 7–10.

79 See O. Kaper, 'The astronomical ceiling of Deir el-Haggar in the Dakhleh Oasis', *JEA* 81 (1995), 175–95, esp. 180.

80 L. Meskell, *Archaeologies of Social Life: Age, Sex, Class etc. in Ancient Egypt* (Oxford, in press).

81 D. Kessler, 'Der satirisch–erotische Papyrus Turin 55001 und das "Verbringen des schönen Tages"', *SAK* 15 (1988), 171–96; J. Assmann, 'Literatur und Karneval im Alten Ägypten', in S. Döpp (ed.), *Karnevaleske Phänomene in antiken und nachantiken Kulturen und Literaturen* (Trier, 1993), 31–57.

82 P. Derchain, 'Observations sur les erotica', in G.T. Martin, *The Sacred Animal Necropolis at North Saqqâra: The Southern Dependencies of the Main Temple Complex*, EES Excavation Memoir 50 (London, 1981), 166–70. Other examples have been discovered in a household shrine of the Persian Period at Tell el-Muqdam; see C.A. Redmount and R. Friedman, 'Tales of a Delta site: the 1995 field season at Tell el-Muqdam', *JARCE* 24 (1997), 57–83, esp. 63–5.

THE FUTURE: FURTHER CODES TO CRACK

Les règles du jeu: tout apprendre, tout lire, s'informer de tout . . . poursuivre à travers des milliers de fiches l'actualité des faits; tâcher de rendre leur mobilité, leur souplesse vivante, à ces visages de pierre . . .

The rules of the game: learn everthing, read everything, inquire into everything . . . pursue the reality of facts across thousands of index-cards; strive to restore to these faces of stone their mobility and living suppleness . . .
M. YOURCENAR, *Carnets de notes de 'Mémoires d'Hadrien'* (1952)

The decipherment of Egyptian hieroglyphs is perhaps the most famous, glamorous and ostensibly one of the most complete of all decipherments. As suggested above, these qualities have often been exaggerated: vast amounts of research remain to be done, and many lacunae in the surviving evidence will probably never be filled. Ancient Egypt remains a comparatively young area of study, and is still haunted by a reputation for exotic mystic wisdom that existed in the pre-decipherment period and has been termed 'Egyptosophia' by Erik Hornung.[1] The public fascination and support, which is in part inspired by this tradition, has been one of Egyptology's greatest assets. The attention given to the bizarre and the spectacular, however, can distract attention from scholarly work that attempts to integrate the study of Egypt with the generality of academic disciplines, such as anthropology,[2] archaeology and art history. Egyptology has often been regarded as a rather conservative, inward-looking discipline, but it is no longer isolated in obsessive dreams of mummies, mystery and gold; textual studies, for example, have begun to make significant progress as Egyptologists engage more fully with linguistic and literary theory.[3]

Nevertheless, there is no full dictionary of the ancient Egyptian language. Work on the great German *Ägyptisches Wörterbuch* continues; since the first edition was issued in 1926–31, whole new corpuses of texts have been published, and others republished. Tools such as the *Lexikon der Ägyptologie* (1975–92) and the *Topographical Bibliography of Ancient Egyptian Hieroglyphic Texts, Reliefs, and Paintings* (Oxford, 1927–, continuously updated) are invaluable reference works. Technological advances in disciplines such as bioanthropology are opening up whole new areas of ancient human experience for analysis. Even with papyri, which form a comparatively limited field of data, and one that has received extensive attention, new texts are constantly being revealed in excavations, museum collections, archives and libraries, such as the Middle Kingdom papyri

from el-Lahun in the Petrie Museum, London. New fragments continue to transform ideas of what could be depicted or written down in antiquity. Computer databases now play an increasingly vital role, as in the valuable Coffin Text online word-index; one multi-media project, which aims to make European museum collections more accessible, is appropriately named the Champollion Project, after the scholar whose decipherment relied on the international circulation of accurate copies of ancient texts. Both of these resources are based at the Centre for Computer-aided Egyptological Research at Utrecht.[4]

As well as new evidence and technology, new methods illuminate long-known evidence: *The Teaching of Amenemhat* which Champollion saw (see pl. 8) has often been interpreted as political propaganda, whereas recent approaches emphasize its cultural role as fictional poetry. There is a general movement away from socio-functional approaches towards attempting to reconstruct individual lives and contexts in more plausible shape and detail, to contextualizing archaeological data and written sources, and modelling the actuality that might have lain beyond the boundaries of this evidence. Approaches based on theoretical models attempt to compensate for gaps and silences in the evidence, and help to control scholars' reconstructions.[5]

As more evidence becomes available, however, it is clear that the cultural code of ancient Egypt is ultimately un-crackable: the past cannot simply be read, we can never know exactly what happened in ancient Egypt, and it is impossible to become an ancient Egyptian. As Clifford Geertz has commented of living cultures, 'the culture of a people is an ensemble of texts, themselves ensembles, which the anthropologist strains to read over the shoulders of those to whom they properly belong'.[6] Since Herodotus visited from Greece in the fifth century BC, Egypt has been regarded as quintessentially 'other' to Western Europe in terms of both its culture and the time-period it inhabited. It is difficult to assess how much this attitude is due to 'Orientalism' and how much to accurate assessments of cultural difference.[7] Even scholars whose profession it is to colonize the ancient world find it difficult to comprehend fully that other cultures do things differently, just as the early modern European colonizers of America assumed that cultures were transparent to one another, and even had difficulty in recognizing linguistic otherness.[8] Such difficulties are inherent in the human condition, as is the difficult realization that even people of one's own time who are other from oneself have, as George Eliot expressed it in *Middlemarch*, 'an equivalent centre of self, whence the lights and shadows must always fall with a certain difference'.

A different alphabet is one basic difference, a different script system is another of a different order, and language itself is yet another, while a culture as a whole is still more complex. In part, the reader of an ancient text must face barriers of different vocabulary, idioms and assumptions; we must attempt to balance asserting the difference of the ancient culture and recognizing similarities and common ground between ourselves and the ancients,[9] such as is occasionally glimpsed in text and artefact. The integration of the cultural resonance of a text or artefact with its capacity to arouse spontaneous wonder in its modern audience,

to use the terms of the literary critic and historian Stephen Greenblatt,[10] is a concern of literary theory as well as of archaeology and museum practice. In seeking such a balance, however, it is all too easy to treat the past as a pageant onto which one unconsciously projects one's own concerns (e.g. cat. 79) – as is unavoidable in any case since every study of the past is permeated with the cultural and political ethos of its own time – or to consider ancient people as schematic beings, mere instances of different social phenomena. It can be a salutary shock to hear the past voice its own concerns in as vivid and sophisticated a way as we can voice ours. They were once as alive as we are, and their experiences were as valid as ours. Humanity is itself a complex hieroglyph that cannot be completely deciphered, but nevertheless some level of understanding between different cultures and ages remains possible, and Egyptology is a far from hopeless struggle.

THE DEATH AND SPREAD OF THE EGYPTIAN SCRIPTS

Although scripts can appear to be abstract systems, they are bound by culture and time as much as the texts they write, and cannot be separated from the institutions that create and use them. This book is itself written in a context that has determined the contents, the language, the means of expression, the style, the script and the style of production. It is not a 'objective' description of ancient Egypt, but is inevitably a particular view from a particular institution by a particular individual.

The culturally embedded nature of scripts and texts can be seen in the latest known hieroglyphic inscription (fig. 56). It is found at Philae, the home of the Bankes obelisk that played a role in the decipherment of hieroglyphs, and it was carved next to a relief of the Nubian god Mandulis that was added to the temple gateway erected by Hadrian (AD 117–38), leading towards the sacred precinct enclosing the supposed tomb of Osiris (the Abaton) on the nearby island of Biga. It reads (right to left):

> Before Mandulis son of Horus, by the hand of Nesmeterakhem, son of Nesmeter, the Second Priest of Isis, for all time and eternity. Words spoken by Mandulis, Lord of the Abaton, great god.

A demotic inscription beside it reads:

> I, Nesmeterakhem, the Scribe of the House of Writings(?) of Isis, son of Nesmeterpanakhet the Second Priest of Isis, and his mother Eseweret, I performed work on this figure of Mandulis for all time, because he is fair of face towards me. Today, the Birthday of Osiris, his dedication feast, year 110.[11]

The inscription, in the two Egyptian scripts found on the Rosetta Stone, is dated by counting from the accession of the emperor Diocletian in AD 285 and corresponds to 24 August 394, around forty years later than the next latest dated hieroglyphic inscription.[12] The title of the inscriber is significant, showing him to have been concerned with sacred writings, that is, hieroglyphs. With Nesmeterakhem the hieroglyphic script disappears; given the close association between hieroglyphs and the means of elite and sacred display, it is fitting that its last securely dated usage should be in connection with a sacred image.

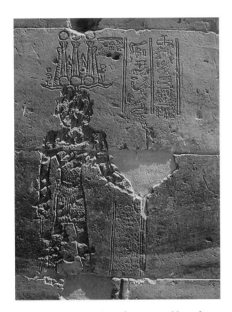

Fig. 56 The inscriptions of Nesmeterakhem from the Gate of Hadrian on Philae, 24 August AD 394. The figure of the god has been deliberately damaged, presumably by Christians. The hieroglyphic text is to the right of the figure's head, and the demotic to the left of his staff. Courtesy C. Andrews.

The figure and inscription were carved in connection with the visits of the pagan Blemmye tribe from the Red Sea hills to the south-east to pay homage to the goddess Isis. The Blemmyes' patronage of the goddess ensured that her temples at Philae remained open despite the Christianization of Egypt and the edict of the emperor Theodosius, which closed the temples in Egypt in AD 392. A campaign by the Byzantine general Maximinus against the Blemmyes at the time of the great church council of Chalcedon (AD 451–2) aimed to close the temples, but ended in a treaty still allowing them to worship annually at the temple. At this period demotic was still occasionally written, and it is uncertain exactly when the last person to use, or at least to read, the ancient scripts will have lived. The last known demotic inscription is also from Philae, dated to 11 December AD 452, on the roof of the pronaos of the great temple of Isis; the fact that the treaty and the inscription are of the same date is probably not a simple coincidence. It is now very faint, and records a pilgrimage to the temple, reading: 'The feet of Panakhetet the lesser'. It is presumably a caption to a commemorative drawing of feet (see cat. 16).[13]

There were by now Christian churches on the island, and the final centuries of pagan Philae passed into Christian legend. A Coptic history of the first monk-bishops of Philae was written in AD 992, but records earlier events, perhaps of the fourth century AD. It tells how Bishop Apa Macedonius deviously gained access to a sacred falcon in the temple and burned it, the last successor to the sacred falcon seen there by the Greek geographer Strabo four centuries earlier.[14] Between AD 535 and 537 the emperor Justinian (AD 527–65) ordered the temple's closure, the imprisonment of the priests, and the removal of its statues to Constantinople by General Narses. This event marks the definitive end of pharaonic written culture; the temple was rededicated to Saint Stephen and further churches were erected on the sacred island. The hieroglyphic and demotic scripts did not die because other more efficient scripts evolved, but because of other cultural and political factors.[15]

Although quintessentially Egyptian, the Egyptian scripts had some influence on those of other contemporaneous cultures. During the pharaonic period, Egyptianizing inscriptions are attested in the ancient Near East on objects such as seals which were apparently copied for prestige without any understanding of the script's significance, as was occasionally done in Egypt itself.[16] The Romans later continued this blind copying, as can be seen on a Roman obelisk now in the Museo Archeologico in Florence, which is carved with material derived from a hieroglyphic autobiography that degenerates into a 'free combination of signs' in its later sections.[17] Meaningless hieroglyphs continued to be produced through the Renaissance and beyond, and they still cover tourist souvenirs, completely illegible, but relying on the impressive evocation of only the idea of sacred writing.

As well as numerous pseudo-hieroglyphs, several genuine developments from the script are known. Julian Reade and Irving Finkel have suggested that a sophisticated imitation of Egyptian hieroglyphs was used to decorate monuments

of the Assyrian rulers Sargon II (721–705 BC) and Esarhaddon (680–669 BC).[18] The Hittite hieroglyphic script used in Anatolia in the late second and early first millennia BC shows a superficial resemblance to Egyptian hieroglyphs, but they have syllabic values derived from the Luvian language, which they were certainly invented to write. Despite this, it is probable that the script was developed under inspiration of Egyptian hieroglyphs.

A definite descendant of Egyptian hieroglyphs and of Egyptian demotic is the Meroitic script, used by the Kushite (Meroitic) civilization in the Sudan;[19] Kushites also worshipped at the temple of Isis on Philae. This script was identified in the early nineteenth century, and was deciphered in 1910 by Francis Llewellyn Griffith, who correlated the hieroglyphic and cursive forms of each letter and compiled a list of characters. He used various sources, especially the Wad Ban Naqa bark stand now in Berlin (pl. 30), to establish the values of each letter; it is the 'Rosetta Stone' of Meroitic. The stand for a sacred bark was erected in the temple of Isis at Wad Ban Naqa in *c.* AD 25. In the scenes on the sides the rulers are shown supporting the sky with two deities and are named as King Natakamani and Queen Amanitore. Their throne names are written in Egyptian, while their birth names are in Meroitic hieroglyphs. The longer captions to the scenes crucially also include the same birth names in Egyptian hieroglyphs.[20]

The script was derived from the Egyptian hieroglyphic script used by the Kushites of first-millennium BC Nubia to compose inscriptions in Egyptian. It depends in particular upon the system used in Egyptian texts of the early Kushite, Napatan Period (7th to 4th centuries BC) to write non-Egyptian words. It was devised for the native language following the probable rise of a new dynasty in the mid-third century BC, and has been interpreted as an assertion of cultural autonomy. The earliest dated Meroitic inscription known is the name of Queen Shanakdakheto at Naqa, not far from Wad Ban Naqa, from the late second century BC. The script survived the fall of the Kushite kingdom, the last surviving inscription being by a Blemmye king Kharamaoye on the façade of the temple at Kalabsha, from the fifth century AD. The script may have lingered on until the adoption of Christianity and the Coptic alphabet in Nubia in the sixth and seventh centuries.

Following the division between the Egyptian scripts, Meroitic has two forms, cursive and hieroglyphic, which are modelled on hieroglyphs and demotic as prototypes. The two scripts were probably intended to be used in a manner similar to Egyptian hieroglyphic and cursive scripts, but the division worked differently in practice: in funerary inscriptions, hieroglyphs were reserved for royalty, while only the cursive script was available to non-royal individuals. Long royal inscriptions were always written in cursive, suggesting that usage of the hieroglyphic version of the script was very restricted. There is increasing evidence that the cursive script was quite widely used on papyrus.

The Meroitic script is alphabetic, with word dividers, and comprises fifteen consonant signs, four syllabic signs and four vowel signs (fig. 57). However, little of the language is understood. Personal and place names, and some titles, words

hieroglyphs	cursive	transliteration
		initial *a*
		e
		o
		i
		y
		w
		b
		p
		m
		n
		ne
		r

hieroglyphs	cursive	transliteration
		l
		ḫ
		ḫ
		se
		s
		k
		q
		t
		te
		to
		d
		word divider

Fig. 57 The Meroitic script, after P.T. Daniels and W. Bright (eds), *The World's Writing Systems* (New York and London, 1996), 85.

and phrases have been identified, especially where the terms are loan-words from Egyptian (e.g. *pelmeš*, 'general', from Egyptian *p3 jmj-r3 mšʿ*). In other words, the script, but not the language, is deciphered. Conventional inscriptions on offering tables (fig. 58) and the like can be read to a considerable degree, but the longer commemorative inscriptions, including EA 1650 which has been thought to mention Rome, are largely unread. Some features of Meroitic linguistic structure are known and suggest that the language might belong to a group of north Sudanese languages, including Nubian. Attempts to find cognate languages have been thwarted up to now by the chronological and genetic distance between Meroitic and currently known languages.

Another, more controversial, descendant of Egyptian hieroglyphs is the 'Proto-Sinaitic' script, known principally from a small number of votive offerings and inscriptions at the Egyptian mining site of Serabit el-Khadim in the Sinai (cf. cat. 75).[21] The best known of the objects in question is a red sandstone royal sphinx (fig. 59, pl. 31) (EA 41748). Petrie stated that he discovered the sphinx 'in the temple' at the site, but provided no details of

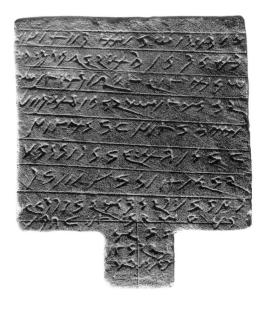

Fig. 58 Sandstone funerary stela in the shape of an offering table with an inscription in cursive Meroitic script. The inscription opens with an invocation to Isis and Osiris and comprises the dedicator's name, filiation and titles followed by funerary formulae. From el-Maharaqa. H. 35.6 cm. EA 901.

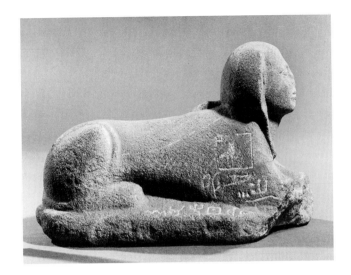

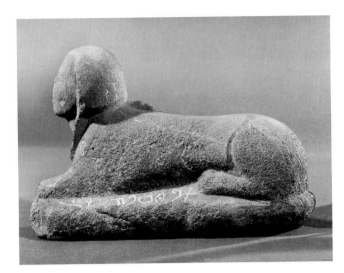

Fig. 59 A red sandstone sphinx from the Middle Kingdom temple at Serabit el-Khadim with inscriptions in Egyptian hieroglyphs and in the Proto-Sinaitic script. L. 23.7 cm. EA 41748.

sign (with variants)	transliteration
∂	*3*
⌂ □	*b*
∟	*g* (?)
⇨	*d*
ψ ψ	*h*
♀	*w*
=	*ḏ*
⊟ ◻ ꙮ ꙮ	*ḥ*
↳ ⌐	*y*
⩗	*k*
◡ ℮ ꞓ	*l*
⩘ ⩙	*m*
⌒ ⌐ ⌐ ⌐	*n*
◌ ◊	*ʿ* (?)
⌣	*p*
⋎ Υ	*ṣ*
8	*q*
ꝰ ꝰ ꝰ	*r*
ꙍ ꙗ	*š*
+ ×	*t*
⊢◦ ꙗ ♡ ⊞	signs with unknown value

exactly where.[22] The sphinx was initially dated to the New Kingdom, but a date in the Middle Kingdom (*c.* 1800 BC) now seems certain.

The sphinx bears incised inscriptions on the right shoulder, front base and sides, in both the Egyptian hieroglyphic and Proto-Sinaitic scripts. The Egyptian is crudely carved, and reads 'Beloved of Hathor, [Mistress] of turquoise'. Scholars have proposed that the texts are a virtual bilingual, with the group: ⬭ being read as *bʿlt* ('Baʿalat'), the name of a goddess comparable in nature to Hathor. The sign ⬭ is a ground plan of a house derived from the Egyptian hieroglyph ▭ *pr*, but derives its sound from the Semitic word for 'house' (*beth* > *b*), rather than the Egyptian (fig. 60). There is still some controversy as to whether the script has been fully and correctly deciphered. The attempted decipherment by Alan H. Gardiner in 1916, later elaborated and developed by W.F. Albright (1891–1971), relied on four assumptions: that Proto-Sinaitic was an alphabetic script, that the signs had Egyptian prototypes, that the letters were pictographic and their values acrophonically derived, and that the language was West Semitic.[23] Some scholars have also doubted, perhaps unnecessarily, whether the Semitic-speaking miners would have been in a position to dedicate inscribed objects to the goddess. The script is likely not to have originated in Sinai but in Palestine or Syria.[24]

Such uncertainties are difficult to resolve since the texts are few and short; the discovery of further texts might confirm or disprove the proposed decipherment; the proposed decipherment is perhaps uncertain and incomplete, but is at least plausible in many ways.

Fig. 60 Proto-Sinaitic signs. From B. Sass, *The Genesis of the Alphabet and its Development in the Second Millennium B.C.*, ÄUAT 13 (Wiesbaden, 1988), Table 4.

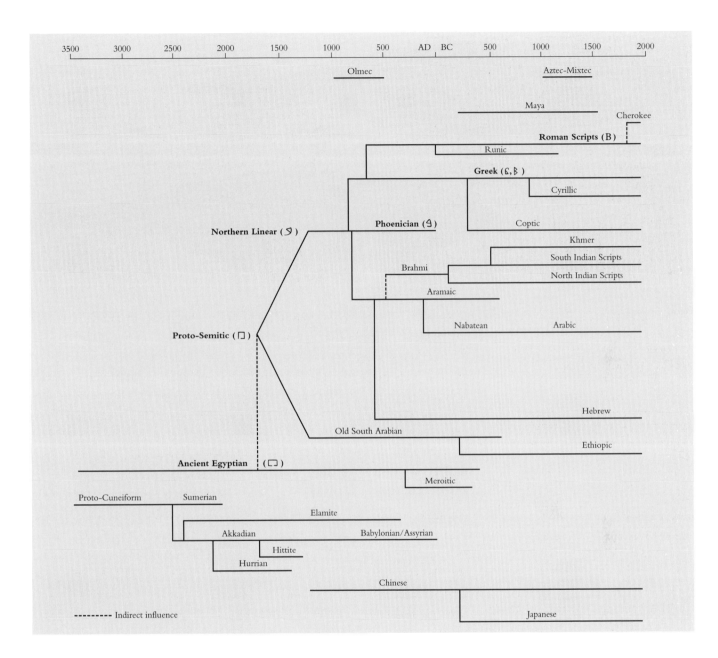

Fig. 61 Historical relations between some scripts, adapted from B. Trigger, *Norwegian Archaeological Review* 31 (1998), 58, fig. 1. The signs indicate the development of the roman letter 'B'.

Modern Western readers will instinctively view the study of writing in terms of the evolution of the Western 'roman' alphabet.[25] The alphabet is, however, neither a revolutionary type of writing system, nor a uniquely efficient one, and there is no single possible family tree for this particular alphabet. As indicated above for the disappearance of hieroglyphs, successive changes in systems are inspired by various considerations, not by partaking in a unidirectional development towards the best possible way of recording speech. The possible historical relationships between different scripts is summarized in fig. 61. If this reconstruction is valid, there is a sense in which, as Gardiner commented, the hieroglyphs live on within the Western alphabet.[26] However, the origin of the Semitic linear scripts in the Proto-Sinaitic script and its origins in hieroglyphs are highly debatable.[27] The date at which the consonantal Phoenician script was adopted by

Fig. 62 Arrowhead with inscription in Proto-Canaanite/Phoenician. The incised text probably records the weapon's ownership and reads: 'Arrow of *'d'*, son of *b'l*'. Mid-eleventh to early tenth century BC. Probably from Lebanon. H. 1.5 cm, L. 9.1 cm.

Fig. 63 Drawing of the 'Tarkondimos boss'. This small silver boss was initially acclaimed by Sayce as the Rosetta Stone of Hittite hieroglyphs. Around the edge is a text in cuneiform, read by Sayce as 'Tarkondimos king of the land of Erme', and the same text is written twice in hieroglyphs down either side of the figure of the king. H. 0.7 cm.

the Greeks as an alphabet is also uncertain (fig. 62). The Greek alphabet inspired the Etruscan alphabet and other Italian peninsula alphabets, one of which in turn developed into the Latin alphabet, which has been adapted to write the majority of the world's languages. The modern order of the alphabet, which is of course a convention, is the so-called Levantine order, which follows the order of the Phoenician and Hebrew scripts, as preserved in acrostic poems and in 'abecedaries' (that is, texts written out as mnemonics to aid memorizing the alphabet). An alternative order, which is present in Ethiopic and Old South Arabian, has been shown to be as ancient as the Levantine order, and may be the same as that used by the Egyptians.[28]

OTHER DECIPHERED AND UNDECIPHERED SCRIPTS AND LANGUAGES[29]

Just as the decipherment of Egyptian is not a single completed process, so the multitude of decipherments of scripts of other cultures is often overlooked in the glamour surrounding Champollion's achievements.

Hittite hieroglyphs were used largely for purposes of display, carved in stone, although there were probably administrative uses which may have been on surfaces now largely lost, such as wooden tablets.[30] It is a mixed system using phonetic and logographic signs. The script was first discussed by Silvestre de Sacy and Thomas Young; the Revd Archibald Henry Sayce (1845–1933), later professor of Assyriology at Oxford, worked on the script, and used a silver boss as a bilingual (fig. 63). The cuneiform script on the boss includes the name Tarkondimos, and it allowed Sayce to propose probable values for two logograms and one phonetic sign. Determinatives for country/town allowed place names to be identified, and correlations between such names and modern names allowed phonetic values to be gradually deduced. Excavations in the Hittite capital of Boghazköy in the first two decades of the twentieth century produced many thousands of

cuneiform tablets in a variety of languages. All of these languages were written in the cuneiform script, which was well known by then. The main hitherto unknown language in the find was identified by Bedrich Hrozn as Indo-European; it is now termed Hittite, although that was not its own ancient name. A separate but related language, less well represented in the find, was termed Luvian. This has since been identified as the language of the hieroglyphic script, which is therefore now termed Hieroglyphic Luvian (fig. 64).

Many scholars have contributed to this decipherment, using a variety of methods, so that it has been described as the 'least dramatic of all decipherments',[31] but it is perhaps one of the most consistently effective. Essential features of the language have been identified comparatively recently and major breakthroughs have come from comparative Indo-European studies.

Among the most spectacular of modern decipherments was that of Linear B, a script known from sites in Crete and on the Greek mainland (fig. 65).[32] The script comprises a syllabary and a large number of ideograms, including numerals, punctuation and so-called commodity signs. The script was discovered by Sir Arthur Evans (1851–1941) at the palace complex of Knossos on Crete, written on unbaked clay tablets when damp; it may also have been written on other lost media such as papyrus.

The Western fascination with Aegean culture ensured that these discoveries caused considerable excitement. Decipherment was hampered in part by the slow publication of the corpus of tablets, which was greatly extended by finds at Pylos in the 1930s and 1940s. The innovative work of Alice Kober (1907–50) on the distributional analysis of the signs marked significant progress; she attempted to work out the inflectional patterns but argued that the script could not be deciphered until the language was identified. After her death, the architect

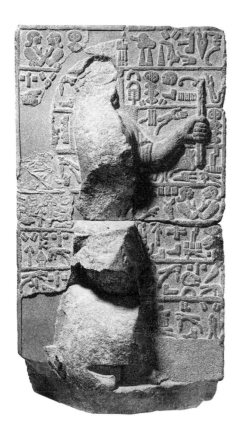

Fig. 64 A relief of a king, perhaps King Pisiri, with a Luvian hieroglyphic inscription recording a royal dedication. Probably from a monumental stairway up to the citadel at Carchemish. *c.* 730 BC. WA 125003.

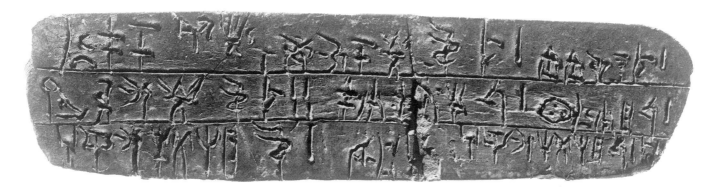

Fig. 65 Linear B clay tablet, with text apparently recording quantities of oil offered to various deities. Minoan, from Knossos, *c.* 1450–1373 BC. BM, GR 1910.4–21.1.

Michael Ventris (1922–56) continued, compiling syllabic grids of mutually substitutable signs and producing a tabulation of signs that he posited must share the same consonant or the same vowel. Like Kober, he worked in the abstract, without assigning values to the consonants and vowels. As he fixed more signs on his grids, the possibility of assigning values and identifying the language grew. Like Champollion, however, Ventris was hampered by a generally held misconception about Linear B. In this case it was about the language, which everyone assumed

Fig. 70 Limestone lintel panel in raised relief with Mayan hieroglyphs, from 'Structure 25' at the city of Yaxchilan. Lady Xoc views a vision of her dynastic ancestor Yat-Blam in a blood-letting rite. Yat-Blam emerges from the open jaws of a double-headed serpent. *c.* AD 725. H. 129.5 cm. BM Ethno 1886–316.

could not be Greek, since the Greeks were thought to have arrived in the region after the fall of the Minoan–Mycenean civilization.

Ventris' breakthrough came when, in the search for possible phonetic values, he tested whether major Aegean place names might fit a category of sign groups he had identified in his grids. The resulting words ended in vowels, and not consonants, at first reinforcing the assumption that the language could not be Greek. Ventris eventually hypothesized that final consonants might be omitted in the script. The result was that some crucial sign groups could be identified as Greek words. His proposals were circulated to a small group of scholars in the famous Work Note 20, 'Are the Knossos Tablets Written in Greek?' of 1 June 1952. The following year, the then Oxford philologist John Chadwick (1920–98) joined forces with Ventris to prepare a more detailed study of evidence for an early Greek dialect in the tablets, and while this was in press, a tablet was discovered at Pylos with ideograms of tripods and a text which, when read according to the Ventris–Chadwick decipherment, contained descriptions of the tripods in Greek dialect. The identification of the script as syllabic and the language as Greek has not passed unopposed, but despite the absence of any bilingual confirmation, the theory, so brilliantly and thoroughly argued, is now overwhelmingly accepted. Most texts are now known to be inventories and accounts. The script may have been borrowed from a language that did not have many closed syllables, and so could have originated in Semitic.

Among the most recent of decipherments is that of Mayan hieroglyphs, acclaimed as one of the greatest intellectual achievements of the twentieth century.[33] At least fifteen writing systems are known from Central America, of which Mayan hieroglyphs are the most extensively attested, in reliefs, pottery and bark-paper codices. They are attested from AD 250, and were still in use, long after the late eighth century collapse of Classic Maya civilization, in the sixteenth century, when the culture was exterminated by the Spanish invaders; the first century of its use is thus contemporaneous with the final century of the Egyptian hieroglyphic script. Under 600 characters are known, but they are found with baroque elaborations similar in their artistic qualities to the Egyptian hieroglyphic script (fig. 70). The codification of the signs, despite their graphic variations, was largely done by scholars such as Eric Thompson (1898–1975), although (like Thomas Young with Egyptian hieroglyphs) he never believed that the script recorded a full language. As with Egyptian hieroglyphs, the ornate pictorial appearance of the signs convinced scholars that the script could not be phonetic, despite the existence of an alphabet compiled from native informants by Bishop Diego de Landa (1524–79). A manuscript copy of Landa's alphabet was first discovered in a Madrid library in 1862, and was the 'Rosetta Stone' of Mayan, although its potential was not realized for many years. It was only in 1952 that the Russian linguist Yuri Knorosov (born 1922) first applied it as a syllabary to read the glyphs as the modern Maya language. There has been rapid progress in decipherment in the past decades, most of it in North America. The script is now established as both syllabic and logographic: texts can be read to a

Fig. 71 Limestone funerary stela with a Carian inscription below the first register. The top two registers are in an Egyptianizing style and show a man worshipping Osiris and Isis, and Thoth worshipping the Apis bull. The bottom register, in a provincial East Greek style, shows a woman laid on a bier surrounded by mourners. Sixth century BC. From the Lower Baboon Gallery, North Saqqara. H. 62.8 cm. EA 67235.

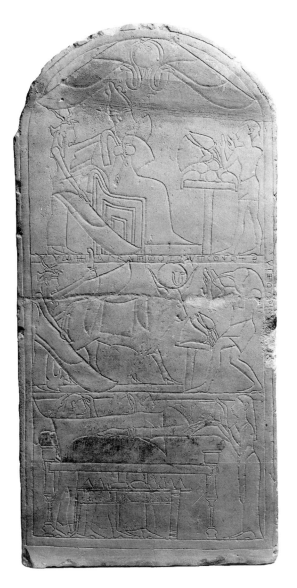

considerable extent, and the ancient languages of the Classic Maya cities are similar to the modern Cholan languages. The surviving texts include historical as well as astronomical-religious compositions. Among the world's scripts, Mayan hieroglyphs are perhaps the closest to Egyptian hieroglyphs in their usage as a means of elite display and their integration with pictorial representation.

In Egypt, the Carian script is known from inscriptions from the sixth to fourth centuries BC (fig. 71); the first Carian inscription to be identified in modern times is at Abu Simbel, close to the inscription by Greek mercenaries (see p. 46).[34] The Carians were natives of Caria in Anatolia (south-western Asia Minor), and are mentioned as allies of the Trojans in Homer's *Iliad*; they are best attested in ancient sources as mercenaries serving in Egypt under Psammetichus I onwards. Like other Anatolian alphabets, the script is based on the Greek alphabet, though not directly. It is now largely deciphered; it comprises forty-five signs, of which thirty or so have been assigned values that are widely accepted. Despite the existence of bilingual inscriptions with Greek and with hieroglyphic Egyptian, progress with the language, which belongs to the Indo-European

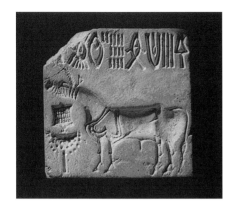

Fig. 72 Mature Harappan seal (2550–1900 BC.). White burnt steatite, excavated at Mohenjo-Daro. The seal shows a so-called unicorn and a standard, with an inscription above in the Indus script. H. 4.55 cm. BM OA 1947.4–16.2.

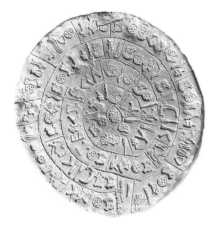

Fig. 73 The Phaistos Disk, side A. From a facsimile; the original is in the Archaeological Museum of Iraklion, Crete.

Fig. 74 Wooden tablet with Rongorongo inscription. The inscription is executed as a continuous line of glyphs starting from the lower left-hand corner toward the right. When the line is completed, the tablet is turned upside down and the inscription continues from left to right. Every other line is thus upside down. BM Ethno 1903–150. L. 11 cm.

family, has been limited since the inscriptions tend to be very short, but significant advances are being made by scholars such as John Ray.

Several scripts of the ancient world are undeciphered and may remain so unless further evidence is discovered. The Indus script of the Harappan civilization is among the best known of these (fig. 72).[35] It appears around 2500 BC, perhaps the result of stimulus diffusion from civilizations to the west, and disappears c. 1900–1700 BC together with the civilization that produced it. The script was first identified in 1875, but it remains largely inaccessible, since there are no known translations of any Indus texts and the civilization had no direct descendants, nor is there any information about the culture's language or texts known from other sources. Around 400 different signs have been identified, which suggests that the script may be is logosyllabic. The language may well belong to the Dravidian family, now represented by many languages in South India such as Tamil. Unfortunately, the average length of the surviving texts, about 60% of which are inscriptions on seals, is only five signs, although a monumental inscription has been discovered. As yet, no proposed decipherment has gained wide acceptance.[36] Scholars have also often guessed values for individual signs simply on the basis of their similarity in shape with those of other unrelated writing systems.

Several Aegean scripts have proved more recalcitrant than Linear B, including Linear A, the Minoan Pictographic script, and the script of the Phaistos Disk (fig. 73).[37] The last of these is a clay disk with 242 impressed signs which were made by forty-five different stamps. These forty-five signs are probably syllabic, but they are undeciphered, despite many claims to the contrary. It is possible that the Phaistos Disk, which may date to 1700 BC, was not made in Crete, where it was found, but was brought from elsewhere.

From the other side of the world, the Easter Island script is known from recitation (rongorongo) boards of the people of Easter Island in the Pacific Ocean (fig. 74), who had, however, lost the ability to read them by the time European missionaries noticed the writing. (The script may have been inspired

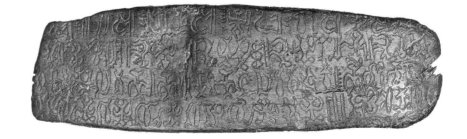

by the visit of the Spanish in 1770, when a written document of annexation was given to the islanders to sign.) It appears to be a mixed ideographic and phonetic system.[38] Dr Steven Fischer has recently proposed a convincing decipherment, arguing that the rongorongo boards record creation chants.

DECIPHERMENT VERSUS CRYPTANALYSIS
By Whitfield Diffie and Mary Fischer

As a couple made up of an Egyptologist and a cryptographer, it sometimes appears that we have spent the greater part of our life together explaining the difference between decipherment and cryptanalysis. We often find people thinking that our work is very similar; in truth, although our activities are connected by some underlying principles, in practice they are quite different. Archaeological decipherment is a linguistic discipline, modern cryptography a mathematical one. When codebooks were the primary means of encryption, these fields were closely related, but between the world wars linguists gave way to mathematicians in the cryptographic bureaux. Since then encryption has increasingly been done by operations that act on individual characters without regard for higher-level constructs such as words or phrases.

Ancient languages were not designed to confuse their readers or conceal the content of the messages they conveyed. Like the god whose hand Einstein saw behind the workings of the natural world, they may be subtle, but they are not malicious. Human languages are perhaps the most complex product of humanity and learning one as an adult is always difficult. The reason that learning an ancient language is more difficult than learning a modern one is that we must not only learn the language, we must learn the world it describes. To some extent, this is true of modern languages as well. Language classes often try to teach their students to speak and read about the things they will encounter when visiting places where the language is spoken. If the places also have different architecture, different clothing, different religions, different customs and different food from those with which the students are familiar, the students will have to learn many things that are not strictly speaking part of the language. This is part of the reason that it is often easier to learn a language in its native land.

There is no way of going to a place where an ancient language is spoken; the languages and the cultures they represent died hundreds or thousands of years ago. When an ancient language is newly encountered, it is not only the language but the culture that is unknown. Faced with a passage written on papyrus, on stone or on a clay tablet, the archaeologist has no way of knowing what was being written about. The writing may represent commerce or civic administration or accounting. Then again, it may be prayer or mythology or poetry. Even if the broad category can be surmised, the message may still be beyond reach. The archaeologist may not know what goods were traded, what customs were enshrined in law or what gods were worshipped. As a result, ancient writings may keep their secrets indefinitely.

When people in the contemporary world want to communicate privately by telephone or radio or Internet, they often encrypt their communications – transform them into a jumbled form from which they hope that eavesdroppers will not be able to recover the original meaning. Attempting to defeat the codes and ciphers used to conceal information in modern communications presents an

entirely different problem. These systems are less complex than human languages. At present no one knows how to construct a genuinely artificial human language. Languages of human design – from Esperanto to Elvish[39] – are invariably modelled on one or more natural languages. In one famous case, a human language was successfully used as a military code. The 'Navaho code talkers' were enlisted as communications officers by the US military in World War II. They provided secure tactical communications using codes based on Navaho. But Navaho is a natural language and the case is famous precisely because this is rarely feasible.

What cryptographic systems lack in subtlety, they make up for in malice: it is their purpose to conceal information. Part of this malice is called 'keying'. Even when two message are encrypted in the same 'system' – piece of equipment, program or codebook – they are generally encrypted in different keys. Along with the message, the code clerk enters a word or phrase or a string of random digits that will control the pattern of encryption. The least change in the key will cause the encrypted message to appear entirely different. In this respect, cryptographic systems behave in exactly the same way as locks on doors. Every door in a building may have the same lock, that is the same model of lock from the same manufacturer, yet no two doors may have the same key and the key to one door may not open any other.

The act of attempting to understand encrypted messages without the grace of knowing the keys that were used is called 'cryptanalysis'. The word is of twentieth-century origin and was coined to distinguish the attempt to break codes from the activities of the 'legitimate receivers' who decipher messages using the appropriate keys.

The intent to conceal and the use of keys may put the cryptanalysts at a disadvantage by comparison with the archaeologist, but in another respect they are at a great advantage. Unlike archaeologists, the people who attempt to analyse encrypted communications know virtually everything about the messages they are trying to read – everything except what the messages mean. Cryptanalysts almost invariably know where and when a message was sent. Frequently they know who sent it and to whom. Typically they know the language in which the message was written. They may even know the general subject matter. All they lack is the precise content, but as with the archaeologists, it is the precise content that must be recovered. A message from a client to a stockbroker almost certainly says 'buy' or 'sell'. A message from a field marshal to a general may be either 'attack' or 'retreat'. A message from a plaintiff to a solicitor may say 'sue' or 'settle'. In each case, which it is makes all the difference.

The context that surrounds contemporary messages produces another difference. In modern cryptanalysis, it is usually clear when the cryptanalysts get it right. The guiding principle is that if a decrypting rule is correct, it will produce meaningful plain text from a quantity of cipher text far larger than would be required to describe the rule. If a 'simple' mechanical process produces a thousand words of English, German or Russian from an intercepted cipher text,

there can be no doubt that the message was in the cipher text, not in the translation process.

In the case of ancient languages, this is rarely the case. When so little is known of the society that sent the message, judging the correctness of the translation is an integral part of the translation process. The deciphered text may look like gibberish but, in the absence of cultural context, there may be no way of knowing whether it is, in fact, an accurate rendition. Many decipherments of ancient scripts, including Champollion's, remained hypotheses for considerable periods of time after they were proposed. An ancient religious text describing the afterlife may allude to geography, architecture and people in a way that makes it difficult to distinguish it from a text describing a journey in the material world. The problem is compounded by the greater complexity of linguistic decipherment. It is something done by scholars rather than machines, and every line of the text may be accompanied by an explanation of the principles that the translator believes apply. Often an equally compelling set of reasons can be given for other choices.

In a fundamental sense, cryptanalysis of contemporary communications is easy by comparison with the decipherment of ancient languages. Viewed in this light, the task of the code maker seems difficult to the point of impossibility, a view whose validity is attested by the many cryptographic systems that have been broken by opponents. Perhaps the most famous of these is the Enigma, a German division-level cryptographic machine. An early version of this system was broken by Polish cryptanalysts. Later versions were broken by the British and made an essential contribution to the Allied victory in World War ii. In an effort to avoid this fate, the standard of unbreakability for more recent systems has been set very high.

At the very least, the Rosetta Stone allowed the ancient Egyptian written language to be deciphered far sooner than it would otherwise have been by providing equivalent passages of text in both known and unknown languages. This event, so rare and fortunate in archaeology, is commonplace in modern cryptography. A diplomatic communiqué that is encrypted as it travels from the foreign ministry to an embassy will likely be presented to the host government the following day. The received message will be in plain language and the recipients will probably be able to identify the corresponding encrypted message from the traffic of the day before. Placed side by side, the two messages provide a 'Rosetta Stone' to attack the cryptographic system being used. Such 'Rosetta Stones' are common in encrypted communication; their exploitation is called a 'known-plaintext attack'.

At one time this problem was countered by altering the plain text of the message after it was decrypted – a practice that must have done wonders for the precision of diplomatic language. Today it is possible to demand that cryptographic systems must be resistant to known-plaintext attack. No matter how much corresponding plain text and cipher text an opponent has available, it must still be impossible to decipher any additional text for which the plain text is not available.

It is because human languages are not designed to deceive and because they are not resistant to known-plaintext attack that the Rosetta Stone provided the gateway it did into ancient Egyptian writing and culture.

READING ANCIENT WRITING: TOWARDS A DIALOGUE

Civilization is often considered synonymous with writing, but this is not true: oral cultures can produce highly 'civilized' artefacts and societies, as is shown by the Inca empire, which lacked any writing system. Languages change and many are lost without ever having been recorded in any form. Thus, the native languages of Tasmania are now all extinct, without any significant description of them having been made. Many of the native languages of Australia are undergoing rapid change and tending towards extinction due to the social position of aborigines; for example, the Warumungu language is spoken by only a few hundred people in the Northern Territory.[40] Such extinction also affects European languages: the last native speaker of Manx, the language of the Isle of Man, died in December 1974. Writing offers an illusory permanence but itself changes, and the complexity of interpreting written texts is often insufficiently acknowledged. Even familiar and canonical texts change in their meaning for their audience, as is seen for the modern reader in Shakespeare's *The Merchant of Venice*, which is inescapably affected by the Holocaust.[41] All interpretation is appropriation, and all reading is a dialogue between reader and author.

The Egyptians displayed more awareness of the complexity of what is written and of the limitations imposed by conventions of interpretation than do many

Fig. 75 The king offering to the gods of writing, from Edfu. After E. Chassinat, *Le temple d'Edfou* X (Cairo, 1928), pl. 107.

Egyptologists. In the First Intermediate Period the difference between rhetorical records and the reality they evoked was explicitly acknowledged.[42] Thus, the funerary biography from the mastaba of the Overseer of Priests Mereri from Dendera (*c.* 2100 BC)[43] contains a protestation of veracity, stating that his claims are made: 'in truth: these matters are not spoken as an office of the necropolis'. The 'office of the necropolis' is a phrase referring to the status of the deceased in the Otherworld, and implies that funerary inscriptions could be regarded as a form of discourse which inherently contained formulaic, non-truthful assertions of achievement.

A passage that extols the invention of writing expresses its wide multivalent cultural significance in ancient Egypt, from administration to upholding the cosmic order. It is a caption to a scene at the top of the east exterior wall of the pronaos of the temple of Horus at Edfu, carved about a century after the Rosetta Stone (fig. 75).[44] King Ptolemy X is offering a palette and a cartouche-shaped

inkwell to Thoth, Seshat and seven falcon-headed gods, who are called the 'Utterances' (*ḏ3jsw*). These deities personify the written word, and are described as having 'caused memory to begin because they wrote'. The accompanying caption describes them as follows:

> These mighty ones created writing in the beginning
> in order to establish heaven and earth in their moment
> . . . lords of the art of acting exactly,
> a mooring post for those who travel on mud,
> craftsmen of knowledge,
> leaders of teaching,
> nurses of the person who fashions perfect words,
> lords of the standard, rulers of accounts,
> whose true work is everything that ensures the well-being
> of the entire land;
> shepherds of the whole world,
> who steer perfectly without falling into the water,
> fulfilling the need of all that is and all that is not,
> reassuring the hearts of the gods, and taking care of the established world,
> its watchmen, who watch without sleeping, performing the corvee duties of
> the fields,
> excellent ones who bring the rulership of the land,
> who reckon the confines of the four corners of the sky,
> who provide the offering tables of the great gods,
> and the fields of the officials,
> who guide everyone to their share,
> judging truthfully without those bribes on which everyone else relies in their
> trade.
> The heir speaks with his forefathers,
> when they have passed from the heart:
> A wonder of their excelling fingers,
> so that friends can communicate when the sea is between them,
> and one man can hear another without seeing him!

The decipherment of hieroglyphs that was achieved in 1822 is often acclaimed as the creative act of Egyptology, but such an identification obscures the limited understanding of Egyptian civilization that it allowed. It falsely equates the remains of a civilization with writing and ignores the immense importance of archaeological data and analysis, so often underrated in Egyptology.[45] There have also been too few attempts to integrate the full range of data preserved from ancient Egypt and to produce a multi-dimensional analysis of aspects of Egyptian culture. Archaeological theory now foregrounds the individual, drawing on comparative and anthropological approaches to call for a more multi-dimensional investigation of the tangled complexities of human experience in practice and theory. Archaeology involves not just artefacts or the political explanations for cultural

remains, but also the lived experiences of ancient individuals, intellectual, sensual and emotional.

If decipherment is seen as 'the key' to ancient Egypt, this also restricts the idea of interpreting the past to one of simply cracking a code. Popular imagination has tended to adopt this idea, which suggests that one can open a window on the past by using a single piece of recondite knowledge. This attitude can be seen in popular tales such as E.E. Nesbit's *The Story of the Amulet* (1906), in which children travel to ancient Egypt, and recently in the film *Stargate* (1994), where the inhabitants of a distant planet still speak ancient Egyptian and can only be reached though an inscribed and encoded 'gate'. Much recent historical literary criticism, however, moves away from the idea of travelling to the past to one of attempting a dialogue with the past.[46]

Despite its limitations, the metaphor of a code evokes the excitement of interpreting the past by implying a discovery of important secrets and hidden wonders. The 'code' of the Egyptian script is cracked, but the divisions between the modern reader and the ancient culture are as durable as the Rosetta Stone itself; to paraphrase Thomas Young, the key is turned in the lock, but the door can never be opened. It is easy to trace with one's fingertips the signs incised on the Stone, but it is another matter to trace the minds that composed them, the minds that carved them, the minds of the priests and courtiers who formulated the Decree, or the minds of the more ancient authors of the earlier decrees that influenced the composition of the Memphis Decree. The Stone has a deliberately monumental presence, redolent of a united elite ideology, but behind it is a multitude of diverse, competing voices. This is true of all historical artefacts, none of which can be entirely comprehended: as the great French Académicienne Marguerite Yourcenar remarked, 'historians propose systems of the past that are too complete, series of causes and effects too exact and too clear, ever to have been entirely true'.[47]

Since any communication between contemporaries face to face is rarely complete and unmistaken – a theme of much written literature from *The Tale of Sinuhe* (*c.* 1850 BC) to *Emma* (AD 1816) and beyond – it is clearly impossible to read an ancient text such as the Rosetta Stone with the eyes, spirit and responses of the ancients, let alone a text produced two thousand years earlier in a culture that was even more different from our own than that of the Alexandrian court. Nevertheless, one can attempt a certain reconstruction; the ancients and the modern reader share a common human condition. As 'the precious life blood of a master spirit, embalmed and treasured up',[48] texts have a presence as vivid as any mummy and can assist in the archaeological resurrection of a culture and of its individual lives.

The decipherment of the Egyptian scripts is not a single event that occurred in 1822, when a code was cracked, but is a continuous process that is repeated at every reading of a text or artefact. Such study is the closest one can come to speaking with the dead. Like any act of reading, it is a process of dialogue. The decipherment of the Rosetta Stone and of ancient Egypt is a dialogue that has scarcely begun.

...Iornung, 'Hermetische Weisheit: ...mrisse einer Ägyptosophie', in E. Staehelin and B. Jaeger (eds), *Ägypten-Bilder: Akten des 'Symposions zur Ägypten-Rezeption', Augst bei Basel, vom 9.–11. September 1993*, OBO 150 (Freiburg Schweiz, 1997), 333–42.

2 See, e.g., J. Lustig (ed.), *Egyptology and Anthropology*, Monographs in Mediterranean Archaeology 8 (Sheffield, 1997).

3 A. Loprieno (ed.), *Ancient Egyptian Literature: History and Forms* (Leiden, 1996).

4 These and other sites can be accessed through 'Egyptology Resources', at www.newton.cam.ac.uk/egypt/; review: L. Meskell, 'Electronic Egypt: the shape of archaeological knowledge on the Net', *Antiquity* 71 (1997), 1073–6.

5 A model example of such an approach is J. Baines, 'Contextualizing Egyptian representations of society and ethnicity', in J.S. Cooper and G. Schwartz (eds), *The Study of the Ancient Near East in the Twenty-first Century* (Winona Lake, IN, 1996), 339–84.

6 C. Geertz, *The Interpretation of Cultures* (London and New York, 1973), 452.

7 See, for example, S.M. Burstein, 'Images of Egypt in Greek historiography', in Loprieno, *Ancient Egyptian Literature,* 591–604.

8 S. Greenblatt, 'Kidnapping language', in *Marvellous Possessions: The Wonder of the New World* (Oxford, 1991), 86–118.

9 E.g. L. Meskell, 'Intimate archaeologies: the case of Kha and Merit', *World Archaeology* 29 (1998), 363–79, on attitudes to death.

10 S. Greenblatt, *Learning to Curse: Essays in Early Modern Culture* (New York and London, 1990), 161–83.

11 PM VI, 254.4; F. Ll. Griffith, *Catalogue of the Demotic Graffiti of the Dodecaschoenus* (Oxford, 1935), Ph. 436; D. Devauchelle, '24 Août 394–24 Août 1994 1600 ans', *BSFE* 131 (1994), 16–18. Translation kindly provided by C. Andrews.

12 AD 340: J.-C. Grenier, 'La stèle funéraire du dernier taureau Bouchis', *BIFAO* 83 (1983), 197–208.

13 Griffith, *Demotic Graffiti* (Oxford, 1935), Ph. 377. Translation kindly provided by C. Andrews.

14 British Library Or. 7029; W. Budge, *Miscellaneous Coptic Texts in the Dialect of Upper Egypt* (London, 1915), 432–502.

15 E.g. David Frankfurter, *Religion in Roman Egypt: Assimilation and Resistance* (Princeton, 1998).

16 E.g. B. Teissier, *Egyptian Iconography on Syro-Palestinian Cylinder Seals of the Middle Bronze Age*, OBO Series Archaeologia 11 (Fribourg and Göttingen, 1996).

17 A. Roullet, *The Egyptian and Egyptianizing Monuments of Imperial Rome* (Leiden, 1972), no. 88.

18 I.L. Finkel and J.E. Reade, 'Assyrian Hieroglyphs', *Zeitschrift für Assyriologie und Vorderasiatische Archäologie* 86 (1996), 244–68.

19 N.B. Millet, 'The Meroitic script', in P.T. Daniels and W. Bright (eds), *The World's Writing Systems* (New York and London, 1996), 84–7; L. Török, *The Kingdom of Kush: Handbook of the Napatan-Meroitic Civilization* (Leiden, 1997), 49–52, 62–7.

20 PM VII, 263; D. Wildung (ed.), *Sudan: Ancient Kingdoms of the Nile* (Paris and New York, 1997), no. 279.

21 B. Sass, *The Genesis of the Alphabet and its Development in the Second Millennium B.C.*, ÄUAT 13 (Wiesbaden, 1988); *Studia Alphabetica: On the Origin and Early History of the Northwest Semitic, South Semitic and Greek Alphabets*, OBO 102 (Fribourg and Göttingen, 1991).

22 A.H. Gardiner, T.E. Peet and J. Černý, *The Inscriptions of Sinai* (Oxford, 1952 [2nd edn]), no. 345; Sass, *Genesis of the Alphabet*, 12–14 (also more generally 8–50, passim).

23 P.T. Daniels, 'The first civilizations', in 'Epigraphic Semitic scripts', in Daniels and Bright, *The World's Writing Systems*, 21–31; see also M. O'Connor, 'Epigraphic Semitic scripts', in ibid., 88–107.

24 Texts in Proto-Canaanite scripts are attested in Egypt by the late Middle Kingdom; M. Dijkstra, 'The so-called Ahituh-inscription from Kahun (Egypt)', *Zeitschrift des Deutschen Palästina-Vereins* 106, 51–6. A similar text, from el-Lahun, is BM EA 70881.

25 As in I.J. Gelb, *A Study of Writing* (Chicago, 1963 [1st edn 1952]).

26 A.H. Gardiner, 'The Egyptian origin of the Semitic alphabet', *JEA* 3 (1916), 1–16.

27 W.D. Whitt, 'The story of the Semitic alphabet', in J.M. Sasson *et al.* (eds), *Civilizations of the Ancient Near East* (New York, 1995) IV, 2379–97.

28 See Chapter 2.

29 This and following sections draw on the accounts in Daniels and Bright, *The World's Writing Systems*.

30 H.C. Melchert, 'Anatolian hieroglyphs', in P.T. Daniels and W. Bright (eds), *The World's Writing Systems*, 120–4.

31 M. Pope, *The Story of Decipherment: From Egyptian Hieroglyphic to Linear B* (London, 1975), 145.

32 See, e.g., J. Chadwick, 'Linear B and related scripts', in J.T. Hooker *et al.*, *Reading the Past: Ancient Writing from Cuneiform to the Alphabet* (London, 1990), 136–95; E.L. Bennett, 'Aegean scripts', in Daniels and Bright, *The World's Writing Systems*, 125–33, esp. 125–30.

33 See, e.g., S.D. Houston, *Reading the Past: Maya Glyphs* (London, 1989); Michael Coe, *Breaking the Maya Code* (New York, 1992); M.J. Marci, 'Maya and other Mesoamerican scripts', in Daniels and Bright (eds), *The World's Writing Systems*, 172–82.

34 See, e.g., J. Ray, 'An approach to the Carian script', *Kadmos* 20 (1981), 150–62; 'The Carian Script', *Proceedings of the Cambridge Philological Society* 208, n.s. 28 (1982), 77–90; P. Swiggers and W. Jenniges, 'The Anatolian alphabets', in Daniels and Bright, *The World's Writing Systems*, 281–7, esp. 285–6.

35 A. Parpola, 'The Indus script', in Daniels and Bright, *The World's Writing Systems*, 165–9.

36 A. Parpola, *Deciphering the Indus Script* (Cambridge, 1994).

37 See, e.g., Chadwick, 'Linear B', 178–82, 190–4; E.L. Bennett, 'Aegean scripts', in P.T. Daniels and Bright, *The World's Writing Systems*, 125–33, esp. 132–3.

38 See, e.g., M.A. Marci, 'Rongorongo of Easter Island', Daniels and Bright, *The World's Writing Systems*, 185–8; S.R. Fischer, *Rongorongo: The Easter Island Script* (Oxford, 1997).

39 Esperanto was one of several nineteenth-century attempts to create an international language in the wake of the decline of Latin as a scholarly tongue. As expressed in the sound of its name, Esperanto leaned heavily on the Romance languages. Other efforts include Latin-based Interlingua and the Germanic Volapük. The Elvish languages which appear in J.R.R. Tolkien's fictional works, including *The Lord of the Rings* (London, 1954–5) are modelled on Welsh and Finnish.

40 See J. Simpson, 'Warumungu (Australian – Pama-Nyungan)', in A. Spencer and A.M. Zwicky (eds), *The Handbook of Morphology* (Oxford, 1998), 707–36.

41 See, for example, J.L. Halio, *Shakespeare: The Merchant of Venice* (Oxford, 1993), 1–83; A. Sinfield, *Cultural Politics: Queer Reading* (London, 1994), 1–20.

42 L. Coulon, 'Véracité et rhétorique dans les autobiographies égyptiennes de la Première Période Intermédiaire', *BIFAO* 97 (1997), 109–38.

43 See H. Fischer, *Dendera in the Third Millennium B.C.* (New York, 1968), 136–53; two blocks from the mastaba are now in the British Museum: EA 1260 and 1264.

44 É. Chassinat, *Le temple d'Edfou* IV (Cairo, 1929), 389–91; study and translation: P. Derchain, 'Des usages de l'écriture: réflexions d'un savant égyptien', *CdE* 72 (1997), 10–15.

45 E.g. B. Kemp, 'In the shadow of texts: archaeology in Egypt'. *Archaeological Review from Cambridge* 3.2 (1984), 19–28; D. O'Connor, 'Ancient Egypt: Egyptological and anthropological perspectives', in Lustig, *Egyptology and Anthropology*, 13–24.

46 J. Hawthorn, *Cunning Passages: New Historicism, Cultural Materialism and Marxism in Contemporary Literary Debate* (London and New York, 1996), 75–81.

47 *Mémoires d'Hadrien* (1951), in *Oeuvres romanesques* (Paris, 1982), 302–3.

48 J. Milton, *Areopagitica: A Speech of Mr John Milton for the Liberty of the Unlicens'd Printing, to the Parliament of England* (London, 1644).

THE DEMOTIC TEXT
OF THE MEMPHIS DECREE
ON THE ROSETTA STONE

A TRANSLATION BY R.S. SIMPSON

Revised version from R.S. Simpson, *Demotic Grammar in the Ptolemaic Sacerdotal Decrees* (Oxford, 1996), 258–71.

[Year 9, Xandikos day 4], which is equivalent to the Egyptian month, second month of Peret, day 18, of the King 'The Youth who has appeared as King in the place of his Father', the Lord of the Uraei 'Whose might is great, who has established Egypt, causing it to prosper, whose heart is beneficial before the gods', (the One) Who is over his Enemy 'Who has caused the life of the people to prosper, the Lord of the Years of Jubilee like Ptah-Tenen, King like Pre', [the King of the Upper Districts and] the Lower Districts 'The Son of the Father-loving Gods, whom Ptah has chosen, to whom Pre has given victory, the Living Image of Amun', the Son of Pre 'Ptolemy, living forever, beloved of Ptah, the Manifest God whose excellence is fine', son of Ptolemy and Arsinoe, the Father-loving Gods, (and) the Priest of Alexander and the Saviour Gods and [the Brother-and-Sister Gods and the] Beneficent [Gods] and the Father-loving Gods and King Ptolemy, the Manifest God whose excellence is fine, Aetos son of Aetos; while Pyrrha daughter of Philinos was Prize-bearer before Berenice the Beneficent, while Areia daughter of Diogenes was [Basket]-bearer [before Arsi]noe the Brother-loving, and while Eirene daughter of Ptolemy was Priestess of Arsinoe the Father-loving: on this day, a decree of the *mr-šn* priests and the *ḥm-nṯr* priests, and the priests who enter the sanctuary to perform clothing rituals for the gods, and the scribes of the divine book and the scribes of the House of Life, and the other priests who have come from the temples of Egypt [to Memphis on] the festival of the Reception of the Rulership by King Ptolemy, living forever, beloved of Ptah, the Manifest God whose excellence is fine, from his father, who have assembled in the temple of Memphis, and who have said:

Whereas King Ptolemy, living forever, the Manifest God whose excellence is fine, son of King Ptolemy [and Queen] Arsinoe, the Father-loving Gods, is wont to do many favours for the temples of Egypt and for all those who are subject to his kingship, he being a god, the son of a god and a goddess, and being like Horus son of Isis and Osiris, who protects his father Osiris, and his heart being beneficent concerning the gods, since he has given much money and much grain to the temples of Egypt, [he having undertaken great expenses] in order to create peace in Egypt and to establish the temples, and having rewarded all the forces that are subject to his rulership; and of the revenues and taxes that were in force in Egypt he had reduced some or(?) had renounced them completely, in order to cause the army and all the other people to be prosperous in his time as [king; the arrear]s which were due to the King from the people who are in Egypt and all those who are subject to his kingship, and (which) amounted to a large total, he renounced; the people who were in prison and those against whom there had been charges for a long time, he released; he ordered concerning

the endowments of the gods, and the money and the grain that are given as allowances to their [temples] each year, and the shares that belong to the gods from the vineyards, the orchards, and all the rest of the property which they possessed under his father, that they should remain in their possession; moreover, he ordered concerning the priests that they should not pay their tax on becoming priests above what they used to pay up to Year 1 under his father; he released the people [who hold] the offices of the temples from the voyage they used to make to the Residence of Alexander each year; he ordered that no rower should be impressed into service; he renounced the two-thirds share of the fine linen that used to be made in the temples for the Treasury, he bringing into its [correct] state everything that had abandoned its (proper) condition for a long time, and taking all care to have done in a correct manner what is customarily done for the gods, likewise causing justice to be done for the people in accordance with what Thoth the Twice-great did; moreover, he ordered concerning those who will return from the fighting men and the rest of the people who had gone astray (*lit.* been on other ways) in the disturbance that had occurred in Egypt that [they] should [be returned] to their homes, and their possessions should be restored to them; and he took all care to send (foot)soldiers, horsemen, and ships against those who came by the shore and by the sea to make an attack on Egypt; he spent a great amount in money and grain against these (enemies), in order to ensure that the temples and the people who were in Egypt should be secure; he went to the fortress of Šk3n [which had] been fortified by the rebels with all kinds of work, there being much gear and all kinds of equipment within it; he enclosed that fortress with a wall and a dyke(?) around (*lit.* outside) it, because of the rebels who were inside it, who had already done much harm to Egypt, and abandoned the way of the commands of the King and the commands [of the god]s; he caused the canals which supplied water to that fortress to be dammed off, although the previous kings could not have done likewise, and much money was expended on them; he assigned a force of footsoldiers and horsemen to the mouths of those canals, in order to watch over them and to protect them, because of the [rising] of the water, which was great in Year 8, while those canals supply water to much land and are very deep; the King took that fortress by storm in a short time; he overcame the rebels who were within it, and slaughtered them in accordance with what Pre and Horus son of Isis did to those who had rebelled against them in those places in the Beginning; (as for) the rebels who had gathered armies and led them to disturb the nomes, harming the temples and abandoning the way of the King and his father, the gods let him overcome them at Memphis during the festival of the Reception of the Rulership which he did from his father, and he had them slain on the wood; he remitted the arrears that were due to the King from the temples up to Year 9, and amounted to a large total of money and grain; likewise the value of the fine linen that was due from the temples from what is made for the Treasury, and the verification fees(?) of what had been made up to that time; moreover, he ordered concerning the artaba of wheat per aroura of land, which used to be collected from the fields of the endowment, and likewise for the wine per aroura of land from the vineyards of the gods' endowments: he renounced them; he did many favours for Apis and Mnevis, and the other sacred animals that are honoured in Egypt, more than what those who were before him used to do, he being devoted to their affairs at all times, and giving what is required for their burials, although it is great and splendid, and providing what is dedicated(?) in their temples when festivals are celebrated and burnt offerings made before them, and the rest of the things which it is fitting to do; the honours which are due to the temples and the other honours of Egypt he caused to be established in their (proper) condition in accordance with the law; he gave much gold, silver, grain, and other items for the Place of Apis; he had it adorned with new work as very fine work; he had new temples, sanctuaries, and altars set up for the gods, and caused others to assume their (proper) condition, he having the heart of a beneficent god concerning the gods and enquiring after the honours of the temples, in order to renew them in his time as king in the manner that is fitting; and the gods have given him in return for these things strength, victory, success(?), prosperity, health, and all the (*sic*) other favours, his kingship being established under him and his descendants forever:

With good fortune! It has seemed fitting to the priests of all the temples of Egypt, as to the honours which are due

to King Ptolemy, living forever, the Manifest God whose excellence is fine, in the temples, and those which are due to the Father-loving Gods, who brought him into being, and those which are due to the Beneficent Gods, who brought into being those who brought him into being, and those which are due to the Brother-and-Sister Gods, who brought into being those who brought them into being, and those which are due to the Saviour Gods, the ancestors of his ancestors, to increase them; and that a statue should be set up for King Ptolemy, living forever, the Manifest God whose excellence is fine – which should be called 'Ptolemy who has protected the Bright Land', the meaning of which is 'Ptolemy who has preserved Egypt' – together with a statue for the local god, giving him a scimitar of victory, in each temple, in the public part of the temple, they being made in the manner of Egyptian work; and the priests should pay service to the statues in each temple three times a day, and they should lay down sacred objects before them and do for them the rest of the things that it is normal to do, in accordance with what is done for the other gods on the festivals, the processions, and the named (holi)days; and there should be produced a cult image for King Ptolemy, the Manifest God whose excellence is fine, son of Ptolemy and Queen Arsinoe, the Father-loving Gods, together with the (sic) shrine in each temple, and it should be installed in the sanctuary with the other shrines; and when the great festivals occur, on which the gods are taken in procession, the shrine of the Manifest God whose excellence is fine should be taken in procession with them; and in order that the shrine may be recognized, now and in the rest of the times that are to come, ten royal diadems of gold should be added – there being one uraeus on them each, like what is normally done for the gold diadems – on top of the shrine, instead of the uraei that are upon the rest of the shrines; and the drouble crown should be in the centre of the diadems, because it is the one with which the King was crowned in the temple of Memphis, when there was being done for him what is normally done at the Reception of the Rulership; and there should be placed on the upper side of (the) square(?) which is outside the diadems, and opposite the gold diadem that is described above, a papyrus plant and a 'sedge' plant; and a uraeus should be placed on a basket with a 'sedge' under it on the right of the side on top of the shrine, and a uraeus with a basket under it should be placed on a papyrus on the left, the meaning of which is 'The King who has illumined Upper and Lower Egypt'; and whereas fourth month of Shemu, last day, on which is held the birthday of the King, has been established already as a procession festival in the temples, likewise second month of Peret, day 17, on which are performed for him the ceremonies of the Reception of the Rulership – the beginning of the good things that have happened to everyone: the birth of the King, living forever, and his reception of the rulership – let these days, the 17th and the last, become festivals each month in all the temples of Egypt; and there should be performed burnt offerings, libations, and the rest of the things that are normally done on the other festivals, on both festivals each month; and what is offered in sacrifice(?) should be distributed as a surplus(?) to the people who serve in the temple; and a procession festival should be held in the temples and the whole of Egypt for King Ptolemy, living forever, the Manifest God whose excellence is fine, each year, from first month of Akhet, day 1, for five days, with garlands being worn, burnt offerings and libations being performed, and the rest of the things that it is fitting to do; and the priests who are in each of the temples of Egypt should be called 'The Priests of the Manifest God whose excellence is fine' in addition to the other priestly titles, and they should write it on every document, and they should write the priesthood of the Manifest God whose excellence is fine on their rings and they should engrave it on them; and it should be made possible for the private persons also who will (so) wish, to produce the likeness of the shrine of the Manifest God whose excellence is fine, which is (discussed) above, and to keep it in their homes and hold the festivals and the processions which are described above, each year, so that it may become known that the inhabitants of Egypt pay honour to the Manifest God whose excellence is fine in accordance with what is normally done;

and the decree should be written on a stela of hard stone, in sacred writing, document writing, and Greek writing, and it should be set up in the first-class temples, the second-class temples and the third-class temples, next to the statue of the King, living forever.

GLOSSARY

Akhet
The first of the three seasons of the Egyptian civil calender, the 'inundation'.

alphabet
A type of writing system that records consonants and vowels.

biconsonantal sign
A sign writing two consonants.

bilingual
A text written in two languages.

biscript
A text written in two scripts.

cartouche
An elongated *shen* sign enclosing royal names, symbolic of the king's power encircling (*shen*) the world, and a protective emblem.

colophon
Text at the end of a manuscript copy, often naming the copyist.

consonant
A short part of an utterance in which obstruction to the air stream is created in the vocal tract.

cuneiform
Type of script with signs comprising wedge-shaped lines, originally written on mud tablets, used to write a range of languages, including Akkadian and Sumerian.

demotic
The highly cursive Egyptian script and the language written in this script.

determinative
A sign indicating the lexical class of a word in Egyptian.

Dual King
A title, literally perhaps 'He of the Reed, He of the Bee', which refers to two aspects of the kingship that were paired with Upper and Lower Egypt, so that it is often rendered 'King of Upper and Lower Egypt'. It introduces the royal prenomen (throne name).

Golden Horus
The third element of the royal titulary; it refers to the king as the triumphant god Horus.

hieratic
A cursive version of the hieroglyphic script, designed to be written by pens.

hieroglyph
A sign of the ancient Egyptian writing script, comprising pictorial images.

Horus
The first element of the royal titulary, acclaiming the king as the royal god.

House of Life
The temple scriptorium.

ideogram
A sign recording a concept or idea.

Ipetsut
The temple of Amun at Karnak.

ligature
Two or more signs joined together.

logogram
A sign that records the meaning but not the pronunciation of a word/morpheme.

logosyllabary
A type of writing system whose signs record words, and some of whose signs are also used for the phonetic (and not semantic) value.

l.p.h.
An abbreviation for 'May he live, be prosperous, and healthy!' – an invocation of well-being for superiors, especially the king – written after names. It is partly a graphic convention, and was probably never read out loud.

mastaba
(Arabic 'bench') A term for a type of tomb with a superstructure resembling Arabic mud-brick benches.

nomarch
The governor of a 'nome', one of the forty-two provinces of Egypt.

orthography
The standardized spelling of words and texts.

ostracon
A flake of limestone or pottery used as a convenient, and often disposable, writing surface.

P.
Papyrus, followed by a name or museum number.

palette
1. Portable surface on which to grind pigments and eye-paint, often ceremonial; 2. Scribal implement, usually combining pen-case and inkwells.

Peret
The second season of the Egyptian civil calendar, 'winter'.

Person
A term designating the physical person of the king or of a god; often conventionally rendered 'majesty'.

phoneme
A minimal sound of speech.

phonogram
A sign that records a sound.

recto
The 'front' of a papyrus sheet or roll (with horizontal fibres uppermost) and of a writing board.

rubric
Phrase or passage of a manuscript which is written in red ink.

serdab
A sealed statue chamber in Egyptian mastaba tombs.

semogram
A sign recording meaning, rather than specific sounds or words.

shabti
A funerary statuette placed in the tomb to act as a substitute of the deceased for labour-duty in the other world, often commemorative.

Shemu
The third season of the Egyptian civil calendar, 'summer'.

Son of the sun-god
A title of the king, prefacing the nomen (birth name), and alluding to his divine lineage.

stela
An inscribed and/or decorative tablet.

syllabary
A type of writing system whose signs record syllables.

transcription
The Egyptological process of copying an inscription or cursive text into modern versions of the hieroglyphic signs.

transliteration
The Egyptological process of transferring a text from the Egyptian scripts into a modified version of the roman alphabet.

triconsonantal sign
A sign recording three consonants.

true-of-voice
An epithet referring to judgement after death, thus indicating the person as 'deceased'.

Two Ladies
The patron goddesses of Upper and Lower Egypt, who appear on the royal diadem; a royal title, introducing the second element of the titulary.

Two Lands
Egypt: the strips of land on either side of the Nile, the two halves of the country.

uniconsonantal sign
A sign recording a single consonant.

uraeus
An image of a serpent worn on the royal brow, a protective symbol to strike down the king's enemies.

verse-point
A (almost always) red dot placed in hieratic texts to indicate the end of a metrical line of verse.

verso
The 'back' of a papyrus sheet or roll (with vertical fibres uppermost), and of a writing board.

vowel
A short part of an utterance in which no obstruction to the air stream is created in the vocal tract.

SELECT BIBLIOGRAPHY

Andrews, C., *The Rosetta Stone* (London, 1982).

Andrews, C. and Quirke, S., *The Rosetta Stone: Facsimile Drawing* (London, 1988).

Assmann, J., 'Ancient Egypt and the materiality of the sign', in H.U. Gumbrecht and K.L. Pfeiffer (eds), *Materialities of Communication* (Stanford, 1994), 15–31.

Bagnall, R. *Egypt in Late Antiquity* (Princeton, 1993).

Boas, G., *The Hieroglyphics of Horapollo*, with foreword by A.T. Grafton; Bollingen Series 23 (Princeton, 1993 [1st edn 1950]).

Bowman, A.K. *Egypt after the Pharaohs 332 BC–AD 642: From Alexander to the Arab Conquest* (London, 1986).

Černý, J., *Paper and Books in Ancient Egypt* (Chicago, 1977 [1st edn 1952]).

Chauveau, M., *L'Égypte au temps de Cléopâtre 180–30 av. J.-C.* (Paris, 1997).

Collier, M., and Manley, B., *How to Read Egyptian Hieroglyphs* (London, 1998).

Daniels, P.T., and Bright, W. (eds), *The World's Writing Systems* (New York and London, 1996).

Davies, W.V., *Reading the Past: Egyptian Hieroglyphs* (London, 1987).

Depauw, M., *A Companion to Demotic Studies*, Papyrologica Bruxellensia 28 (Brussels, 1997).

Derchain, P., *Le dernier obélisque* (Brussels, 1987).

Dewachter, M., *Champollion: un scribe pour l'Égypte* (Paris, 1990).

Dewachter, M., and Fouchard, A. (eds), *L'égyptologie et les Champollion* (Grenoble, 1994).

Eco, U., *The Search for the Perfect Language* (London, 1997 [1st edn 1993]).

Faulkner, R.O., *A Concise Dictionary of Middle Egyptian* (Oxford, 1962).

Fiechter, J.-J., 'La pierre de Rosette et les autres antiquités égyptiennes prises par les anglais en 1801', *RdE* 48 (1997), 283–9.

Fischer, H.G., *L'écriture et l'art de l'Égypte ancienne: quatres leçons sur la paléographie et l'épigraphie pharaoniques* (Paris, 1986).

___, 'Hieroglyphen', *LÄ* II (Wiesbaden, 1977), 1189–99.

Gardiner, A.H., *Egyptian Grammar: Being an Introduction to the Study of Hieroglyphs* (3rd edn; Oxford, 1957).

Geertz, C., *The Interpretation of Cultures* (London and New York, 1973).

Goldwasser, O., *From Icon to Metaphor: Studies in the Semiotics of the Hieroglyphs*, OBO 142 (Fribourg and Göttingen, 1995)

Goody, J., *The Interface Between the Written and the Oral* (Cambridge, 1987).

Hannig, R., *Großes Handwörterbuch Ägyptisch–Deutsch* (Mainz, 1995).

Hartleben, H., *Champollion: sa vie et son ouevre 1790–1832* (Paris, 1983 [1st edn, German, 1906]).

Hooker, J.T. *et al.*, *Reading the Past: Ancient Writing from Cuneiform to the Alphabet* (London, 1990).

Iversen, E., *The Myth of Egypt and its Hieroglyphs in European Tradition* (Copenhagen, 1961).

Johnson, J.H., *Thus Wrote Onchsheshonqy: An Introductory Grammar of Demotic* (Chicago, 1991 [1st edn 1986]).

Junge, F., 'Sprache', in *LÄ* IV (1984), 1176–1214.

___, *Einführung in die Grammatik des Neuägyptischen: ein Lehrbuch* (Wiesbaden, 1996).

Kettel, J., *Jean-François Champollion le jeune: répertoire de bibiliographie analytique 1806–1989* (Paris, 1990).

Lacouture, J., *Champollion: un vie de lumiéres* (Paris, 1988).

Laissus, Y. *et al.*, *Il y a 200 ans, les savants en Égypte* (Paris, 1998).

Le Roy Ladurie, E. *et. al.*, *Memoires d'Égypte: hommage de l'Europe à Champollion* (exhibition publication; Strasbourg, 1990).

Lambdin, T.O., *Introduction to Sahidic Coptic* (Macon, GA, 1983).

Lichtheim, M., *Ancient Egyptian Literature: A Book of Readings*, 3 vols (Berkeley, 1973–80).

Loprieno, A., *Ancient Egyptian: A Linguistic Introduction* (Cambridge, 1995).

___ (ed.), *Ancient Egyptian Literature: History and Forms* (Leiden, 1996).

Malek, J., *A B C of Egyptian Hieroglyphs* (Oxford, 1994).

Parkinson, R.B., *Voices from Ancient Egypt: An Anthology of Middle Kingdom Writings* (London, 1991).

Parkinson, R. and Quirke, S., *Papyrus*, Egyptian Bookshelf (London, 1995).

Pestman, P.W., *The New Papyrological Primer* (Leiden, 1990).

Pope, M., *The Story of Decipherment: From Egyptian Hieroglyphic to Linear B* (London, 1975).

Sass, B., *The Genesis of the Alphabet and its Development in the Second Millennium B.C.*, ÄUAT 13 (Wiesbaden, 1988).

___, *Studia Alphabetica: On the Origin and Early History of the Northwest Semitic, South Semitic and Greek Alphabets*, OBO 102 (Fribourg and Göttingen, 1991).

Sasson, J.M. *et al.* (eds), *Civilizations of the Ancient Near East*, 4 vols (New York, 1995).

Simpson, R.S., *Demotic Grammar in the Ptolemaic Sacerdotal Decrees* (Oxford, 1996).

Thompson, D.J., *Memphis Under the Ptolemies* (Princeton, 1988).

Thompson, J., *Sir Gardner Wilkinson and his Circle* (Austin, TX, 1992).

Tiradritti, F., *Sesh: Lingue e scritture nell'antico Egitto* (Milan, 1999).

Trigger, B.G., 'Writing systems: a case study in cultural evolution', *Norwegian Archaeological Review* 31 (1998), 39–62.

Valbelle, D. and Solé, R. *La pierre de Rosette* (Paris, in press).

Whitehouse, H., 'Egypt in European thought', in J.M. Sasson *et al.* (eds), *Civilizations of the Ancient Near East* (New York, 1995) I, 15–31.

Wood, A. and Oldham, F., *Thomas Young: Natural Philosopher 1773–1829* (Cambridge, 1954).

CONCORDANCE
OF BRITISH MUSEUM EA INVENTORY NUMBERS

Inventory numbers are listed with catalogue entry numbers in bold;
other numbers refer to figure and plate numbers.

EA 24	figs 3, 5, 6, 7, 8, 11; pls 1, 3	EA 2291	**9**	EA 10735.10	**13**	EA 46655	**2**
		EA 2295	**14**	EA 10759.3	**15**	EA 47547	fig. 30
EA 103	**51**	EA 2331	**44**	EA 10808	fig. 21	EA 47962	**16b**
EA 137	**39**	EA 2436	fig. 20	EA 12778	**60**	EA 47963	**16c**
EA 194	**10**	EA 4947	**19**	EA 12784	**58**	EA 47971	**16d**, pl. 16
EA 205	**65**	EA 5521	**59**	EA 12896	**31c**	EA 48109	**85**
EA 253	fig. 25	EA 5547	**61**	EA 13355	**50**	EA 48703	**11**
EA 374	**72**	EA 5610	**5**, pl. 12	EA 13714	**31d**	EA 49343	**53**
EA 467	**41**	EA 5629	**79**, pl. 28	EA 14222	**28**	EA 50714	**82**
EA 571	fig. 54	EA 5634	**76**	EA 20945	**23**	EA 50716	**20**
EA 576	**36**	EA 5640	**67**	EA 23424	**83**	EA 52882	**66**
EA 616	fig. 10	EA 5646	**64**	EA 24405	fig. 28	EA 52883	fig. 47
EA 636	**3**, pl. 10	EA 6640	**21**	EA 24430	**40**	EA 54460	**29**, pl. 17
EA 644	fig. 27	EA 7925	**52**	EA 24653	**45**	EA 54829	**48**
EA 694	**75**	EA 9901.8	fig. 29	EA 26794	**31b**	EA 55586	**1**
EA 695	**75**	EA 9935B.1	**78**	EA 29547	**63**	EA 57372	**62**
EA 782	**6**, pl. 13	EA 9994.5	fig. 45	EA 29562	**43**	EA 58953	**31a**, pl. 19
EA 838	**24**	EA 9994.7	**47**	EA 30360	**7**, pl. 14–15	EA 59205	**74**
EA 872	**33**, pl. 20	EA 10016.2	**81**, pl. 29	EA 32782	**27**	EA 59776	**18**
EA 888	**37**	EA 10018.2	fig. 55	EA 33940	**70**, pl. 27	EA 61610	fig. 31
EA 901	fig. 58	EA 10051.4	**12**	EA 35401	**49**	EA 63783	**69**
EA 1000	**54**	EA 10061	**77**	EA 35878	**56**, pl. 25	EA 65224	fig. 22
EA 1020	fig. 9	EA 10070.2	**25**	EA 36298	pl. 9	EA 65453	fig. 23
EA 1072	**35**	EA 10113	**22**	EA 37925	**84**	EA 66830	**17**
EA 1102	**55**	EA 10182.1	pl. 8	EA 37976	**38**, pl. 21	EA 67235	fig. 71
EA 1104	**8**	EA 10183.10	**80**	EA 37978	**38**, pl. 22	EA 67970	**31e**
EA 1291	fig. 49	EA 10202	fig. 26	EA 38276	**32**	EA 71005.3	**26**
EA 1419	**16a**	EA 10284	**73**	EA 41077	fig. 32	EA 71539	**4**, pl. 11
EA 1429a	**34**	EA 10298	fig. 19	EA 41541	**71**	EA 90380	**86**
EA 1471	fig. 33	EA 10303	fig. 35	EA 41573	**42**, pl. 23	EA 90422	fig. 24
EA 1514	**46**	EA 10470.22	fig. 44	EA 41643	**30**, pl. 18		
EA 1542	fig. 42	EA 10683.3	**68**	EA 41748	fig. 59, pl. 31		
EA 1623	fig. 39	EA 10731	fig. 43	EA 43468	**57**, pl. 26		

CHRONOLOGY

All dates before 664 BC are approximate; the chronology follows
J. Baines and J. Malek, *Atlas of Ancient Egypt* (Oxford, 1980).

Predynastic Period, followed by 0th Dynasty	4500–2920
Early Dynastic Period	2920–2575
1st Dynasty	2920–2770
2nd Dynasty	2770–2649
3rd Dynasty	2649–2575
Old Kingdom	2575–2134
4th Dynasty	2575–2465
5th Dynasty	2465–2323
6th Dynasty	2323–2150
7th/8th Dynasty	2150–2134
First Intermediate Period	2134–2040
9th/10th Dynasty	2134–2040
11th Dynasty	2134–2040
Middle Kingdom	2040–1640
11th Dynasty (all Egypt)	2040–1991
12th Dynasty	1991–1783
13th Dynasty	1783–after 1640
Second Intermediate Period	1640–1532
14th–16th Dynasties	1640–1532
17th Dynasty	1640–1550
New Kingdom	1550–1070
18th Dynasty	1550–1307

Ramesside Period	1307–1070
19th Dynasty	1307–1196
20th Dynasty	1196–1070
Third Intermediate Period	1070–712
21st Dynasty	1070–945
22nd Dynasty	945–712
23rd Dynasty	828–712
24th Dynasty	724–712
25th Dynasty	770–712
Late Period	712–332
25th Dynasty (all Egypt)	712–657
26th Dynasty	664–525
27th (Persian) Dynasty	525–404
28th Dynasty	404–399
29th Dynasty	399–380
30th Dynasty	380–343
Second Persian Period	343–332
Greco-Roman Period	332 BC–AD 395
Macedonian Dynasty	332–304 BC
Ptolemaic Dynasty	304–30 BC
Roman Period	30 BC–AD 395
Coptic Period	AD 395–639

INDEX